Ocean
Endangered

AUTHORS

Russell Arnott studied at the National Oceanography Centre and after working as a commercial oceanographer, eventually retrained to become a science teacher. Leaving formal education to form Incredible Oceans, a marine education non-profit, Russell is also a researcher at the University of Bath where he studies plankton dynamics. www.incredibleoceans.org

Celine van Weelden worked with the World Cetacean Alliance and its educational partner, Incredible Oceans, for several years during which she acted as a marine educator and science communicator with marine organizations across the globe. Having studied Environmental Sciences at Leiden University College (Netherlands), Celine's expertise and passion focuses on the impacts of climate change on marine mammals.

FOREWORD

Maya Plass has been a dedicated marine science communicator and educator for over twenty years. During this time she has established her own marine education business, digressed into TV broadcasting and become an author of seashore books. Ultimately, her experience and passion in communicating marine science has led to her position as Head of Communications at The Marine Biological Association (Devon, UK).

Publisher and Creative Director: Nick Wells
Commissioning Editor: Polly Prior
Editorial Director: Catherine Taylor
Art Director: Mike Spender
Digital Design and Production: Chris Herbert
Copy Editor: Catherine Bradley

Special thanks to Dawn Laker and Helen Snaith

FLAME TREE PUBLISHING
6 Melbray Mews
Fulham, London SW6 3NS
United Kingdom

flametreepublishing.com

First published 2021

21 22 23 24 25
1 2 3 4 5 6 7 8 9 10

© 2021 Flame Tree Publishing Ltd

A CIP record for this book is available from the British Library upon request.

ISBN: 978-1-83964-482-5
SPECIAL ISBN: 978-1-83964-824-3

Printed in China

Used under license from Shutterstock.com and © the following: Cigdem Sean Cooper 1 & 100; Edward Haylan 6 & 84; Ethan Daniels 7 & 107, 94 inset; fokke baarssen 8 & 186; Noah Labinaz 9 & 187; ginger_polina_bublik 10; TravelMediaProductions 13; GROGL 14; Ekaterina Uryupova 17; Tony Brindley 18; Tarpan 19 inset, 124; Sergey 402 23; james_stone76 25 & 3; LouieLea 26; FloridaStock 27; Adwo 28; AMFPhotography 29; Ulannaq Ingemann 30 inset; knyazev vasily 31; Love Lego 32; muratart 34; reisegraf.ch 35; lunamarina 36; AndreAnita 39; Ondrej Prosicky 40; Pajor Pawel 42; Helen Hotson 45; Ken Morris 46; Heather Lucia Snow 47; Kim Pin 48; nwdph 49; Brandon B 50; Andi111 51 inset; Anita Kainrath 53; Nattapon Ponbumrungwong 54, 95; Michael G McKinne 55; Arturo Verea 56 inset; Daniel Humberto Umana 57; Ting Cheng 58; Studio Peace 60; Debbie Ann Powell 61; Daniel Carlson 62, 68; megastocker 64; Ryan Yee 66; Kristi Blokhin 67 inset; Jenny Kellam 69; Roschetzky Photography 70; Luca Fabbian 73; Baronb 74; Jacquie Klose 75 inset; Solarisys 76; Jen Watson 80; Joe Belanger 81; wildestanimal 83, 148; Richard Whitcombe 85; Martin Voeller 86; JP74 87; Vladimir Krupenkin 89 inset; Jonathan Hernould 92 & 192; Damsea 93; Suzana Tran 96; Vojce 98; Jesus Cobaleda 101 inset; Dietmar Temps 103; Oleg GawriloFF 104; Maximillian cabinet 106; Subphoto 108; ChameleonsEye 109; ScubaPonnie 110; Brocreative 112; Letowa 113; Ovidiu Hrubaru 115; James Jones Jr 116; MAGNIFIER 118; Graham D Elliott 119; Anthony Pierce/Splashdown 120; Broadbelt 121; Gonzalo Jara 123; Sergey Uryadnikov 125; Petr Civis 126; thediver 128; Andrea Izzotti 129; Riska Parakeet 130; Rich Carey 132; andrey polivanov 133; MOHAMED ABDULRAHEEM 134; David Pereiras 135 inset; Choksawatdikorn 136; Atosan 137; Alex Linch 139; Maui Topical Images 141; Fedorova Nataliia 142; Conny Pokorny 143; sergemi 147; Picture Partners 152 main; Anney_Lier 168; n/a 169 inset; feathercollector 170; JeremyRichards 174; The Art of Pics 175; Chase Dekker 178; Monkey Business Images 181; Tunatura 182; Inside Creative House 183; jo Crebbin 185; Russ Heinl 188; Marius Dobilas 189. **Supplied by SuperStock and the following:** Alex Mustard/NaturePL 5 & 79; Ton Koene/VWPics/Visual & Written 15; Flip Nicklin/Minden Pictures 16 inset, 21, 78 inset; Steve Bloom/Steve Bloom Images 20; G&M Therin-Weise/robertharding 22; Stocktrek Images 24; World History Archive 33 inset, 162, 163, 171; Minden Pictures 38, 153 inset; ALFRED PASIEKA/SPL/Science Photo Library 59; Marga Werner/age fotostock 65; imageBROKER/Mathieu Foulquié 88, 91; Westend61 99; Biosphoto 105, 122, 159; Photoshot 114, 161; Helmut Corneli/imageBROKER 138 main; Pete Oxford/Minden Pictures 138 inset; BlueGreen Pictures 144, 152 inset, 167bl; SeaTops/imageBROKER 146 inset, 176; Doug Perrine/NaturePL 151; Norbert Wu/SuperStock 154; 1/NaturePL 155; Steve Downeranth/Pantheon 156; Nature Picture Library/NaturePL 157 inset, 158; © 2015 Norbert Wu, www.norbertw/Minden Pictures 160; VICTOR HABBICK VISIONS/SPL/Science Photo Library 172; NHPA 184 inset. **Courtesy of Natural History Museum, London, UK/Bridgeman Images:** 149 inset. **Courtesy of the NOAA Office of Ocean Exploration and Research:** 167br; 2016 Deepwater Exploration of the Marianas 164, 165, 167tr, 167cr; UAF/Oceaneering 166; Exploration of the Gulf of Mexico 2014 167tl. **Courtesy of Ifremer/Nautile/Nodinaut, 2004/© Ramirez-Llodra et al./Creative Commons Attribution 4.0 International license:** 173.

Ocean
Endangered

**Russell Arnott &
Celine van Weelden**

Foreword by Maya Plass

FLAME TREE
PUBLISHING

Contents

Foreword

My personal relationship with the ocean started at a very young age. Moving to live by the coast, a lifelong love of all things marine (both scientific and adventurous) was embedded deep in my veins. This led to my studying marine biology, as I was keen to understand more about the ocean that I had grown to love and rely on. Through my studies, I realized the true importance of our ocean environment to many aspects of all our lives, wherever we might live.

However, it soon became dishearteningly apparent that too few knew the wonders of our ocean, considering how much we need a healthy ocean for a healthy life. Our ocean experiences increased threats from human activities. It is therefore vital that we ensure our wider society knows and becomes passionate about this 'natural wonder and vital resource' that Arnott and van Weelden so well describe in *Ocean: Endangered*.

Without a comprehensive understanding or our ocean and all that it holds, from coastlines to coral reefs, from our open ocean to its greatest depths, we are unlikely to feel passionate enough to want to support better practices which will secure a healthy future for our ocean and us. *Ocean: Endangered* covers much of the impressively diverse aspects of our ocean. It highlights the incredible adaptations of myriad marine species with wonderful imagery that will impel the reader to want to do more about harmful activities that threaten all areas of our ocean – and which are so clearly described.

Whether or not you live by the coast, *Ocean: Endangered* will nurture a love of our ocean, remind you of its value and provide solutions which have and will ensure our marine environment continues to sustain life on this awe-inspiring blue planet Earth.

Maya Plass

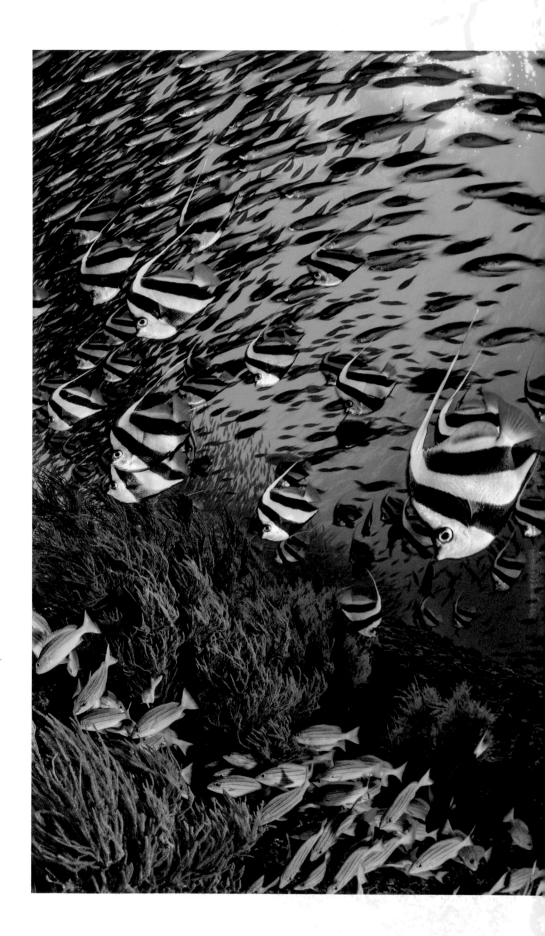

Introduction

We call our home, a small blue island floating in the vastness of space, Earth. But this name belies the fact that we are a planet of water. With over 70 per cent of Earth's surface covered by ocean, it is water that gives Earth its colour and water that has allowed life to flourish here. We now recognize that our ocean is vital to all life on Earth; whether at sea or only a few miles from the coast, the ocean sustains us all. Despite this, however, it is under threat as never before.

Our Blue Planet

Every schoolchild learns the different names of the ocean basins by rote: the Atlantic, the Pacific, the Indian Ocean, the Southern Ocean and so on. Displayed on the land-centric maps that adorn every classroom wall, it is easy to think of these as separate entities, walled in by the continents. Yet this could not be further from the truth. Looking at the ocean-centric map, or Spilhuis Projection, it is easy to see that we do indeed have only one ocean.

Throughout this book, you will find mention only of the singular 'ocean': a massive, all-encompassing expanse of water. This subtly highlights the interconnectedness of the aquatic realm. A shipment of 28,000 rubber ducks offers a bizarre testament to this. Having accidentally fallen overboard in the northern Pacific Ocean in 1992, rubber ducks quickly made landfall in Alaska and Hawaii. Gradually they started turning up on beaches further and further afield: Chile, Indonesia, even Australia. These ducks, having survived their trip across the Arctic Ocean, now wash up on beaches across Northern Europe.

Another important point is that referring to the singular 'ocean' may encourage us to care for it better. After all, an object becomes more precious if we know that we only have one of them.

A Watery Home

Often called the largest habitat on Earth, the ocean holds within it an immense variety of life. As well as covering a majority of Earth's surface, the ocean also comprises 99 per cent of the habitable space on this planet. The terrestrial habitat is effectively a two-dimensional plane, whereas the ocean is an ever-changing three-dimensional space. The marine biologist Diva Amon has summed it up best: 'we have only experienced around 0.1 per cent of our ocean.'

As well as the larger charismatic marine animals – turtles, whales, dolphins, seals – there are also the ubiquitous fish. At the time of writing, science recognizes at least 33,000 different species of fish, one quarter of which live on coral reefs around the world.

Feeding these fish are the tiny zooplankton; at their microscopic scale, water is as thick and viscous as treacle is to you or me. And just as land-based herbivores feed upon plants, these zooplankton feed upon phytoplankton – microscopic single-celled plants that not only underpin the marine foodweb but also, as plants, provide up to 80 per cent of the oxygen that you are currently breathing.

If we zoom in further still we encounter swarms of nanoplankton: countless bacteria that endlessly recycle elements and repurpose chemicals so that other organisms may use them. A single millilitre of water can hold up to one million bacteria. Multiplied over the entire ocean volume, their numbers become greater than the number of stars in the universe.

Carbon Capture

As plants, the phytoplankton not only produce oxygen but also absorb carbon dioxide (CO_2) from the atmosphere. Trapping this CO_2 inside them, the carbon then works its way along the foodweb, eventually descending into deep ocean sediments as organisms die and sink. When a whale carcass sinks into the deep ocean, an event known as a whale fall, it not only provides a bountiful feast for deep sea organisms but also sequesters around two tons of carbon per whale. However, it's not just whales that do this. Events known as jelly falls see enormous blooms of jellies descend into the depths, taking with them an estimated 6.8 billion tons of carbon – the equivalent of the entire annual carbon emissions of the US.

Overall, the ocean has absorbed around 40 per cent of the excess CO_2 we have released into the atmosphere by burning fossil fuels. But by continually

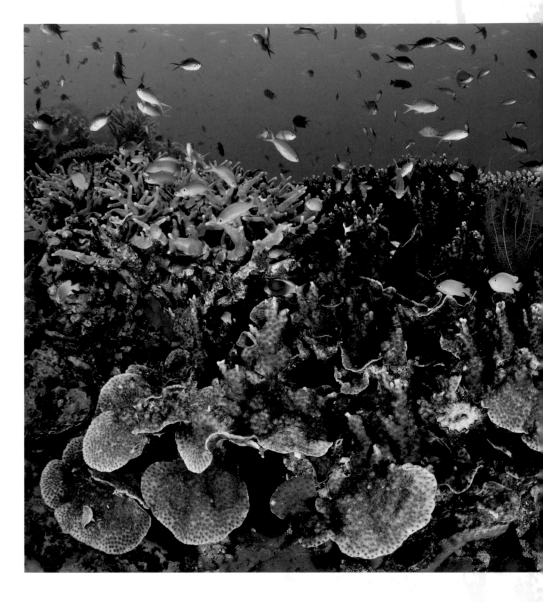

increasing the concentration of CO_2 in our atmosphere, we are forcing extra CO_2 into our ocean. While this does act to reduce the carbon in our atmosphere, a good thing for our climate, it comes at a cost; the CO_2 absorbed into the ocean reacts with water molecules to form carbonic acid, slowly acidifying our ocean in the process. Naturally our ocean would be slightly alkaline, but CO_2 absorption since the Industrial Revolution has made our ocean 30 per cent more acidic. This process, known as ocean acidification, is having dire consequences for marine life, affecting organisms' physiology, development and behaviour. Studies have also shown that acidified waters have a detrimental effect on the taste and texture of our seafood.

Climate Central

As well as absorbing additional CO_2 from our atmosphere, our ocean also absorbs heat. Heat radiation from the Sun is absorbed by water vapour and carbon dioxide in our atmosphere, but a sizeable proportion of this heat is also taken into our ocean. Over the past 40 years the ocean has absorbed a whopping 93 per cent of the additional heat created by global warming. Had this heat not been absorbed by the ocean, the average global surface air temperature would have increased by 36°C (65°F) instead of the 1.1°C (2°F) increase we are experiencing today.

The role of our ocean in regulating our climate has long been known. The wet, temperate climate of Ireland, the UK and Western Europe is a result of the Gulf Stream transporting warm water from the Caribbean across the North Atlantic. This ensures that these areas experience temperatures up to 10°C (18°F) higher than equivalent places at the same latitude. Compare the mild English winters to the harsh snowy conditions experienced in Nova Scotia, Canada.

It is often better to view the ocean and atmosphere as a coupled system working in tandem, each affecting the other. Nowhere is this more apparent than with the *El Niño* events of the equatorial Pacific. Under 'normal' conditions, the prevailing winds cause upwelling along the western coast of the South American continent. These nutrient-rich waters fertilize the upper ocean, resulting in a highly productive food web and thus productive fishing grounds. However, roughly every four years *El Niño* occurs, shifting wind patterns and effectively shutting down this upwelling. Named after the newborn Christ due to its occurrence at Christmas time, this phenomenon results in a total collapse of the fisheries. On the other side of the Pacific, an *El Niño* episode causes hot, dry summers in Australia, increasing the chance of bush fires, while India suffers from weaker monsoons and higher temperatures.

Rich Resource

The ocean offers us a rich bounty of food and minerals that are to be found within. The World Wildlife Fund (a.k.a. World Wide Fund for Nature) has estimated the total value of the ocean to be £18 trillion ($24 trillion). To put it another way, if the ocean were a country, it would have the seventh largest economy in the world – larger than that of Brazil or Russia. Further exploration only yields more resources; as our extraction technology improves, companies have begun to cast their eyes on the ocean floor. New estimates suggest that gold deposits hidden in the deep ocean could be worth up to £114 trillion ($150 trillion) – enough to give £16,000 ($21,000) to every person on Earth.

Then, of course, there is tourism. As millions flock to the seaside each year, our coasts throng with tourists looking to get their annual ocean fix. With over 70 million people a year visiting our coral reefs alone, this generates an annual income of £27 billion ($36 billion) for those countries lucky enough to have pristine reefs on their doorsteps. Just a single square kilometre of reef can generate £760,000 ($1 million) a year.

Monetary values aside, our ocean's true worth cannot be whittled down to a simple inventory or a budget list. Recent research is now also showing the health benefits to be gleaned from spending time in, on or around our ocean. While sea water itself has anti-inflammatory properties that can improve skin problems such as dermatitis and psoriasis, breathing sea air is known to improve sleep, depression and anxiety. Simply living next to the sea increases your longevity, in part because statistically people near the coast lead more active lifestyles. Who can put a price on that?

In Danger

Considering our ocean's importance in regulating our climate, feeding us and providing us with an income, you would think that we would have an innate respect for it. Unfortunately, this is far from the truth. For centuries humanity has treated the ocean as an infinite resource ripe for plundering, while simultaneously using it as a never-ending dumping ground. As research has progressed, we are becoming more aware than ever of the multitude of threats our ocean faces.

Overfishing, oil and gas extraction and plastic pollution are obvious and tangible impacts; we can quickly see, and feel, the consequences of these. But new, more subtle impacts, such as climate change and ocean acidification, are not only invisible and incremental; they are also difficult to comprehend. Trying to get scientists to communicate these intangible and abstract concepts to politicians and policy-makers is a challenge in itself – and that's before we even attempt to solve these issues.

Unfortunately, properly understanding our ocean means coming to grips with the array of multifaceted problems confronting it. As the philosopher Aldo Leopold put it, 'one of the penalties of an ecological education is that one lives in a world of wounds'.

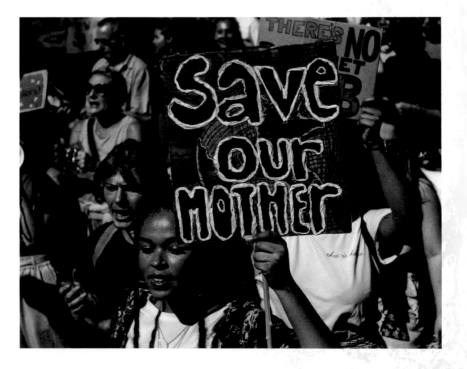

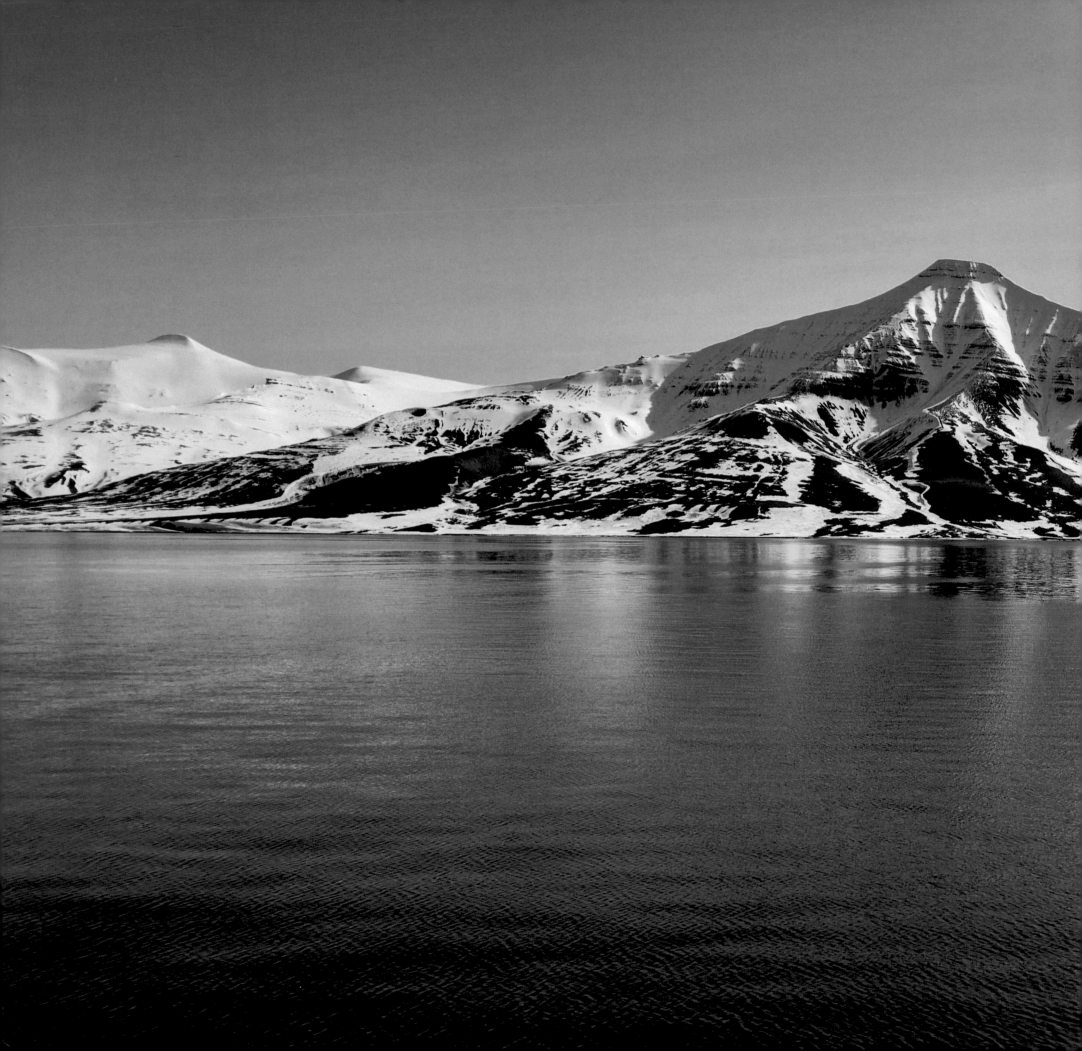

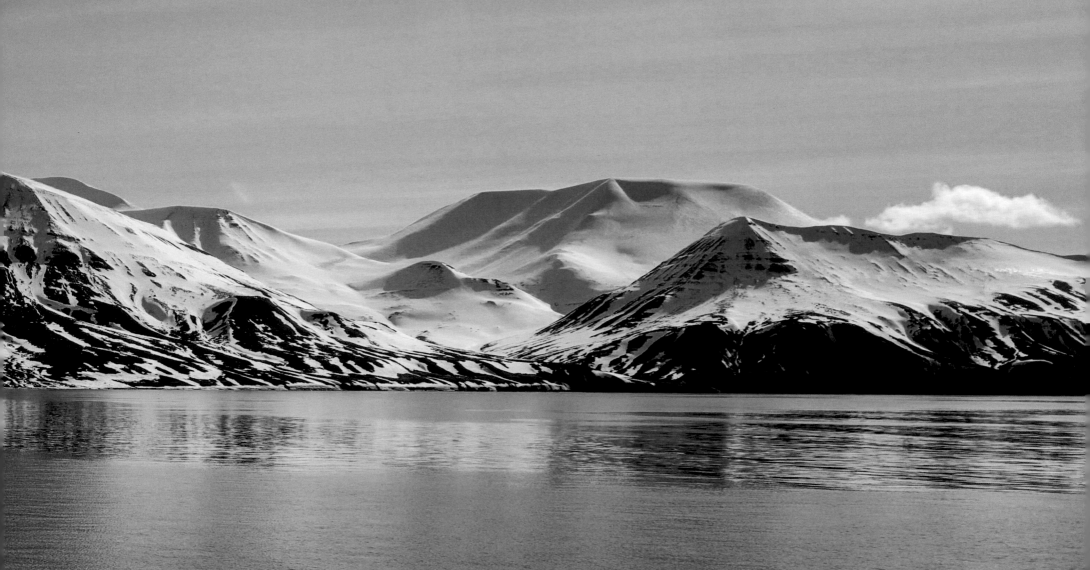

Polar Regions

The Ends of the Earth

White as far as the eye can see, with biting winds and months on end where the Sun does not rise or never sets. Despite temperatures as low as -80°C (-112°F) and up to 30 days of continuous darkness every year, these regions are home to an amazing variety of species. To many of us the icy wilderness of the polar regions appears untouched and pristine. Yet these unique ecosystems are already under extreme pressure and could change entirely within our lifetimes.

Polar Opposites

While to many people the poles are just two similar regions covered in snow and ice that happen to be at opposite ends of the globe, they are actually as different as they are far apart. The Arctic is a body of ice floating above an ocean basin that we are only beginning to explore. It has been the centre of many geopolitical conflicts as it lies within the territories of eight different countries and is home to over 40 distinct ethnic groups. Antarctica, on the other hand, is the world's most remote continent, almost 1000 km (621 miles) from the closest landmass, South America. Due to its isolation and lack of indigenous population, Antarctica cannot be legally owned by any single country. So little precipitation falls there that it is considered the largest desert on Earth. Yet although it is the driest continent, the Antarctic ice sheet contains almost 99 per cent of the fresh water on the planet. Except for a few thousand scientists, Antarctica remains uninhabited, but 13.1 million people currently live within the Arctic Circle.

Previous page: A sunny day off Spitsbergen, Svalbard, Norway.
Right: Towering sharp-edged glaciers resemble an immense stunning ice sculpture in Paradise Bay, Antarctica.

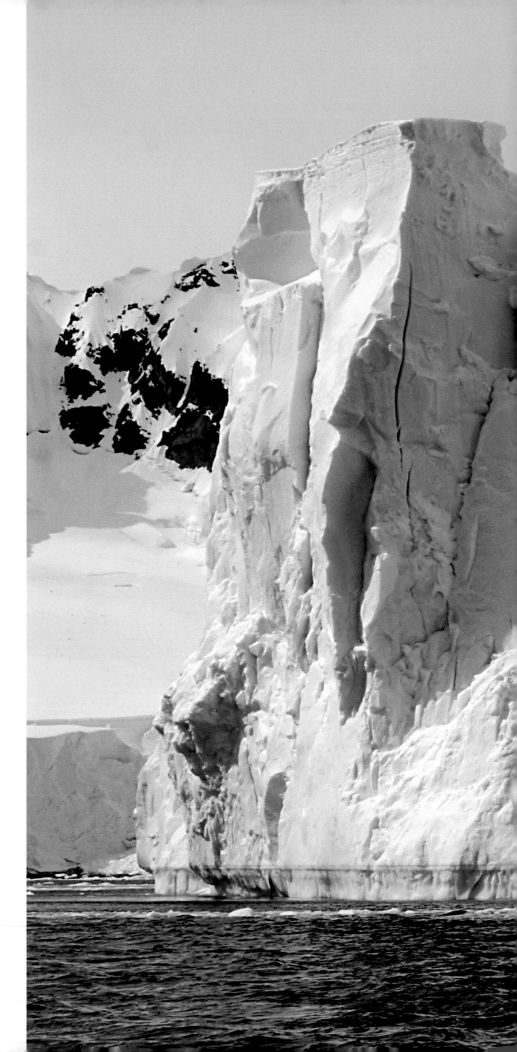

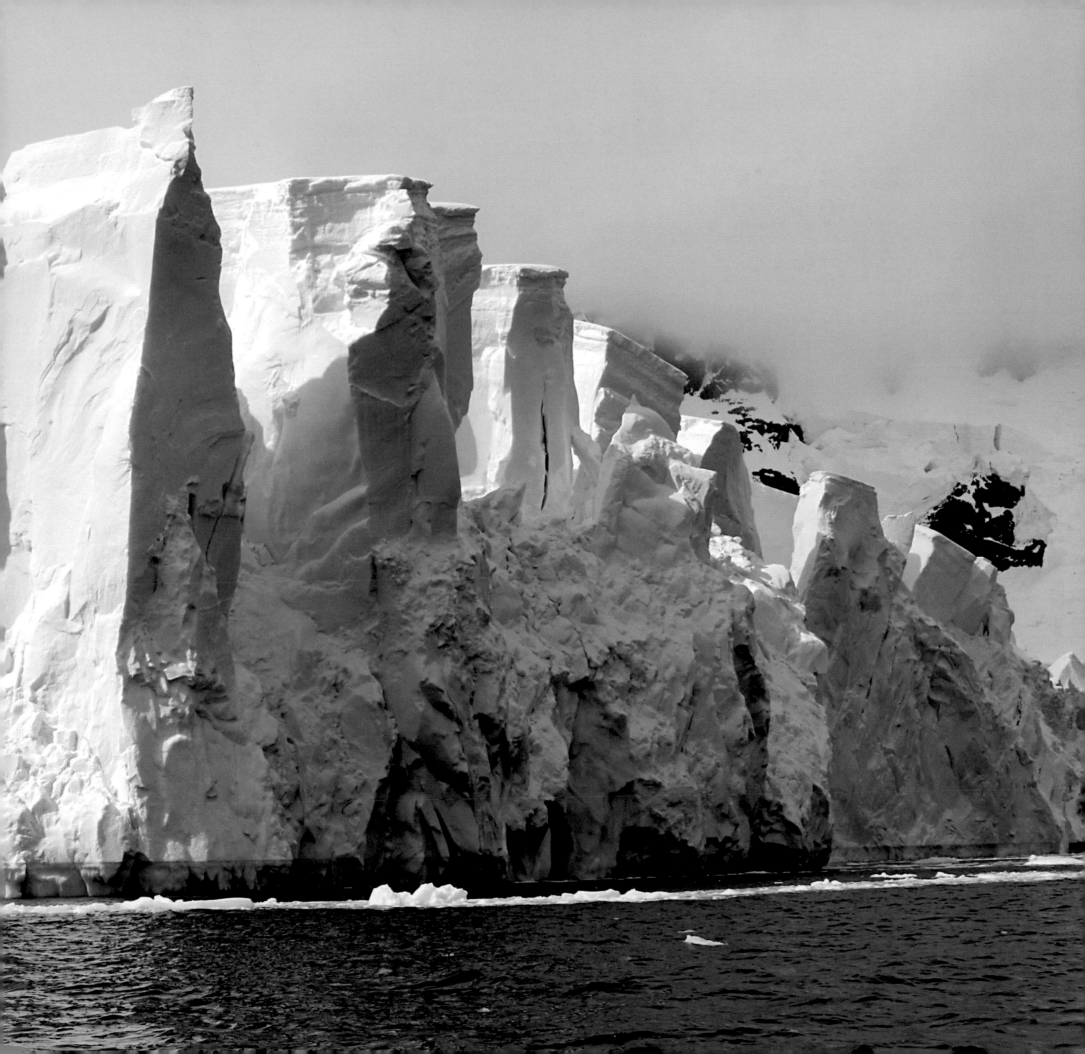

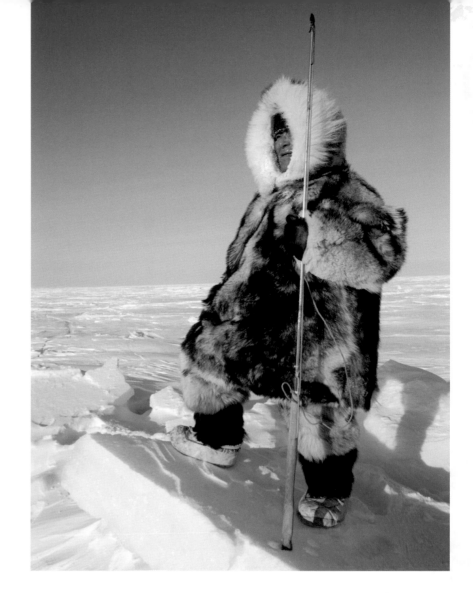

Freeze and Thaw

Twice a year the polar regions undergo a major transformation. As the days get warmer in spring, the sea ice begins to melt. In the Southern Ocean the change is staggering. Ice cover shrinks from 18 million km² (11 million square miles) to just 3 million km² (1.9 million square miles) in just a couple of months. These huge fluctuations in the physical habitat of these two ecosystems has resulted in many ice-dependent species adopting a migratory lifestyle.

Sea ice has a large influence on our global climate. Its bright surface has a high reflectivity (albedo), meaning that nearly all the heat it receives from

Above: Inuit hunters have a close connection with, and deep respect for, the animals of the Arctic.
Left: The sea ice melts as the temperatures rise each summer, breaking into smaller and smaller fragments.

the Sun 'bounces' back into the atmosphere rather than being absorbed by water or land. The high albedos of polar regions are part of the reason they are so cold.

Polar ice caps also provide a valuable record of the concentrations of different gases in the atmosphere throughout history. By taking cores of the ice that has accumulated over hundreds of thousands of years, it is possible to reconstruct past climates.

Plenty of Productivity

With its extreme conditions, you might think that sea ice is devoid of life – but this could not be further from the truth. Sea ice is extremely porous in comparison to its freshwater counterpart. This is because when sea water freezes, salt accumulates in the gaps between the ice crystals. This 'antifreeze' solution creates a tunnel network within the ice, allowing a diverse community of microorganisms to move around within the ice. The photosynthetic phytoplankton congregate in such large numbers within and below the ice that it appears to turn a green-brown colour. During the brighter spring and summer months, these organisms photosynthesize at an astonishing rate. The Arctic algae *Melosira arctica* grows in strands of up to 5 m (16.4 feet) suspended beneath ice floes, as well as inside bubbles within the ice. Melosira may be solely responsible for almost half the primary productivity in the Arctic. As the ice melts with the approaching Arctic spring, photosynthetic organisms trapped in the ice are released into the water triggering massive blooms tens of kilometres wide.

Inset: *Millions of copepods swarm beneath the ice. These zooplankton are an important source of food for many fish, providing a crucial link in the marine foodwebs.*
Right: *Algae bloom turns the ice brown, Antarctica.*

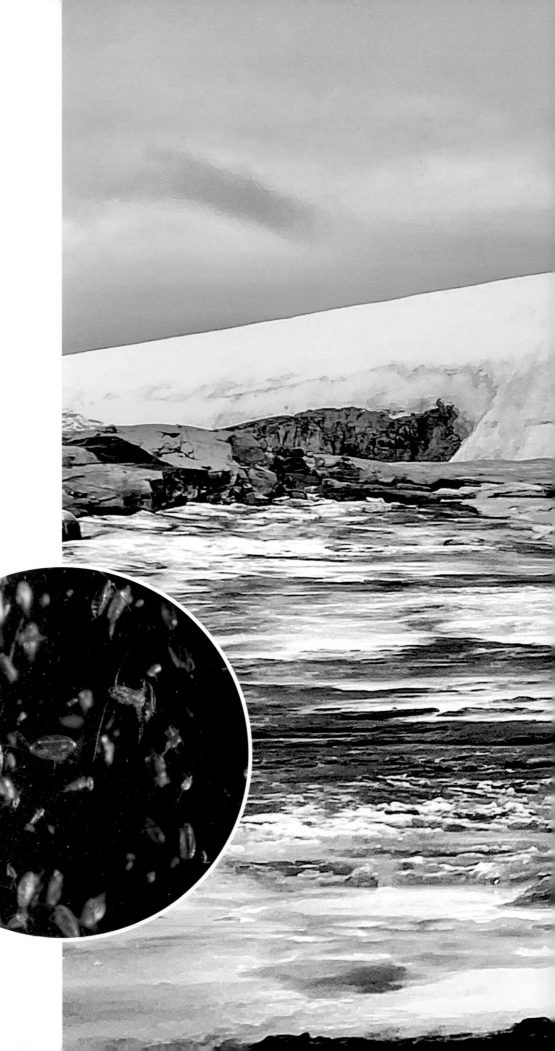

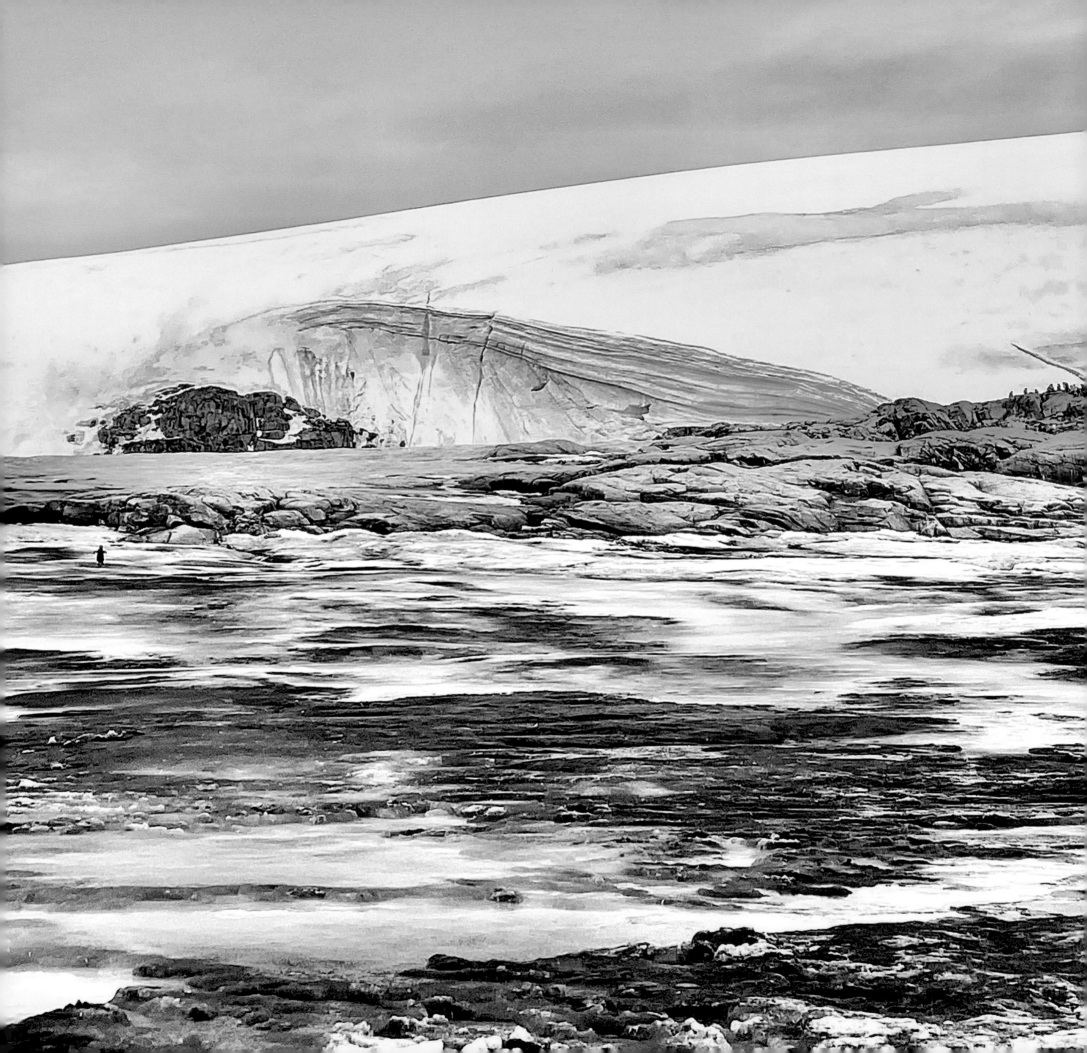

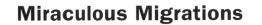

Miraculous Migrations

From blue whales the size of three buses parked end to end, to small seabirds, countless species traverse vast distances to feed on these immense, nutrient-rich summer blooms. Humpback, fin and minke whales make the long journey from the warmer latitudes where females give birth to their calves. These baleen whales use the sheets of keratin that line their mouths like a giant sieve to catch thousands of tons of krill. In the summer over 50 million seabirds migrate northwards to the Arctic, where they breed and raise their chicks. Many types of geese, such as the snow goose, flock to the Arctic each spring in perfect 'V' formation. Peregrine falcons breed in the tundra before migrating to South America. However, by far the most impressive traveller is the Arctic tern. This small bird makes an annual journey from the Arctic to the Antarctic and back again, covering a mind-blowing 96,000 km (59,600 miles). Over the course of an Arctic tern's life, it will cover a staggering 2.4 million km (1.5 million miles) – a distance equal to travelling to the Moon and back three times.

Life in the Freezer

Due to the extremely high levels of nutrients present, these polar waters can sustain more life than warmer regions. The Southern Ocean's most important marine species is Antarctic krill, 4–6 cm (1.5–2.3 inches) in length and nearly transparent. Unlike short-lived planktonic species, Antarctic krill can live between five and 10 years, and so must survive the harsh winters when food is limited. Krill do this by lowering their metabolic rate and reverting to a smaller, juvenile state.

Inset: A snow petrel and its chick in a nest in the rocks. This is one of the three bird species that only breed in Antarctica.
Left: Arctic terns returning to their partners with food for their chicks.

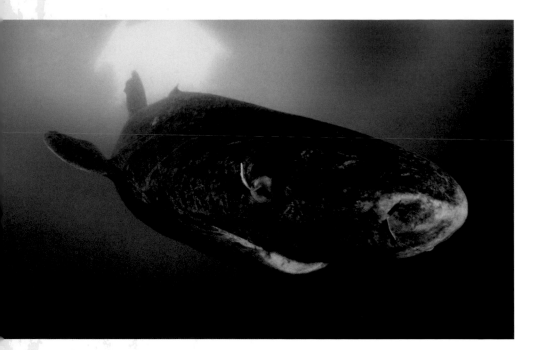

Three species of whale spend the entire year in the Arctic. Bowhead whales use their large, triangular skulls to break through ice of up to 17 cm (6.9 inches) to make breathing holes; they can live up to 200 years. Beluga, also known as white whales or sea canaries, can be easily identified by their flawless, brilliant white complexion. Finally the narwhal, the 'unicorn of the sea', is famous for its mysterious tusk – actually a giant tooth that grows through the whale's upper lip. Only males sport these 3 m (9.8 feet) ivory spikes, the use of which remains unexplained.

Another bizarre creature is the Greenland shark, the only ectothermic (cold-blooded) shark in the Arctic. It prevents itself from freezing by maintaining high levels of urea in its blood. As well as scavenging food from the depths, these sharks hunt by sucking prey into their mouths from up to 1 m (3.3 feet) away. The oldest vertebrate on the planet, they have been recorded at an age of 440 years and are often completely blind, thanks to a specialized parasite that feeds on their eyes.

Above: *An ancient Greenland shark glides beneath the Arctic sea ice. The parasite feeding from its eye will slowly turn it blind.*
Right: *Five male narwhals on the move. These 'unicorns of the sea' are hunted by the Inuit people for their tusks and skin.*

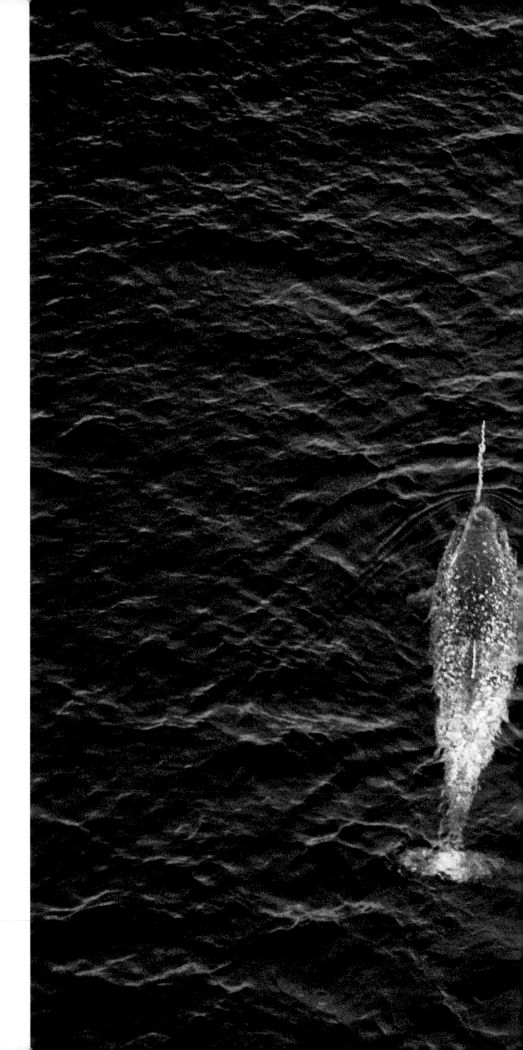

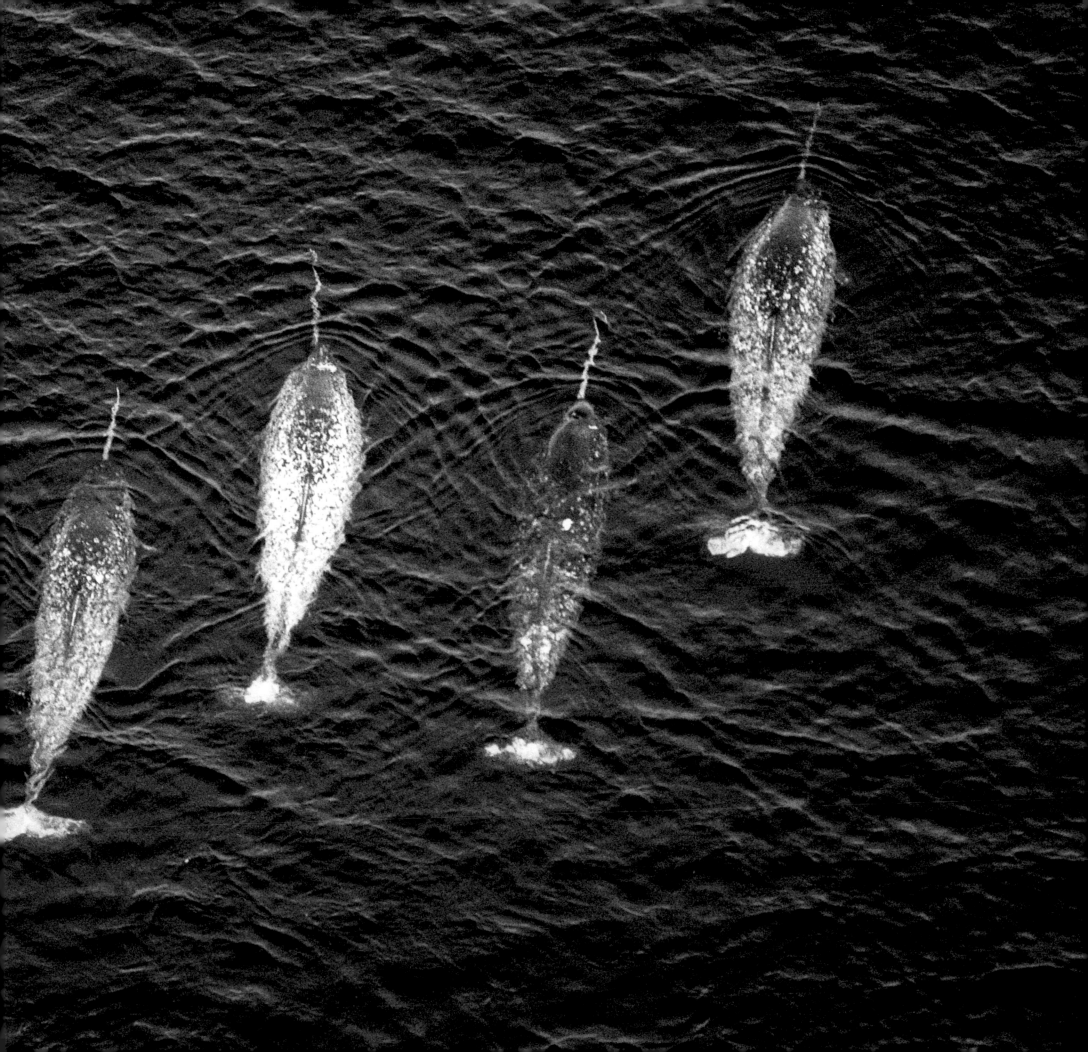

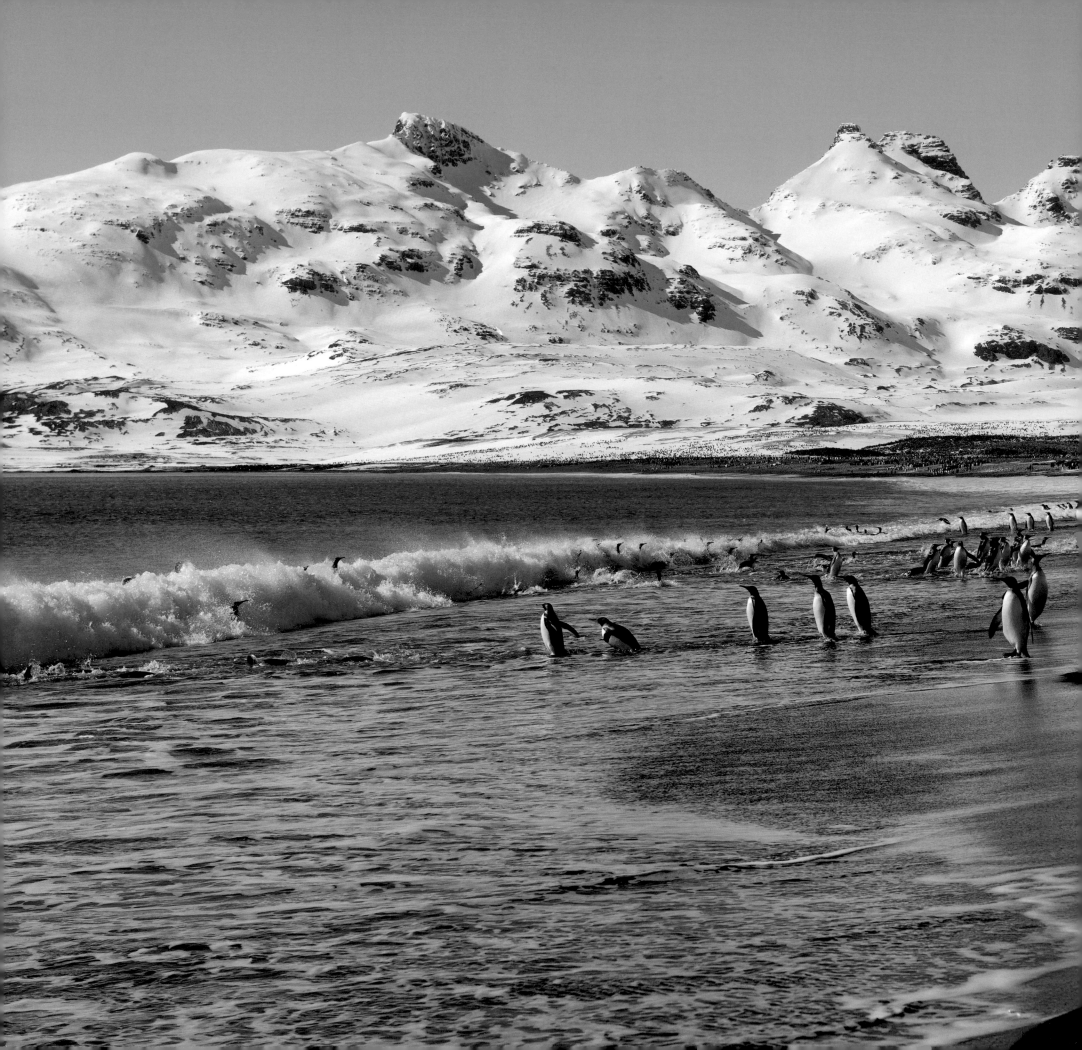

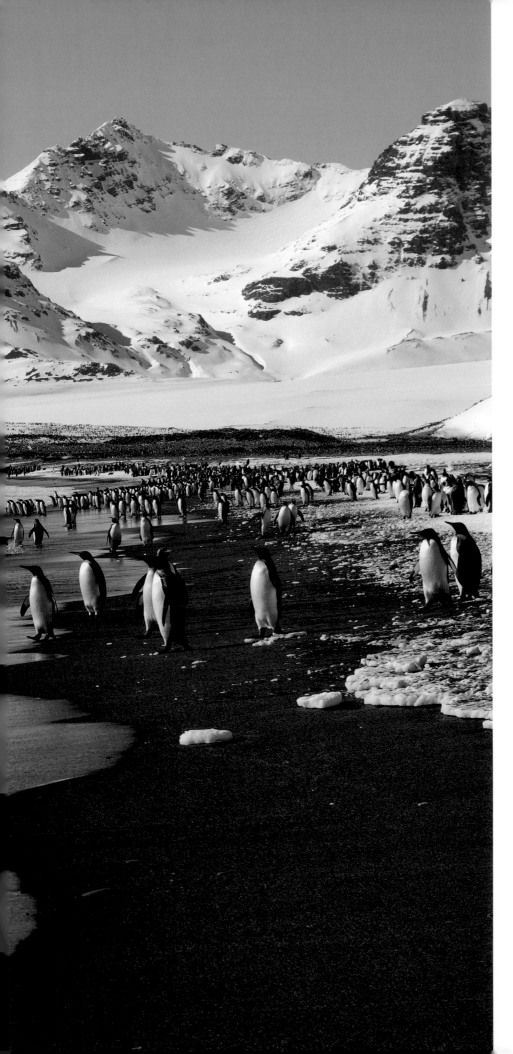

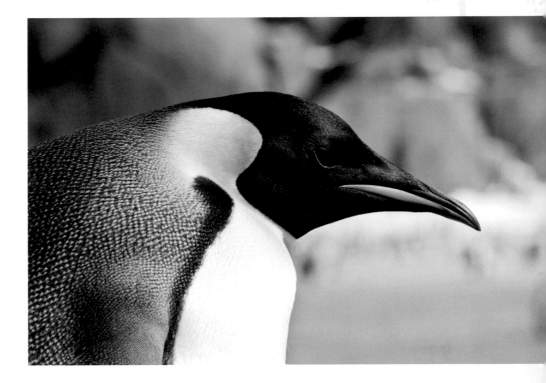

An Icy Existence

Living out on the ice requires special adaptations. Antarctic penguin species have so much blubber (fat) that it can account for up to one-third of their body weight. Their densely packed feathers trap a layer of air much like a wetsuit, which keeps them warm while diving. Polar bears have black skin underneath their white fur to absorb more heat. They have fur on the underside of their paws, which provides good grip and protects them from the cold ground. This huge carnivore roams the ice sheets in search of seals and other prey. Adults can swim for many hours at a time to reach distant ice floes.

Yet these individual adaptations are not enough to ensure survival in the coldest place on Earth. Both king and emperor penguins, which inhabit the freezing inland regions, must huddle together in their thousands to minimize heat loss during the long dark winter. Seals, which can be found in both the

Above: An emperor penguin.
Left: A group of king penguins leaving for a fishing trip. They will regurgitate some of the fish they catch in order to feed their chicks when they return.

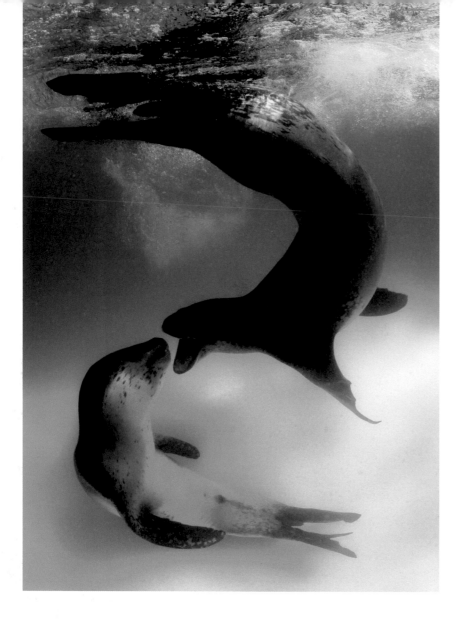

Arctic and the Southern Ocean, are dependent on sea ice for feeding, resting and pupping. Most seal species are great divers and can remain submerged for between 20 and 30 minutes at a time. However, as air-breathing mammals, they must surface periodically to breathe. When the ice extends in the late autumn, seals use specially made breathing holes, where they are vulnerable to polar bears and hunters. Leopard seals are lethal predators, lurking under icebergs to ambush unsuspecting penguins and other seals. They rarely catch the six or so penguins needed to sustain them, so leopard seals supplement their diet with krill, sucked through grooves in their back teeth that act like a sieve.

Above: A pair of leopard seals interacting, a rare sight for this solitary predator.
Right: A Weddell seal takes a much-needed breath at a breathing hole in the Antarctic ice.

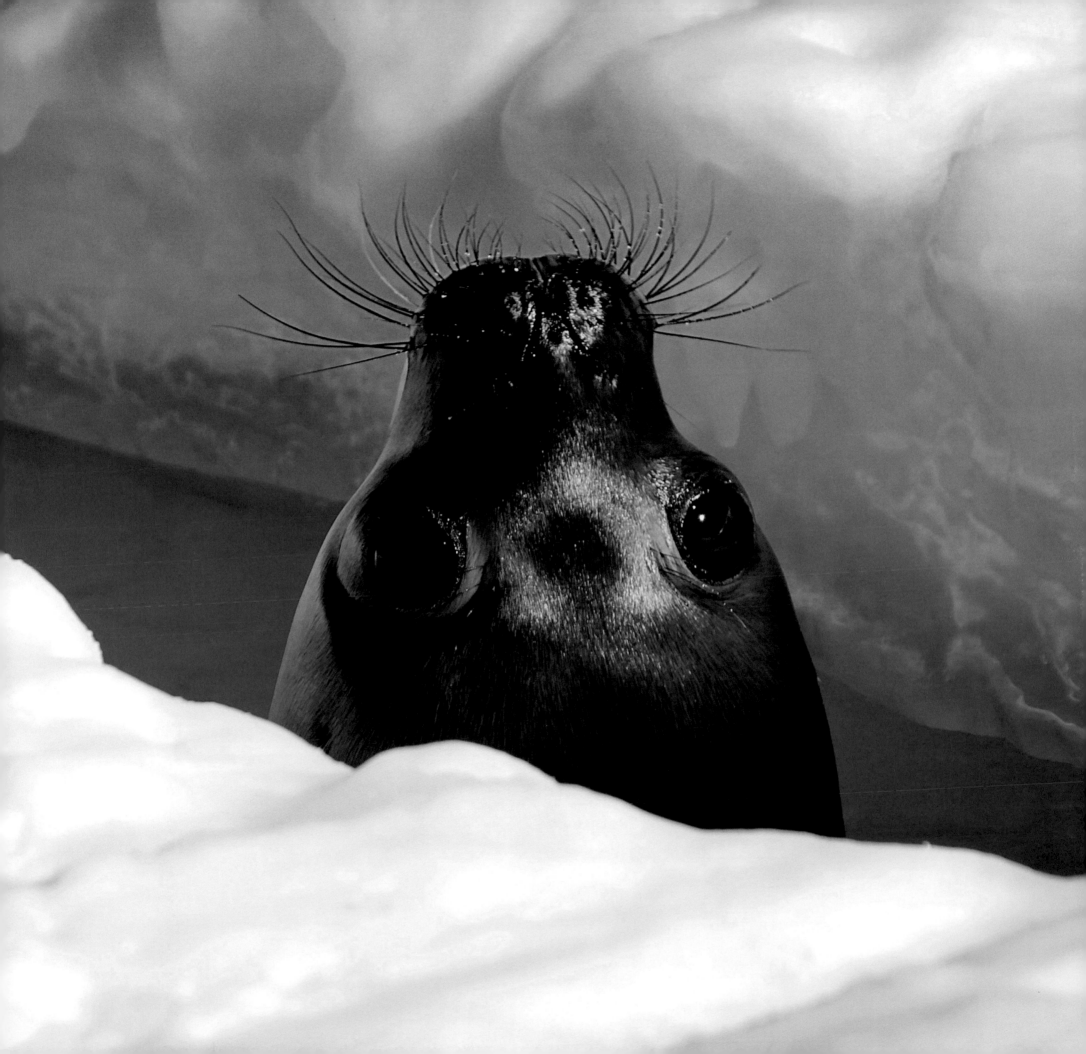

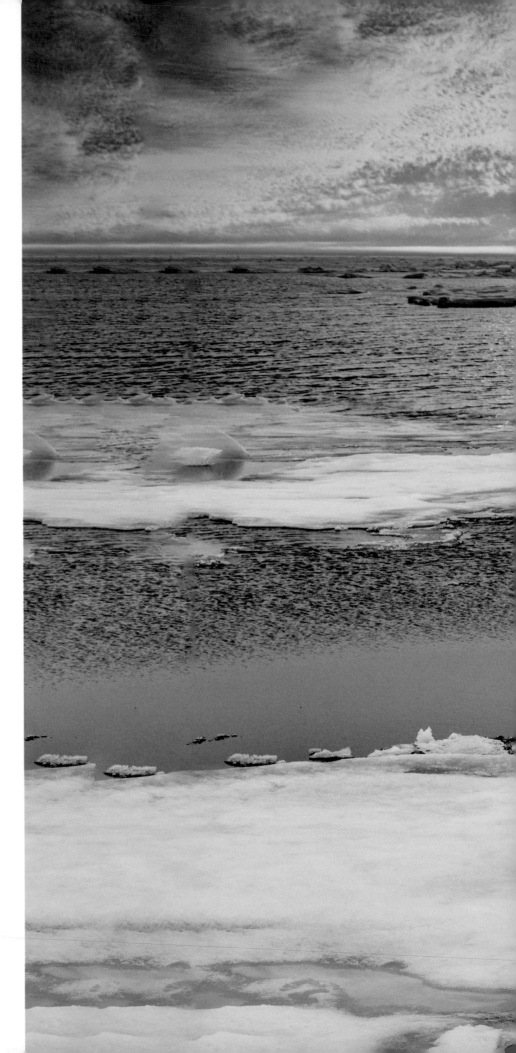

Melting Away

Crumbling ice sheets and receding glaciers draw our attention to the warming of the poles. The ecosystems of the polar regions are extremely fragile and increasingly at risk from rising global temperatures. Even if humanity succeeds in meeting the target of keeping global warming below 2°C (3.6°F), the Arctic will already be 4°C (7.2°F) warmer within the next decades. While an increase of only a few degrees may sound minor, it would push our climatic system into a new, highly unstable and unpredictable state.

On Thin Ice

Two hundred years ago a Russian expedition made what is believed to have been the first sighting of Antarctica. This vast expanse of ice seemed so immense that it was thought it could never be altered by the actions of a single species. It previously took up to three thousand years for the snowfall on a glacier to break off into an iceberg and then melt into the ocean. But due to rising temperatures this is now happening much faster. Parts of the Western Antarctic

Right: A polar bear sow and her cub at the edge of the receding sea ice.
Below: Rising temperatures mean that icebergs are breaking up and melting more quickly.

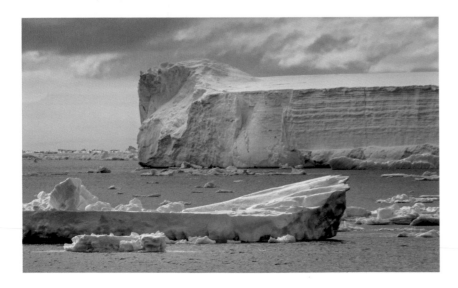

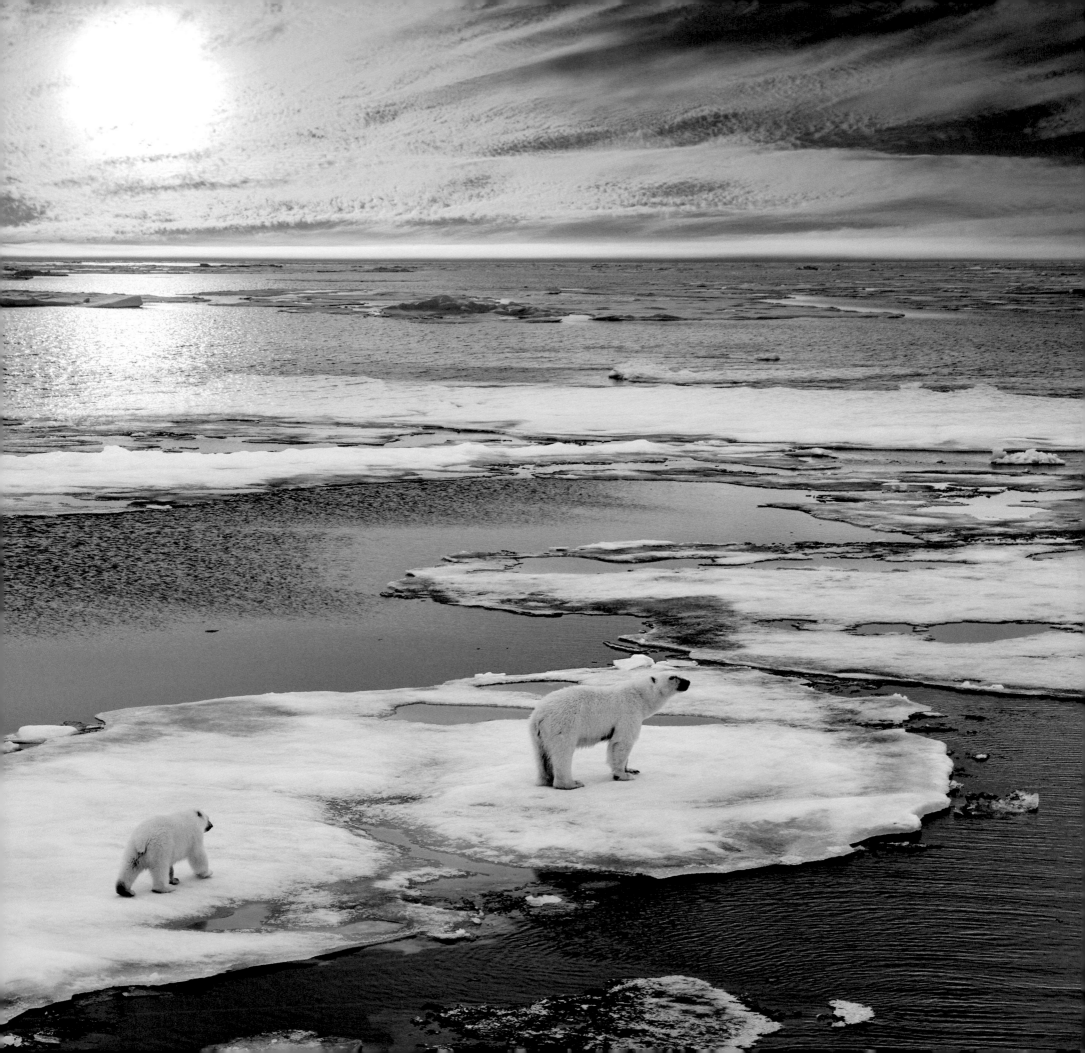

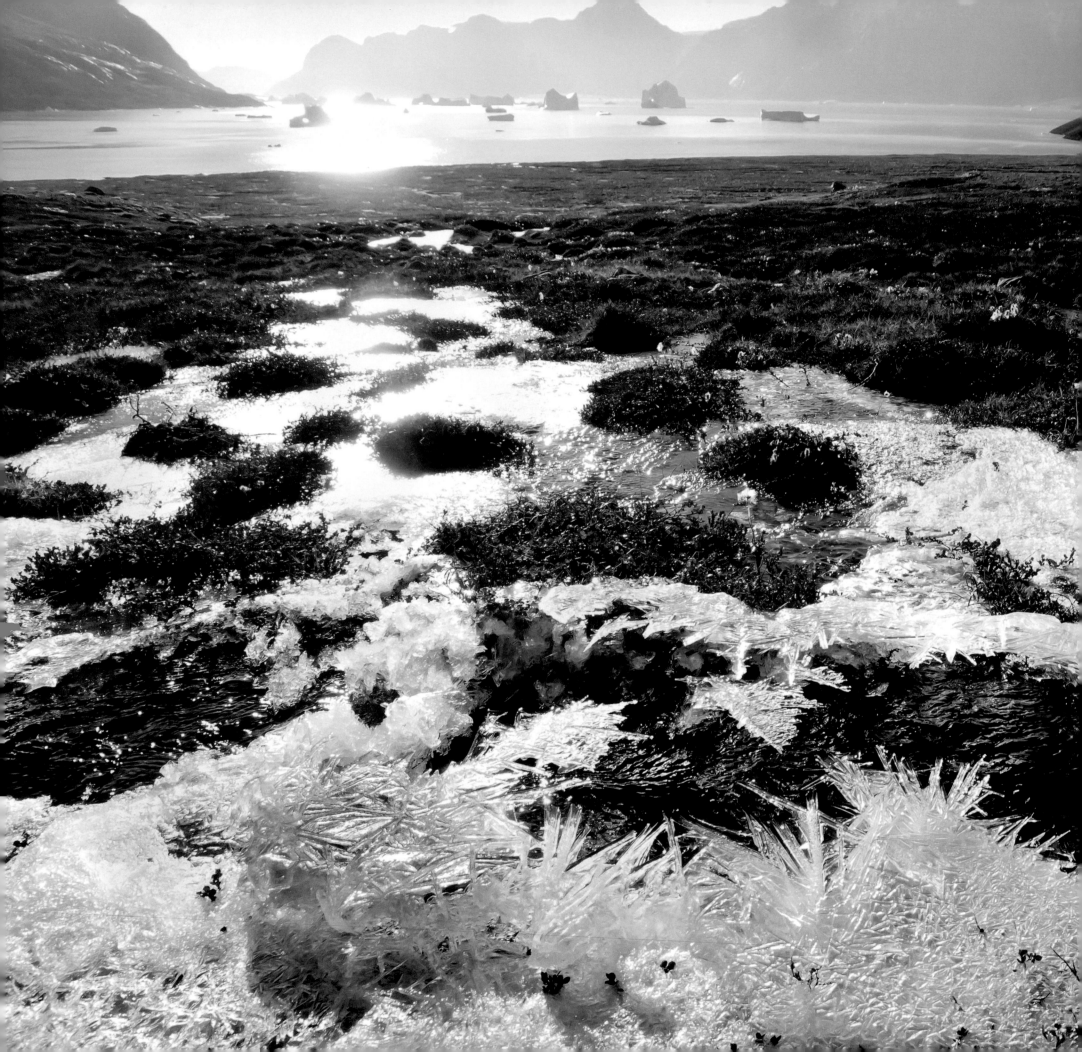

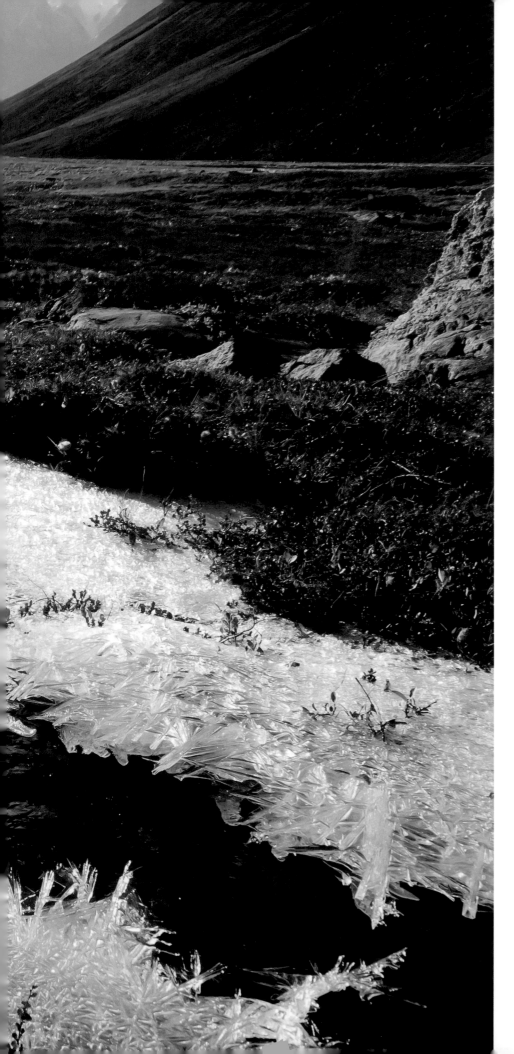

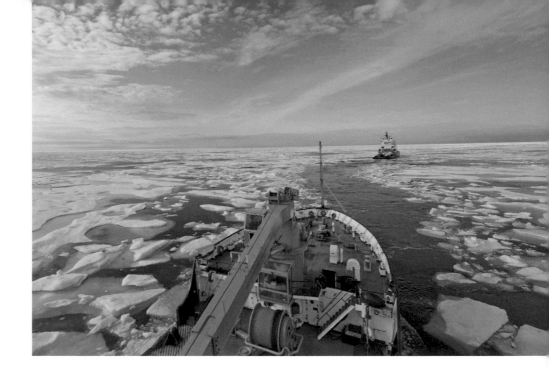

Ice Sheet have experienced a temperature rise of 0.47°C (0.85°F) every ten years since the 1970s. The ice sheet is 35,000 km² (21,700 square miles) smaller than it was 60 years ago, a difference roughly the size of Belgium.

On the other side of the globe, the Arctic is also thawing. Ships can now pass through the once frozen North West Passage, and scientists believe that the Arctic Ocean summers could be entirely ice free as soon as 2040. Such drastic changes in habitat will have dire consequences for the animals they support. Seals and polar bears, both of which spend much of their life on the ice, will have to travel greater distances to find places to rest and breed.

A Vicious Cycle

As the area covered by ice and snow diminishes, it reveals the darker, less reflective land and water beneath. These surfaces have a significantly lower albedo and therefore absorb much more solar radiation. Local temperatures rise in consequence, causing yet more ice and snow to melt. Belying its name, this positive feedback loop is in fact a vicious cycle. Since the poles act as the

Above: Melting sea ice opens up sea routes for vessels – but at what cost?
Left: Rising temperatures mean permafrost ground, such as shown here in Greenland, will thaw, releasing vast amounts of carbon into the atmosphere.

Polar Regions

planet's cooling system, if they begin to disappear the entire world will experience accelerated warming. Permafrost is carbon-rich soil which remains frozen for years at a time. It has been estimated that Arctic permafrost stores five times more carbon than has been emitted by human activity since the mid-19th century. As temperatures rise, the ground will start to melt, releasing colossal amounts of organic carbon into the atmosphere and further exacerbating climatic change.

Too Much Traffic

The ocean is a much noisier place than it was a few hundred years ago. Individual whales could once communicate with each other across entire ocean basins, but this is no longer possible because of the surge in ambient underwater noise. Marine traffic is increasing worldwide; as the ice retreats, new polar areas become accessible to shipping, fishing and mining activity. While this might shorten certain shipping routes, increased maritime traffic will inevitably result in elevated ocean noise levels.

Noise pollution is a serious threat to many marine creatures, particularly those such as cetaceans which rely on echolocation to hunt and navigate. It can interfere with their abilities to forage and communicate or even damage sensory organs, resulting in mass strandings. Recent research has demonstrated that simpler species such as fish, squid and oysters can also be impacted by noise pollution. The seismic air guns used to map the ocean floor and detect oil and gas reserves emit a low-frequency boom capable of killing zooplankton almost 1 km (0.6 miles) away. With more vessels, there is also a heightened risk of boat strikes. Such collisions cause traumatic injuries or death in slow-moving species such as the bowhead whale.

Inset: Noise pollution in the ocean is harmful to all kinds of marine creatures, including those who use echolocation, such as whales.
Right: The increase in polar marine traffic creates more noise pollution underwater.

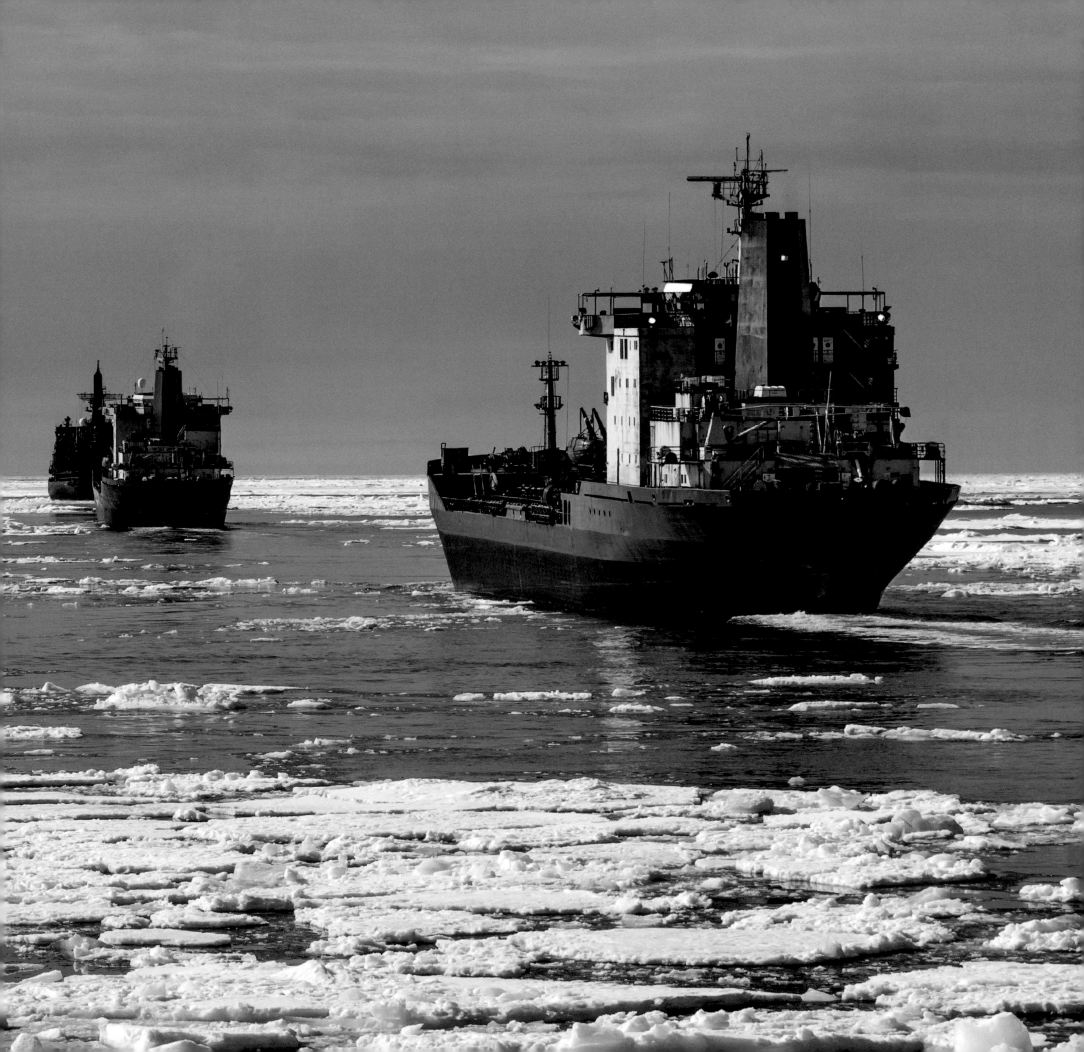

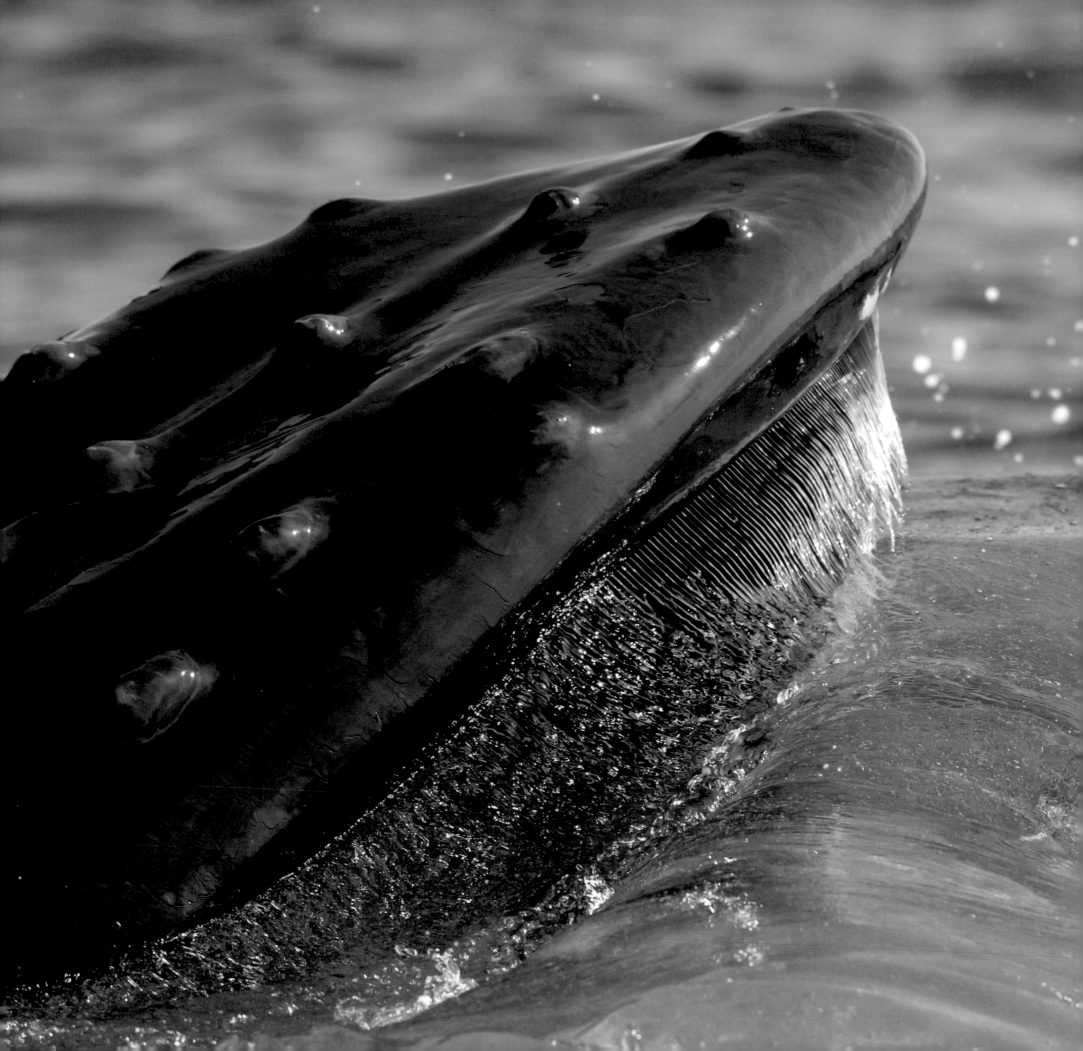

Not So Many Fish Left in the Sea

Since the eighteenth century when we began fishing and hunting in the Southern Ocean, countless species have been driven to the brink of extinction. Human greed takes over and we harvest the limited resources in an excessive, utterly unsustainable fashion, moving on to the next area once one has been exhausted. The fur trade almost wiped out fur seals and the demand for whale oil and meat brought about the deaths of millions of whales before both practices were eventually banned. While most countries now abide by the 1986 Global Moratorium on Whaling, up to two thousand whales and dolphins are still killed each year by countries that defy the whaling ban: Japan, Iceland, Norway and the Faroe Islands. Despite the massive reduction in whaling, the damage may have already been done as an estimated 2.9 million whales were slaughtered between 1900 and the 1986 ban. Many whale populations have still not recovered from this massacre.

Since then, the fishing industry has shifted its focus to krill. Krill-based health products for anything from depression to heart disease are rapidly gaining popularity. Their global populations have already declined by 80 per cent in the past 50 years, due to climate change. Worryingly, advances in fishing technology now allow hundreds of tonnes of krill to be sucked up daily by a single vessel. Since krill constitute an integral part of the food chain, if their numbers continue to deteriorate there may be dire ramifications for the species that feed on them.

Inset: Prince Albert and the crew of the Princess Alice, a whaling vessel, in 1912. The men pose alongside a recently caught whale.
Left: Humpback whales are just one of the many creatures for whom krill, increasingly harvested by humans, is an important food source.

Cooling it Down

In order to prevent the poles from becoming unrecognizable within our lifetime, we need to greatly reduce our emissions of greenhouse gas (GHG). This goal can only be achieved through a combination of individual and collective actions. It is possible to make a difference by weaving simple changes into our lifestyles and by making more responsible choices regarding food and travel. Additionally, international collaboration in the form of treaties and protective regulations have – and will – continue to play a major role in the preservation of the polar wilderness.

Act Local, Think Global

Flying less is an obvious way to reduce our emissions. Nowadays, we take for granted the idea that we can step on a plane and be anywhere on the planet in less than 24 hours. Some say it makes travel easier, but at the same time it removes the element of adventure. Other more sustainable forms of transport such as trains allow us to appreciate the distance covered and enjoy wonderful views along the way.

Above: *Flying less would help decrease our emissions.*
Right: *Crabeater seals on ice floe, Antarctic Peninsula. We need to protect our polar wildernesses.*

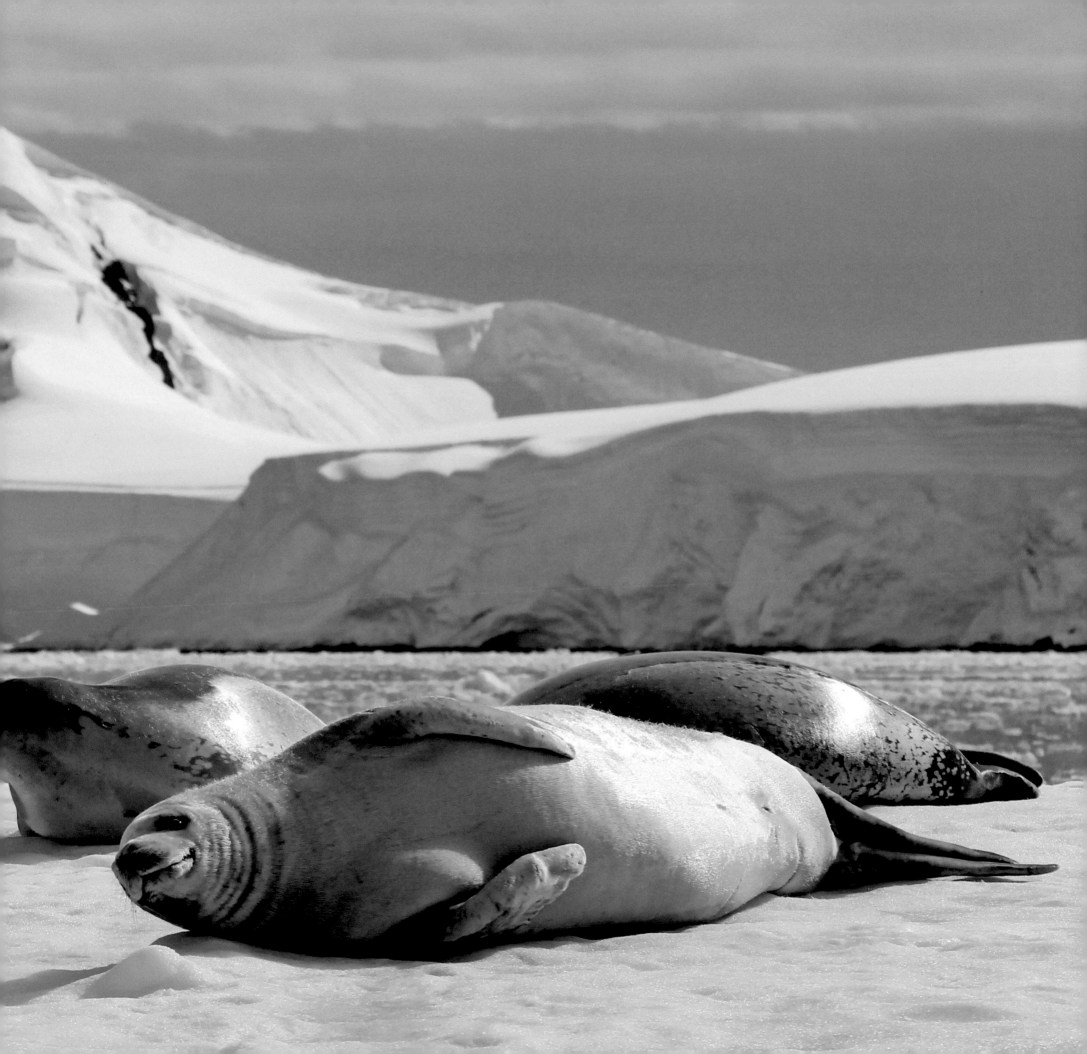

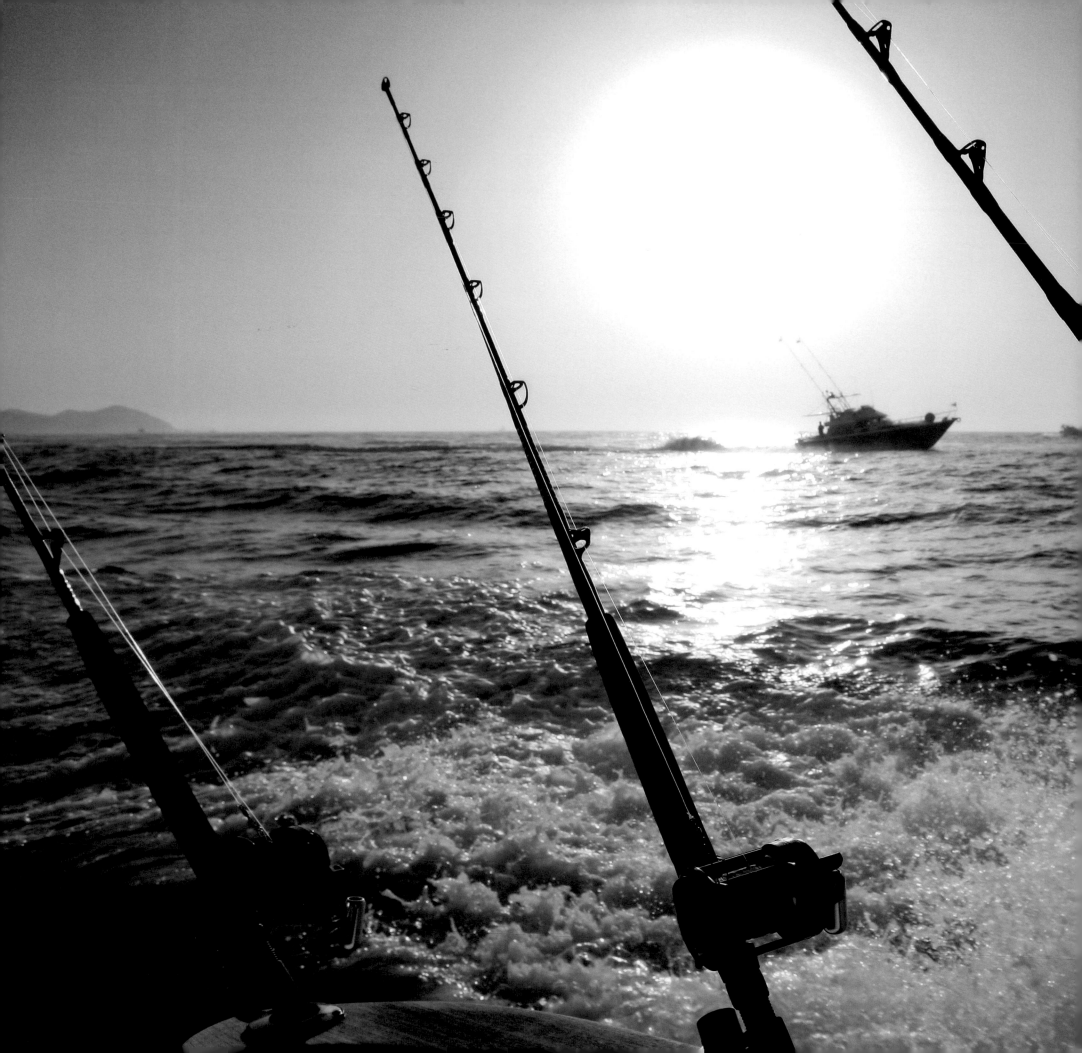

Our dietary choices also have huge implications for the climate. In particular, the meat and dairy industries are highly damaging, releasing methane (a greenhouse gas over 20 times more potent than CO_2) as well as gallons of slurry that result in ocean 'dead zones'. A good rule of thumb is to use plant-based alternatives where possible. Saying that, we have grown accustomed to finding every exotic fruit and vegetable imaginable on the shelves of our supermarkets, no matter where from or at what time of year. It is time for us to reconnect with the sources of our food. Becoming aware which foods are grown locally and when they are in season is essential in trying to minimize our carbon footprint.

When it comes to seafood, local is again better, as well as ensuring that it has been fished sustainably. There are a few ways to make sure the fish you buy causes the least environmental damage. Try buying from a local fishmonger instead of a supermarket as they will know what is in season and how the fish has been caught (choose line-caught where possible). If you are buying pre-packaged fish, look at the label for certifications such as those from the Marine Stewardship Council. Online resources such as the Marine Conservation Society's regularly updated Food Fish Guide, which details what fish to buy and what to avoid, can also be helpful.

Closing the Gap

Ozone (O_3) is a gas that naturally occurs in our atmosphere in extremely low concentrations. This highly reactive gas protects us from the Sun by absorbing its harmful ultraviolet radiation. Unfortunately, this protective layer has been severely depleted by chlorofluorocarbons (CFCs) found in aerosol sprays and refrigerators, particularly the area over the Southern Ocean. Once this destructive relationship was discovered in 1987, the production and use of CFCs were banned under an international treaty,

Left: *Line-caught fish is far more sustainable than trawler-caught.*

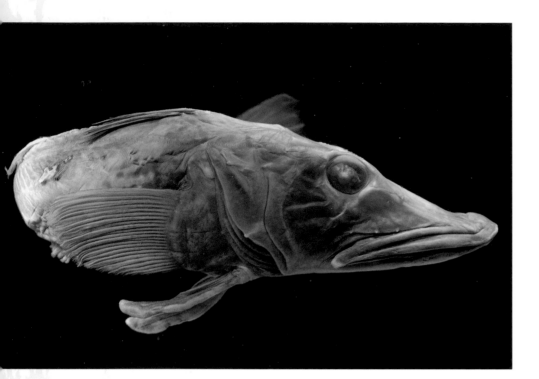

the Montreal Protocol. This is a valuable example of the power and efficacy of international cooperation in aiding environmental conservation.

Over the last half century, conflict in the Antarctic has been mitigated by the Antarctic Treaty. Signed in 1959 by the 12 countries involved in Antarctic research, this convention states that 'Antarctica shall be used for peaceful purposes only'. Since then an additional 37 countries have signed and all partner states have agreed to various supplementary measures to conserve the Antarctic biome. Shifting to the north, a moratorium on all fishing activity within the Arctic Ocean until 2034 has been agreed upon by the EU and nine other nations. Hopefully by the time it expires other protective measures will be in place.

Besides international conventions and treaties, marine protected areas (MPAs) and 'no take zones' can be used to ensure certain areas are able

Above: The blackfin icefish of Antarctica has been found to have suffered DNA damage due to ozone depletion in the atmosphere; it is also at risk from rising sea temperatures.
Right: A group of Adélie penguins head to the water of the Ross Sea, home to the largest marine protected area.

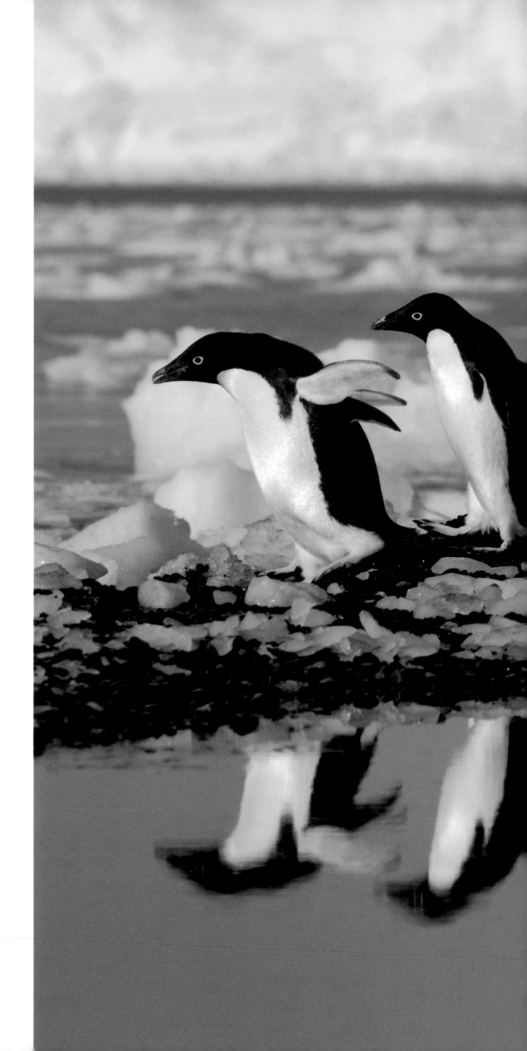

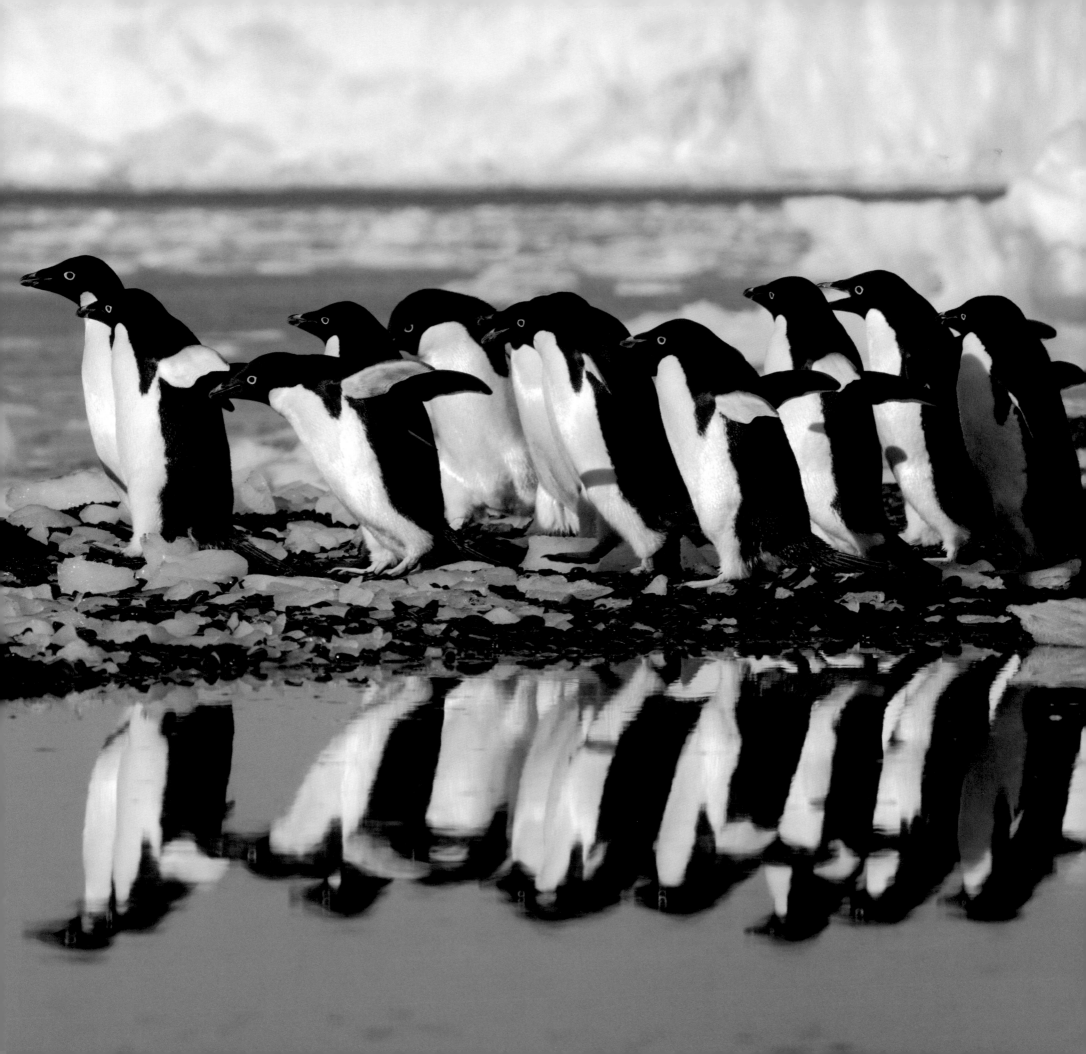

to preserve their abundant marine life. The largest marine protected area to date was established in 2017 within the Ross Sea region, which borders on Antarctica. Sadly this is not a permanent agreement. The area, approximately the size of Greenland, will only remain protected for another 34 years.

Turning Down the Volume

Following the 9/11 terrorist attacks, all boat and air travel ground to a halt. In the silence that ensued, researchers found that stress levels in whales in the Bay of Fundy in Canada dropped significantly, only to rise again once life went back to normal. During the COVID-19 pandemic, the world came to a standstill once again. National lockdowns forced most global trade and the movement of goods and people to be put on hold to reduce the spread of the virus. With minimal air and marine traffic, parts of our ocean became almost as quiet as in pre-industrial times. Scientists jumped at this second opportunity to see how species that had never encountered such conditions would react to this sudden silence. They predicted whales would have more complex communications, rather as we would over a calm cup of tea compared to being at a deafening rock concert. The results of this research have yet to be concluded, but there is little doubt that the ocean benefited greatly from this brief period of tranquillity.

While this is good news, the effects will be short-lived as the world begins to move again. We should also ask ourselves why it took a calamity of such scale to bring this about. This time of transition and uncertainty offers us a great opportunity to change the way we think and act regarding our ocean and our planet. Perhaps we should not rush to return to our 'normal' unsustainable and destructive ways. In the words of Winston Churchill, 'never let a good crisis go to waste'.

Left: *A peaceful Arctic scene, Svalbard, Norway.*

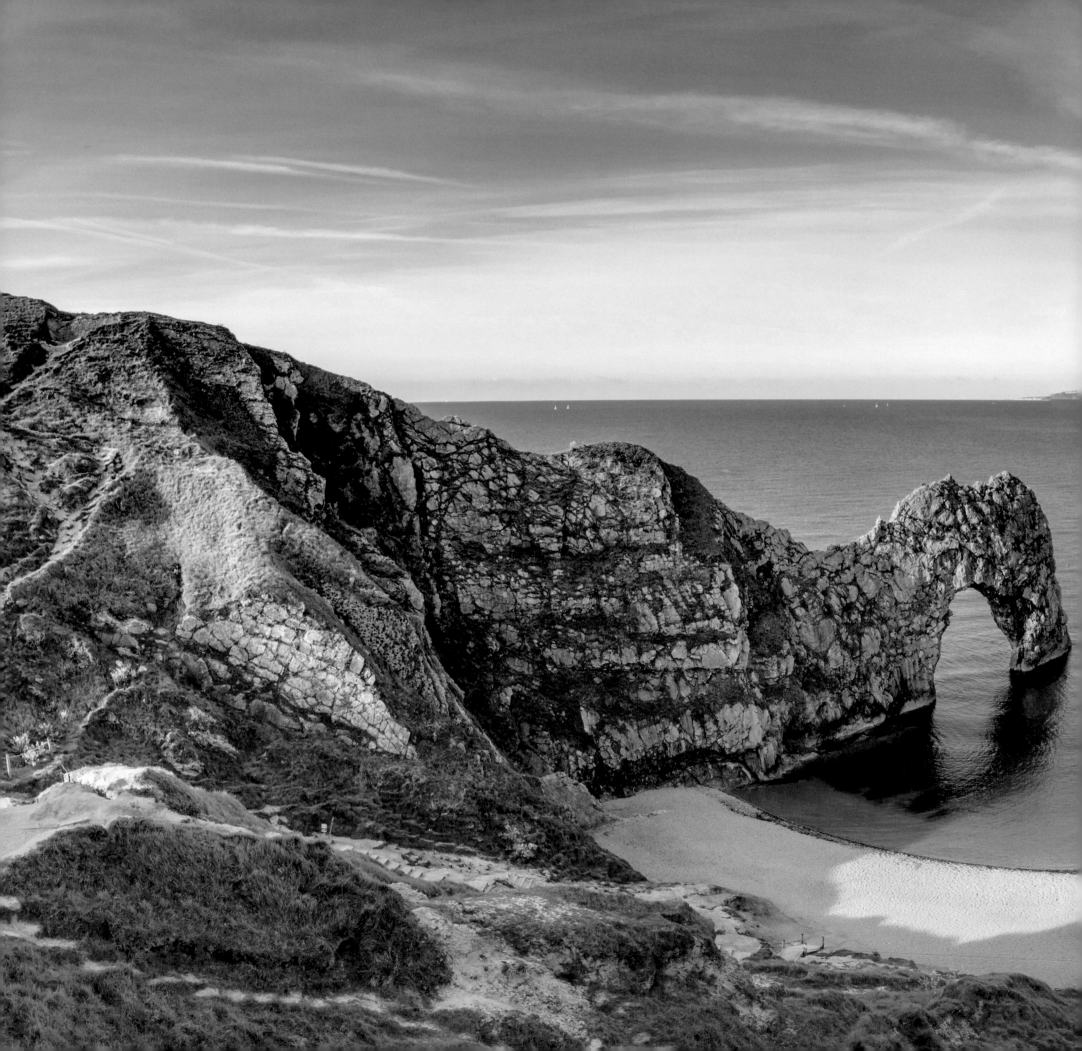

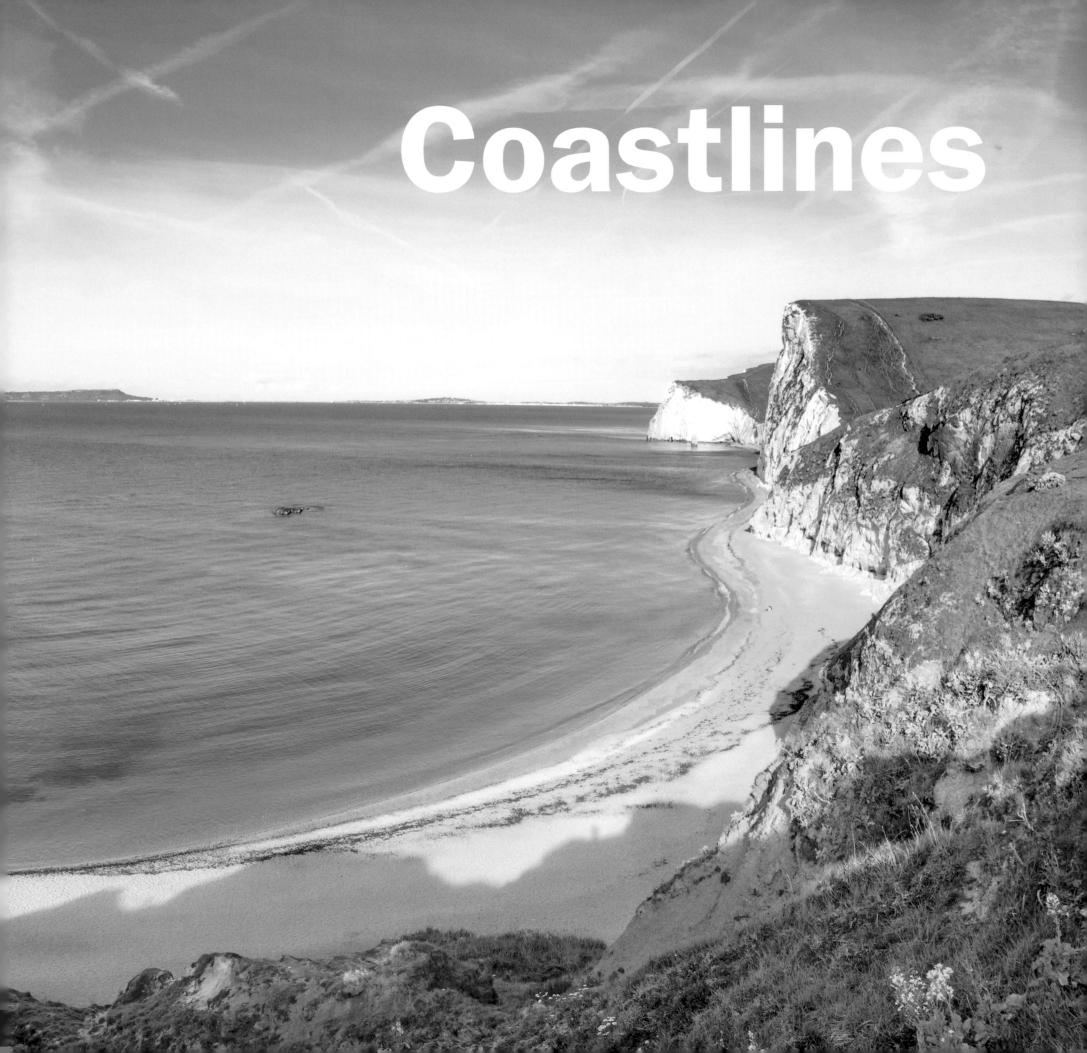

Coastlines

Where Land Meets Sea

The Earth is a planet of coasts. As the interface between land and sea, the global coast is over 1.6 million km (1 million miles) long – a distance that could stretch around the equator over 400 times. As humans, most of our interactions with the marine environment begin with a trip to the coast. Whether we are relaxing on a white sand beach, clambering around on craggy rocks or simply listening to waves move the shingle back and forth, there is something almost primal about being next to our ocean. But for the organisms that live here, the undulating tides and crashing waves provide their own set of challenges.

Ebb and Flood

The Earth is unique in our solar system for many reasons, not the least of which is our Moon. The gravitational attraction from the Moon, when combined with that of the Sun, pulls Earth's water layer outwards into space, forming a tidal wave. As Earth orbits on its axis, this tidal wave rushes around the globe, taking approximately 12.5 hours to go from high tide to low tide and back. As this tidal wave flows, it interacts with land masses and the topography of the ocean floor which can amplify the wave. Rather like a child rocking back and forth in a bath until the floor is drenched, subtle resonances can increase the height of this tidal signal, ranging from around 1 to 2 m (3 to 6 feet) in the open ocean up to a whopping 16.3 m (53.5 feet) in the Bay of Fundy, Canada. Understanding the tides has been crucial for humans, not only for our maritime history and trade but also for coastal

Previous page: Durdle Door on the Jurassic Coast, Dorset, England.
Right: Sand dunes on Balnakeil Beach, Scotland. Dunes form when sand is blown against an obstruction. The mound of sand is then stabilized by vegetation such as marram grass.

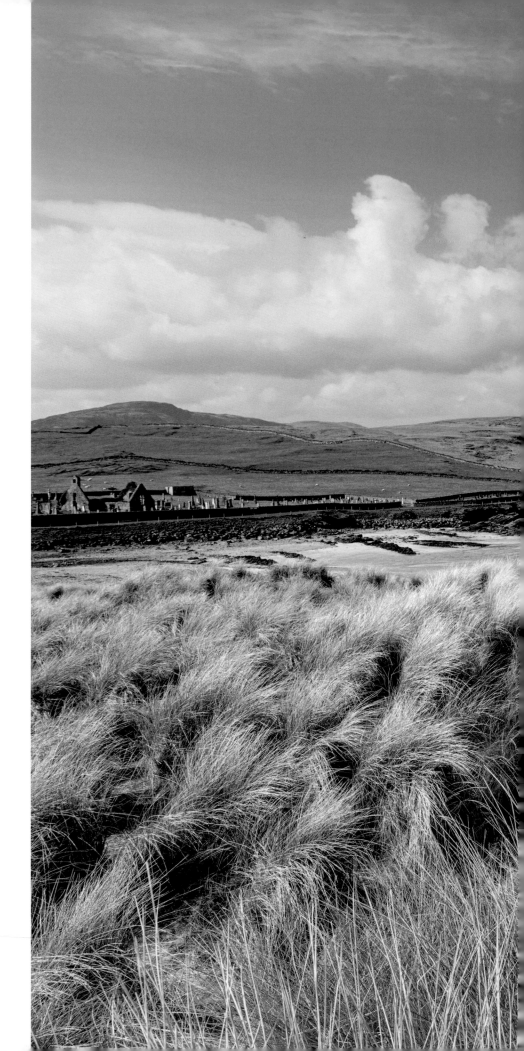

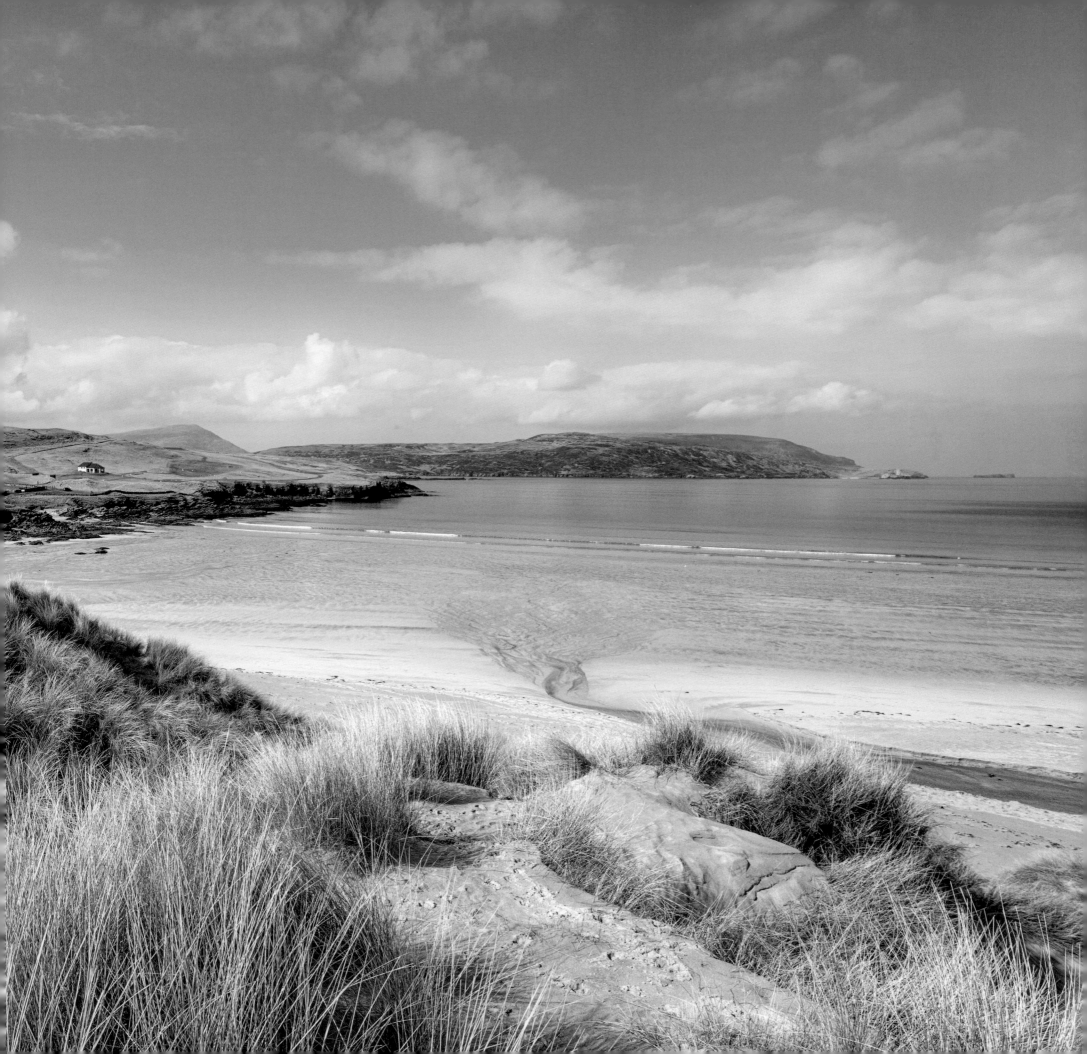

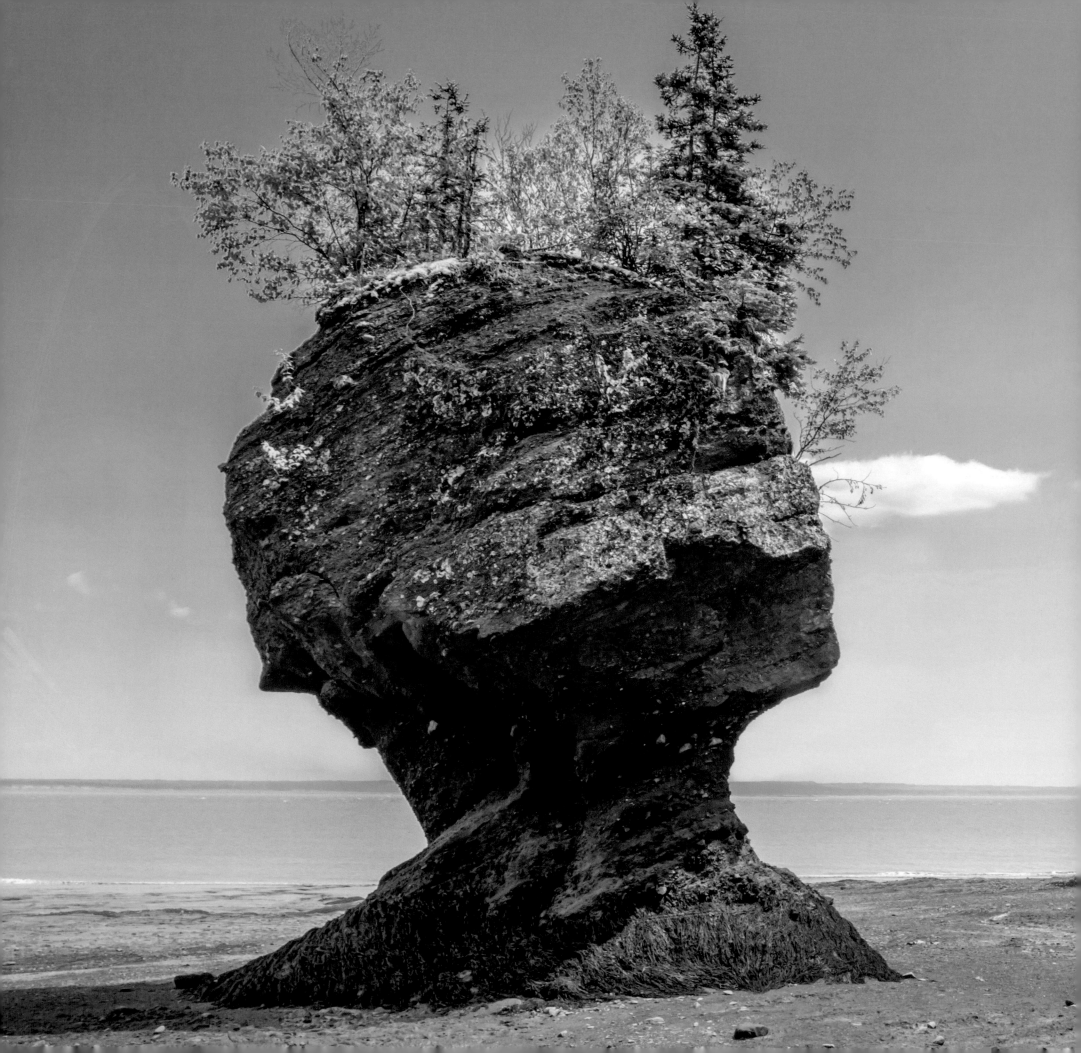

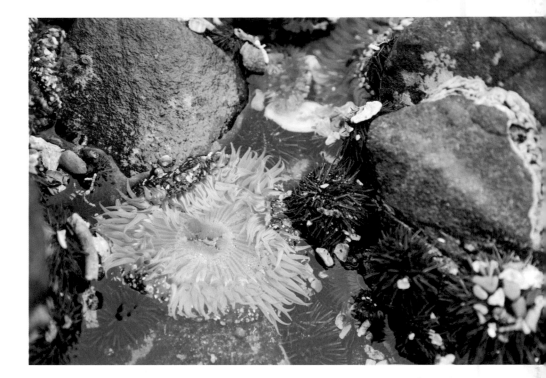

developments. Being able to predict the high-water mark or the probability of a 1-in-100-year high tide is essential when calculating how far from the sea to build houses.

Life's a Beach

For the creatures that live in the intertidal zone, the thin strip of land between high and low water, life can be tough. Twice a day they are submerged with water and pounded with waves until the tide recedes, leaving them exposed to predators and the desiccating heat of the Sun. These organisms have evolved to deal with the harsh realities of land as well as the unforgiving sea. Animals that live on sandy beaches quickly dig down as the water recedes. For those on rocky shores, rock pools offer crabs, anemones, mussels, cockles and whelks safe havens, where they can seek refuge between fronds of seaweed.

Left: The Hopewell Rocks in the Bay of Fundy, Canada, have been sculpted over many centeries by the large volume of water that comes in and out of the bay every day.
Above: Rock pools provide safe havens for animals, such as anemones and sea urchins, at low tide.

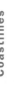
Coastlines

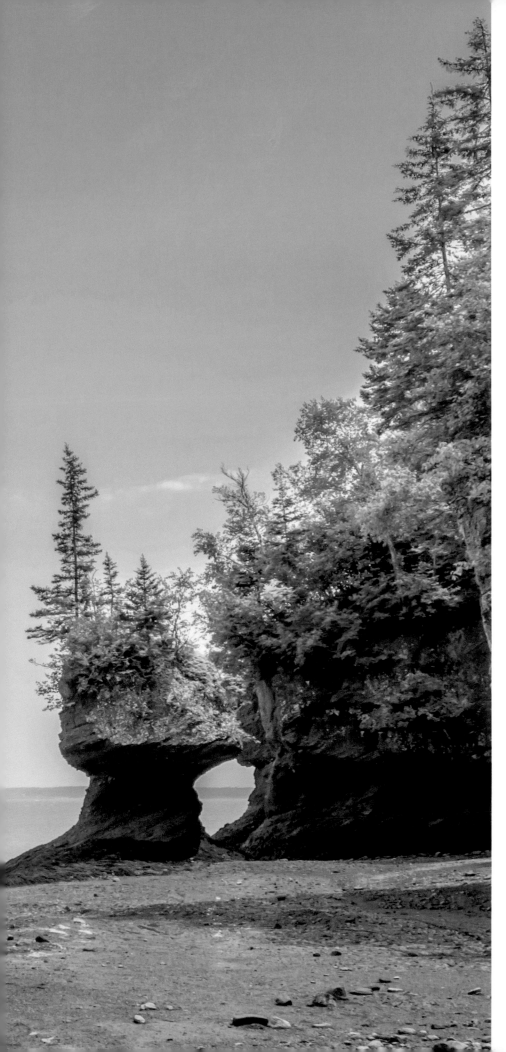

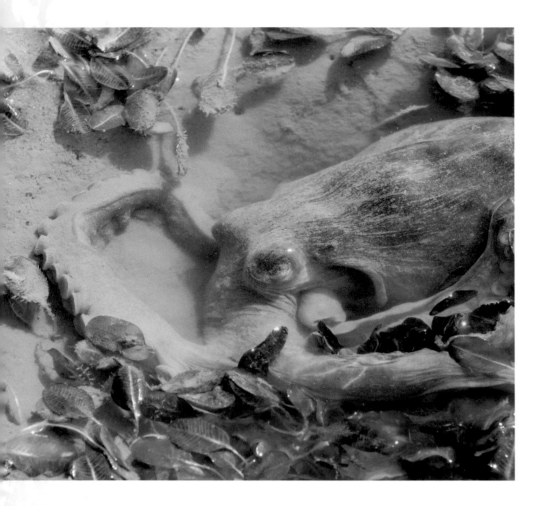

These intertidal species have evolved a whole host of coping mechanisms. Mobile animals such as crabs simply follow the tide or find shelter. Sessile (stationary) organisms such as barnacles, oysters and mussels trap water inside their shells to avoid drying out, while cockles seal their shells with a trapdoor-like operculum. Certain species of seaweeds can withstand losing 90 per cent of their water, shrivelling up when exposed to air to be rehydrated later by the rising tide. Much as humans must hold their breath to visit the underwater realm, marine organisms have to do the same when briefly visiting land. Octopuses are able to hold oxygenated sea water inside themselves as they slink from one rock pool to another in search of crabs and other quarry.

Above: An octopus hunts for crabs in a shallow pool. Once the pool is emptied of prey, the octopus will crawl along the shore to adjacent pools, often completely leaving the water.
Right: *A Sally Lightfoot crab explores a rock pool on the Galapagos Islands. As a popular aquarium species, these crabs have been inadvertently introduced to the Mediterranean.*

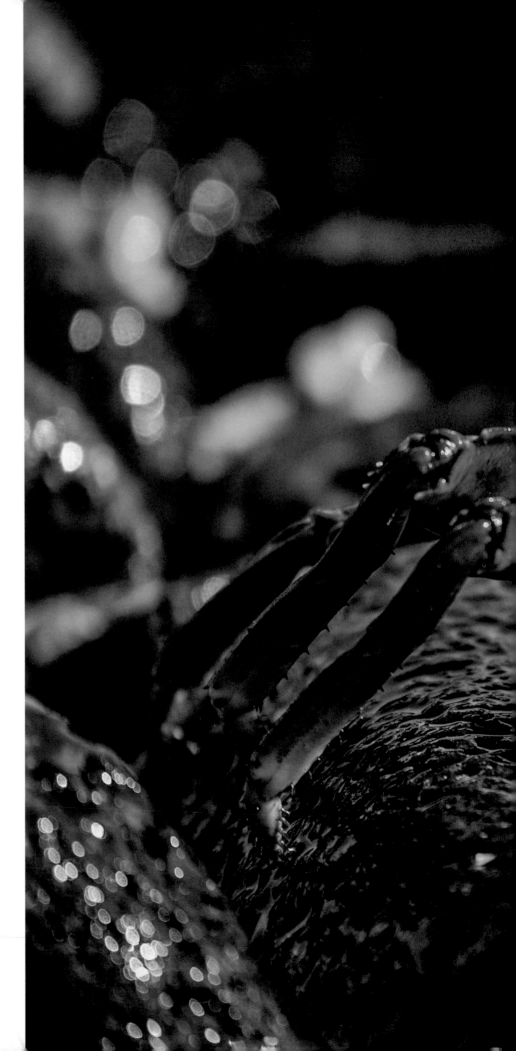

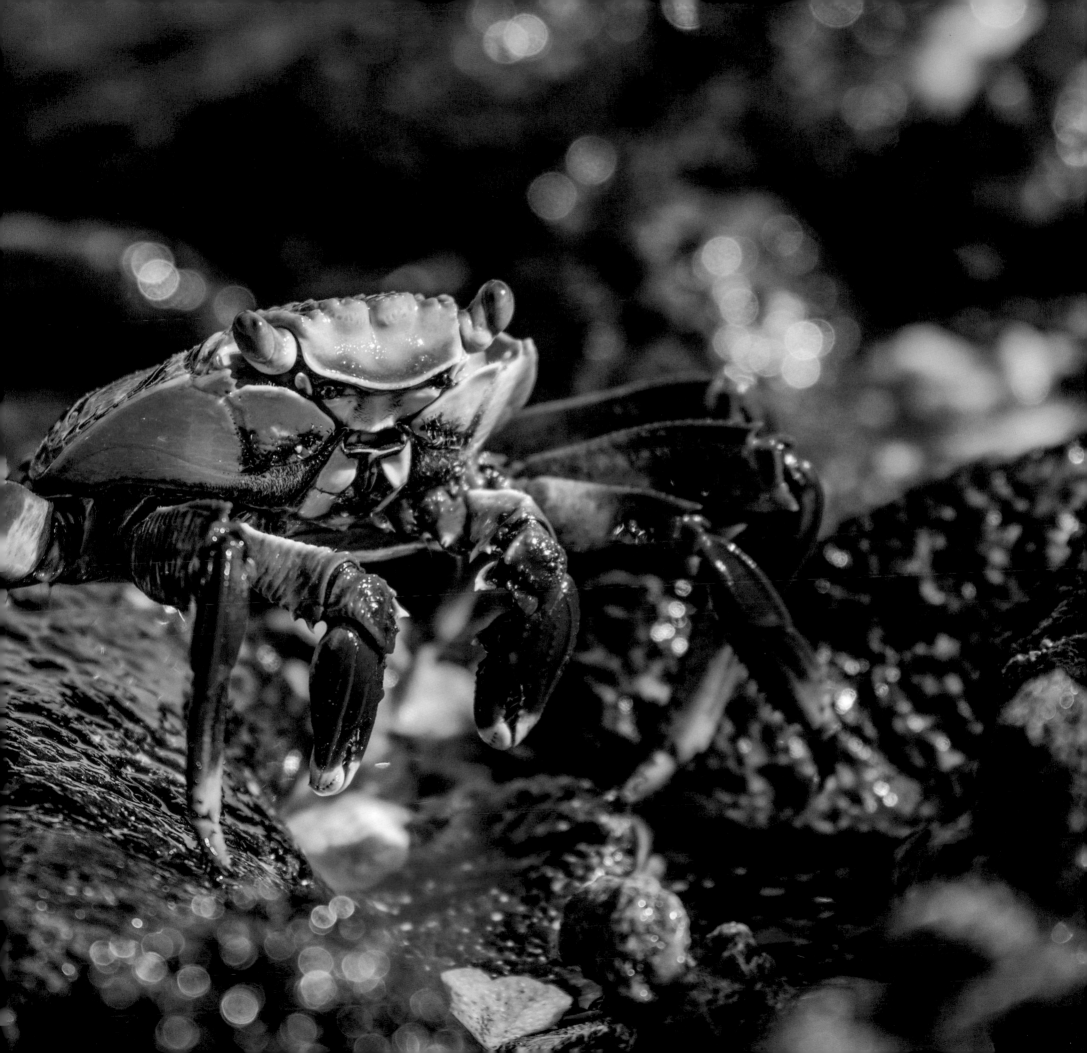

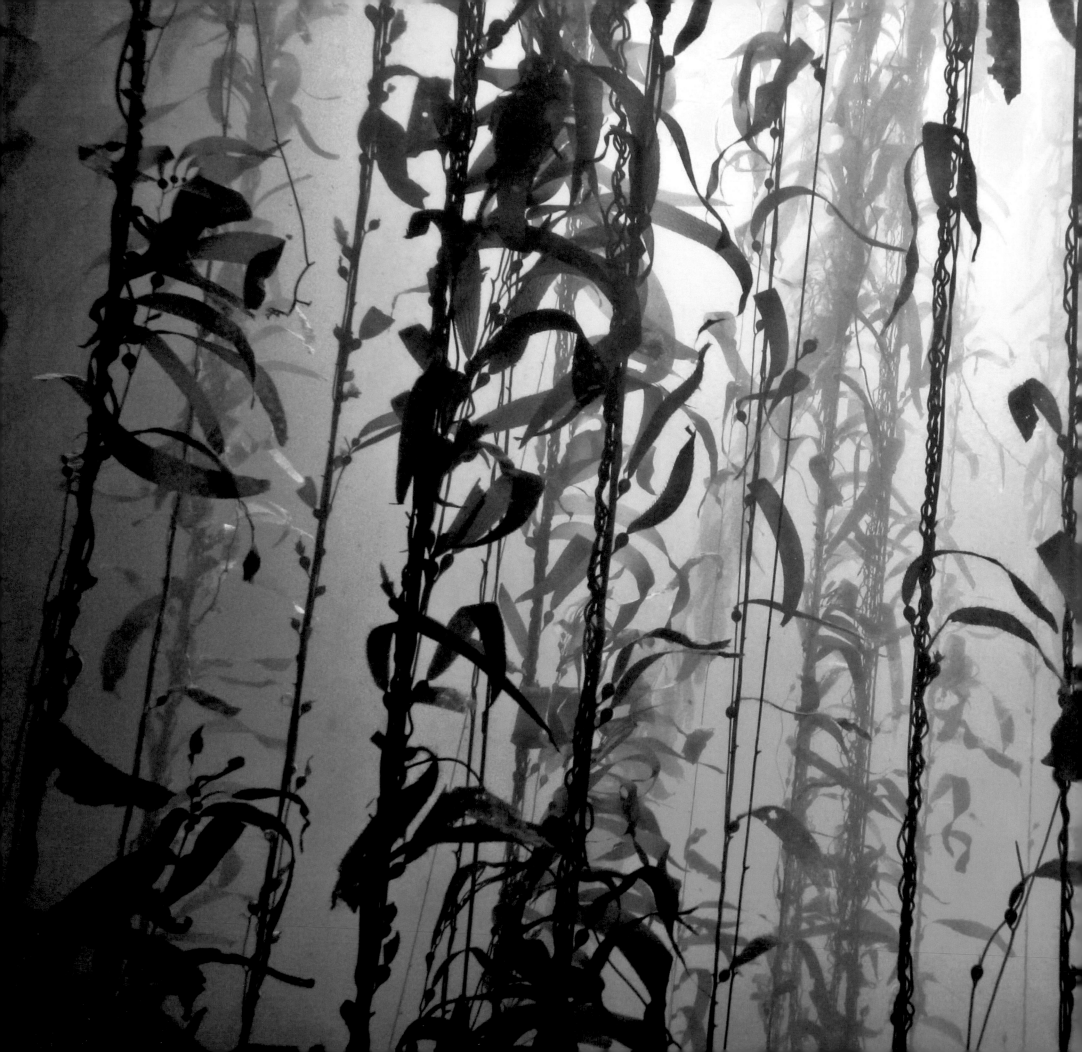

As the tides rise once more, there is little respite. The constant pummelling of waves can easily dislodge and damage creatures in the intertidal zone. Oysters and barnacles cement themselves to rocks with calcareous deposits, while mussels weave dense beards of byssal threads to keep themselves anchored in place. Seaweeds have elastic-like fronds that bend and sway with the motion of the waves.

Underwater Forests

Continuing further offshore, we discover lush pastures and dense forests as diverse and productive as their terrestrial equivalents. Kelp, a species of seaweed, flourishes in the cool waters of temperate latitudes. Here it forms vast forests which attach themselves to rocky outcrops. Absorbing nutrients and carbon dioxide directly from the water, kelp is one of the fastest growing organisms on the planet, able to grow up to 30 cm (1 foot) per day, with vast fronds as long as 30 m (90 feet). Just as forests on land provide habitats for countless animals and birds, kelp forests do the same for creatures of the sea: lobsters, fish, urchins, abalone, sea otters, seals and octopuses all call the kelp forest home. Associated with many commercially important species, kelp forests provide food and income for millions of people across the globe.

Growing on both sandy and mud bottoms are meadows of seagrasses. Different to seaweeds, these are flowering plants that evolved on land and returned to the sea (from where all plant life originated). Originally thought to be fertilized simply by releasing their pollen into ocean currents, new research has observed microscopic zooplankton carrying pollen grains between the

Inset: Mussels and barnacles cling on for dear life, Gower Peninsula, Wales. Mussels act as ecosystem engineers filtering detritus from the water, allowing sunlight to reach deeper.
Left: A kelp forest provides a vital habitat for numerous marine creatures while also absorbing wave energy, which protects our coasts.

flowers of seagrasses. The productivity of their habitats cannot be understated; despite comprising only 0.2 per cent of the world's ocean, seagrasses are responsible for over 10 per cent of the carbon drawdown. Acre for acre, they can store three times more carbon than a terrestrial forest. Setting carbon aside, seagrass meadows provide habitats for clams, crabs, sea cucumbers and sea stars, as well as sustenance for green turtles, manatees and dugongs.

Salt of the Earth

'Why is the sea salty?' – a question asked by generations of children across the globe. Essentially this is because carbon dioxide in Earth's atmosphere dissolves into rainwater, turning it from a neutral pH into slightly acidic carbonic acid. This rain slowly weathers rocks over time, dissolving mineral ions and carrying them across the land back into the ocean. Over millennia these ions accumulate in our ocean basins, where they form salts. Today the mean global salt concentration (or salinity) is 35 g of salt in every litre of water. This may not sound a lot, but this salt has a profound influence, dictating which organisms are able to survive in this habitat.

The mangrove forests, or mangals, of the tropics possess trees that have adapted to use salt water to grow; their roots contain specialist tissues to reduce the amount of salt that enters the plant. Some salt still enters the plant, however, which then needs to be removed. Fortunately mangrove trees can tolerate salt concentrations up to 100 times greater than that of an ordinary plant. Furthermore, glands in the leaves allow salt to crystallize on their underside; these are then washed away with the rain or removed when the leaves fall off. Few creatures are able to exist off mangrove trees alone. However, the trees provide the basis of a rich habitat forming nursery grounds for juvenile sharks, sea horses and other fish.

Right: *A green turtle grazing on a seagrass bed off The Cayman Islands. A single turtle can eat up to 2 kg (4.4 lbs) of seagrass a day.*

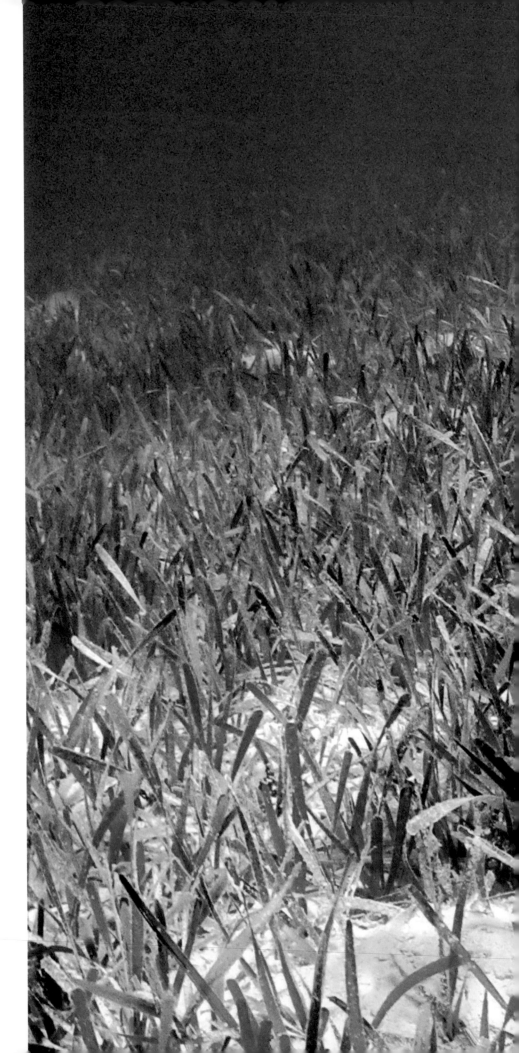

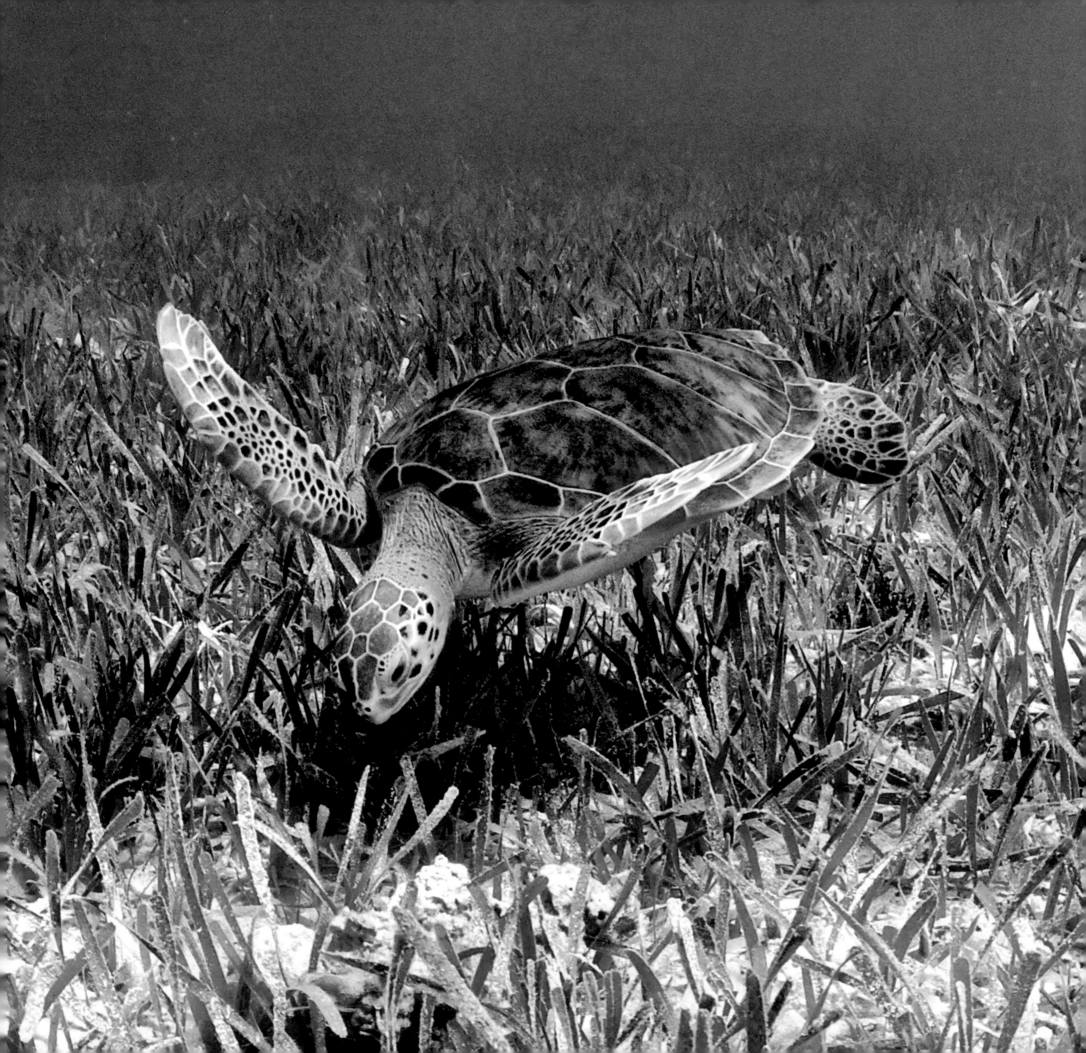

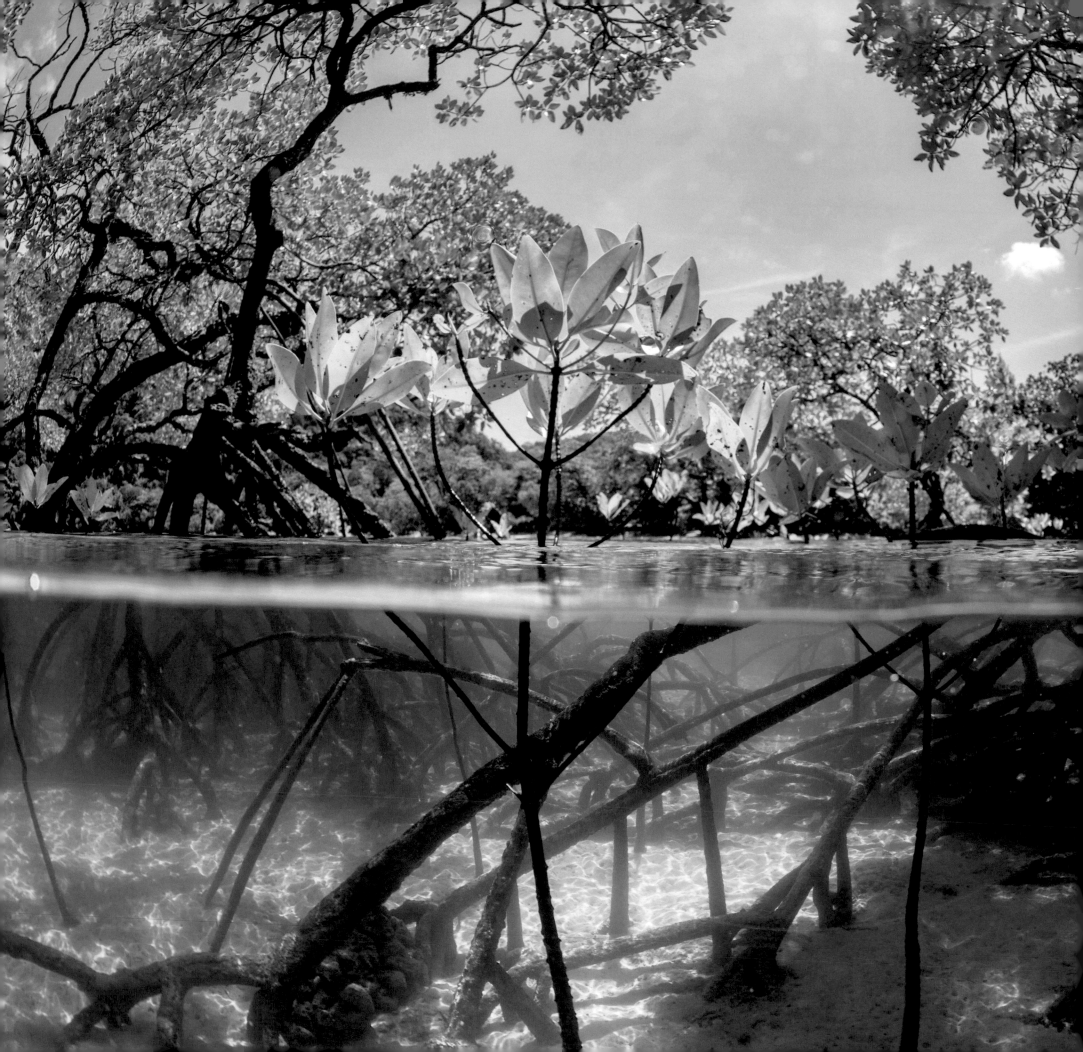

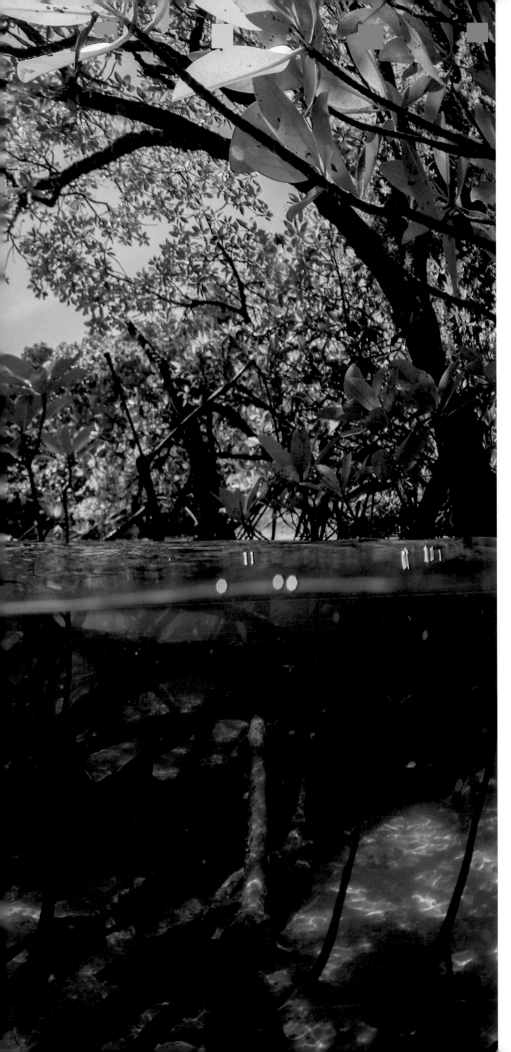

From a human perspective mangroves are not only essential for a number of commercially important fisheries; they are also valuable for creating a protective barrier along the coast. This reduces the impact of tropical storms while simultaneously cleansing polluted water before it enters the wider marine environment.

Moving into temperate climates, mangrove forests give way to salt marshes. Typically forming in sheltered areas that permit fine sediment to be deposited, salt marshes are expansive, low-lying wetlands. Here salt-tolerant shrubs and grasses grow, binding the sediment together. As with mangroves, salt marshes act as nurseries for fish species. They also provide refuges for birds, enabling them to raise their young in a sanctuary replete with food and devoid of predators.

Key to both of these habitats are estuaries: areas of brackish (partially saline) water that form where a freshwater river flows into the marine environment. Estuaries are dynamic systems; they exhibit daily fluctuations in temperature, salinity, currents and turbidity (the clarity of the water), resulting in a highly productive habitat. However, these constantly changing conditions make it difficult for species to survive in an estuary

Left: The stilt roots of mangrove trees not only stabilize and protect coastlines, but also provide nursery habitats for juvenile fish.
Above: Salt marshes form natural coastal defences, protecting communities from flooding by trapping eroded sediment.

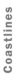

Coastlines

all year round. As rivers flow across farmlands and through cities they collect debris and other pollutants, then spew them out into the ocean. Many of the world's largest ports are located in estuaries, which provide important points for trade and transporting goods further inland – but this only adds more pressure to this habitat.

The Microscopic Menagerie

As any scuba diver will tell you, the visibility (or 'viz') of the water is paramount to the enjoyment of a dive. Yet murky waters can actually be some of the most productive. This 'murk' is in fact millions upon millions of phytoplankton – single-celled aquatic plants that form the basis of the marine food web. During winter months, nutrients slowly accumulate as stormy conditions, cooler temperatures and lower light levels stifle growth. As conditions become more favourable, however, the spring bloom explodes. While phytoplankton exist in all areas of the upper ocean, productivity increases dramatically in coastal waters where nutrient concentrations are at their highest.

Phytoplankton (from the Greek *'phyton'*, meaning plant, and *'planktos'*, meaning drifter) come in all manner of shapes and sizes and can be roughly divided into four distinct groups: diatoms, coccolithophores, cyanobacteria and dinoflagellates. Diatoms are the largest group, forging ornate skeletons out of pure silicon. The coccolithophores form protective shields out of calcium carbonate; these shields, or coccoliths, are eventually released, turning the ocean a milky-white in blooms that can be seen from space. The cyanobacteria, or blue-green algae, are thought to be some of the oldest organisms on Earth. Finally there are the dinoflagellates – a group that significantly stretches the definition of plant. Dinoflagellates can not only detect light, but also possess tiny, whip-like flagella that propel them towards favourable conditions. It is the dinoflagellates

Right and Inset: Estuaries, where river meets sea, are an important and threatened habitat.

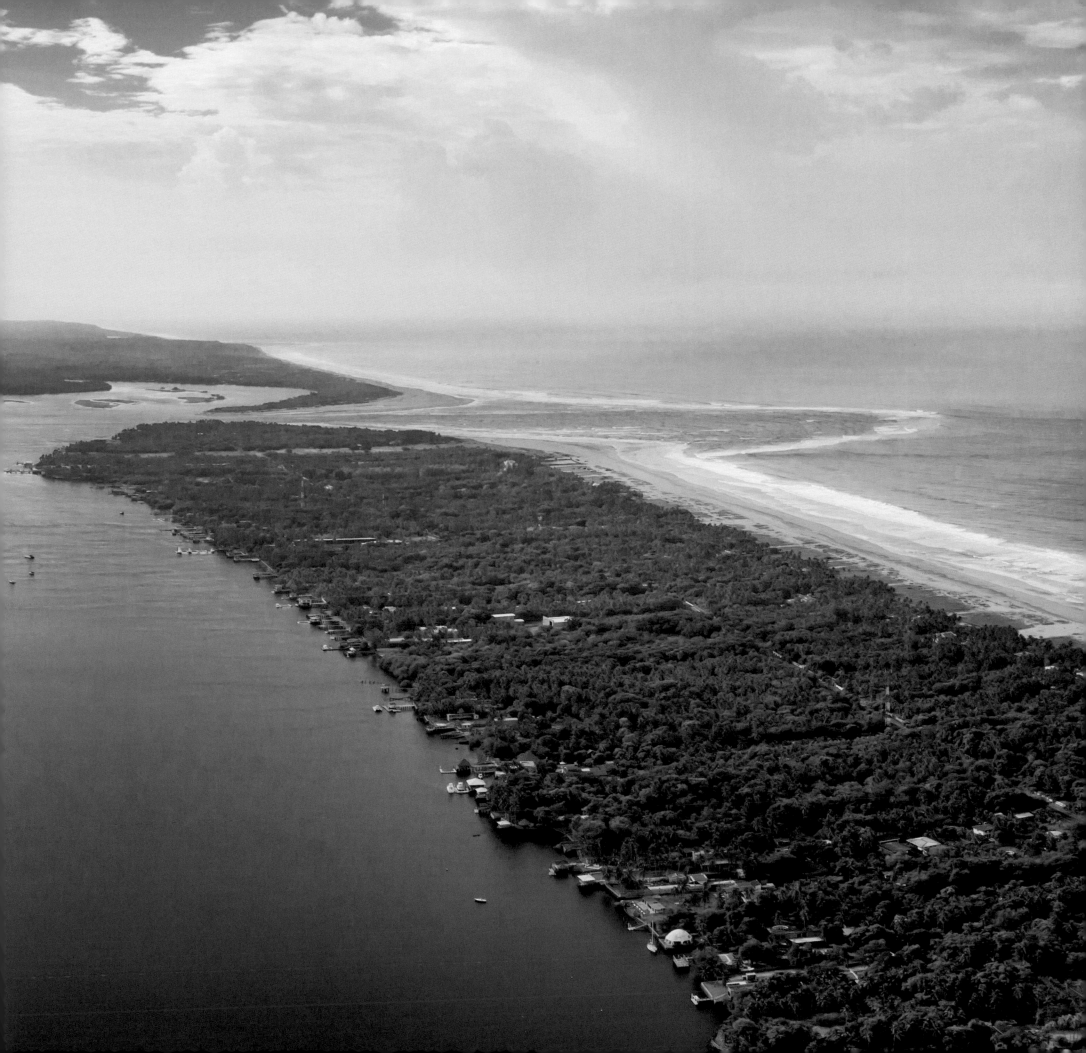

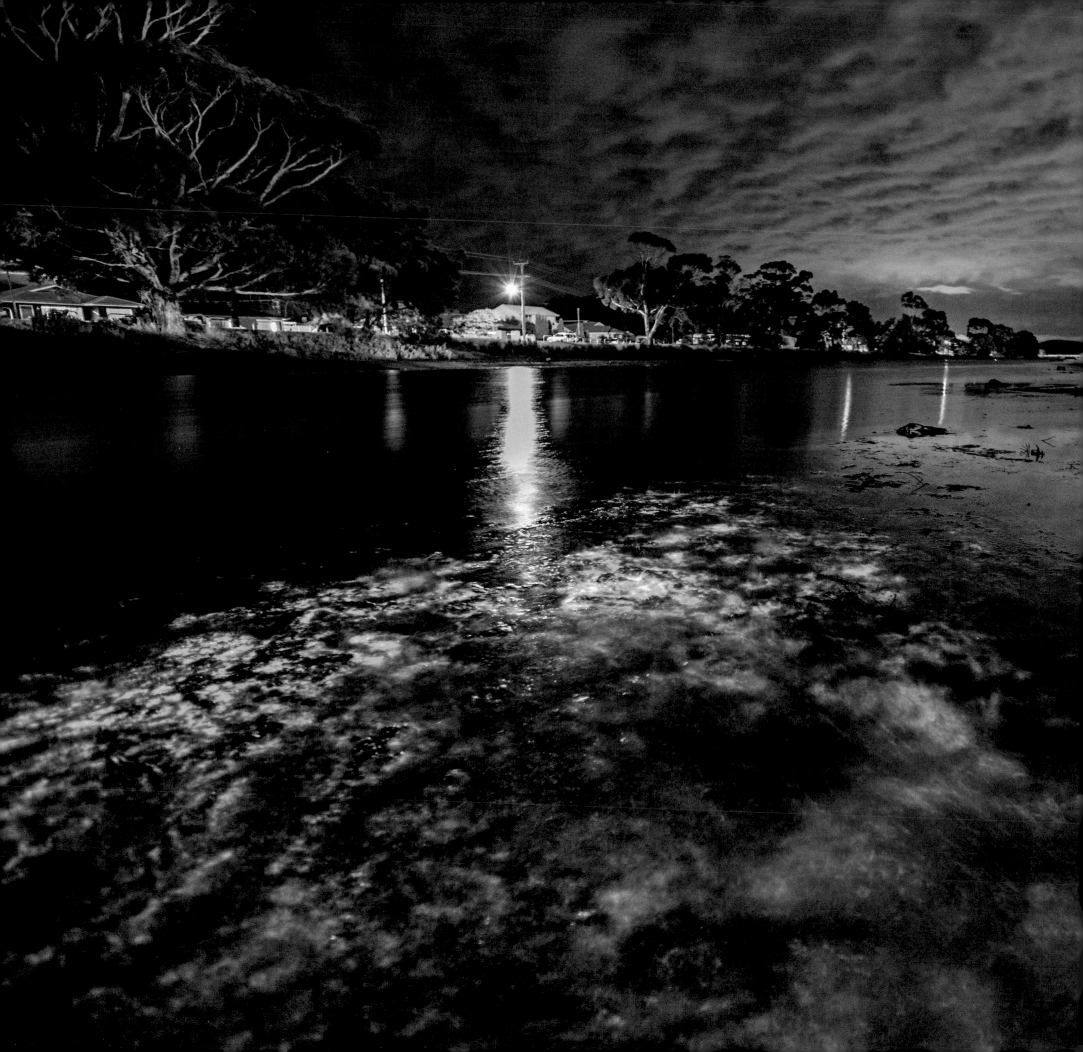

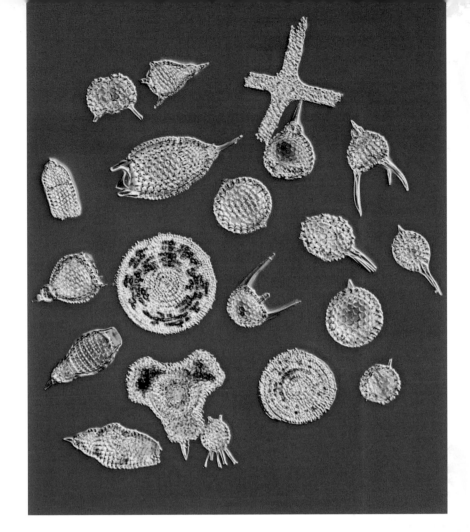

that are responsible for the amazing displays of blue phosphorescent bioluminescence on tropical beaches around the world.

Feeding upon the phytoplankton are the zooplankton. The most famous of these are krill, a source of food for countless whales; there is something poetic about how one of the smallest organisms in the sea can sustain the largest. The zooplankton may spend their entire lives in miniature, existing at a scale where water is as viscous as treacle. Other species spend only a fraction of their lives as plankton; they begin existence as small larvae, then slowly progress up to the macro-scale environment. As so many marine creatures opt for the 'strength in numbers' approach to reproduction, it is estimated that on average only one in a thousand marine organisms survives to adulthood.

Above: Zooplankton come in many shapes and sizes. Radiolaria produce intricate silica shells.
Left: Bioluminescent phytoplankton light up a bay off the coast of Tasmania, Australia.

Coastlines

On the Edge

With 40 per cent of world's 8 billion people living within 100 km (62 miles) of the sea, our coasts provide homes and livelihoods to millions. In terms of our economy, it is estimated that each kilometre of our coastline generates a whopping £19 million million ($24 million million) per year. Yet as our population continues to grow, coastal ecosystems around the world are feeling the pressure in more ways than one.

Too Many Nutrients

To meet our global food demands, farmers often opt to apply chemical cocktails to their lands in an attempt to boost crop yields. Large-scale industrial agricultures make use of high concentrations of artificial fertilizers as well as toxic herbicides and pesticides to kill off competing plants and insects respectively. With ravaged soils becoming increasingly devoid of nutrients, the solution has been continually to increase the dose of these chemicals year upon year. The industrialized farming of cows, sheep and pigs also makes an

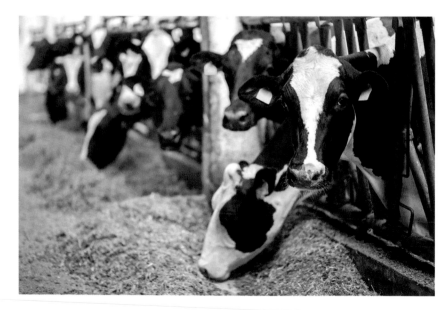

Above: Beef and dairy products are responsible for as many greenhouses gases as all of the vehicles on Earth.
Right: As our population increases, coastal ecosystems are under ever more pressure.

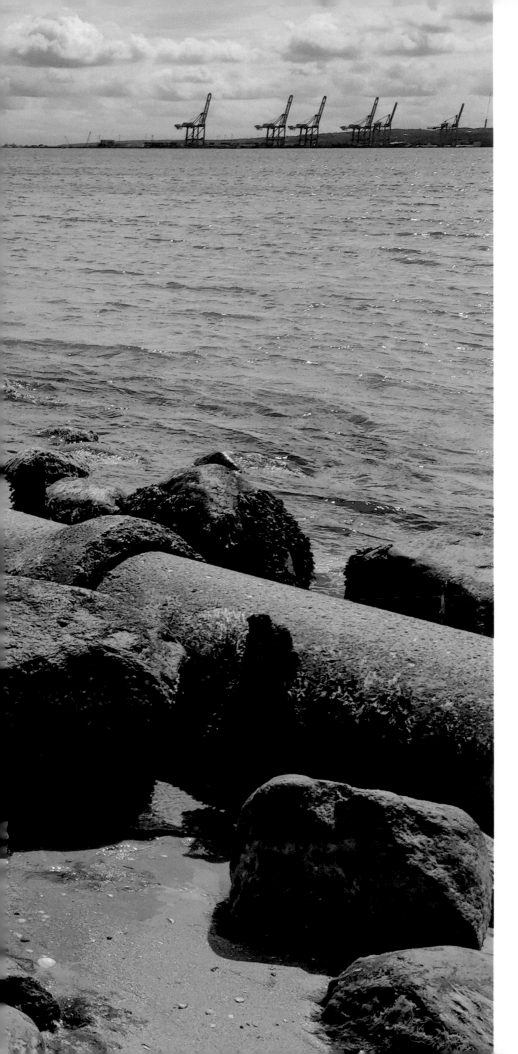

impact on the environment; as well as having to use more land to grow feed for these animals, the sheer quantity of slurry they produce is alarming. The global farm animal population currently produces around 1.3 billion tons of manure per year; as the demand for meat and dairy continues to rise, this figure is expected to reach 4.2 billion tons by 2050.

Nitrates and phosphates from fertilizers and manure get washed over and through the land, entering water courses and making their way inexorably towards our ocean. These chemicals are normally present in water at natural levels that permit the growth of aquatic plants. As these nutrient concentrations ramp up, however, they result in an unrestrained frenzy of plant growth. In a process known as eutrophication, this excess plant growth clogs waterways and blights beaches with deluges of algae and seaweed. Eventually this plant boom peters out, dies and sinks, leaving bacteria to begin the process of decomposition which uses up available oxygen in the water. The results are unsightly bathing waters, mass fish kills and ever-expanding 'dead zones', lacking oxygen and devoid of life. The economic impact on tourism, fisheries, loss of livelihoods and the subsequent amelioration has reached billions of dollars in the USA alone.

Farming our ocean presents a similar set of challenges. As wild fish populations continue to be overfished, we are turning more to the process of fish farming (aquaculture) to meet our demands. This has the benefit of avoiding harmful and wasteful bycatch while also reducing the element of chance; after all, we can cultivate set quantities of specific fish species to meet the necessary requirements. Unfortunately, much like intensive agriculture on land, aquaculture can also adversely impact the marine environment. Such a high density of fish constrained into small holding pens produces a continuous 'rain' of faeces and detritus that smother the seabed beneath the farm. A facility

Left: An outflow of sewage not only introduces excess nutrients into the marine environment, but also brings harmful bacteria that impact water quality.

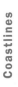

Coastlines

63

with 200,000 salmon discharges the equivalent amount of sewage as a town of 60,000 people. Unfortunately this waste is discharged, untreated, directly into the marine environment. To prevent diseases and parasites from spreading, the captive fish are dosed with antibiotics and pesticides which further pollute the surrounding environment. The impact on wild fish populations is not entirely removed either. Farmed fish are often non-endemic species and may, if they escape, establish populations that compete with native species.

Tiny and Toxic

As phytoplankton are also plants, they too are affected by excess nutrients in their environment (eutrophication). Despite their microscopic size, blooms of phytoplankton can prove hazardous to humans as well as larger marine organisms including whales, dolphins, manatees, seals and sea birds. These hazardous phytoplankton, a majority of which are dinoflagellates, are termed 'harmful algal blooms' (HABs) or, more colloquially, 'red tides' – certain

Above: Though it can help mitigate overfishing, intensive fish farming can have negative effects on the marine environment.
Right: A dense bloom of cyanobacteria forms a harmful algal bloom in the Baltic Sea.

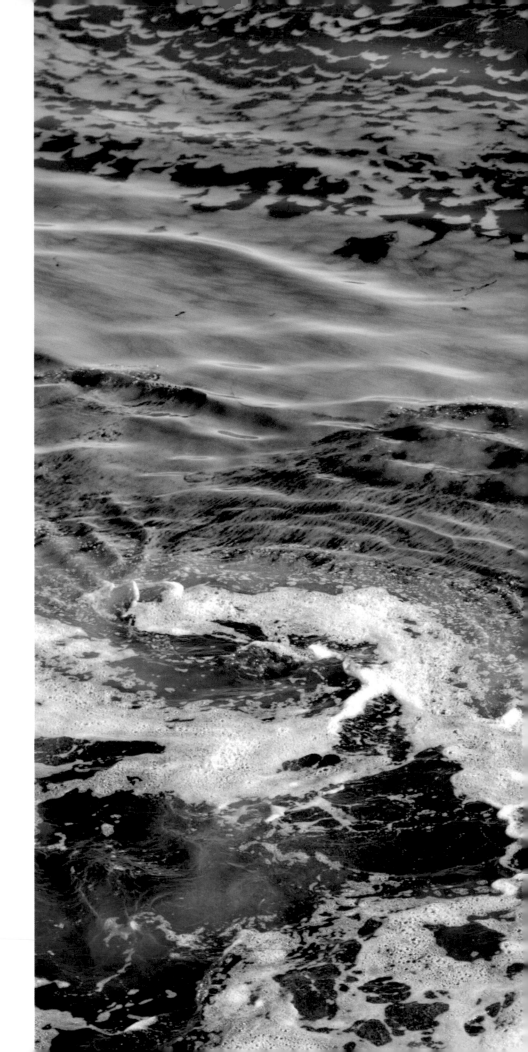

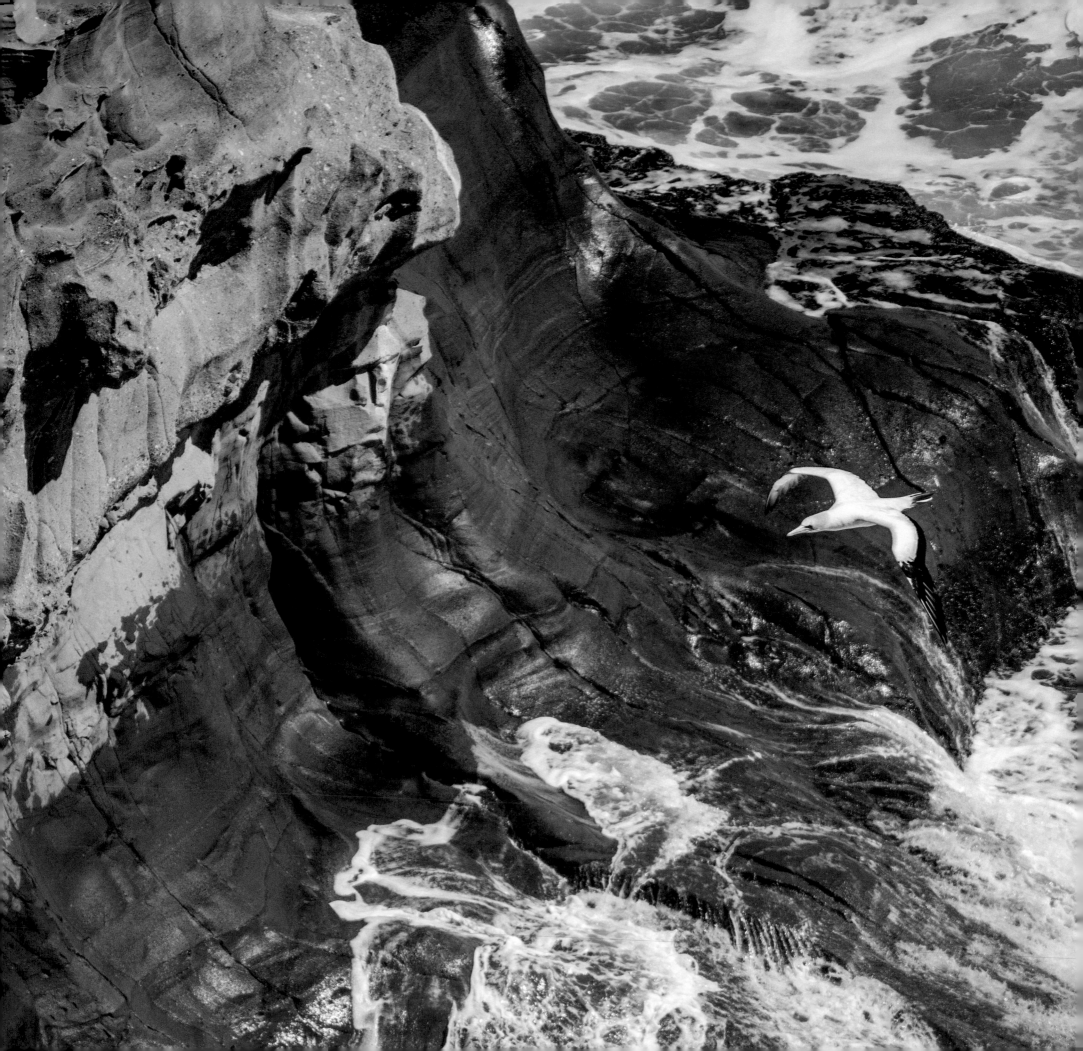

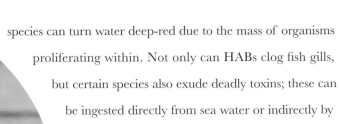

species can turn water deep-red due to the mass of organisms proliferating within. Not only can HABs clog fish gills, but certain species also exude deadly toxins; these can be ingested directly from sea water or indirectly by consuming contaminated organisms that have fed on the bloom. The toxins can build up (bioaccumulate) to such concentrations that ingestion of a single contaminated mussel or oyster may result in nausea, vomiting, paralysis and even death.

While HABs do occur naturally, we have seen an increase in both their frequency and severity as eutrophic conditions continue to spread. Often associated with warmer sea temperatures and calmer periods, climate change is now also thought to play a part in their rise.

Wave Goodbye

The robustness of our coasts relies on a plentiful supply and the movement of muds, sand, gravel and shingle. These sediments are transported from inland via rivers and then dispersed along the coast by wave action and the prevailing tidal currents. We have disrupted the natural flow of sediment to the coast in many ways: by trying to make our rivers more manageable and less prone to flooding, by harnessing fast-flowing waters for hydroelectric power, by dredging watercourses to make them more navigable and by directing rivers into channels to prevent them from meandering. Accretions of sediment at river mouths (deltas) all rely on a constant supply of upstream sediment to replenish them. In the absence of this supply, coasts are eroding at an alarming rate. Often low-lying, deltas are at the mercy of rising sea levels and storms exacerbated by climate change. As sea water permeates

Inset: Dead fish washed up during a 'red tide' algal bloom on Naples beach, Florida.
Left: Our coastlines are constantly battered by wave energy, which slowly erodes even the hardest of rock.

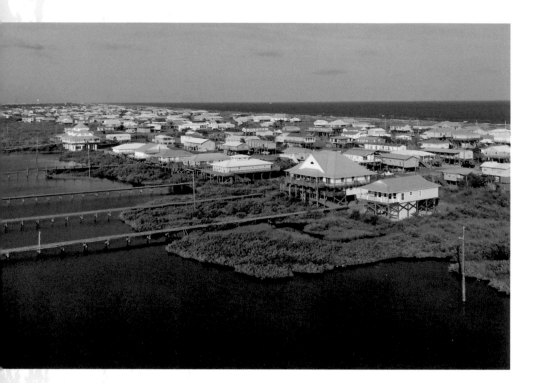

further inland, plant species less tolerant of salt are killed by exposure to it. When these plants die their root systems also perish, no longer holding the sediment together. The result is an erosive feedback loop that allows more and more land to be lost to the sea. The coast of Louisiana in the United States is one of the fastest eroding in the world, currently losing 65 km^2 (25 square miles) of land per annum. 2018 saw the USA's first climate refugees as the regional government no longer had the capacity to protect homes from the impending tides.

There are also tourist pressures. More and more of us flock to the coast each year, attracted to undulating white sand beaches. Too often this sand is obtained offshore or elsewhere; it is dredged up and shipped to the required destination, only to be eroded again in a matter of years. Of all of the illicit commodities to trade, criminal gangs are now branching out into beach theft, stealing natural sand beaches to order. An alternative is to erect lines of groynes

Above: Grand Isle, Lousiana, is an island at the mouth of Barataria Bay in the Gulf of Mexico. Louisiana's coastal wetlands are being steadily depleted.
Right: Beach groynes in Beltinge, Herne Bay, Kent, England. Though groynes prevent local erosion, they deprive the coast downstream of sediment.

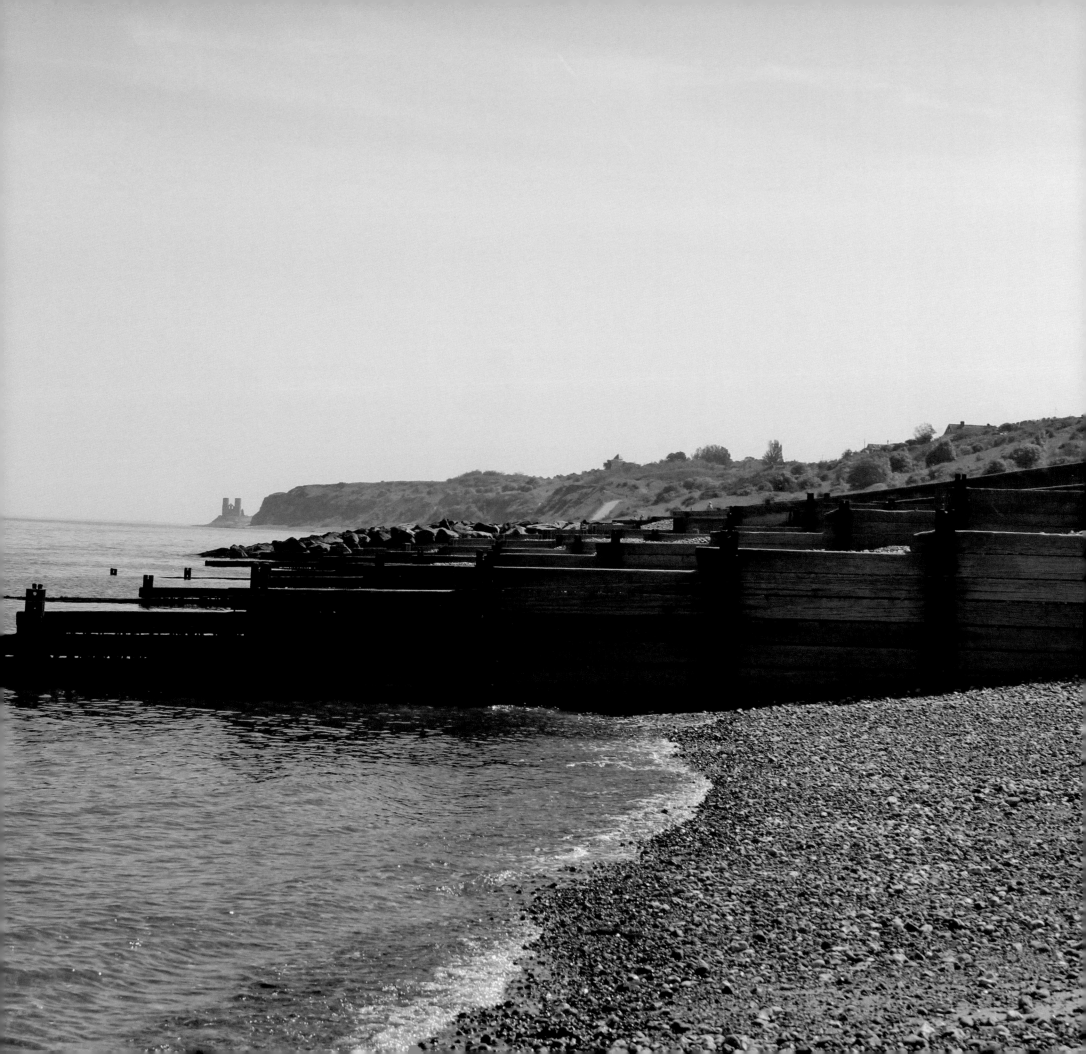

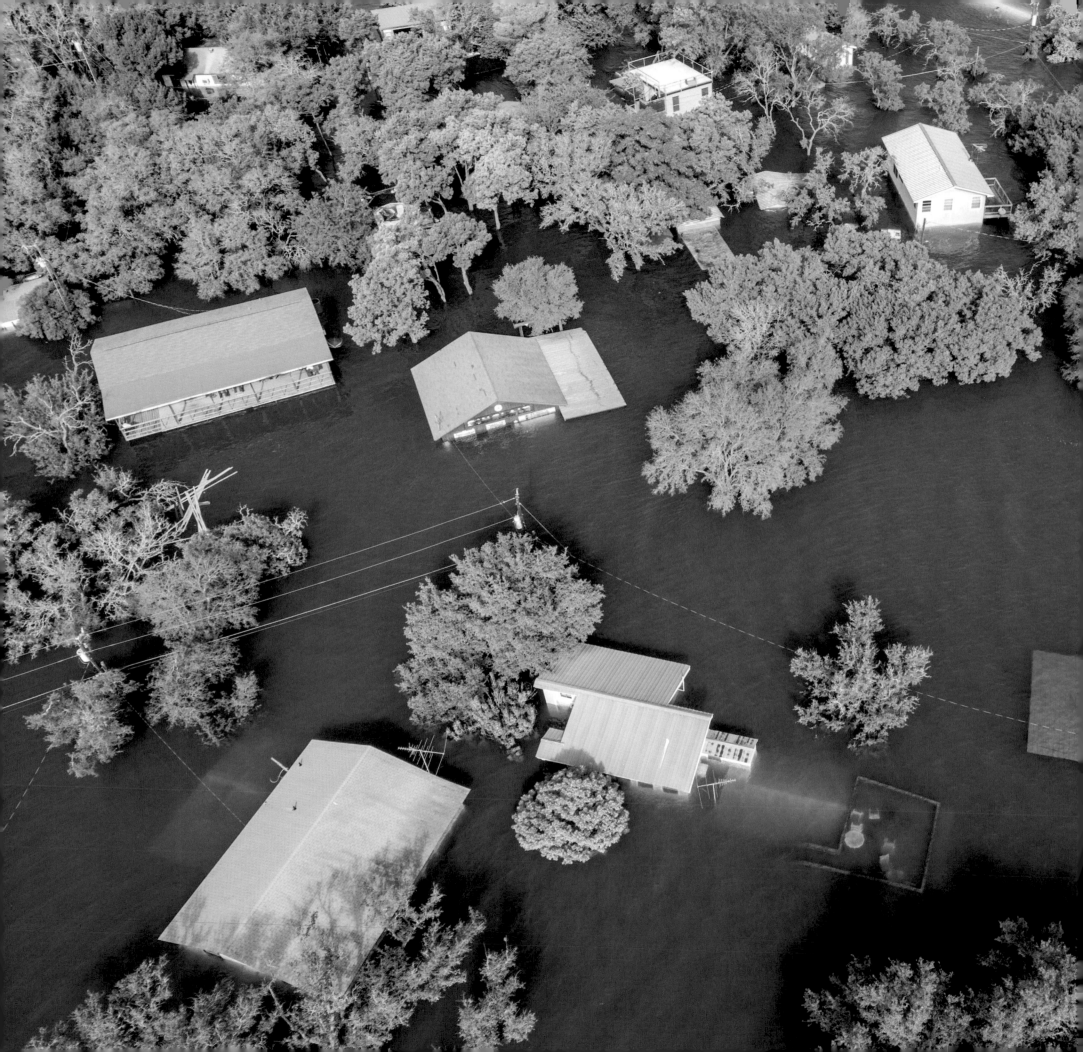

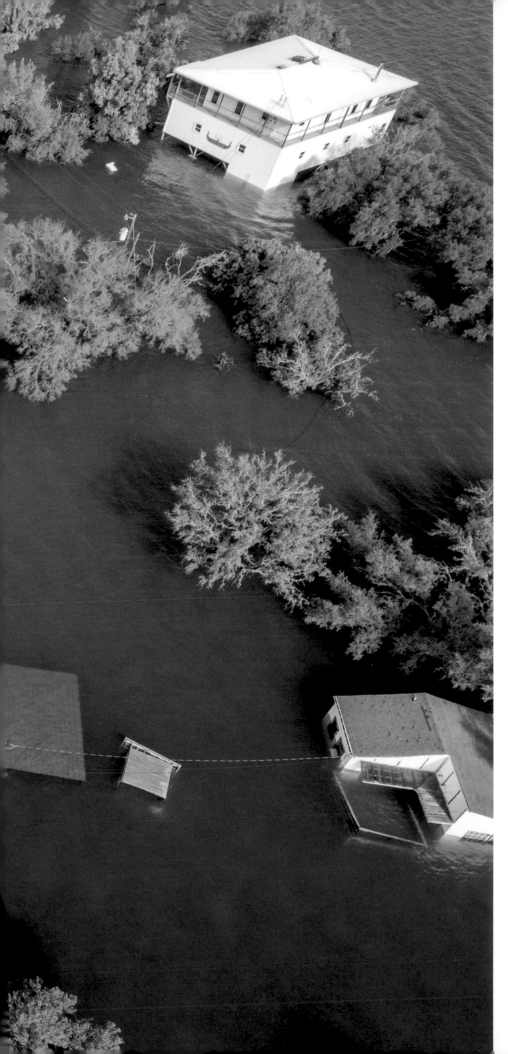

– wooden barriers that trap sand as wave action moves it along the coast. Unfortunately, this serves to deprive the coast downstream of sediment, resulting in the exposure of other populations to coastal erosion. These conurbations erect their own sea defences in turn, creating a coastal 'arms race' that slowly shifts the problem further downstream.

The Tide Is High

Communities that live on the coast have a certain tolerance for the occasional inundation from extreme events. However, in recent years climate change has been making our extreme events more frequent and more severe. Analysis of hurricanes impacting the eastern seaboard of the USA shows that as well as the number of storms increasing each year, the hurricanes themselves are getting stronger and lasting longer. Nine of the ten most destructive hurricanes on record have occurred in the last 20 years, costing over $606 billion (£468 billion), a total adjusted for inflation.

These events are exacerbated by the inexorable rise in our sea level. In much the same way that mercury warms up and expands in a thermometer, our ocean is also thermally expanding as our planet warms. At present, our ocean is expanding at a rate of around 2 mm (0.08 inches) per year; this may not sound a lot, but it is enough to cause concern to the 200 million people who live in coastal regions less than 5 m (15 feet) above sea level. In addition, as we continue to emit greenhouse gases and our planet continues to heat up, water locked in the glaciers of Greenland and the ice sheets of Antarctica will slowly start to be released, further increasing the volume of our ocean. In 2007 the Intergovernmental Panel on Climate Change (IPCC) predicted a total sea level rise of 59 cm (2 feet) by 2100. Unfortunately, Antarctica is melting faster than was predicted, with new forecasts now estimating a rise of 110 cm (3.6 feet) if we do not curb our emissions.

Left: Flooded homes in Texas, USA. Extreme weather events exacerbated by climate change cost the global economy £123 billion ($160 billion) per year.

Rethinking Our Approach

Our coastlines act as the interface between human actions and the sea. It is understandable that the negative impacts experienced here are concentrated and wide-ranging compared to other marine habitats. We must realize that land and ocean are intrinsically linked; you cannot impact one without having a profound effect on the other.

Working with Nature

We are now becoming more aware of where our food has come from and how it has been produced. More and more farmers are realizing that adding ever-increasing amounts of fertilizers, pesticides and herbicides to the soil is not sustainable, either environmentally or economically. With a focus on farming practices that work more closely with natural cycles, using organic techniques and permaculture, we can produce food that is both healthier for us and better for the environment. Fruits and vegetables grown using these techniques are not only devoid of carcinogenic pesticides, but also have higher concentrations of energy and nutrients, meaning that we do not need to consume as much to achieve our daily allowances of minerals and calories. Reducing the need for fertilizers will help to restore our waterways and coasts. Healthier soils are also less prone to erosion. Denser vegetation improves the volume of roots in the soil, binding it together to prevent it from being washed away. The soil is also able to draw down and store more carbon from our atmosphere, reducing the impact of climate change. With livestock currently comprising 67 per cent of vertebrate land animals, it is time to wean ourselves off consuming so much of the costly beef and dairy

Right: *Sheep grazing on the Irish coastline. Farming livestock has an impact on the entire environment – land, air, sea and climate.*

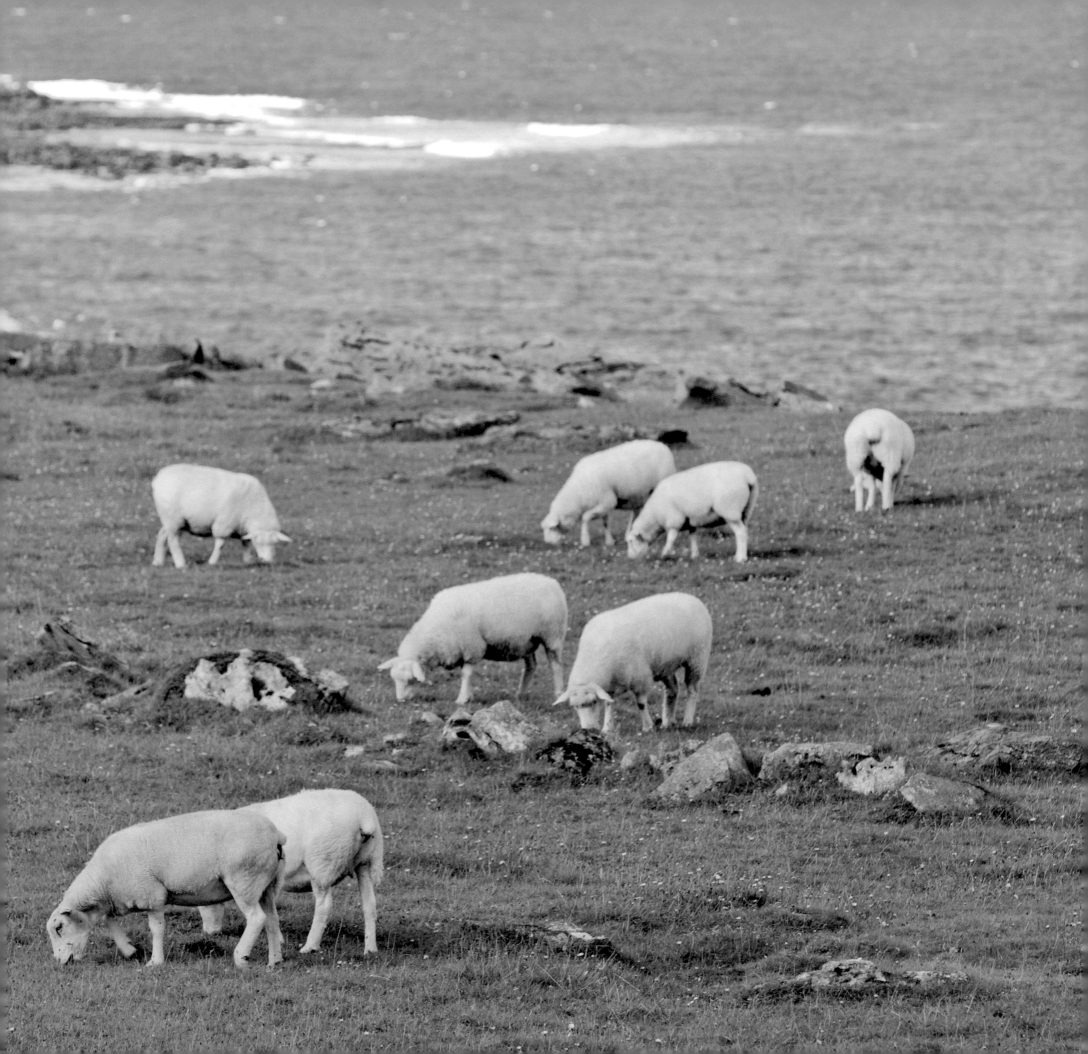

products to which we have become accustomed. Not only can our land be put to more efficient use, but so can our fresh water. The vast quantities of greenhouse gases generated by farming will be drastically reduced, as will the waste manure that contributes to eutrophication and oxygen dead zones.

Defending Our Coasts

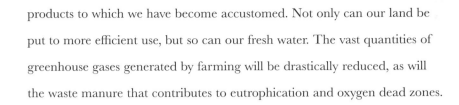

Our initial approach to defending our coast involved treating the ocean like an invader. Like Canute, we tried in vain to hold back the elements, using ever-increasing concrete walls and revetments to repel each oncoming attack. Often unsightly, these hard engineering approaches resulted in a loss of biodiversity and even exacerbated the erosion, yet for years they were seen as a necessary evil. Our approach to coastal management is now changing; viewing the coast holistically, we now understand that any impact in one place has knock-on effects elsewhere. Soft engineering approaches such as gabions disperse wave energy while maintaining shoreline habitats. Dynamic revetments made of pebbles move up and down the beach, protecting it from wave action. Protection of sand dunes provides a natural defence from coastal flooding. As the economic cost of the protection is considered, managed retreats such as these are becoming more and more frequent. Here we allow natural processes to take hold and slowly to reclaim areas of land.

Our coasts are amazingly diverse places, offering enjoyment, food and income for billions of people. As we learn to work with nature, instead of against it, we can continue to enjoy these habitats long into the future.

Inset: Dynamic pebble revetments or 'cobble berms' are a more natural and adaptable way of protecting a shoreline, such as here in Cape Lookout State Park, Oregon.
Left: A sand dune system offers a natural belt, protecting inland communities from flooding.

Coastlines

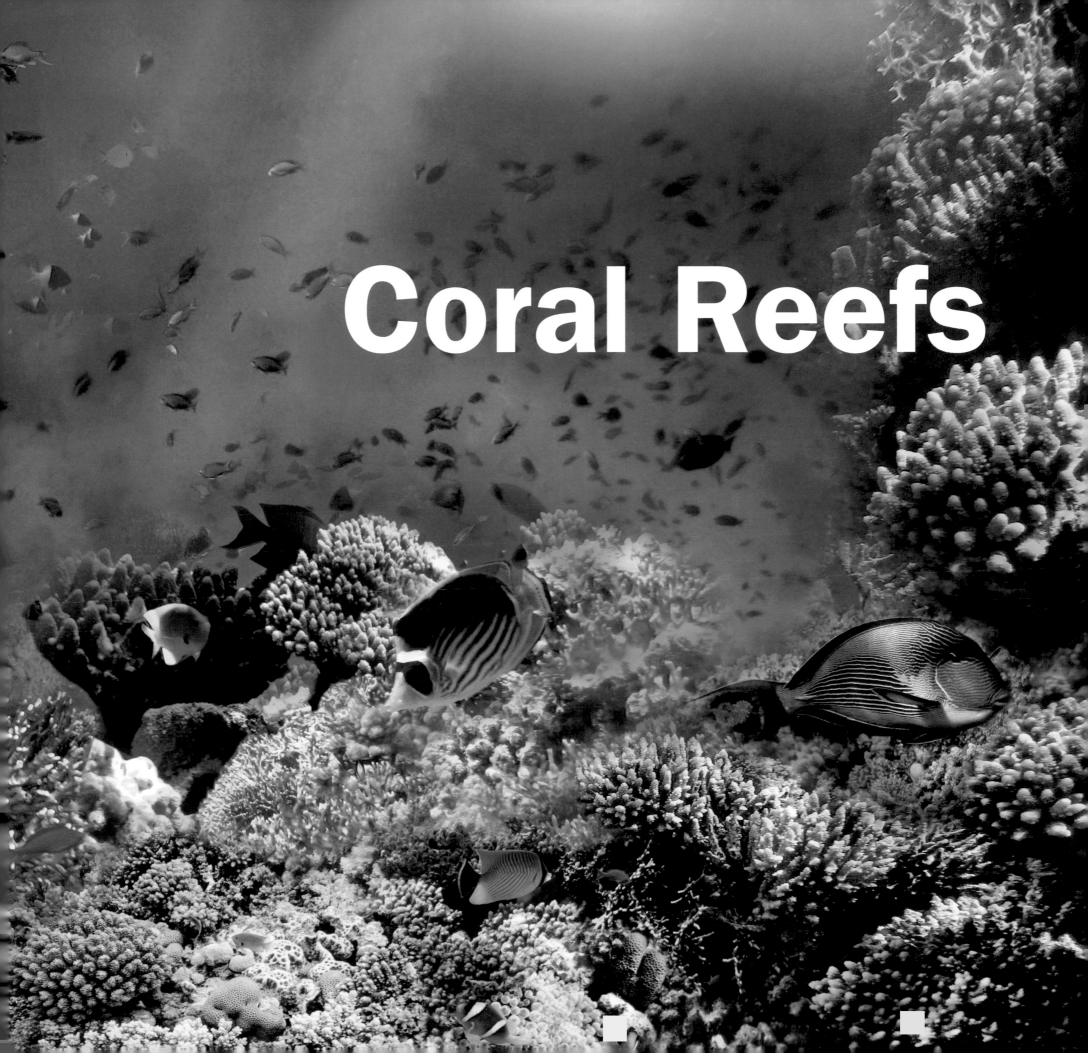

Coral Reefs

Rainforests of the Sea

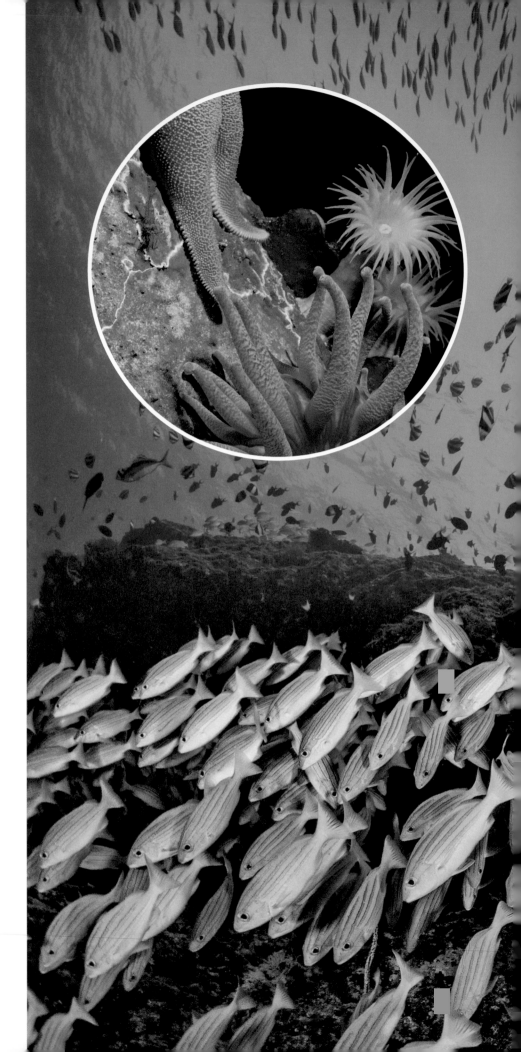

Giant sea fans, shoals of neon fish, circling sharks and gliding turtles. Snorkelling or diving above a coral reef has led many people to fall deeply in love with the ocean. The vibrant colours, intricate designs and general bustle of life on the reef are utterly captivating. Home to over one quarter of all fish species, it is hard to imagine an ocean without these diverse and productive communities.

Plant, Animal or Mineral?

Many people are confused whether corals are plants or animals; often they even resemble rocks. To set the record straight, corals are animals. Nearly all species are colonial, consisting of hundreds of thousands of individual polyps combining to form what appears to be a single structure. Corals can be split into two groups: hard or stony corals, which form the foundation of the reef; and soft corals, which are composed of a jelly-like substance around a spiny 'skeleton'. Hard corals have a rigid limestone skeleton that is the basis of the reef structure. Each polyp closely resembles a sea anemone – which happens to be one of their closest relatives.

Working Together

Corals have a symbiotic relationship with the photosynthetic algae, zooxanthellae. Millions of these single-celled plants inhabit the tissues of all hard and some soft coral species. As well as protection, the coral also provides a supply of carbon dioxide and nutrients needed for photosynthesis.

Inset: A close-up view of a brightly coloured sea star, coral polyps and the tentacles of a sea anemone.
Right: Schools of Bengal snappers, bannerfish and fusiliers above a reef in the Maldives.

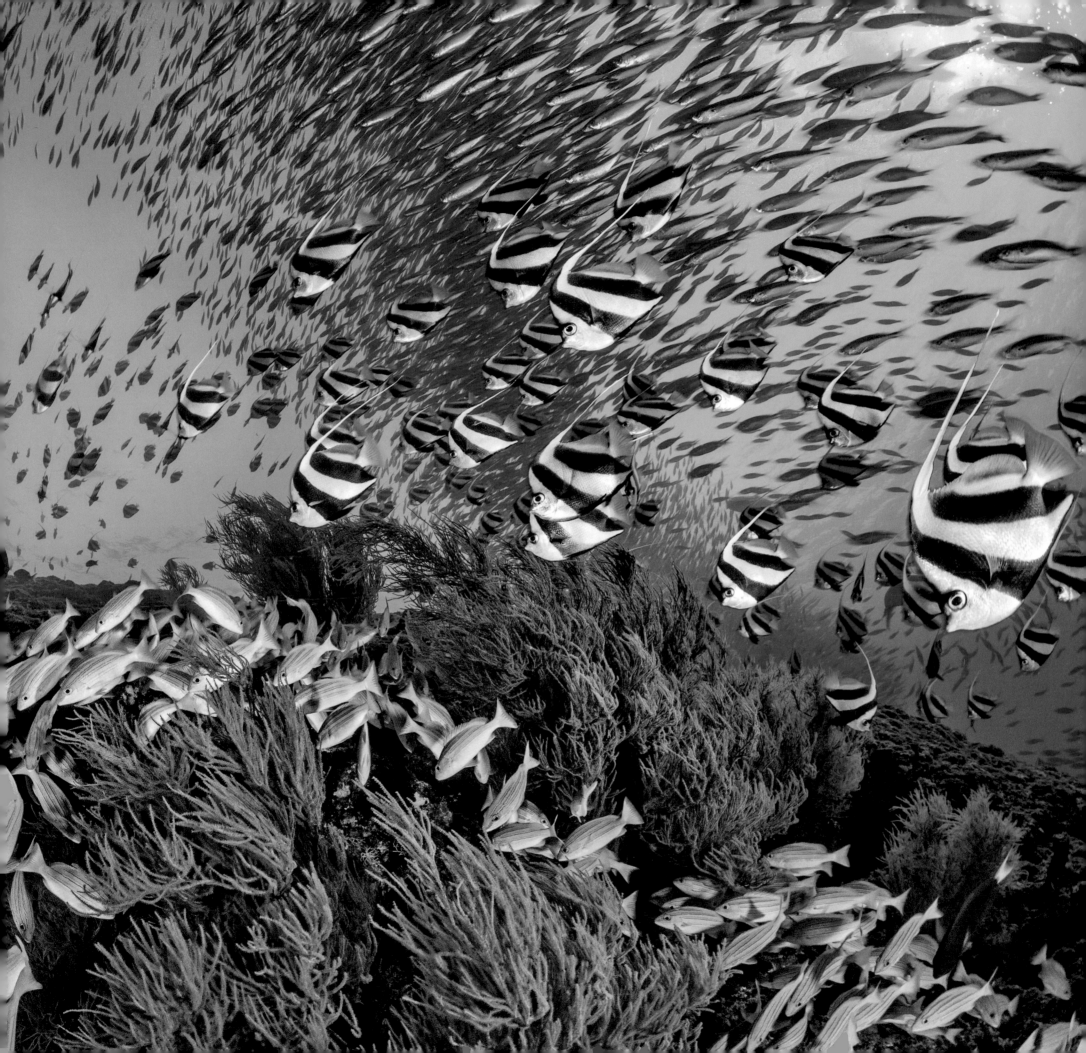

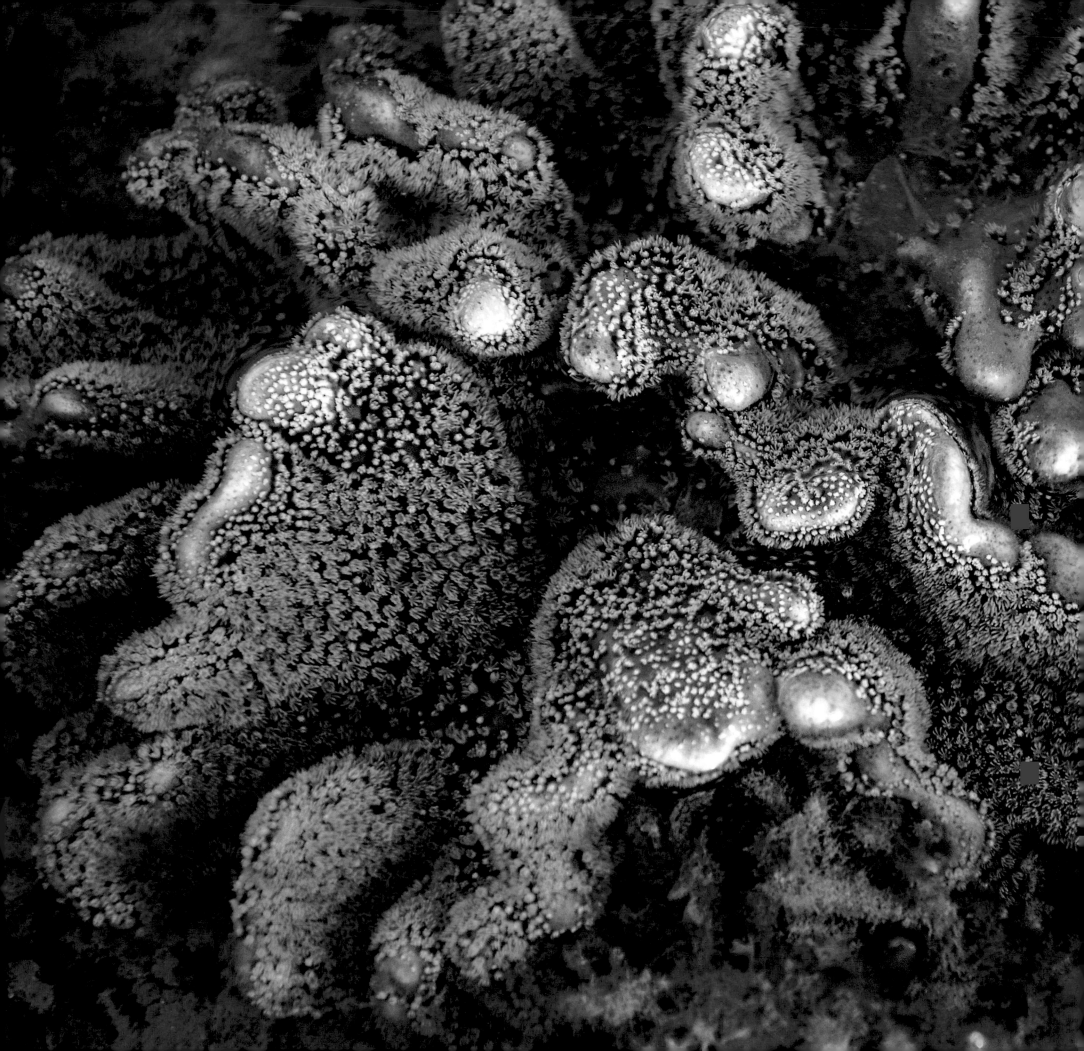

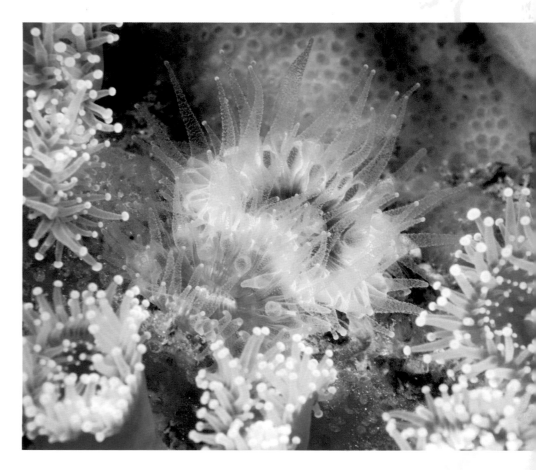

In return, the oxygen and some of the carbohydrates produced by the zooxanthellae are used by the host coral. Corals receive between 50 and 95 per cent of their food from zooxanthellae, depending on the amount of light available. They supplement their diet by catching zooplankton and other microorganisms that drift over the reef. This hunting takes place predominantly under the cover of darkness, when plankton rise from the depths to feed. The corals extend their tentacled polyps and subdue their prey with the toxic, sticky threads that are shot out of specialized stinging cells (nematocysts). Some species of coral have polyps up 15 cm (6 inches) in diameter; they can therefore catch small shrimps and invertebrates as well as juvenile reef fish. Nematocysts can also be used for defence, acting as weapons in the silent, underwater battles that rage between coral colonies over available territory.

Above: *A yellow cup coral surrounded by beautiful strawberry anemones.*
Left: *'Toadstool' coral, visible below the water's surface at low tide, Great Barrier Reef, Australia.*

Coral Reefs

An Underwater Oasis

Corals have very specific habitat requirements: warm clear water, plenty of light, stable salinity levels and a constant food supply. For these reasons they are typically found in shallow, tropical waters, away from estuaries and other freshwater sources. They benefit from wave activity as this aerates the sea water, brings in microorganism prey and removes the sediment that would otherwise block out the light. Due to their stringent preferences, coral reefs cover an area less than 1.2 per cent of the continental shelf. However, they can be between 50 and 100 times more productive than the low-nutrient tropical waters that surround them.

If you have been picturing the azure waters of the Caribbean while reading this, it is worth knowing that coral reefs also occur in less idyllic places. As we continue to explore our deep ocean, we have now uncovered reefs proliferating in cold, deep waters around the world. Cold-water corals can inhabit waters from 4°C (39°F) to 12°C (54°F), to depths of 3000 m (9000 feet). Due to the minimal light found at such depths, these corals survive purely by catching their own food rather than developing a symbiotic relationship with algae as their warm-water cousins do. These algae grow more slowly than their tropical relatives and some have been recorded aged over 4200 years.

Living Cathedrals

Coral reefs can take the form of three distinct structures: fringing reefs, barrier reefs and atolls. Fringing reefs develop within 500 m (1640 feet) of the shoreline and run parallel to it. Barrier reefs are similar but found further out to sea, around 1.5 km (0.9 miles) from the shore. There is normally deep water between them and the coast. Finally, atolls are rings of coral that encircle a protected lagoon and occur far from the coast. These are formed

Right: Coral reefs can also be found in cold regions, such as the Arctic waters of Svalbard.

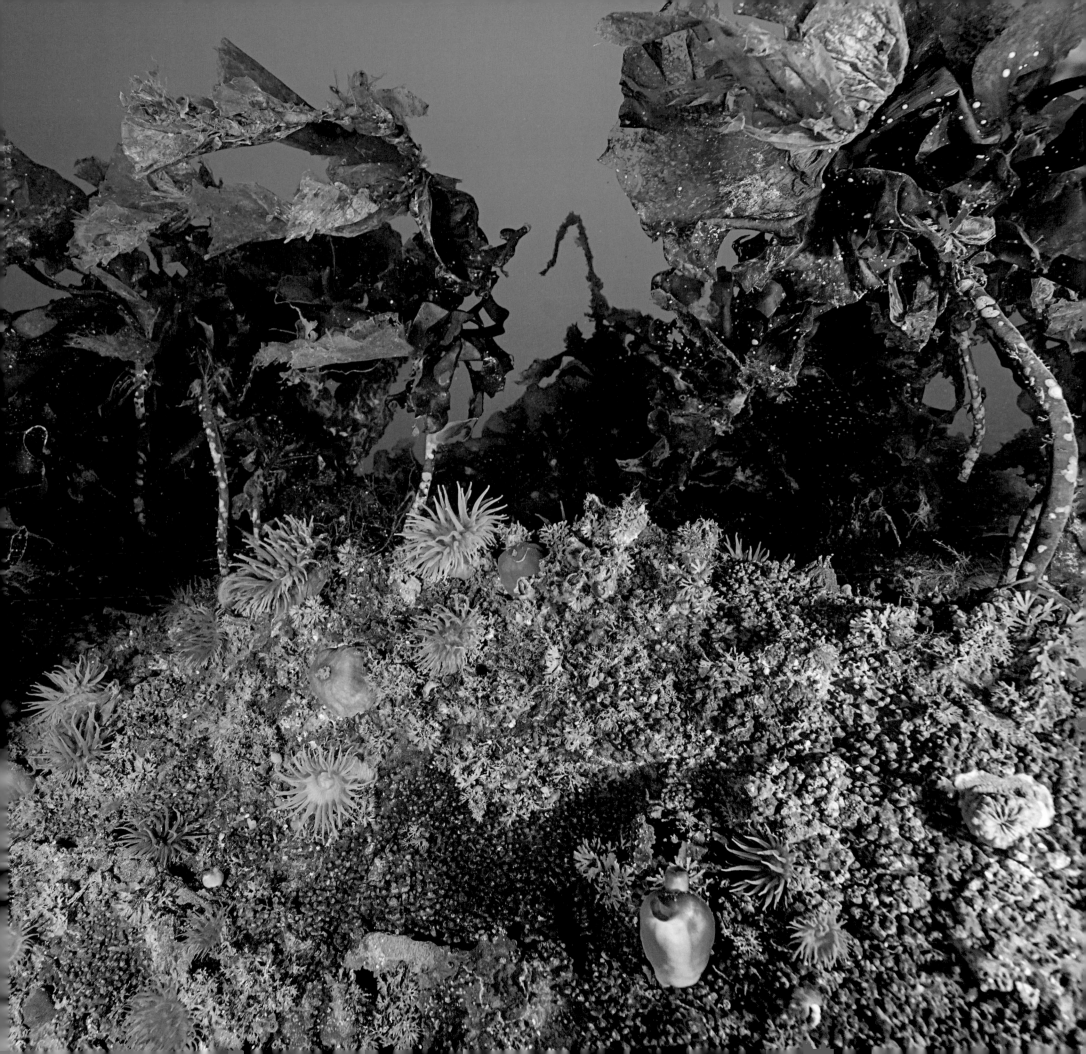

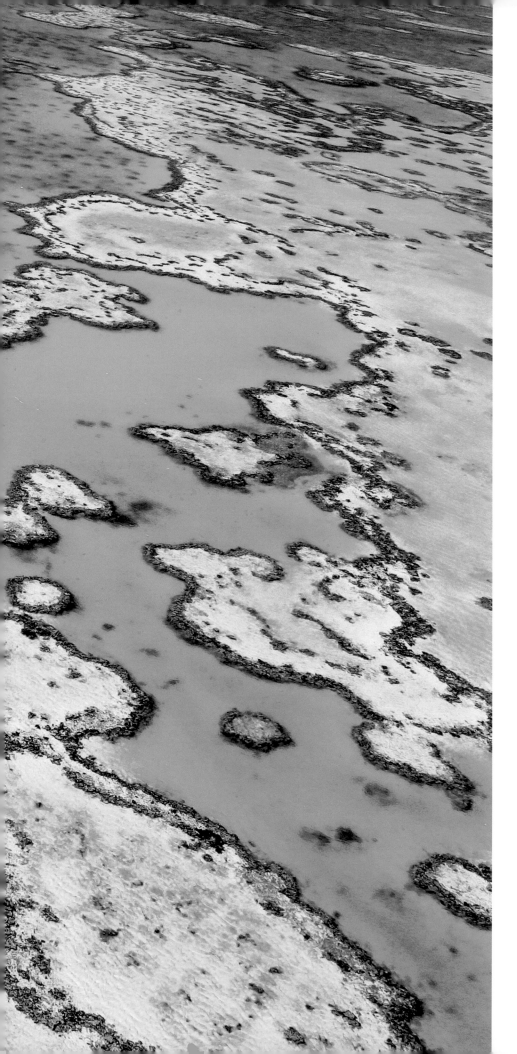

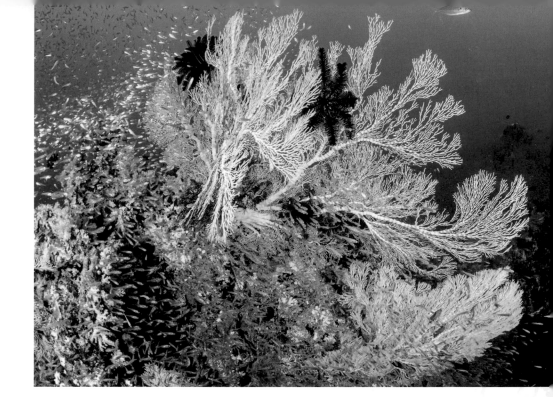

when the exposed top of a marine volcano sinks into the sea, leaving behind what was its fringing reef. Patch reefs are sometimes considered a fourth reef structure. These small, hill-like constructions occur in shallow lagoons, usually less than 20 m (65.6 feet) in depth. Corals grow extremely slowly, only extending their limestone skeletons by a couple of centimetres (~1 in) each year. Despite their slow rate of growth, corals have managed to build the largest living structures on the planet – far larger than anything built by humans. The most famous of all coral reefs, the Great Barrier Reef off the western coast of Australia, is so large that it can be seen from space.

A Living Carpet

Reefs are surrounded by a flurry of fascinating creatures. Spiny sea urchins live alongside damselfish, surgeonfish and other herbivorous fish, all grazing on algae, which prevents it from smothering the reef. Carnivorous sea stars shuffle across the bottom, using tiny tentacles to pull themselves along. Menacing moray eels lurk in dark crevices while gargantuan groupers drift slowly by. Hawksbill and green turtles nap in caves near the ocean bed while

Left: An aerial view of part of the Great Barrier Reef, the largest living structure on Earth.
Above: Sea fans are some of the most intricate and delicate soft coral species.

Coral Reefs

85

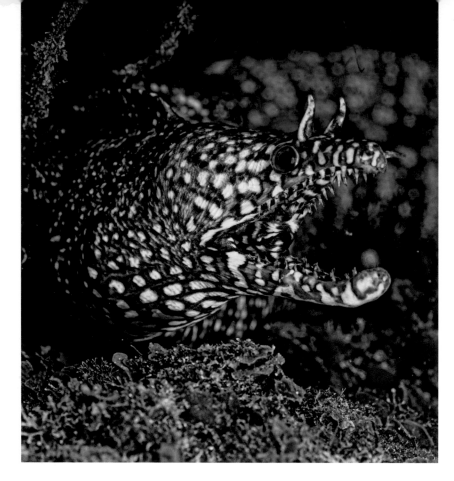

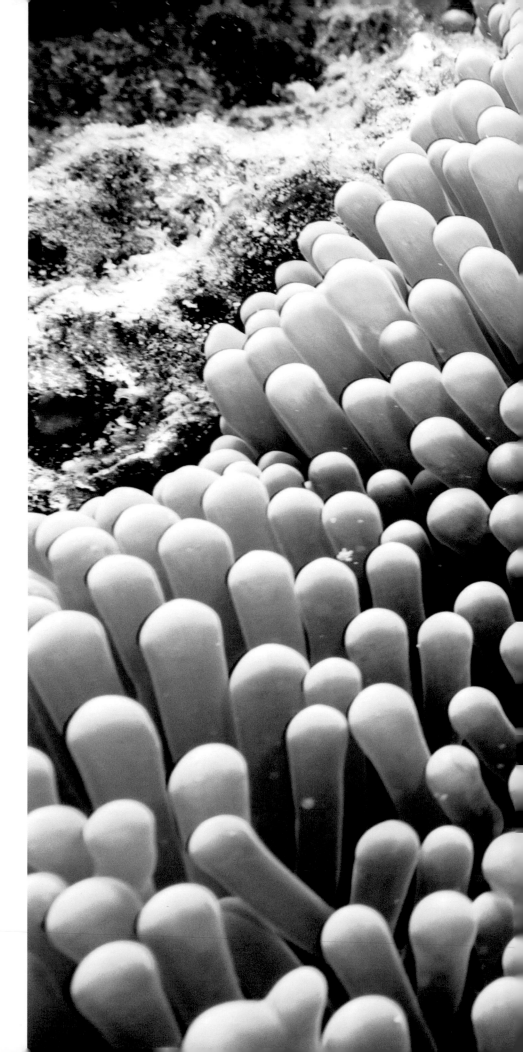

whitetip reef sharks circle the periphery of the reef in search of a fishy snack. Venomous anemones provide a safe haven for clownfish immune to their toxins.

The charismatic clownfish are sequential hermaphrodites, meaning they are able to switch sex when required. Each anemone is inhabited by a mature breeding pair and many younger males. The largest and most dominant is the breeding female. If she dies or is eaten, she will be replaced by the breeding male who will undergo a sex change; one of the smaller males will grow up to replace him. The film *Finding Nemo* would have had quite a different tone had it been more scientifically accurate!

As well as the sound of waves and the shifting of sand, the reef's soundtrack includes the sound of parrotfish crunching on coral. They are actually using their beak-like mouths to scrape off algae growing on the coral, but they

Above: A moray eel opens and closes its mouth to maintain a constant flow of oxygenated water over its gills.
Right: Clownfish hiding in a sea anemone. These intriguing creatures rarely stray more than a few metres from their host anemone.

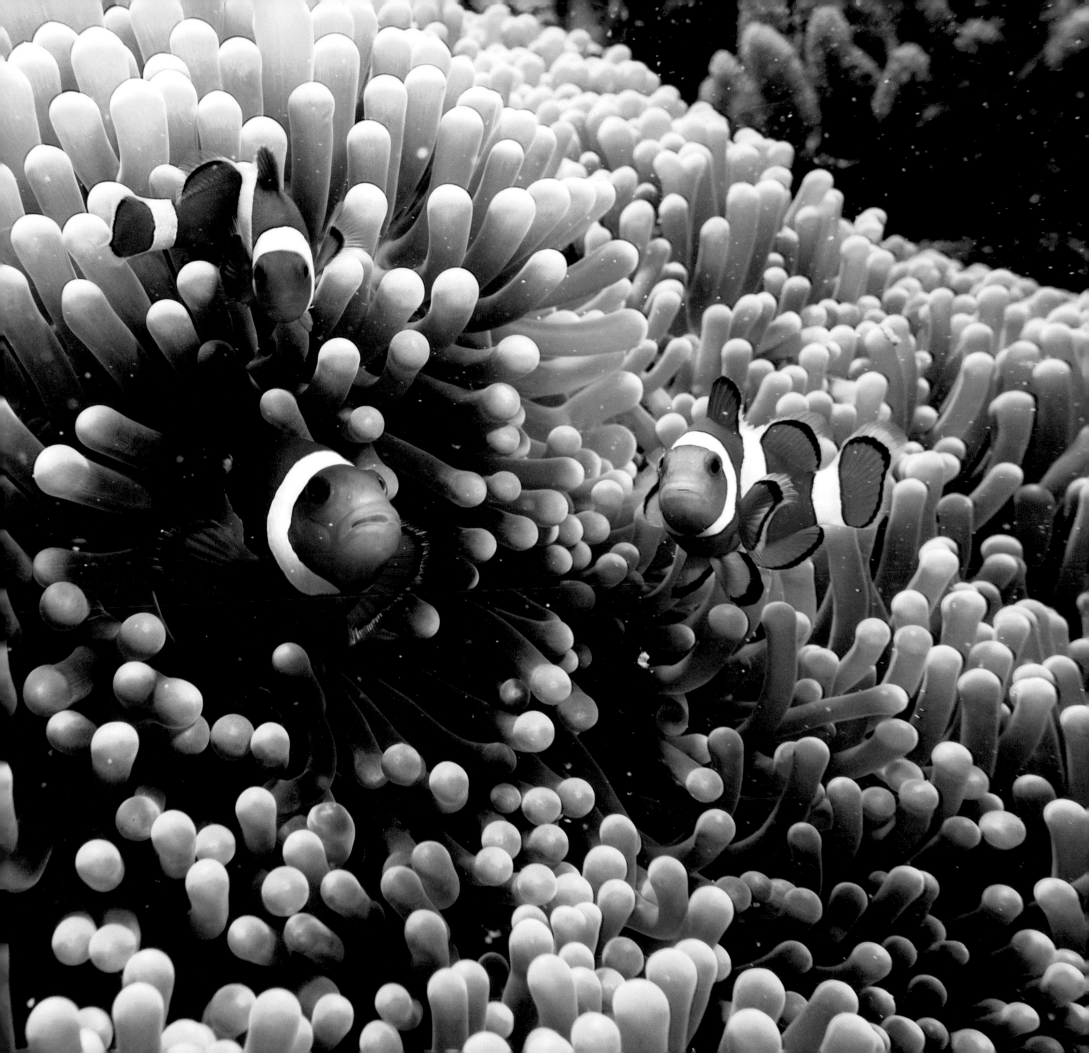

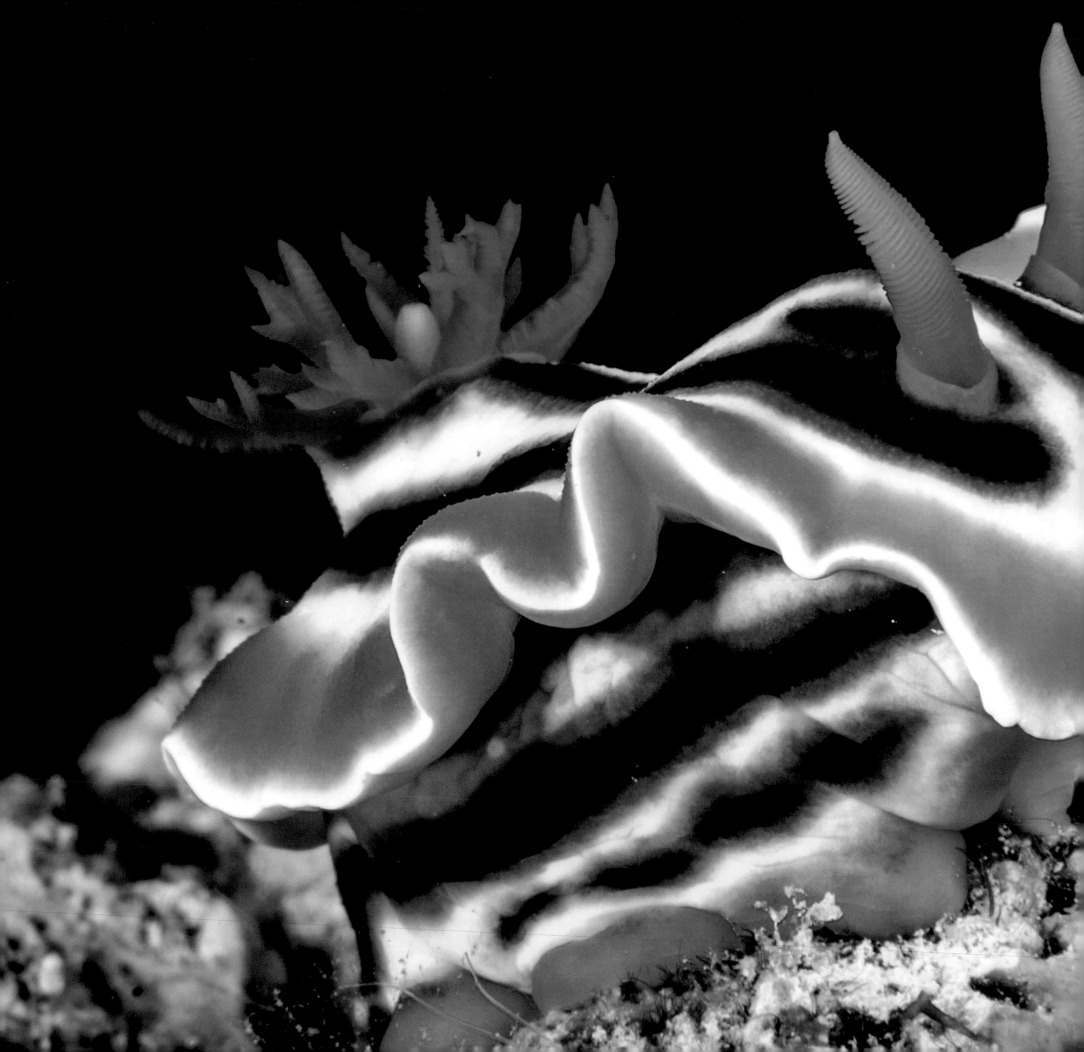

often end up swallowing small lumps of coral as well. This is broken down by their digestive system and excreted; an adult parrotfish can produce up to 90 kg (200 lbs) of sand every year. When next you stroll on a beautiful tropical white sand beach, remember that you are actually probably walking across a huge pile of parrotfish poop.

Fruits of the Sea

Over 500 million people depend directly on coral reefs as a source of food, income and protection from extreme weather events. In less developed countries one quarter of the total fish catch consists of reef fish species; for coastal inhabitants, this is their primary source of protein. Many locals work as fishers, selling their catch in the daily market; others are employed in the recreational and tourism industries. While the reef itself is fundamental to diving and snorkelling tourism, revenue from visitors who come to enjoy the beaches protected by the reef would also be lost were the corals to disappear. Global coral reef recreation and tourism has been valued at £7.4 billion ($9.6 billion).

Reefs also act as a buffer zone, dissipating wave power and minimizing the damage of hurricanes, typhoons, cyclones and tsunamis on coastal communities. By reducing flood risk, reefs also prevent soil erosion, resulting in more stable coastlines. Recent estimates suggest that the many goods and services reefs provide are worth at least £9.2 trillion ($11.9 trillion), roughly £270,000 ($350,000) per hectare. In other words, without coral reefs both ourselves and our planet would suffer.

Inset: A bustling fish market in South East Asia. Such markets are held all over the world, frequented by 3 billion people who rely on seafood as a primary source of protein.
Left: A magnificent nudibranch. There are over 2000 known species of these minute fluorescent sea slugs, with new ones being discovered almost every day.

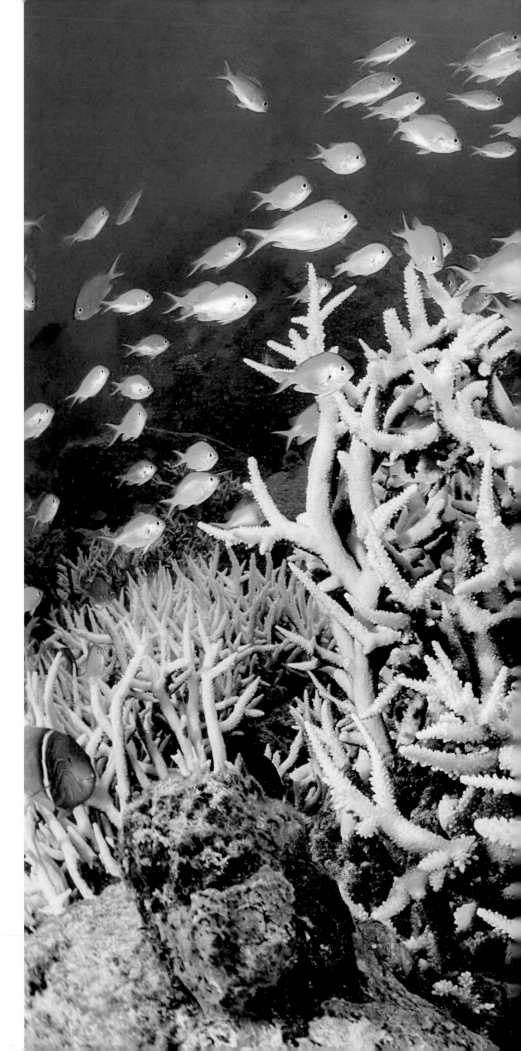

The Bitter Truth

In the last 30 years we have lost 50 per cent of the world's coral. Mass bleaching events have occurred like never before, while ocean acidification is making it difficult for the coral to recover. To make matters worse, we are putting extra pressure on reef ecosystems by overfishing, collecting coral and shells, and introducing invasive species. Coral reefs are an essential component of our ocean, but unless we take action now their future is bleak.

Acutely Acidic

Globally, we release approximately 41 billion tons of carbon dioxide (CO_2) into our atmosphere every year, the equivalent of 1.2 million tons per hour. Over 25 per cent of these emissions are absorbed into the ocean. As CO_2 dissolves into the sea water, it reacts with water molecules to form carbonic acid, making the water more acidic. Since 1870 average ocean pH has dropped from 8.18 to 8.0. While that may appear a minor change, remember that pH is measured on a logarithmic scale. This means that the ocean is actually 30 per cent more acidic than it was 50 years ago; by the end of the twenty-first century it is predicted to become 170 per cent more acidic. Such rapid changes in the chemistry of our ocean have never been witnessed by humans.

Fundamental alterations in the physical properties of their habitat will impact all types of marine life. However, it is species such as shellfish, coral and crabs, who have shells and skeletons made of calcium carbonate, that

Right: Bleached Acropora *coral in the Seychelles. There have been three pan tropical bleaching events in the past three decades.*

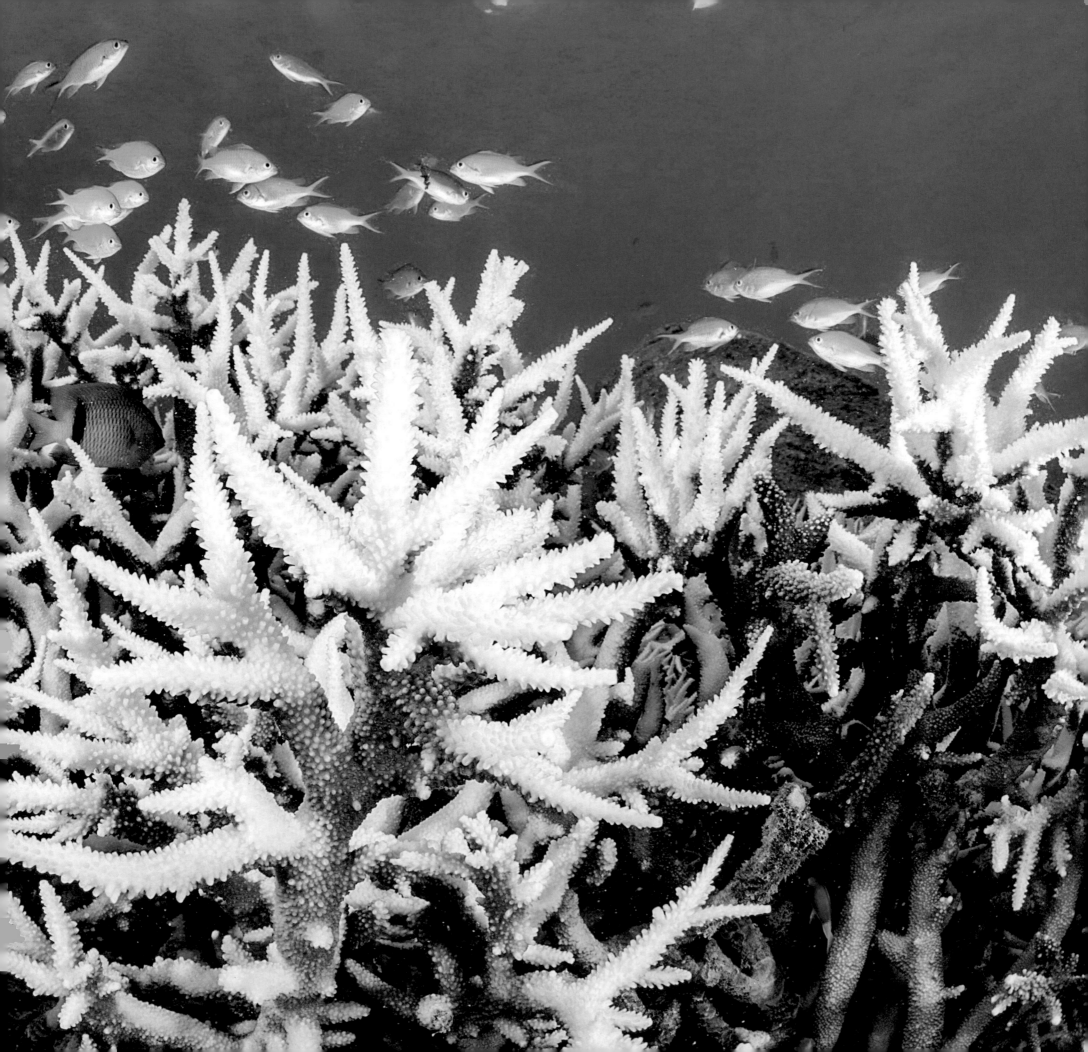

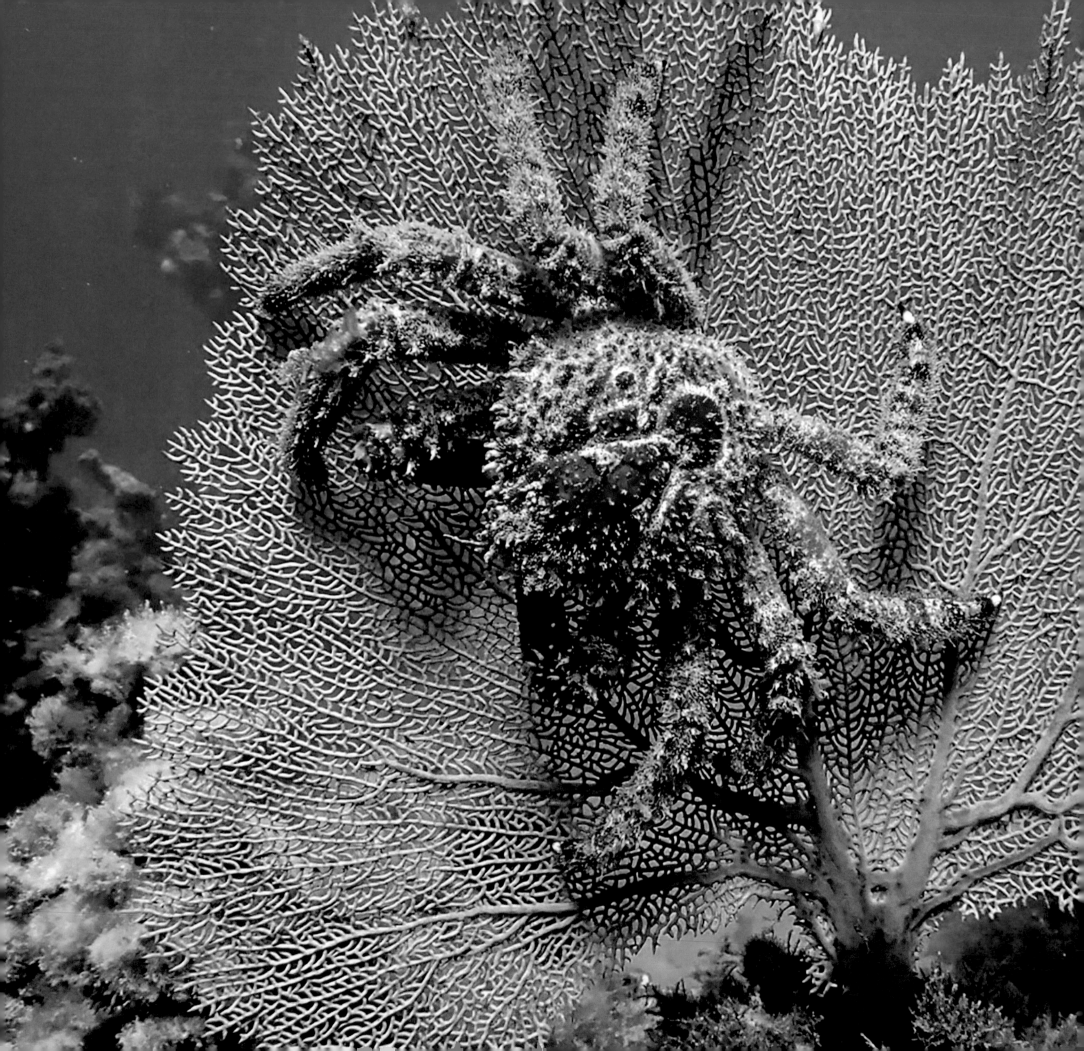

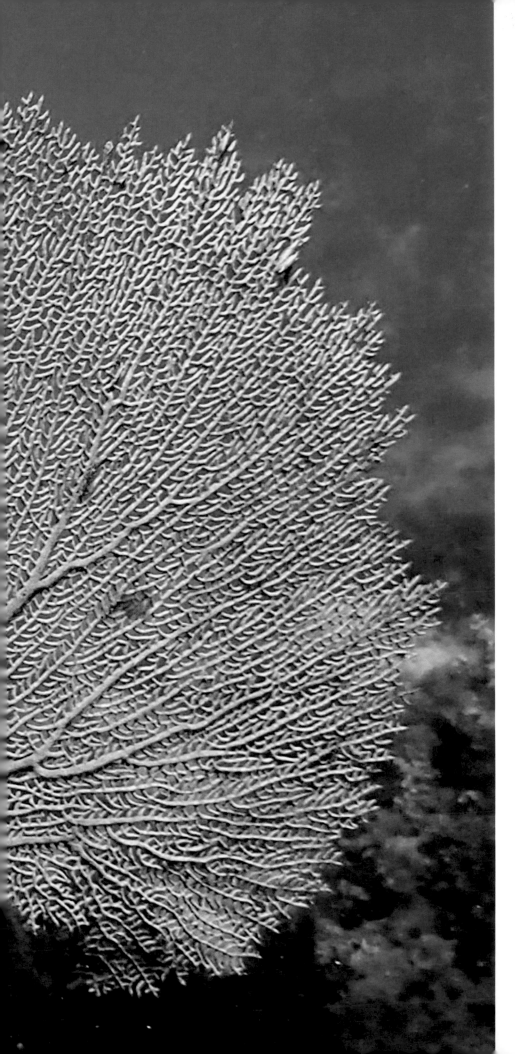

are most at risk. Normally these creatures take up carbonate from the water and combine it with calcium to form their shells. Unfortunately a more acidic ocean removes carbonate from the water, leaving precious little for these species to build their shells. Initially this will prevent coral and shellfish from growing any larger, but eventually it may become so extreme that they will be unable to find enough carbonate to maintain their existing structures. At this point these creatures will slowly begin to dissolve. With current acidification rates, corals will start to disintegrate as soon as 2080.

Mass Bleaching

In the early 1980s large areas of vibrant reef in the eastern tropical Pacific Ocean suddenly turned white over just a couple of weeks. Research revealed that this was not caused by a disease; it was the corals' stress response to the rising temperature of the sea water. If the average water temperature increases by just 2°C (3.6°F), the enzymes used by the zooxanthellae to carry

Left: Caribbean reef crab on a sea fan coral. Creatures with shells are most at risk from acidification.
Below: Half-dead Pocillopora, or 'cauliflower', coral, French Polynesia.

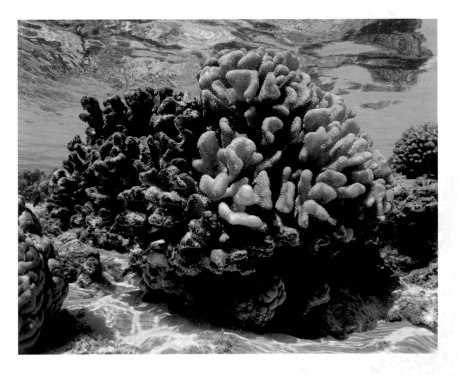

out the process of photosynthesis can no longer function. The corals realize that something is wrong with their photosynthetic lodgers and subsequently evict them. Since the zooxanthellae are what give the corals their vivid colours, without them the corals remain the basic white colour of their calcium carbonate skeletons.

At this stage the corals are still alive, but they cannot survive long without the carbohydrates provided by the zooxanthellae. If the temperature rise is only temporary, the algae cells may be reabsorbed by the corals when the sea water cools down again. However, if the temperature remains elevated, this symbiotic relationship cannot be restored and the corals starve to death. The dead reef quickly becomes overgrown by algae and seaweed, becoming a barren wasteland. At the present rate of ocean warming, scientists believe that 90 per cent of the world's coral could be lost by 2050.

Out of Control

Commercial fisheries target large, valuable reef fish such as barracuda, groupers and snappers. Inevitably, this has countless implications for the rest of the marine food web. The overfishing of herbivorous reef fish in the Caribbean has allowed macro-algae to overrun the reefs. Within a decade, many of the colourful reefs have become seaweed-dominated wastelands. Removing top predators can also lead to explosive growth in the populations of the smaller fish they keep in check. Crown-of-thorns sea stars can be up to 50 cm (1.6 feet) in diameter; they feed on coral polyps. Sea stars have venomous spikes which make them unpalatable to all but a few species of fish and the triton sea snail. Overfishing of these fish, and the collection of triton shells as souvenirs, have reduced these species to the point where they are no longer able to control crown-of-thorns populations.

Inset: The crown-of-thorns sea star is one of the largest sea star species. It is named after the biblical crown of thorns that it resembles.
Right: A hawksbill turtle swims above a dead reef. Algae has smothered the bleached coral, suffocating it and blocking out the light.

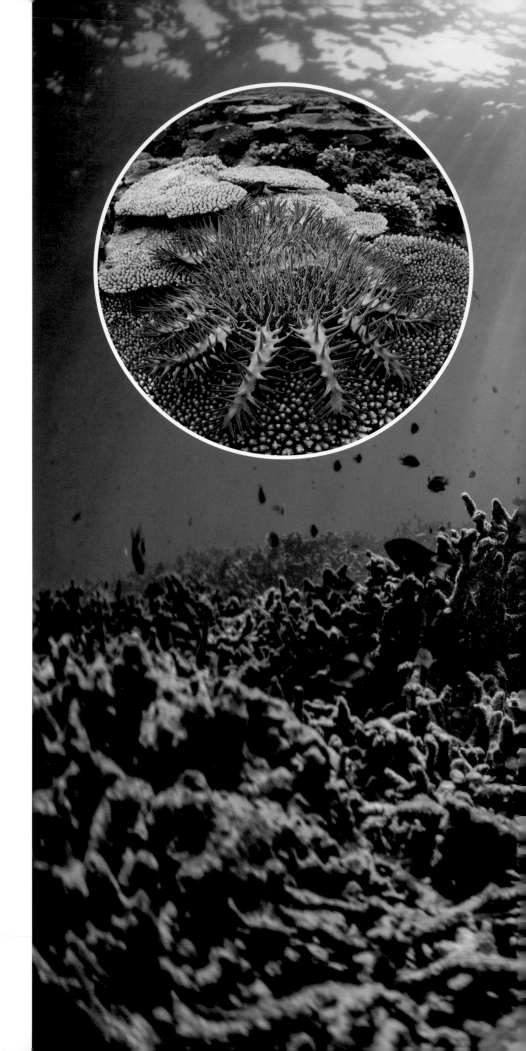

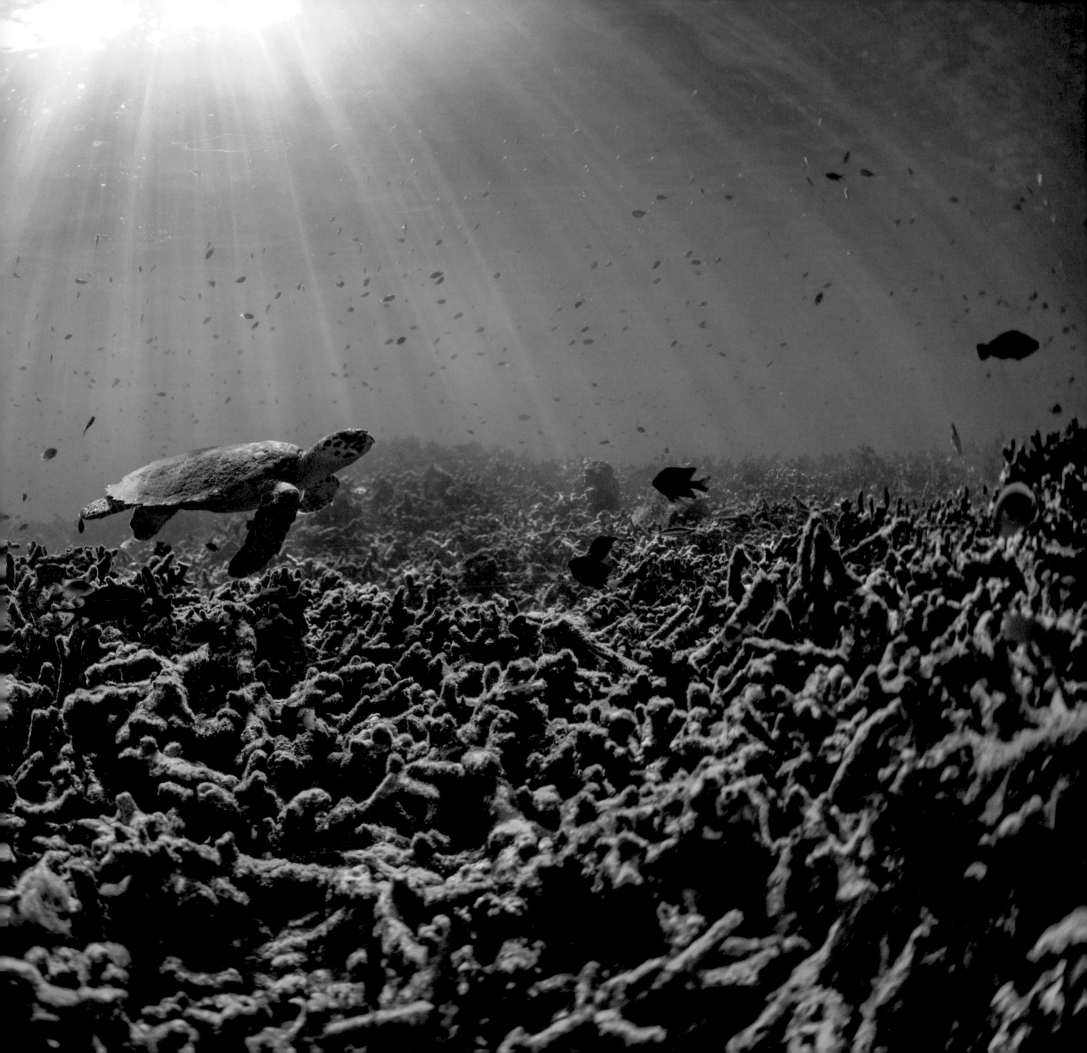

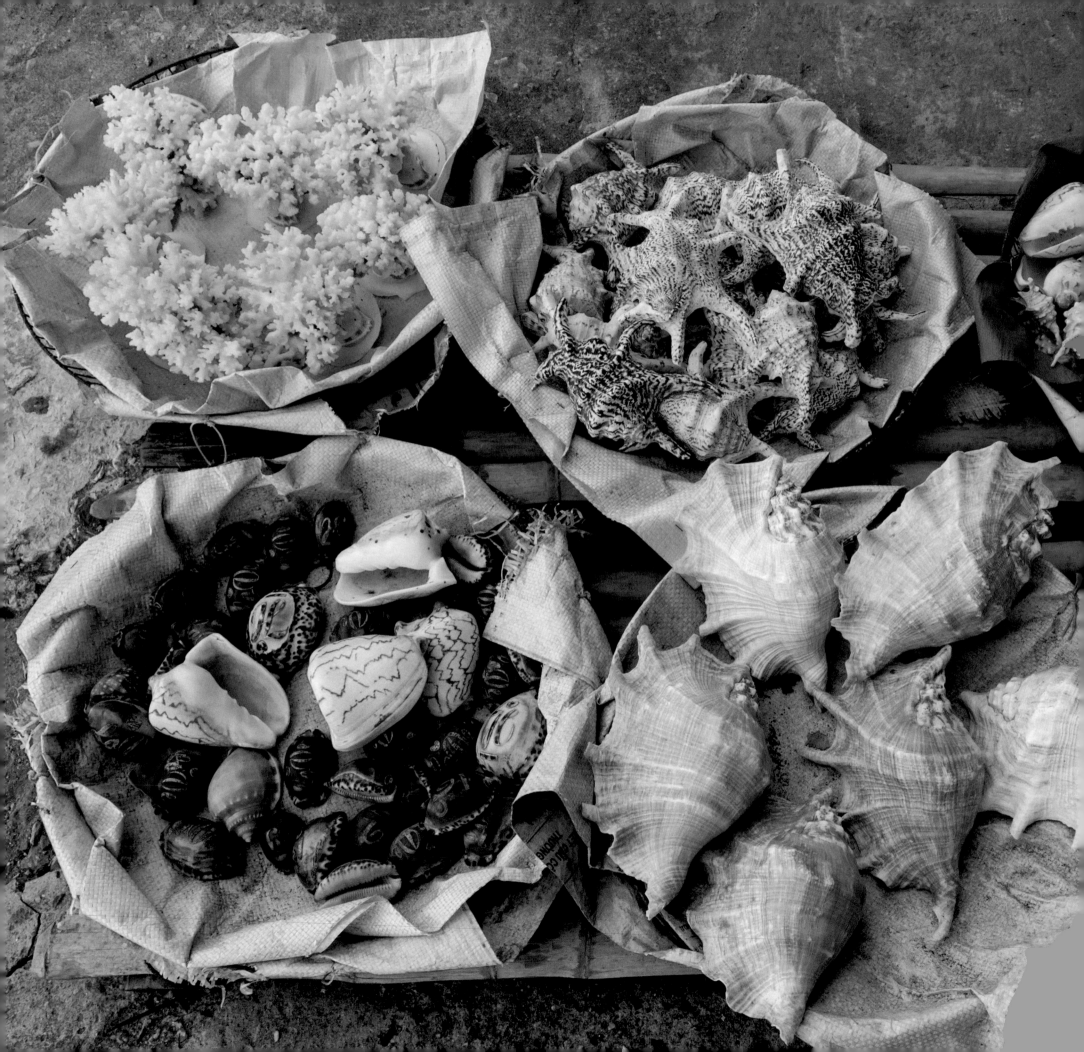

These sea stars would ordinarily occur in densities of less than one individual per hectare, but, in the absence of predators, this can rise to up to 1000 sea stars per hectare. The first recorded crown-of-thorns outbreaks occurred in Japan and Australia in the 1960s, but such episodes are now becoming increasingly common in tropical regions worldwide. The Great Barrier Reef has lost half its coral since 1985, 50 per cent of which was due to crown-of-thorns infestations.

'She Sells Seashells…'

Reef-related tourism is central to the survival of many coastal communities, but it can be very destructive if not managed correctly. Boats and anchors dragging along the bottom can scrape shallow sections of reef. While most divers and snorkellers have little physical contact with the reef, careless and inexperienced individuals can damage the coral by standing on it or kicking it with their fins. Some selfish divers even break off pieces of coral as souvenirs. Kicking movements can also mobilize sediment, blocking out the sunlight and smothering the coral with suffocating silt. Such disturbances stress the corals and can cause them to bleach.

Humans have always been attracted to the intricate beauty of seashells; after all, no trip to the beach is complete without a beachcombing session. Our fascination with shells is ancient and it has endured: cowrie shells were a widely used form of currency in many countries across Africa, Asia and Oceania until the twentieth century. Today the trade in coral and shell trinkets and souvenirs takes its toll on reef ecosystems. Hawksbill turtles have been hunted almost to extinction for their unique mottled shells, used to make tortoiseshell decorative items; an estimated 9 million turtles were killed for this reason between 1844 and 1992. Thankfully the species received CITES (the Convention on International Trade in Endangered Species) protection status in 1997.

Left: Sea shells are popular with tourists as souvenirs.

The chambered nautilus is probably the mollusc most affected by the shell trade. A cephalopod, it is named after the many air chambers in its shell which allow the nautilus to move up and down in the water column rather like a submarine. As a living fossil that has endured numerous mass extinction events, it is a sobering thought that this ancient species could be driven to extinction through our greed for ornaments.

The Great Escape

Watching a myriad of colourful fish to-ing and fro-ing can be very relaxing; many people keep tropical aquariums in their homes for this reason. What most do not know, however, is the amount of damage caused by the illegal marine aquarium trade. Unlike freshwater ornamental species, the majority of which are bred in captivity, 98 per cent of tropical marine species in aquariums have been caught in the wild. This multimillion-dollar industry involves the capture of over 20 million fish each year, mostly around Indonesia and the Philippines. Despite being banned in the 1990s, cyanide fishing is still widely used. The method involves dissolving cyanide into bottles which can be sprayed into crevices in the reef or dropped on the

Right: A pair of chambered nautiluses using their siphons to propel themselves through the water. Having first appeared on Earth 200 million years ago, nautiluses are true living fossils.
Below: The illegal trade in exotic fish for aquariums can be harmful to fish populations and reefs themselves.

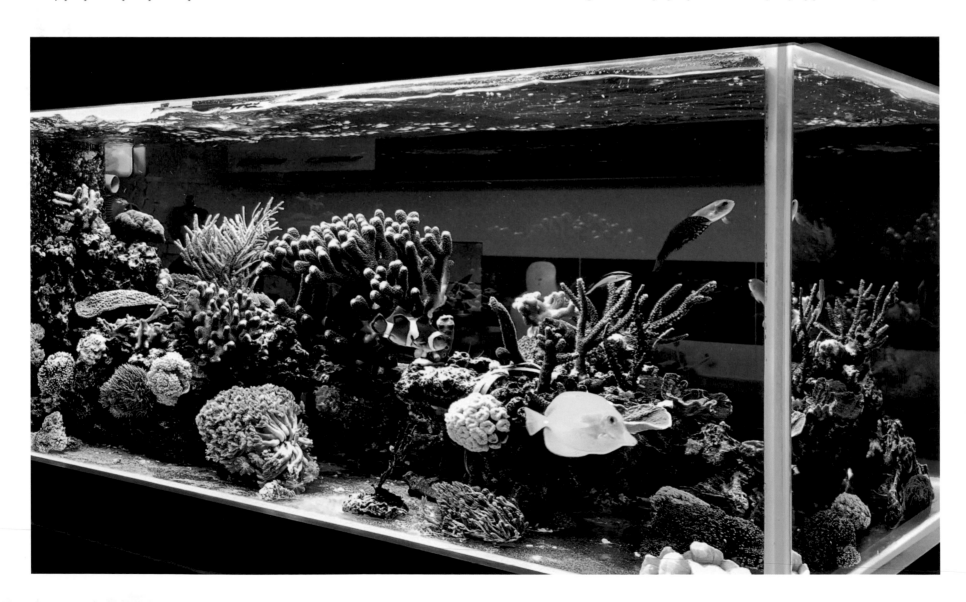

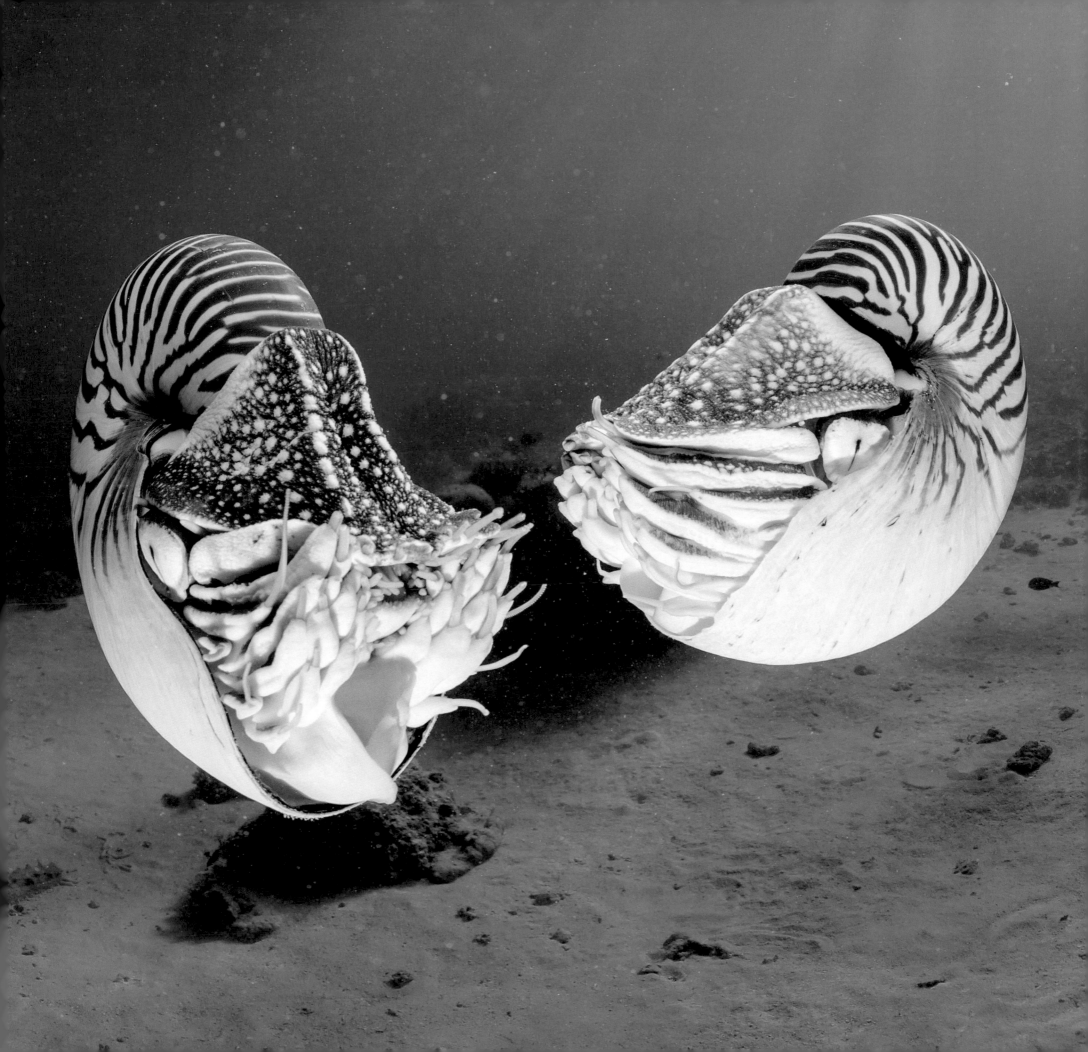

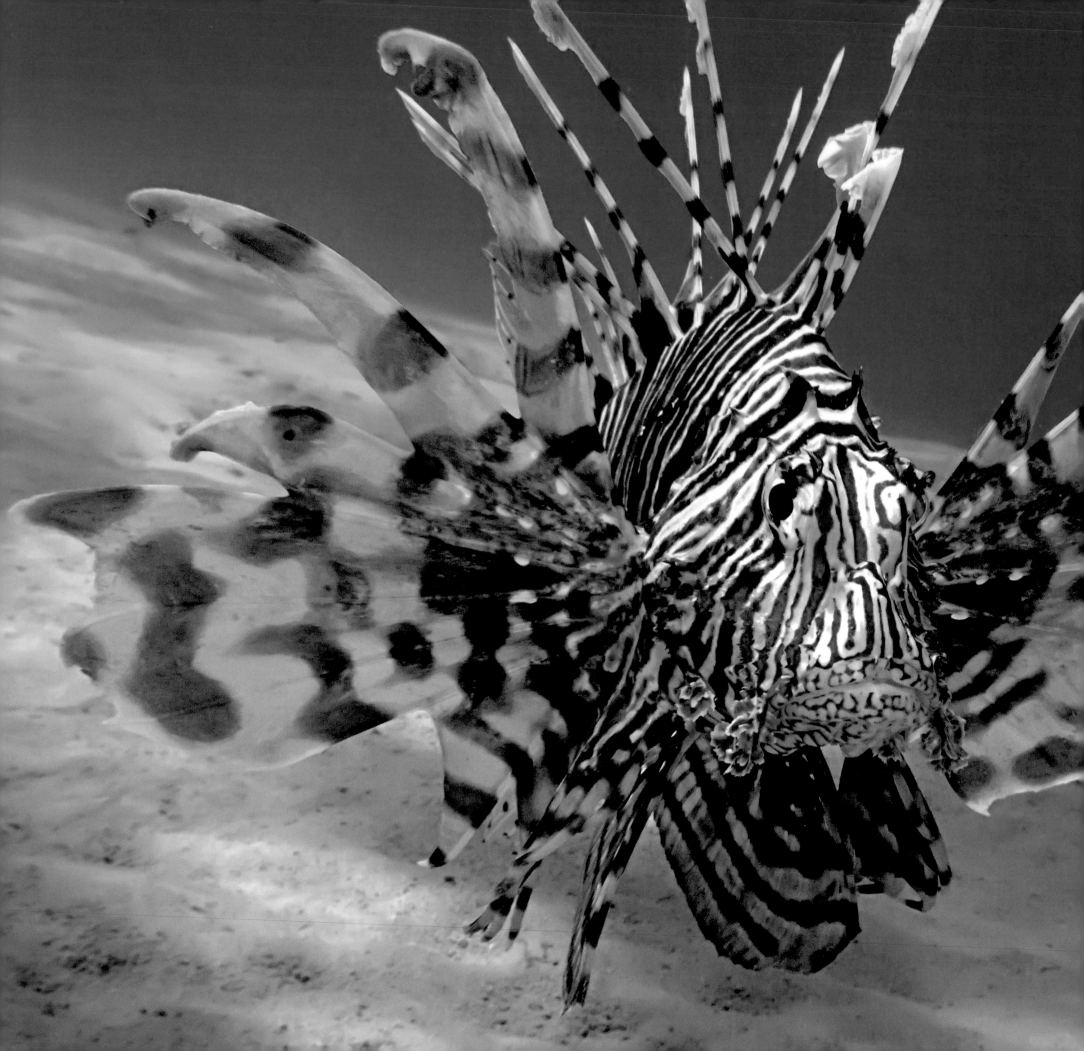

seabed. The cyanide stuns the fish, making them easier to catch. Obviously this poison has lethal consequences; half of the animals exposed to the spray are killed immediately and many more die in the hours and days that follow. For every live fish caught, approximately one square metre (3.3 square feet) of reef is destroyed.

As well as reefs, aquariums have the potential to impact other ecosystems around the world. All too often aquarium owners, bored of their fish or no longer able to fund their hobby, release them into waterways or on coasts. These non-native species can have wide-reaching implications for local ecosystems. The new invaders compete with existing species and introduce new diseases, putting already endangered species under increased pressure. The *Caulerpa* genus of seaweed is native to the Pacific and Caribbean, but its aesthetic qualities mean that it is widely used in aquariums around the world. This species, which had been on display in the Monaco Oceanographic Museum, was found on the shore below the museum in 1984. Eight years later it was spotted off the island of Majorca, 600 km (373 miles) from where it was initially released. With few fish eating this fast-growing seaweed, it quickly smothers the seabed, reducing habitats for many fish species.

The ornate yet venomous red lionfish has successfully invaded the eastern coast of the US after having been released from aquariums in Florida; it is now found from the Caribbean up to New York. In the absence of any natural predators to keep their numbers in check, lionfish can proliferate rapidly. In the Bahamas they have been recorded in densities eight times higher than in their native Indo-Pacific range.

Inset: Caulerpa taxifolia *in Bali, Indonesia, a particularly invasive species of the* Caulerpa *seaweed family.*
Left: *A lionfish floats above the seabed. These splendid creatures have few predators due to their venomous spines.*

Building Back Better

It is often assumed that the best way to protect the environment is to keep humans out, as if we were somehow separate from nature. But coastal communities have been living in harmony with nature for millennia. These people, who rely on the ocean as a primary source of food and income, are the ones who know most about the local conditions and species; they also have the most to gain from conserving them. We need to reimagine marine conservation as an adaptive and empowering movement, guided by those who depend on the ocean to survive.

Nothing Small About Small-Scale

For any conservation project to be successful in the long term, it needs the support and involvement of local communities. This can be challenging when many conservation strategies involve denying the community access to certain areas. When scientists suggest establishing 'no-take zones' on large areas of reef, they can overlook the fact that without such access fishing communities may starve. Without an understanding of the pressures faced by local communities, it is impossible to develop plans that are viable for them. It is therefore crucial for scientists and conservationists working on a project to engage with and listen to the local community.

In Madagascar, a fishing village initially rejected the idea of closing the reef they depended so heavily upon. Discussions revealed that one of their primary target species, a type of octopus, was extremely fast growing.

Right: Traditional fishing pirogues at Anakao, southwest Madagascar.

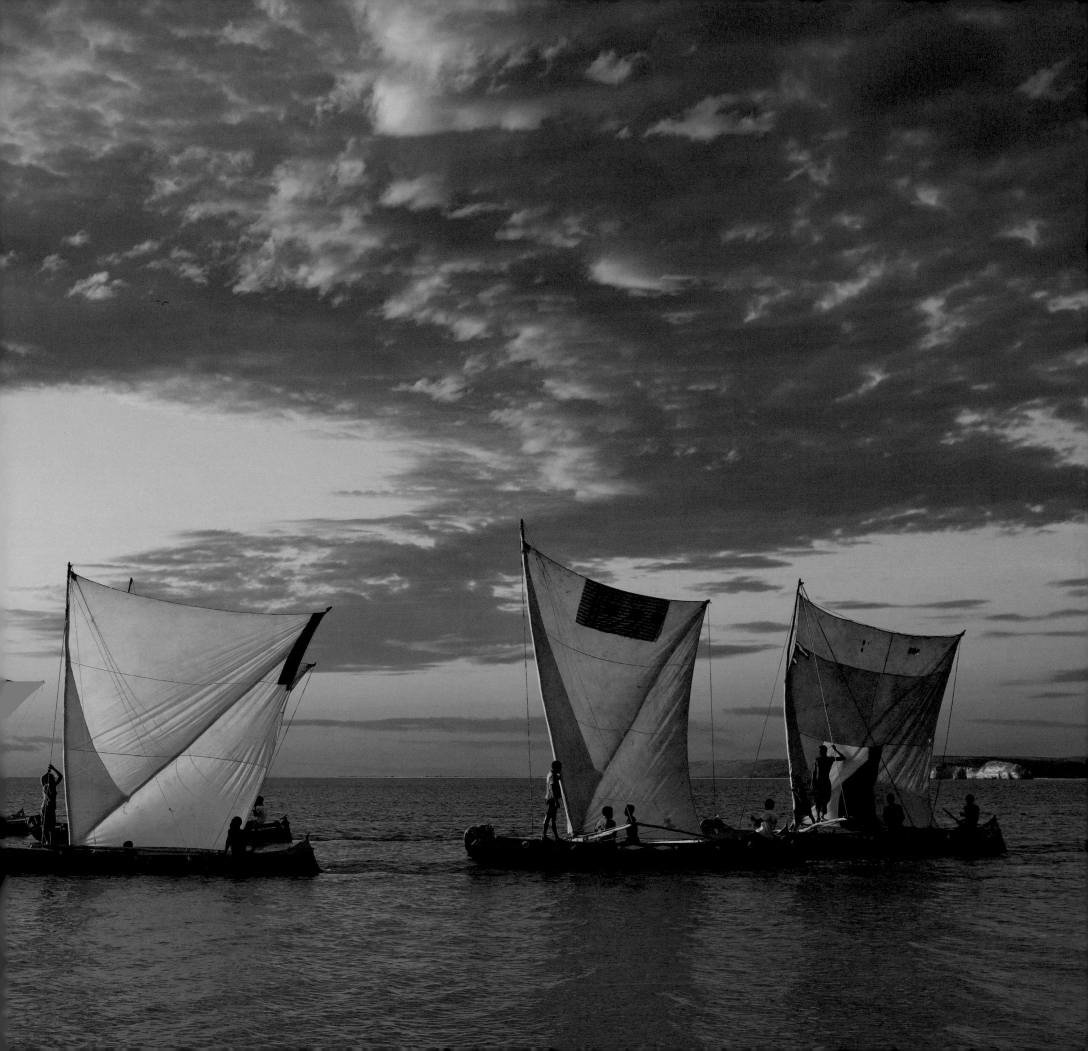

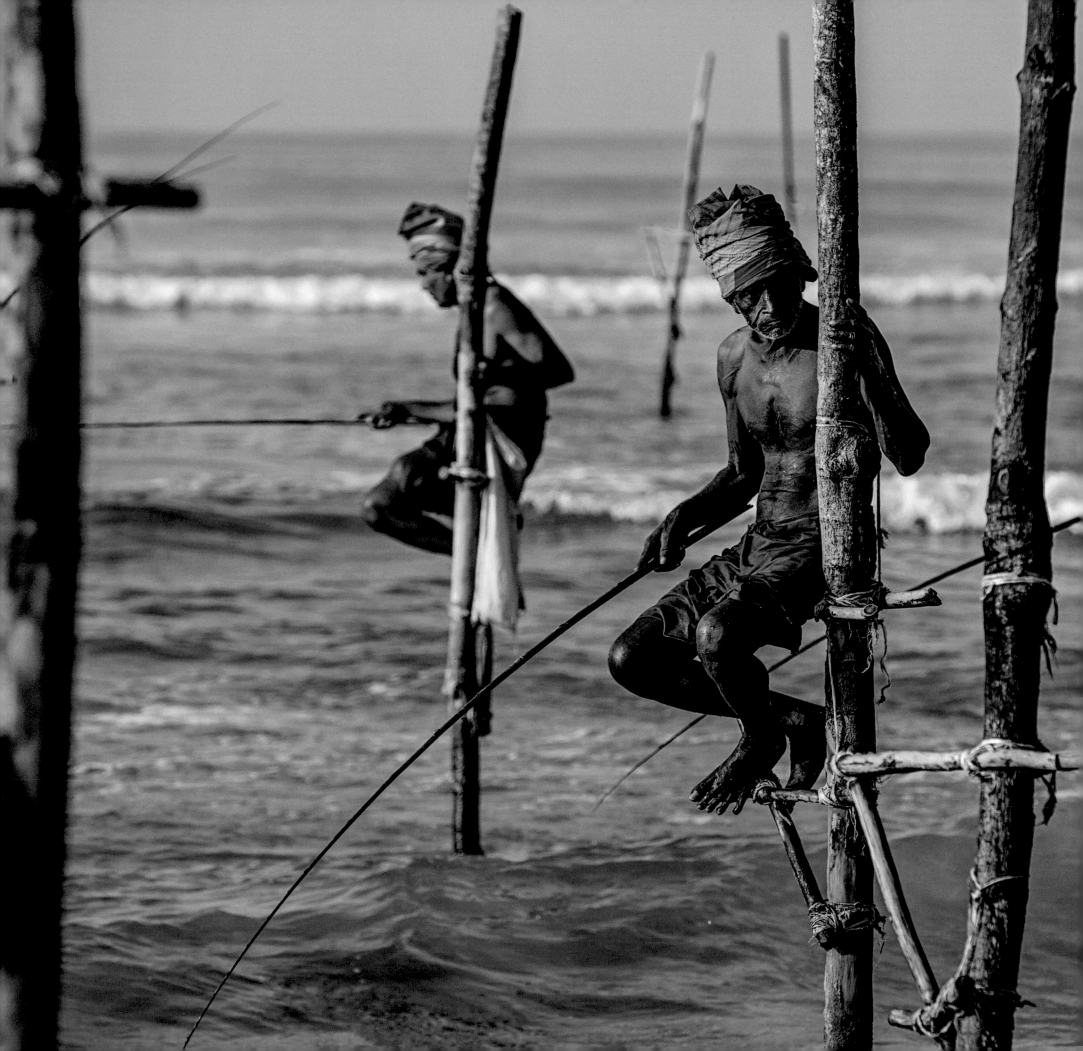

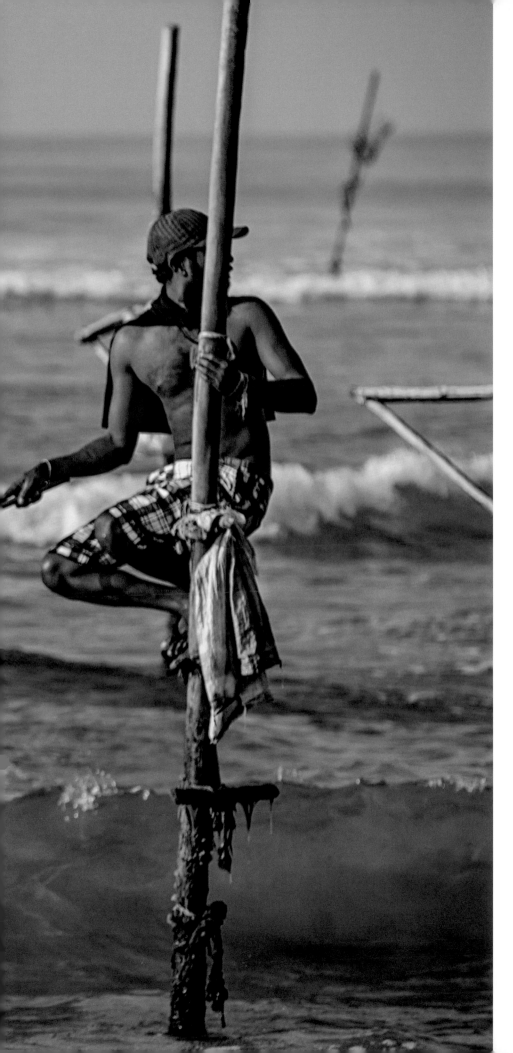

Following this discovery, conservationists suggested closing a small section of reef for just six months to allow the octopus population to grow. The village accepted the proposition and the results were astonishing. Within half a year fishers were able to double their catches – all simply by fishing less for a time. The village went on to collaborate with neighbouring villages in the establishment of an expansive, marine protected area 520 km² (200 square miles) in extent. This is just one of many success stories resulting from community-based fisheries management.

Above: Octopuses are an important income source for the coastal villages of southwest Madagascar, but they can be fished sustainably by closing the reefs regularly for short periods of time.
Left: Sri Lankan fishers using a traditional fishing style. Sustainable methods such as this have been used for generations and do far less damage to the environment than commercial fishing techniques.

Coral Reefs

Despite their name, small-scale fishers account for approximately 90 per cent of the world's fishermen and fisherwomen. The traditional fishing methods they use are almost always more sustainable than those employed by commercial fisheries. Drawing upon indigenous knowledge passed down through generations, traditional fishers are specialists in the species they harvest. By making scientific information readily available to them, we can enhance this expertise and in so doing facilitate conservation and sustainable practices. It is time to empower and support these hundreds of millions of fishers around the world; they are the people most capable of reshaping our relationship with the ocean for the better.

Above: Sri Lankan fishers at work on their traditional Oruwa fishing boats.
Right: The Solomon Islands has a thriving reef system, probably helped by the use of sustainable fishing practices.

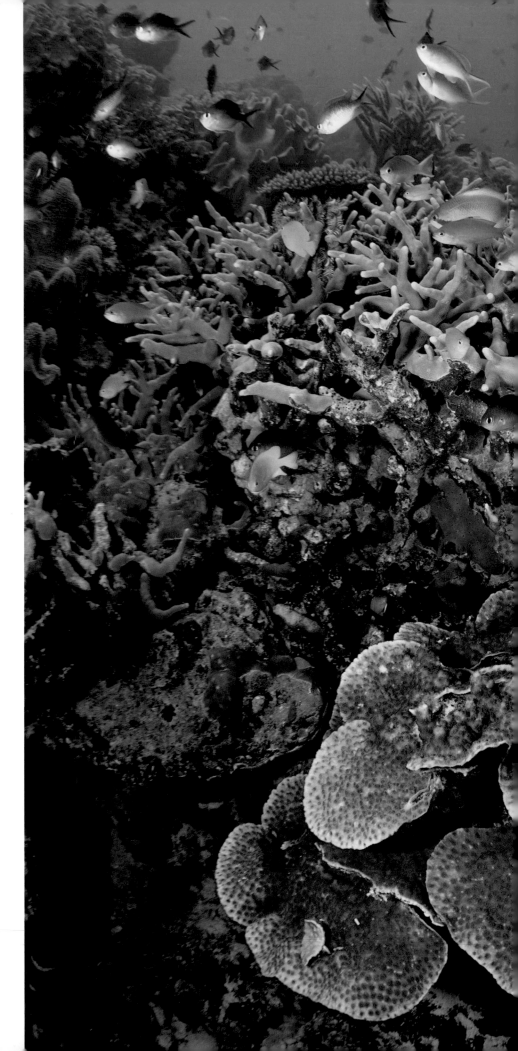

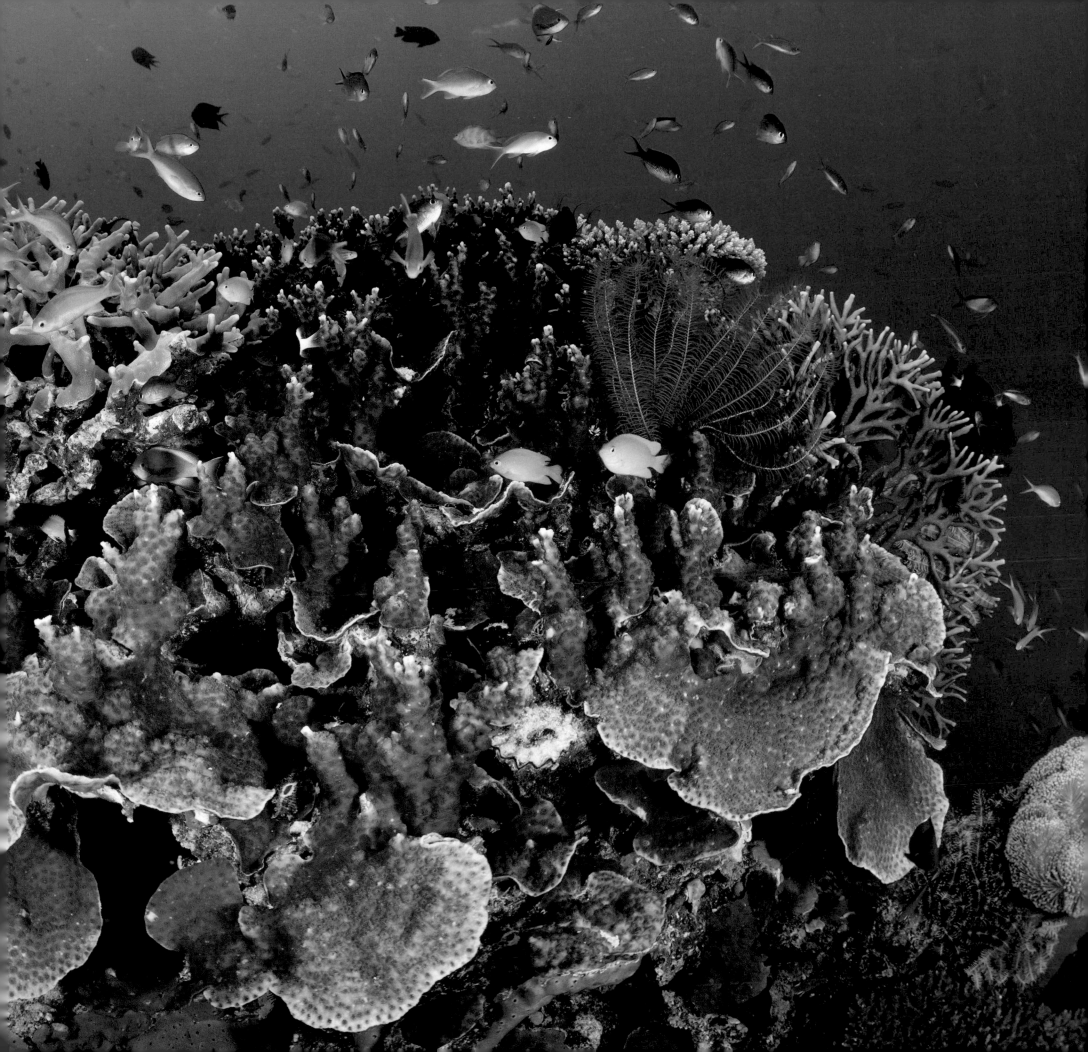

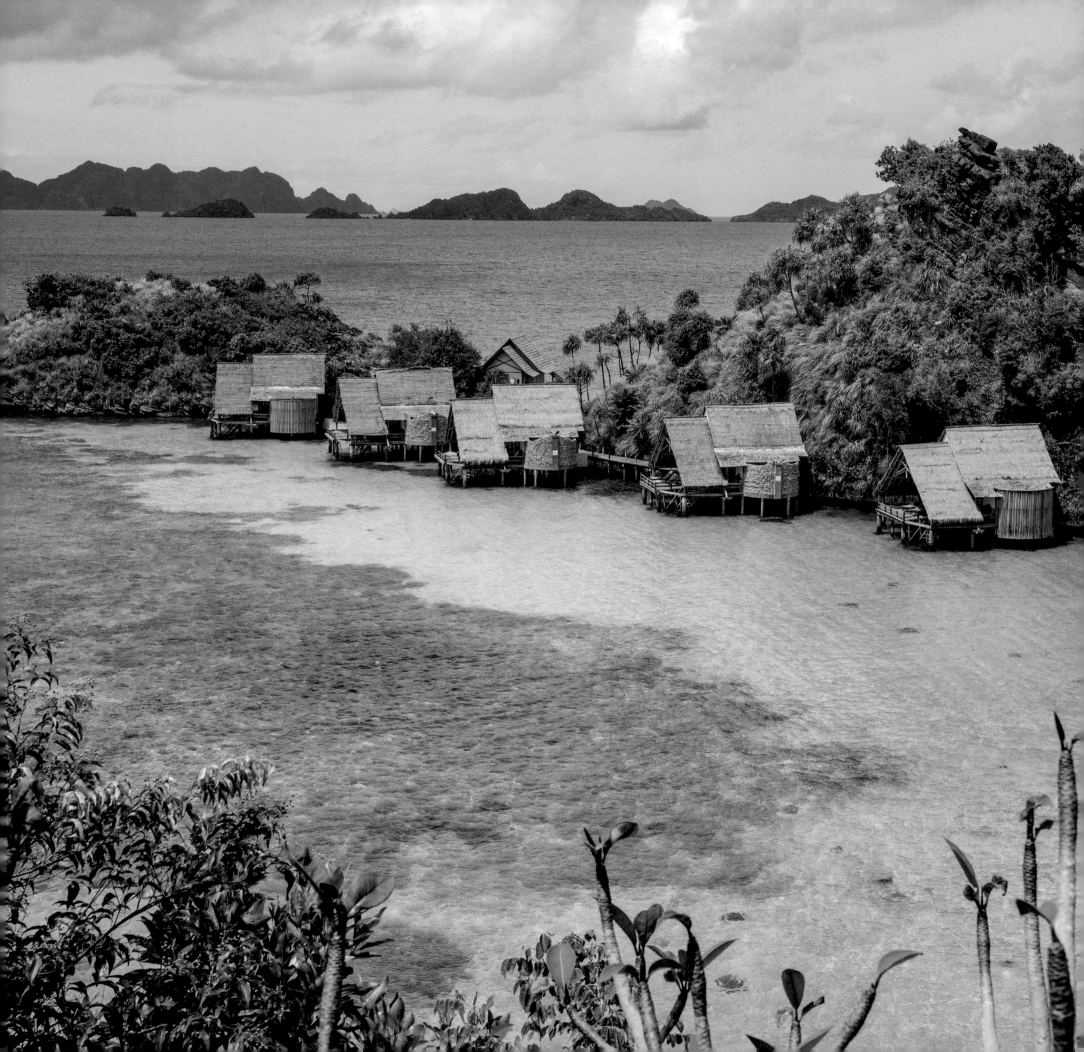

Ecotourism

Promoting sustainable fishing methods is not in itself enough to alleviate the pressure on global fish stocks. Providing alternative livelihood opportunities for fishers is one way of reducing dependence on fisheries; shifting the focus from fishing to tourism, for example, can provide a multitude of job opportunities. Ex-fishers can make use of their marine knowledge by working as guides for people wanting to visit reefs. They can also sell handcrafted products and traditional food items. It is important to remember that while tourism can support the local economy, it can also be environmentally destructive if carried out unsustainably. The rising popularity of ecotourism aims to resolve this dilemma.

The central tenet of ecotourism combines responsible travel with support for environmental conservation and the wellbeing of local communities. It also highlights the importance of robust and continued education, both for tourists and for local people. Comprehensive education schemes can turn a tourist from being a passive observer of nature to an active participant in conservation, raising awareness of marine conservation issues on both a local and a global scale.

Above: A tour guide and visitors sail on a semi-submersible during a Raro Reef Sub Marine Life Eco Tour, Rarotonga, Cook Islands.
Left: A diving resort in the Raja Ampat Islands, West Papua, where marine protected areas have been established.

Coral Reefs

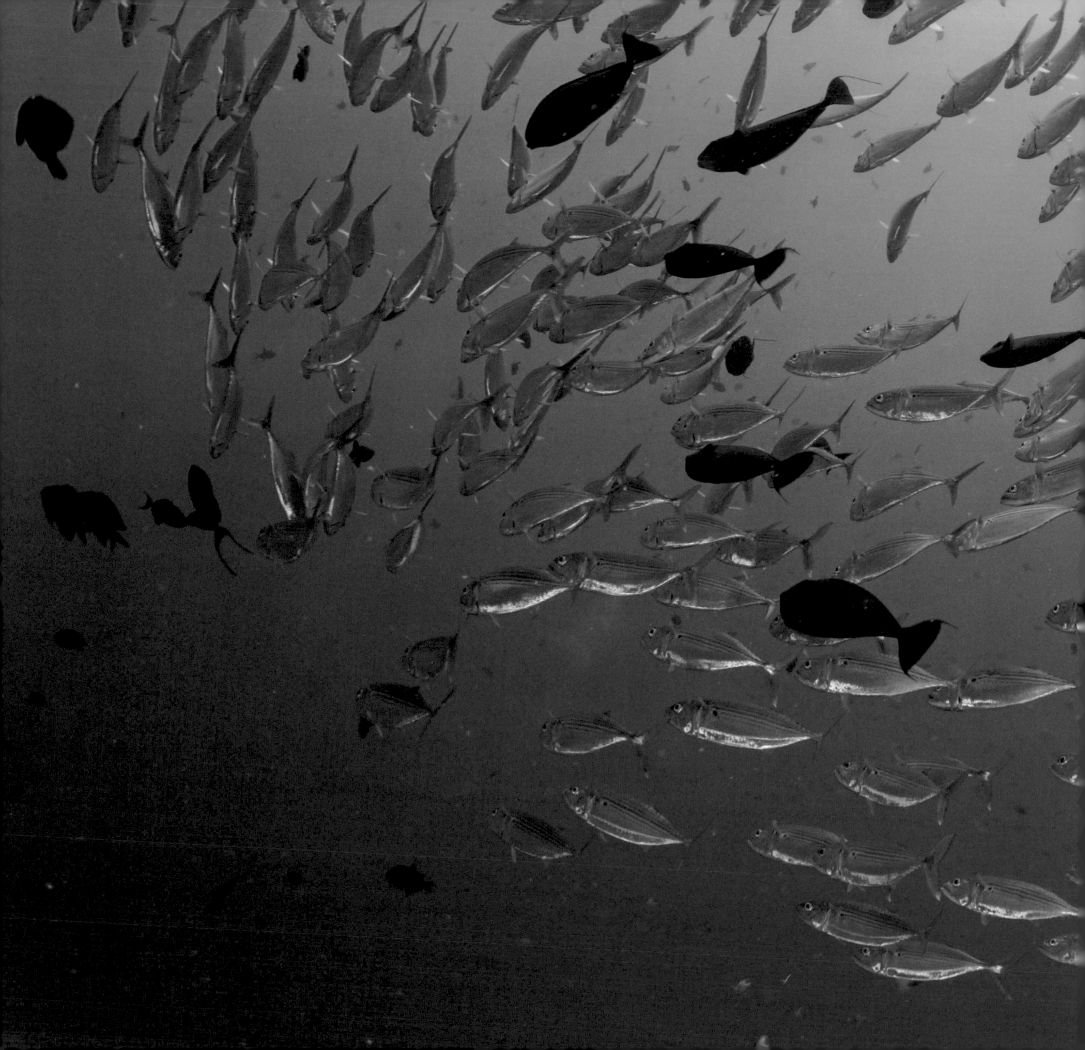

Open Ocean

The Vast Blue

An endless expanse of blue, nothing but water as far as the eye can see. While it may appear empty and lifeless from above, the open ocean is in fact a highly dynamic and variable ecosystem. Everything is constantly on the move: currents transport nutrients and flotsam providing food and refuge to many creatures in an otherwise barren seascape. Predators pursue their prey across vast distances in an endless deadly game of hide and seek.

Go with the Flow

The global ocean is constantly in motion. Surface currents move the top 10 per cent, while deep ocean currents control the lower water masses. At the surface of each ocean basin vast circular currents, known as gyres, are formed by a combination of wind and the perpetual spinning of the Earth. The two gyres in the northern hemisphere, the north Atlantic and the north Pacific, flow clockwise. In the southern hemisphere, the South Atlantic,

Previous page: Fish school in the seemingly infinite waters of the open ocean.
Left: Blue as far as the eye can see...
Below: The Saltstraumen Maelstrom develops from the world's strongest tidal currents, forming whirlpools with every tide.

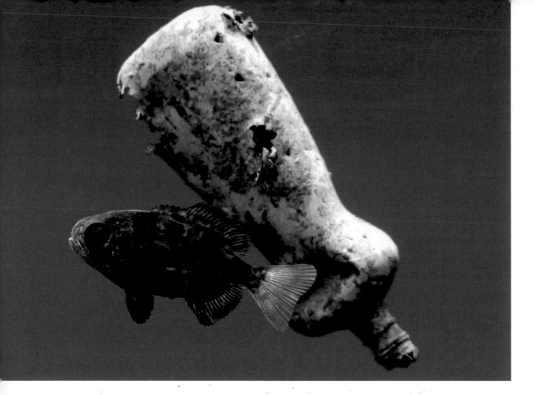

South Pacific and Indian Ocean gyres flow anticlockwise. Each of these gyres measures thousands of kilometres in diameter, and each plays a crucial role in circulating heat, nutrients/plankton and other marine species.

The Oceanic Conveyor Belt

In the deeper ocean, away from the influence of wind, currents are driven by subtle differences in the density of sea water. The colder and saltier the water, the denser it is. So cold and salty water sinks while warm and fresh water rises to take its place. Known as thermohaline circulation (from 'thermo', meaning heat, and 'haline', meaning salt), this cycle combines with wind-driven surface currents to form a slow-moving current that extends to all corners of our ocean. Often referred to as the Oceanic Conveyor Belt, it is effectively the circulatory system of our planet, allowing for the exchange of heat, nutrients and animals between five of the six ocean basins. The distance it covers is vast – a drop of water would take 1000 years to make the full circuit.

Above: A young barrelfish takes shelter beside an old plastic bottle, one of the few places to hide in the open ocean.
Right: Ballast Key, Florida. The Florida Strait carries the Gulf Stream from the Gulf of Mexico.

The Gulf Stream is one of the best-known parts of the Oceanic Conveyor Belt. The trade winds push warm water from the equator northwest to the Gulf of Mexico. Here the water is heated up even more, to around 30°C (86°F), before being transported to Europe by the westerly winds. The Gulf Stream is one of the fastest currents on the planet, propelling 100 million cubic metres of warm water towards Europe every second. It also brings an

Above: *The lagoon and Mount Otemanu of Bora Bora, French Polynesia. Because of its many territories and islands scattered over the planet, France has the largest E.E.Z in the world.*

enormous amount of warm air; one million nuclear power stations would be needed in order to create the same heating effect. Worryingly, climate change seems to be slowing the flow of the Oceanic Conveyor Belt. This is because the temperature difference between the poles and temperate regions is slowly reducing. No one knows exactly what will happen if the global circulatory current continues to slow or even stops altogether. It would certainly send our ocean and climate into untold disarray, with serious consequences for all living things.

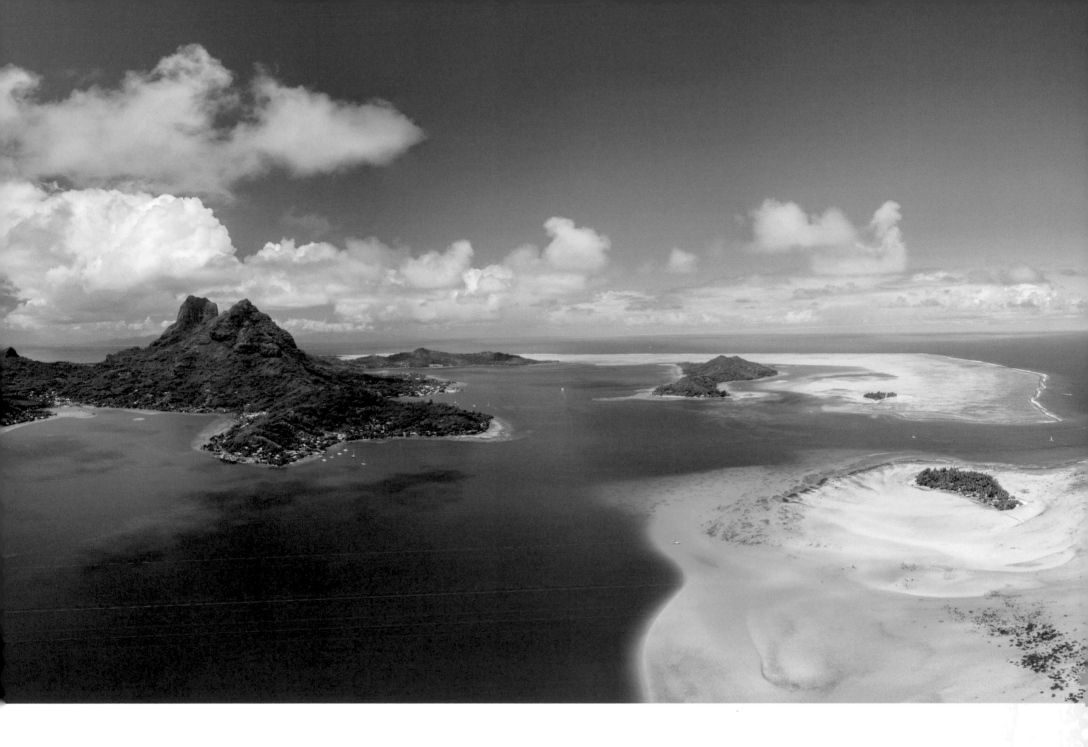

Watery Boundaries

Much like the land, the ocean has been divided up into zones that belong to different countries and have their own particular laws. If you were to get in a boat and travel away from any coastline for 415 km (258 miles), you would have passed through four distinct zones. The first 12 nautical miles from the coast are known as territorial waters, where a nation's domestic laws apply. The next 12 nautical miles are known as the contiguous zone, where domestic laws regarding customs, taxation, immigration and pollution can be enforced. This is followed by the exclusive economic zone (EEZ), which is a further 200 nautical miles. Any resources contained with an EEZ belong to that country. This zonation also applies to islands. Countries with multiple offshore islands may therefore have a much larger total EEZ, giving them an advantage when it comes to accessing marine resources. Some countries have attempted to extend their EEZ by claiming that offshore rocks are islands or even by building artificial islands. Such practices have

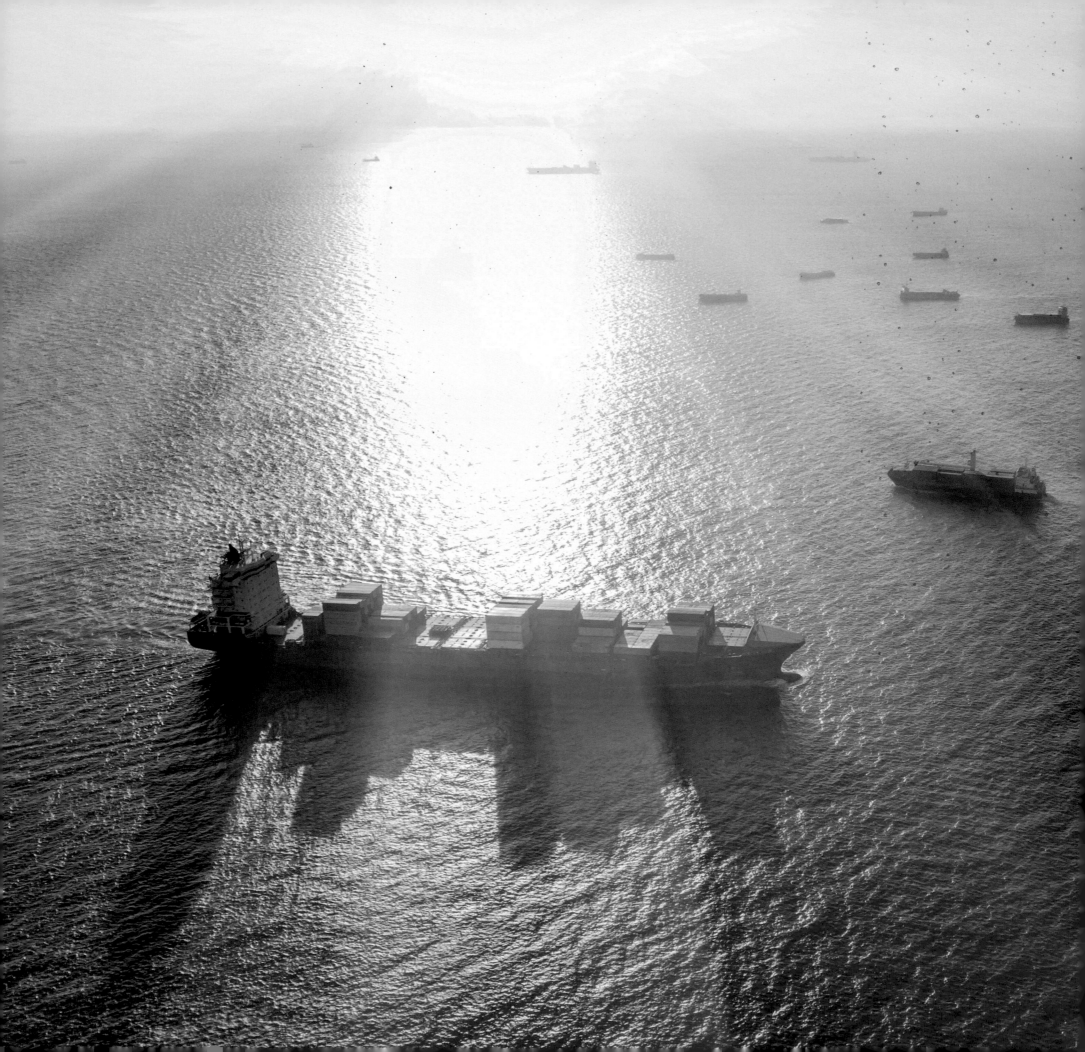

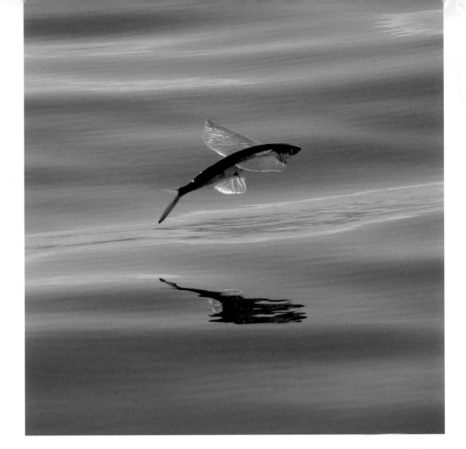

resulted in the decision to define an island as 'naturally formed area of land, surrounded by water, which is above water at high tide', which must be able to 'sustain human habitation or economic life of their own'.

Beyond the EEZ lie the high seas, often referred to as international waters. Whatever happens in these remote waters falls under the jurisdiction of the country to which the vessel involved is registered. This lack of regulation often triggers all manner of international disagreements.

Where Sky Meets Sea

A handful of specially adapted species, collectively referred to as pleuston, inhabit the narrow barrier world between air and water. These organisms live their lives seemingly trapped at the ocean surface, subject to the whims of the winds and the waves.

Above: A flying fish leaps from the water. These marine gliders are attracted to light and fishers often lure them into canoes using torches at night.
Left: The high seas can be busy and disputed territory.

Open Ocean

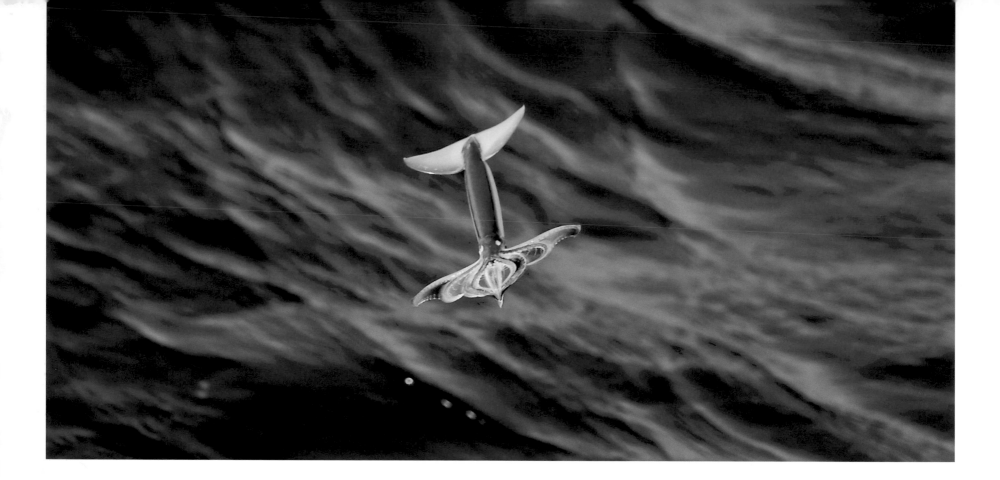

One such organism is the flying fish. This remarkable creature can leap out of the water and glide for up to 200 m (655 feet) on its wing-like pectoral fins. The fish manage this feat by swimming at high speed while still underwater, beating their tails beneath the surface as they taxi before taking off. Flying fish are able to taxi and regain flight without being fully resubmerged, thus evading capture for distances of up to 400 m (1312 feet) at a time. This unique evasive technique allows them to escape underwater predators, but paradoxically often results in them landing in boats. Like many pelagic fish, flying fish lay their eggs in flotsam in order to provide their young with some protection and a source of food when they hatch.

The Portuguese man-of-war, often mistaken for a simple jelly, is actually a siphonophore: a colony of individual polyps all working together as what appears to be a single animal. They are composed of four polyps, each of which has its own function. The gas-filled bladder that floats above the water regulates buoyancy; it can be deflated if the man-of-war needs to submerge and avoid predators. This part resembles the old warships that gives the organism its name. The second polyp is the tentacles, which can extend to a depth of 10 m (33 feet) below the surface. Like anemones, these tentacles are coated in nematocysts which release paralysing venom. Although rarely fatal to humans, a sting from a man-of-war can be excruciatingly painful. The third polyp is where digestion takes place and the fourth houses the reproductive organs. Men-of-war must rely on winds and currents to travel as they are unable to propel themselves. These sailors are also known as blue bottles due to their blue-purple floatation device.

Japanese flying squid are another inhabitant of the interface. Members of this species are often seen flying through the air in their hundreds. Its powerful siphon (propulsion system) allows the squid to leave the water and remain airborne for up to three seconds – in which time it can cover a distance of 30 m (98 feet).

Above: A flying squid in mid-air, roughly 100 nautical miles north of Tristan Da Cunha, South Atlantic Ocean.
Right: A Portuguese man-of-war drifts with the current. If you encounter one washed up on a beach, beware – they can still sting even when dead.

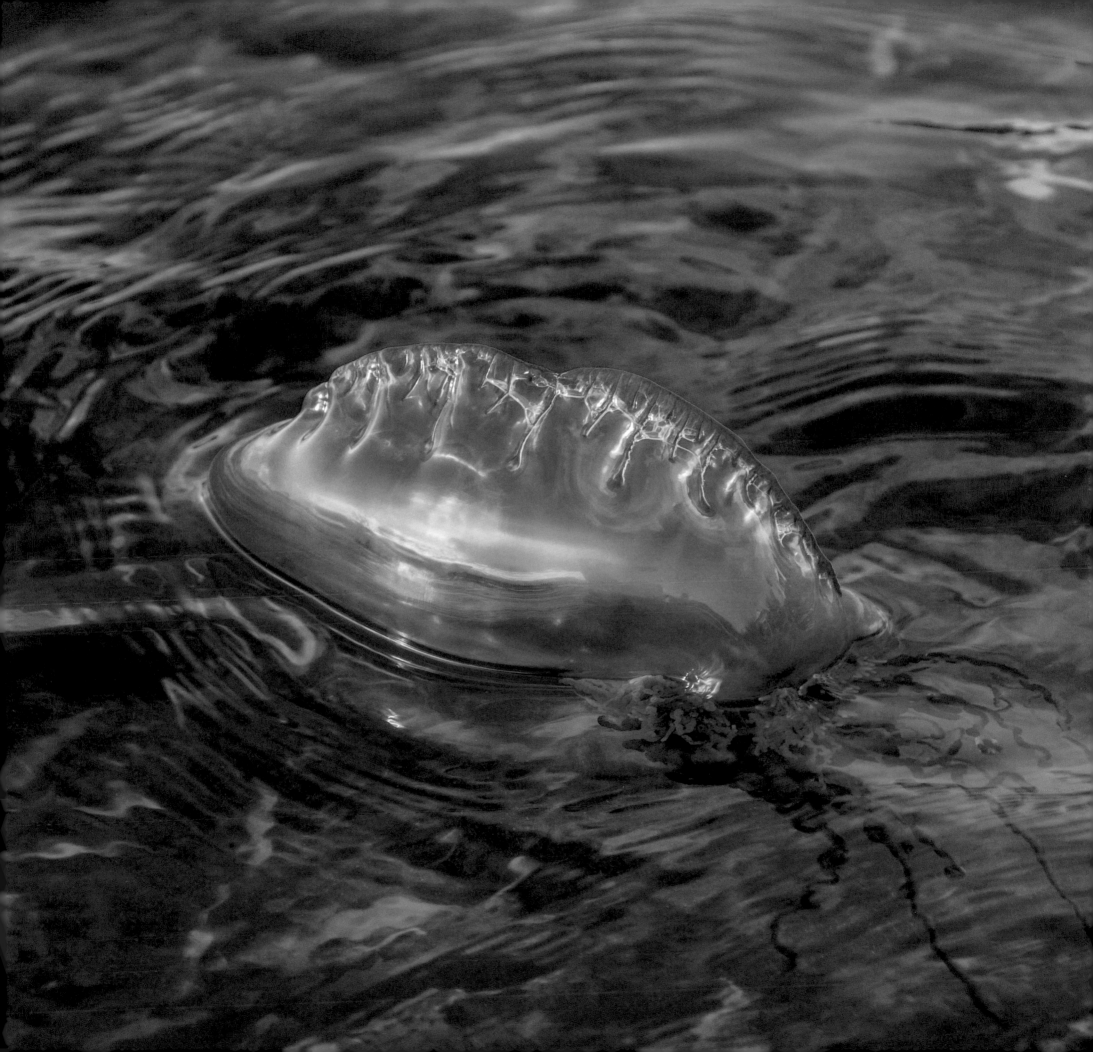

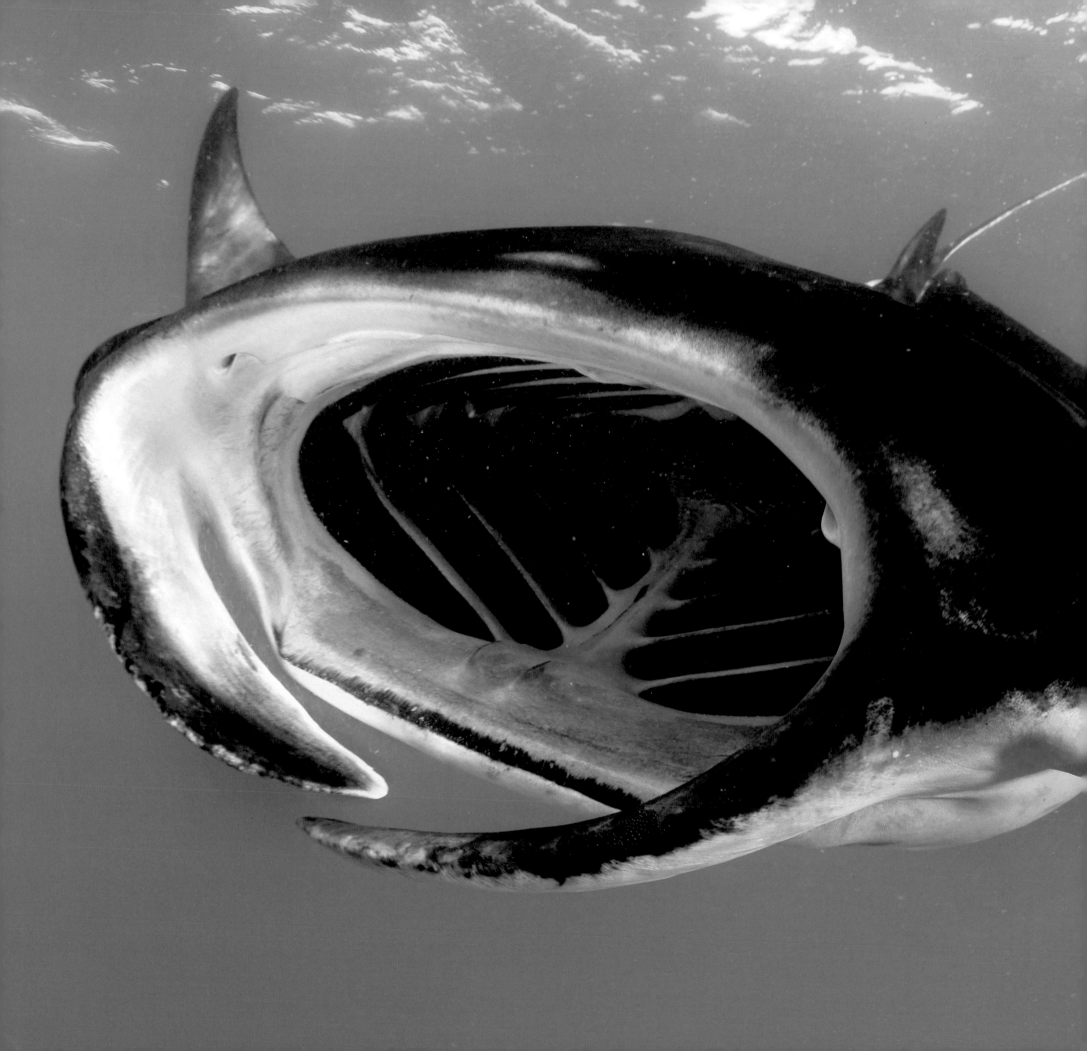

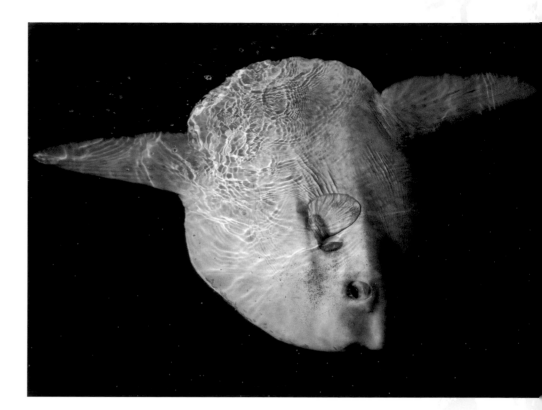

Ocean Wanderers

Giant oceanic manta rays fly through the water, remora hitchhikers swimming in the slipstream of their 3 m (9 feet) wings. Cone jellies catch plankton in their sticky tentacles; cumbersome sunfish bask in the sunlight near the surface, feeding on jellies. These bizarre, disc-like fish frequent floating kelp in search of halfmoon fish which eat the parasites that infest their skin. When desperate, they may even seek out gulls who are capable of digging out the deepest pests with their beaks.

Birds, too, travel the open ocean. The oldest known living bird in the wild is a Laysan albatross called Wisdom. She is 67 years old and has travelled more than four-and-a-half million kilometres (3 million miles) – the equivalent of circling the Earth 85 times! Wisdom is part of one of the largest Laysan

Above: *An oceanic sunfish, the world's largest bony fish, basks in the warm surface waters of the Mediterranean, Catalonia, Spain.*
Left: *A giant manta ray swims with its huge mouth agape to filter plankton from the water.*

Open Ocean

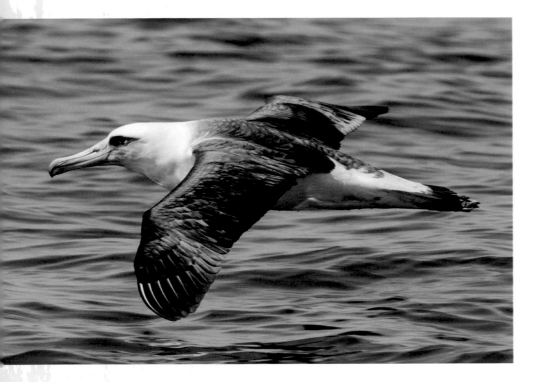

albatross breeding colonies, located on Midway Atoll in Hawaii, where she has reared around 37 chicks. Albatrosses are dependent on their parents for the first 5 to 6 months of their lives. When the young birds fledge they replace their brown fluffy feathers with the regal white and grey of maturity. Once they leave home, albatrosses will not return for between 3 and 5 years. They spend this time at sea, gliding effortlessly on warm air currents to cover vast distances with minimal wing flapping. Like other sea birds, albatross have special salt glands above their eyes to extract salt ions from the bloodstream and excrete them through the bird's nasal passages. These additional, kidney-like organs allow albatrosses to drink salt water without becoming dehydrated.

Pelagic Predators

Sharks are probably the most misunderstood creatures in our ocean. These enigmatic animals have long been considered monsters of the deep, a source of terror and nightmares. Yet while they can be lethal

Above: A Laysan albatross glides over the waters of the Pacific.
Right: A great white shark breaches the water to ruthlessly capture its prey. South Africa.

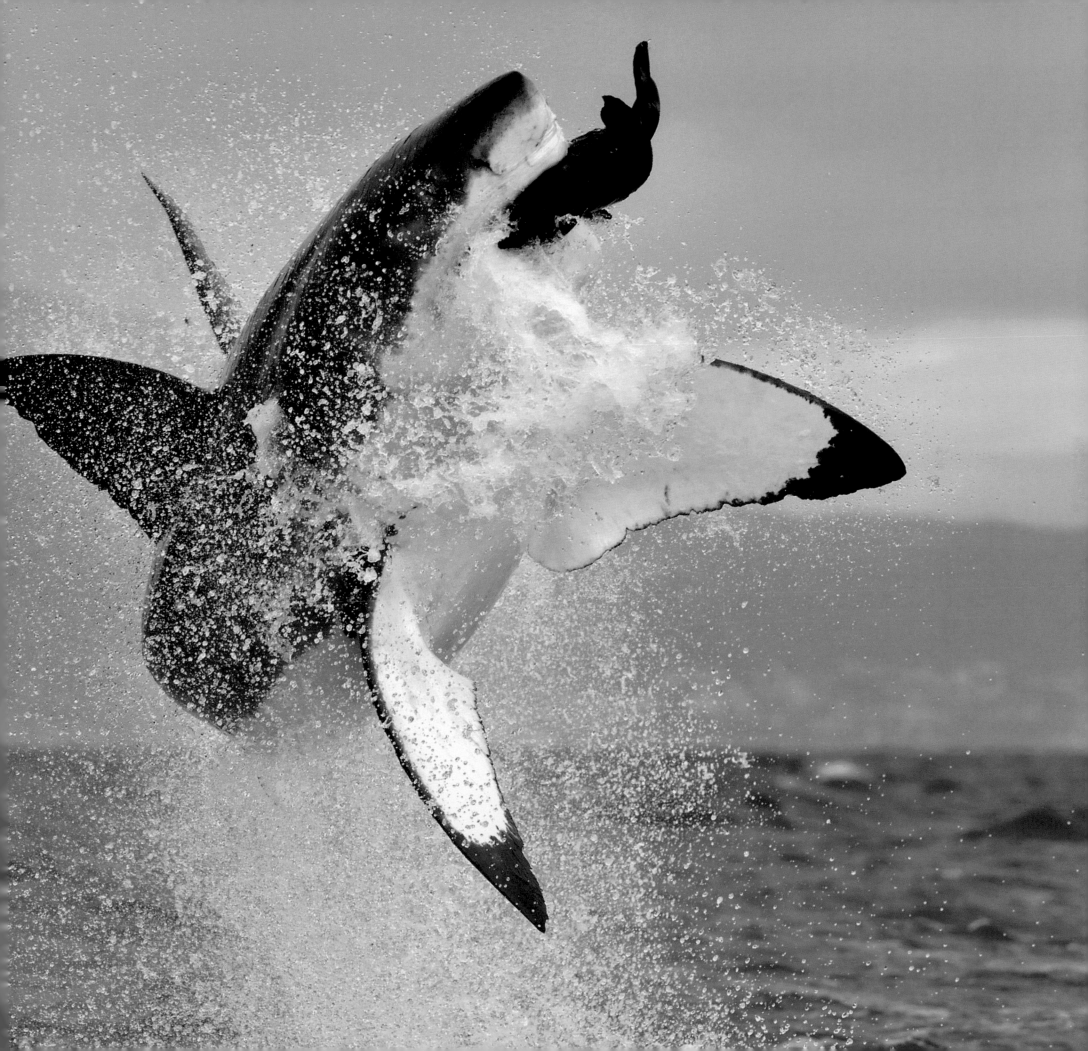

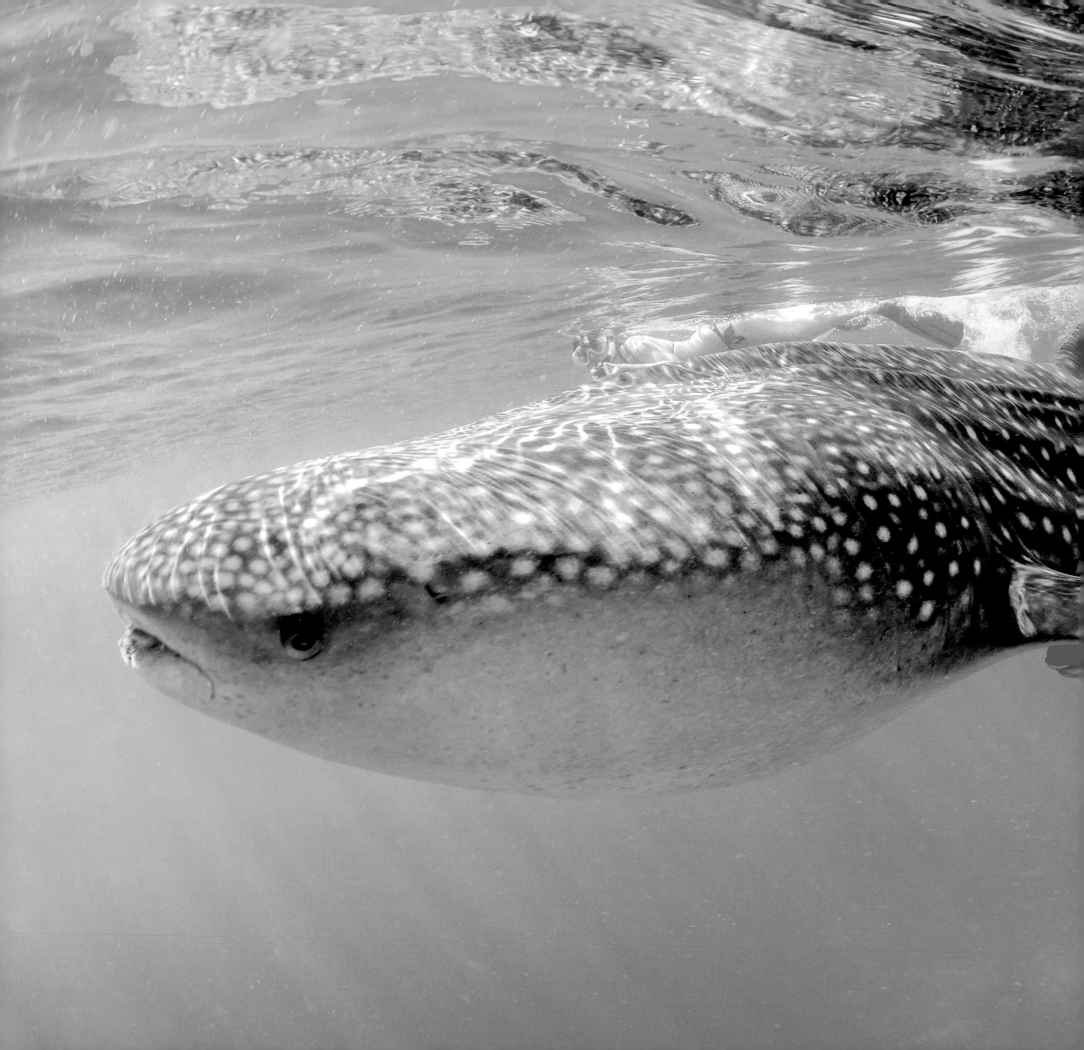

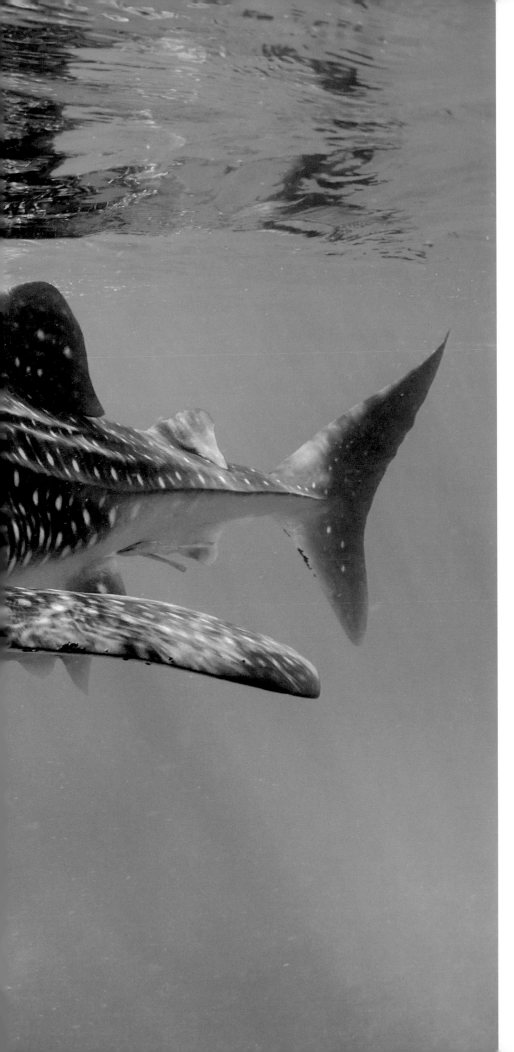

predators, sharks are not the mindless, bloodthirsty killers they are often made out to be by the media. The great white shark is the most notorious species. Growing up to 6 m (9 feet) in length, these legendary fish have row upon row of serrated, triangular teeth. They operate much like a spiky conveyor belt, with new teeth moving forward to replace old, or lost ones. A single great white may go through as many as 20,000 teeth over the course of its life. Despite having so many teeth they do not chew their food, but rather rip it apart by shaking it side to size and then swallowing the pieces whole. Great white shark prey on sea birds, molluscs, crustaceans, seals, sea lions, other sharks and even occasionally small whales.

Hammerhead sharks are named after their distinctive, mallet-shaped head. Like all sharks, hammerheads have hundreds of pores containing electrically conductive jelly, enabling them to sense the electrical fields emitted by other organisms. These pores are spread over their wide heads, allowing the shark to scan the seabed for stingrays, their favourite food. Hammerhead sharks are so sensitive to electromagnetic signals that they are able to detect changes as minute as 10 millionths of a volt.

The largest living fish is the mysterious whale shark. One of only three shark species known to filter feed, these gentle giants consume plankton. It was recently discovered that they are omnivores and gain at least half of their nutrients from plants and algae. The gills of a whale shark are able to process over 6000 litres (1320 gallons) of sea water per hour, equivalent to 30 bathtubs. They can be found in tropical waters and are particularly popular with divers and snorkellers. Despite their prominent size and recognizable white markings, we know very little about this huge species, including how many there are, how long they live for and where they reproduce.

Left: A whale shark the size of a school bus filter feeds on plankton in the azure waters of the tropics.

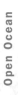

Open Ocean

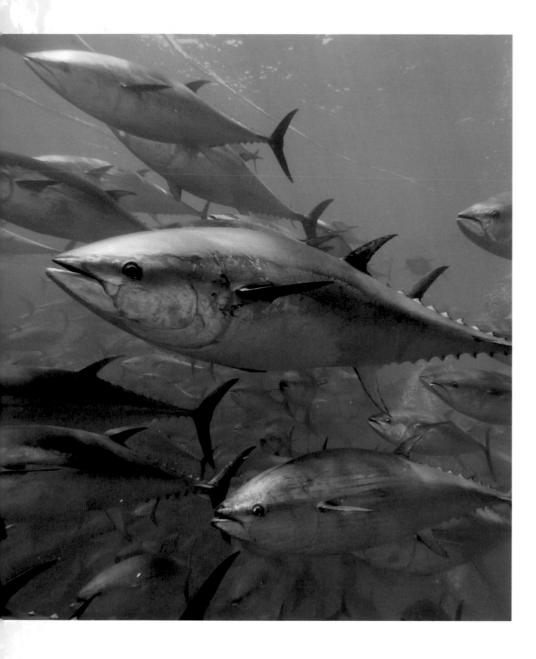

Torpedo-like bluefin tuna shoot through the water, devouring almost anything they can swallow. Usually associated with tiny tins, these top predators can grow up to 4 m (13 feet) in length and weigh over 400 kg (882 lbs). Starting out as 3 mm (0.1 inch) larvae highly appetizing to many marine species, tuna must battle the odds in order to be one of the few in a million that survive to adulthood. Tuna, Atlantic bluefin in particular, is a highly prized fish, with a single fish having allegedly

Above: Bluefin tuna in the Mediterranean sea.
Right: A distressed shoal of sardines form a bait ball to evade the pointed rostrum (bill) of a striped marlin.

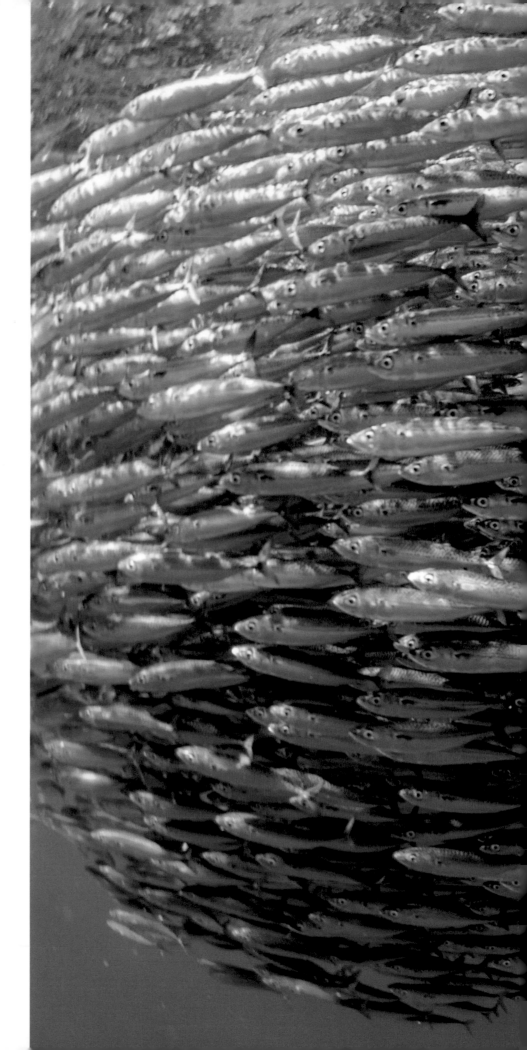

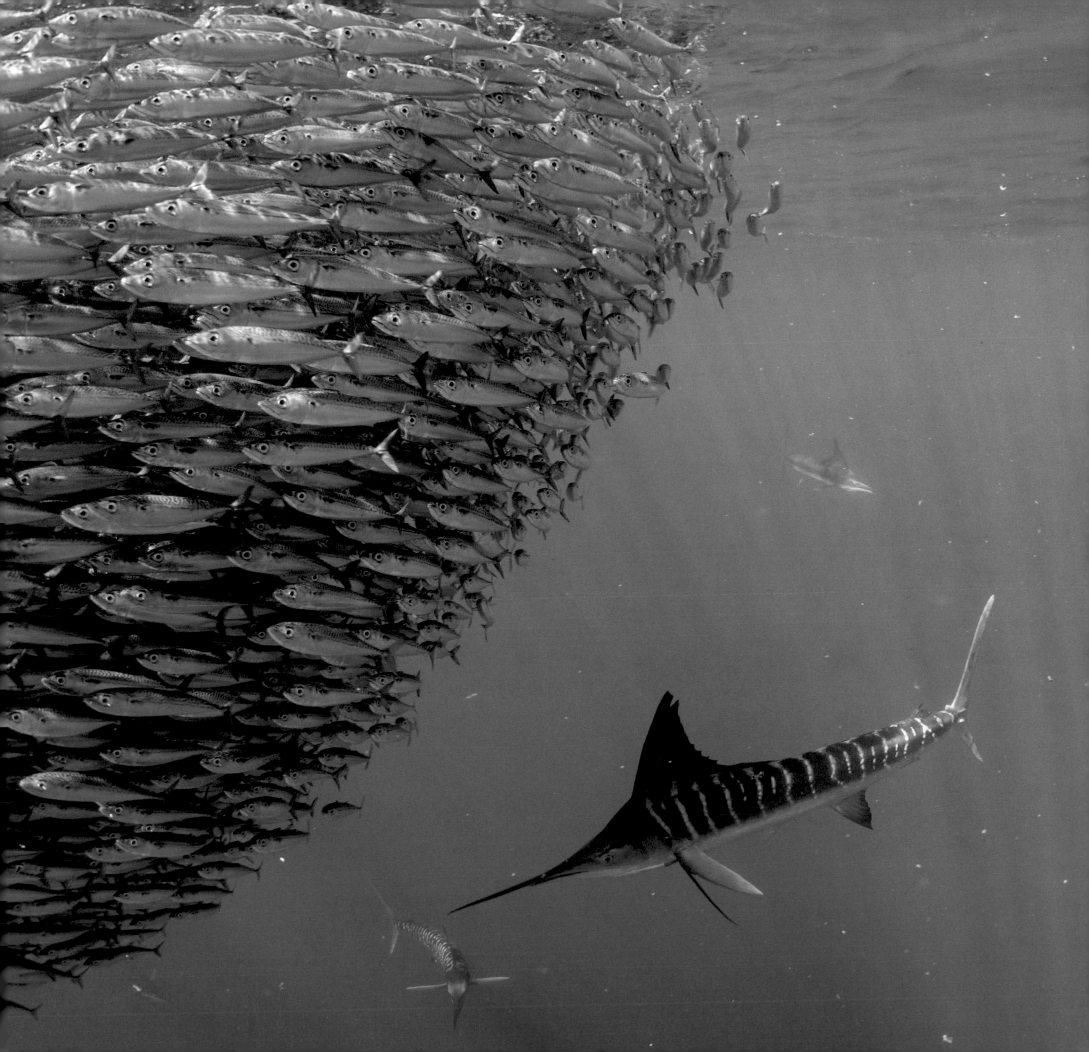

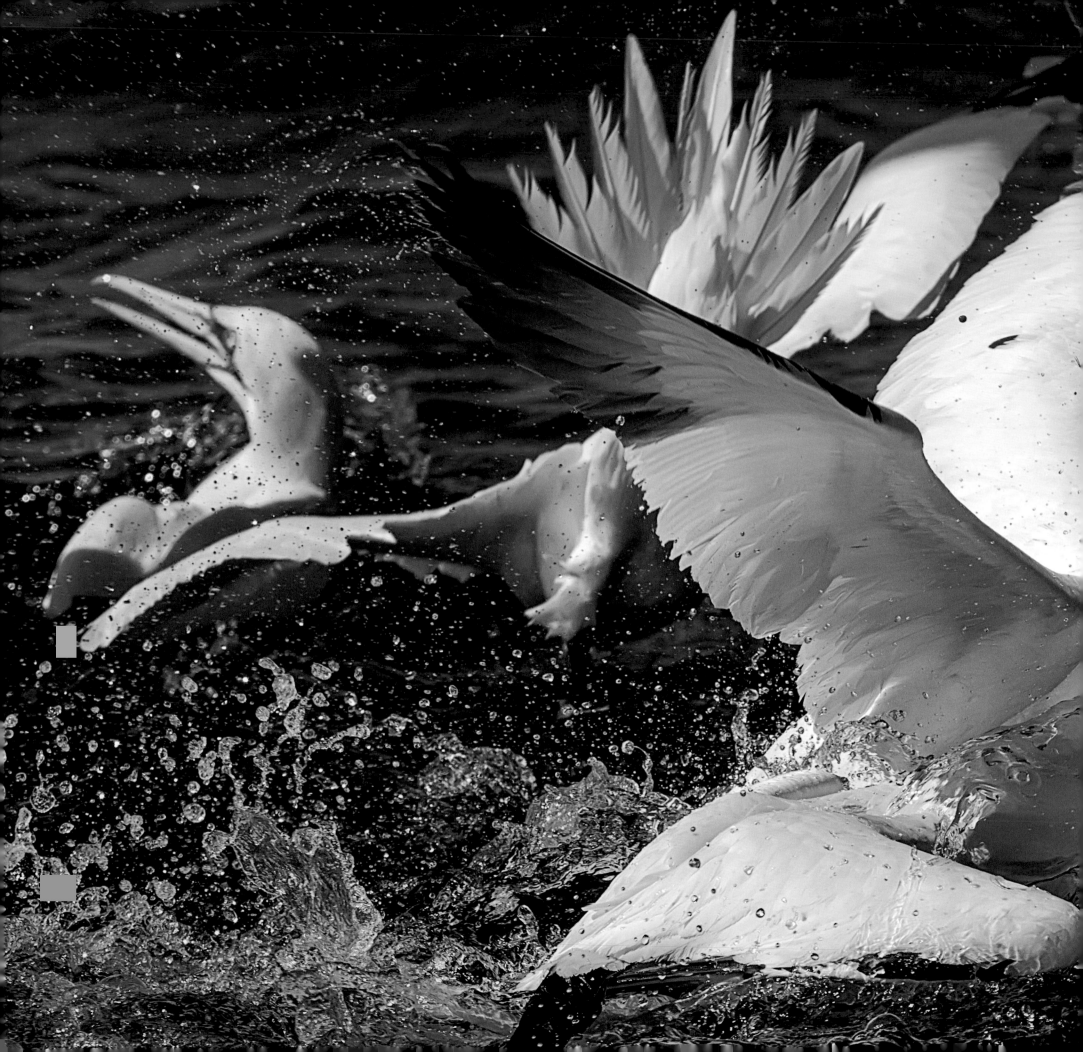

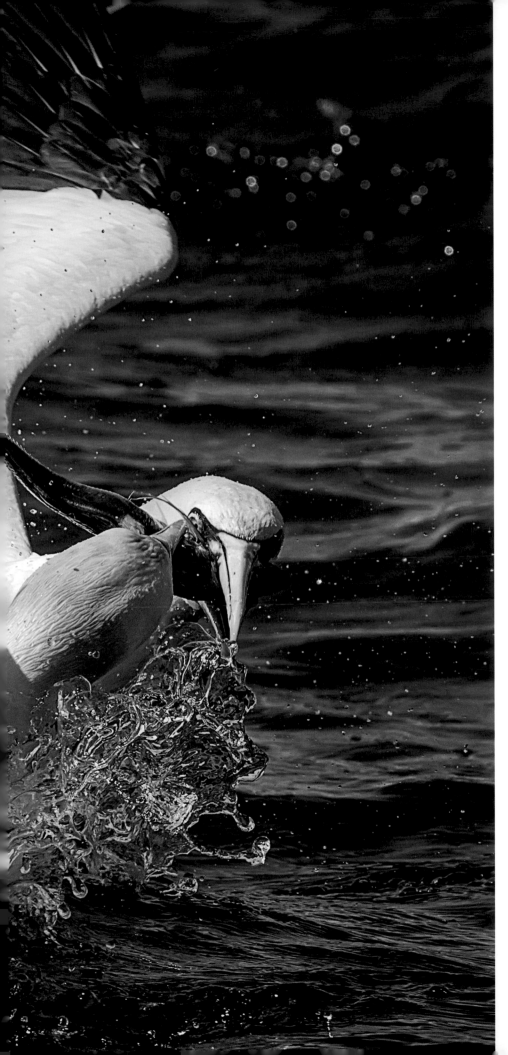

been sold for £1.9 million ($2.5 million) at a market in Tokyo. Sadly these magnificent creatures, named the 'King of the Fish' by Ernest Hemingway, are now endangered due to overfishing.

Feeding Frenzy

Nutrients are not evenly distributed in the open ocean. Many areas remain deserted until the currents carry in clouds of plankton, followed by schools of sardines and other small fish. The millions of sardines attract the attention of various predators. Aware that they are being stalked, the sardines instinctively swarm together into a huge mass of flashing fins and tails. Swimming in tight circles, the bait ball confuses the predators, leaving them unable to identify individual fish.

One such predator is the bottlenose dolphin. After a few disorienting moments the dolphins make their move, swimming through the bait ball and splitting off smaller groups of sardines. They herd these towards the surface, where they take turns picking off stragglers. This is what the gannets have been waiting for. These amazing divers shoot 10 m (33 feet) into the water, reaching speeds of up to 100 km per hour (62 miles per hour), and use their wings to swim a further 10 m (33 feet). The bait ball repeatedly breaks up and reforms as the panicked sardines attempt to survive the two-sided attack. Now the sharks join the feast and lightning-fast striped marlin streak into the shoal. This haunting dance of life and death has now reached the grand finale. A Bryde's whale swallows 10,000 fish in a single mouthful. The predators ignore each other, focusing on the task at hand – devouring what is left of the sardines. Soon all that remains of the sardine school is a few shimmering scales, sinking slowly into the depths. The hunters must move on in search of their next meal.

Left: Gannets fight over a fish at the surface. These birds have specially developed neck muscles to absorb the shock of hitting the water at speed when plunging in to feed.

Open Ocean

131

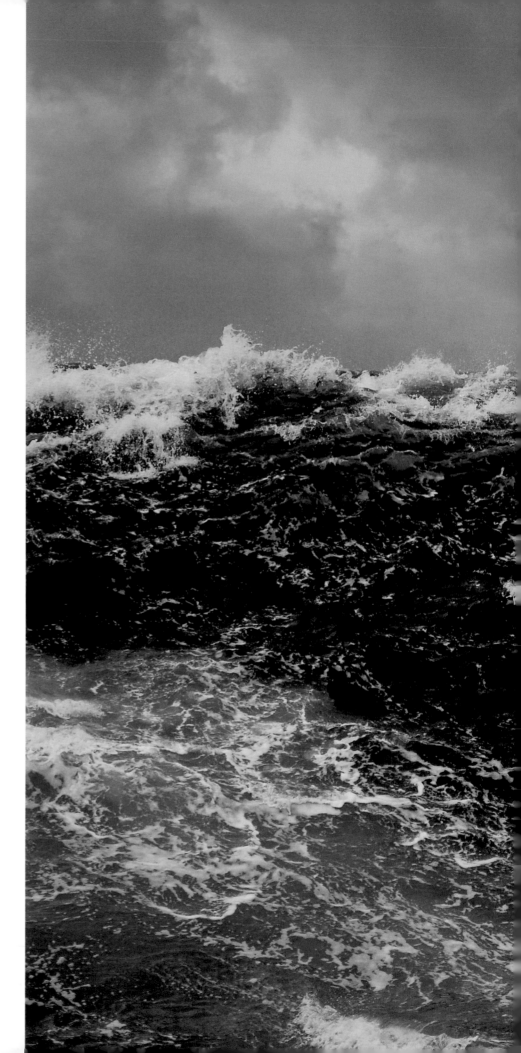

Trouble on the High Seas

The high seas are so far from land that most people will never frequent them. It is thus easy to assume that our actions have no impact on these wilder waters. Yet, with few laws in place to protect them, these distant reaches are at serious risk from over-exploitation, our disposable mindset and wasteful practices.

Wrapped in Plastic

We use plastic for everything, from packaging food to insulating buildings. It makes sense to do so because it is a cheap, durable and easily manipulable substance. The plastic itself is not the problem so much as the disposable way in which we use it. Every year, 12 million tons of plastic end up in our ocean. Roughly 10 per cent of this is so-called 'ghost' fishing gear –

Right: A storm raging on the high seas. Out in these open, unprotected waters, the weather can change very quickly.
Below: Myriad plastics pollute our ocean and cause hazards to sea life.

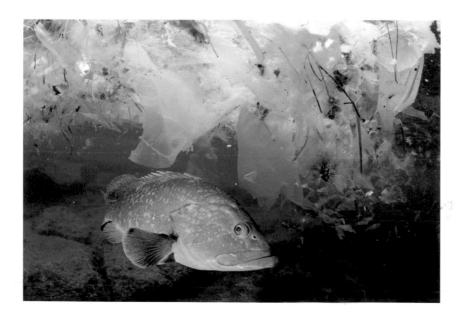

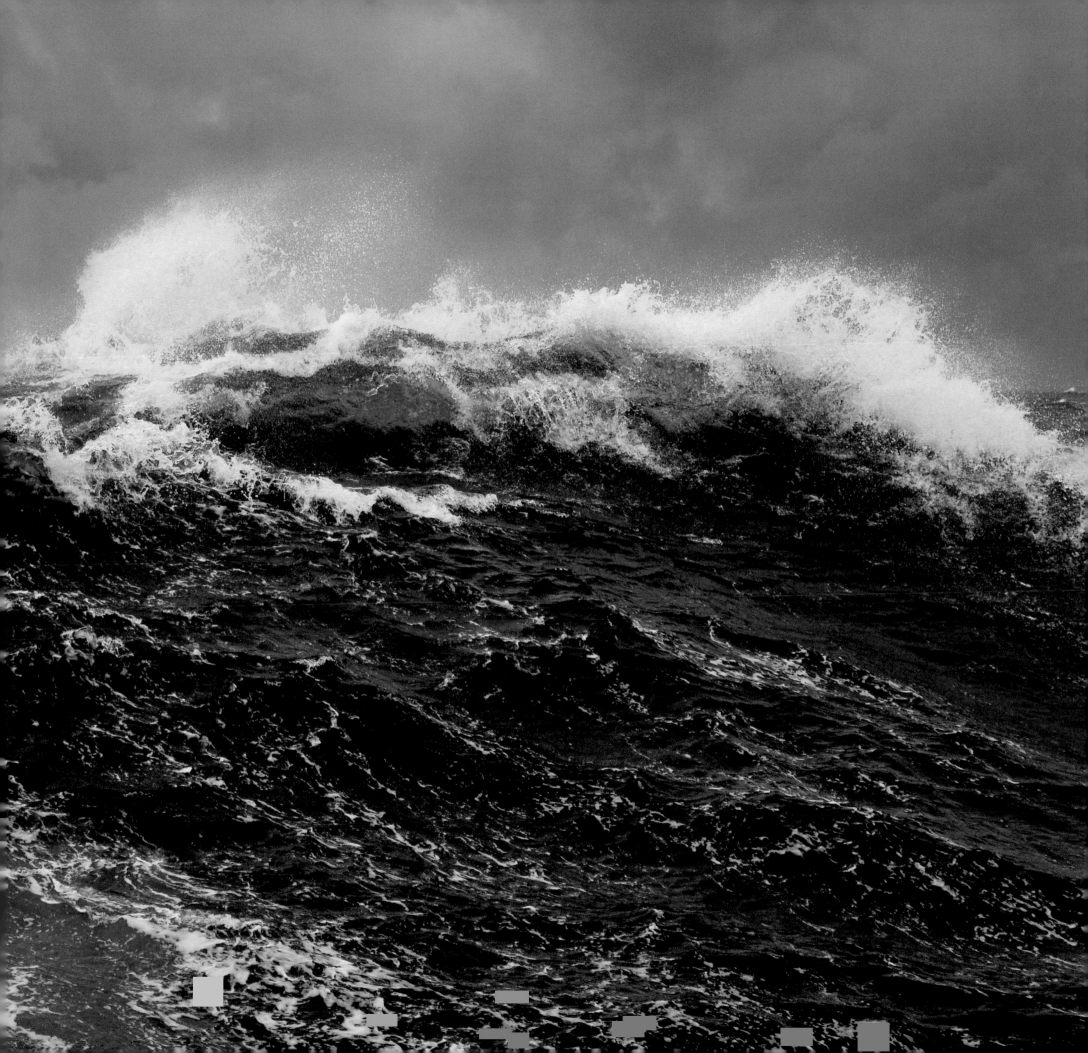

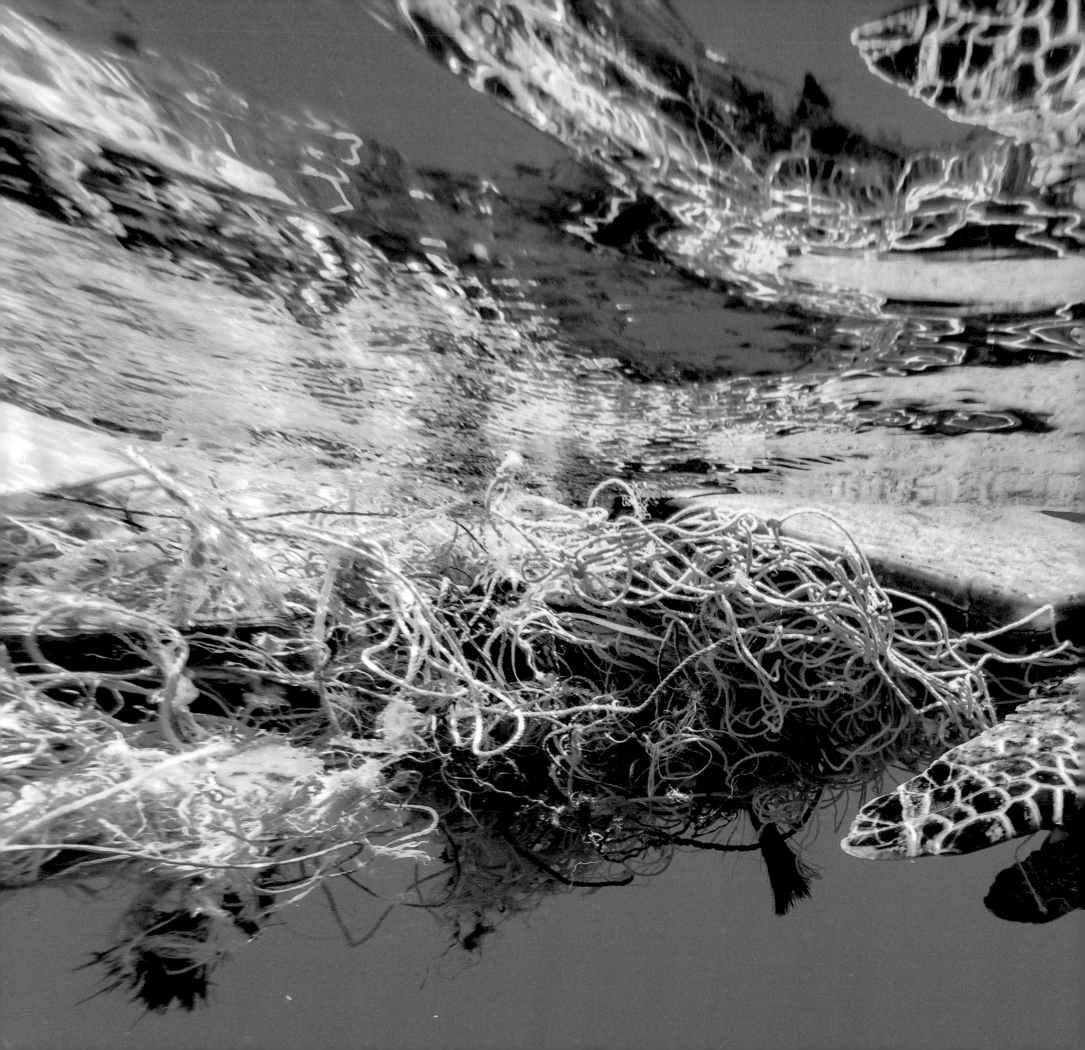

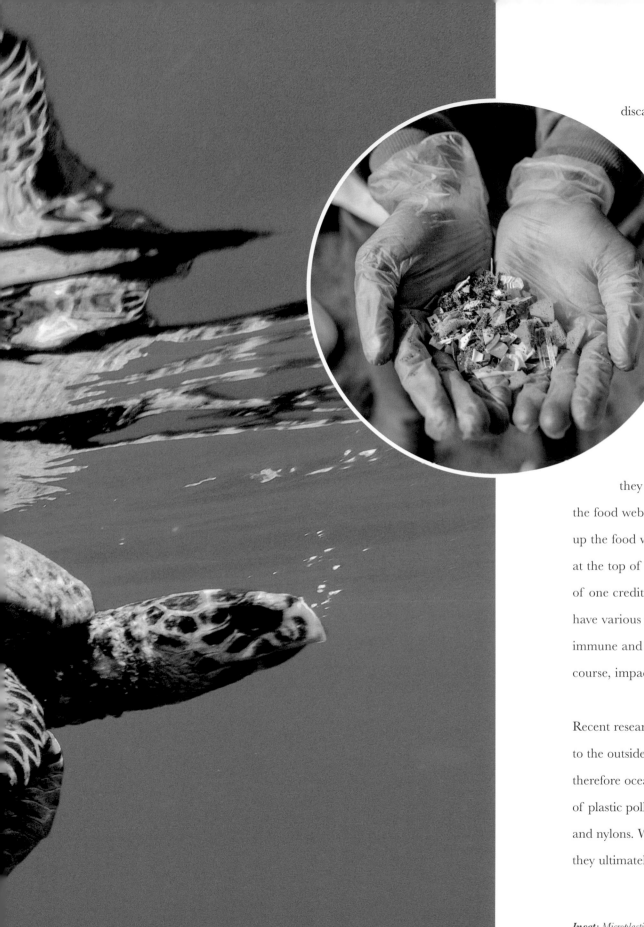

discarded, lost or abandoned fishing gear responsible for the deaths of 650,000 sea creatures a year. Sea turtles, sea birds and marine mammals are just a few of the types of species that become entangled in these deadly webs and die of suffocation, starvation and exhaustion.

The Great Pacific Garbage Patch covers an area of 1.6 million km² (994,000 square miles), three times the size of France, in the North Pacific Ocean. Rather than a mountain of marine debris or a floating island, it is more like a soup of tiny pieces of plastic, brought together by the North Pacific Gyre. The danger of microplastics, these pieces of plastic less than one centimetre (0.4 in) in size, is that they are consumed by microorganisms that form the bottom of the food web. The concentration of these tiny shards increases as you go up the food web in a process known as bioaccumulation. As humans are at the top of most food webs, we are currently consuming the equivalent of one credit card of plastic every week. Microplastics have been shown to have various negative impacts in other species including disrupting their immune and endocrine systems, interfering with reproduction and, of course, impacting on digestion.

Recent research has shown that some of the smallest microplastics stick to the outside of phytoplankton, reducing their chlorophyl content and therefore ocean productivity. Microfibres are a less well-known source of plastic pollution, originating from synthetic fabrics such as polyesters and nylons. When we wash our clothes, these fibres become detached; they ultimately end up in the ocean where they are consumed by marine

Inset: Microplastics collected during a beach clean-up.
Left: A green turtle struggles to swim while entangled in a ghost fishing net. Discarded fishing gear is a major threat to marine life.

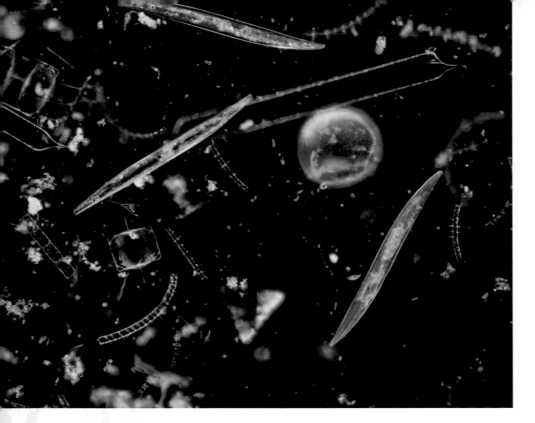

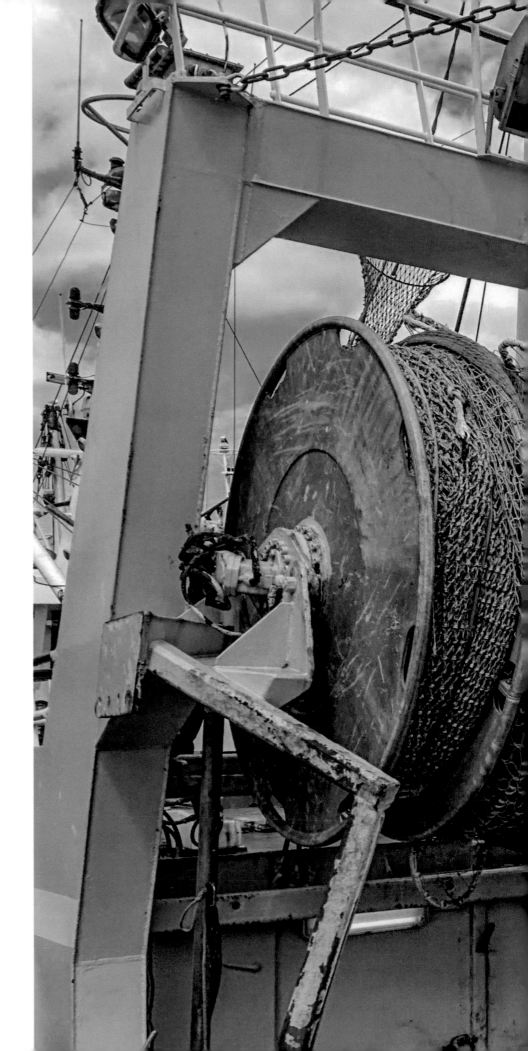

organisms. The volume of microfibres released daily into the marine environment by a city the size of Berlin is equivalent to 5000 plastic bags.

Unchartered Waters

The high seas make up almost two-thirds of the world's ocean and provide a wealth of benefits including oxygen, food, climate regulation and employment. It is so vast that for centuries we have behaved as though its resources are inexhaustible and its biodiversity endless and enduring. But sadly this is not the case. This extensive area of water, larger than all continents combined, can belong to no single country. However, due to the lack of rules and regulation/legislation, it is exploited by many nations. Since no one owns these waters beyond the reach of national jurisdiction, no one is responsible for managing them or for ensuring that their resources are used sustainably. Less than one per cent of the high seas is protected from commercial activities; even these few areas that claim to be protected may

Above: *Diatoms are photosynthesizing algae (phytoplankton) with a siliceous skeleton. Even they are at risk from microplastics.*
Right: *The nets of a fishing trawler, another substantial environmental hazard. In commercial fishing they are dragged along the sea floor, damaging anything in their path.*

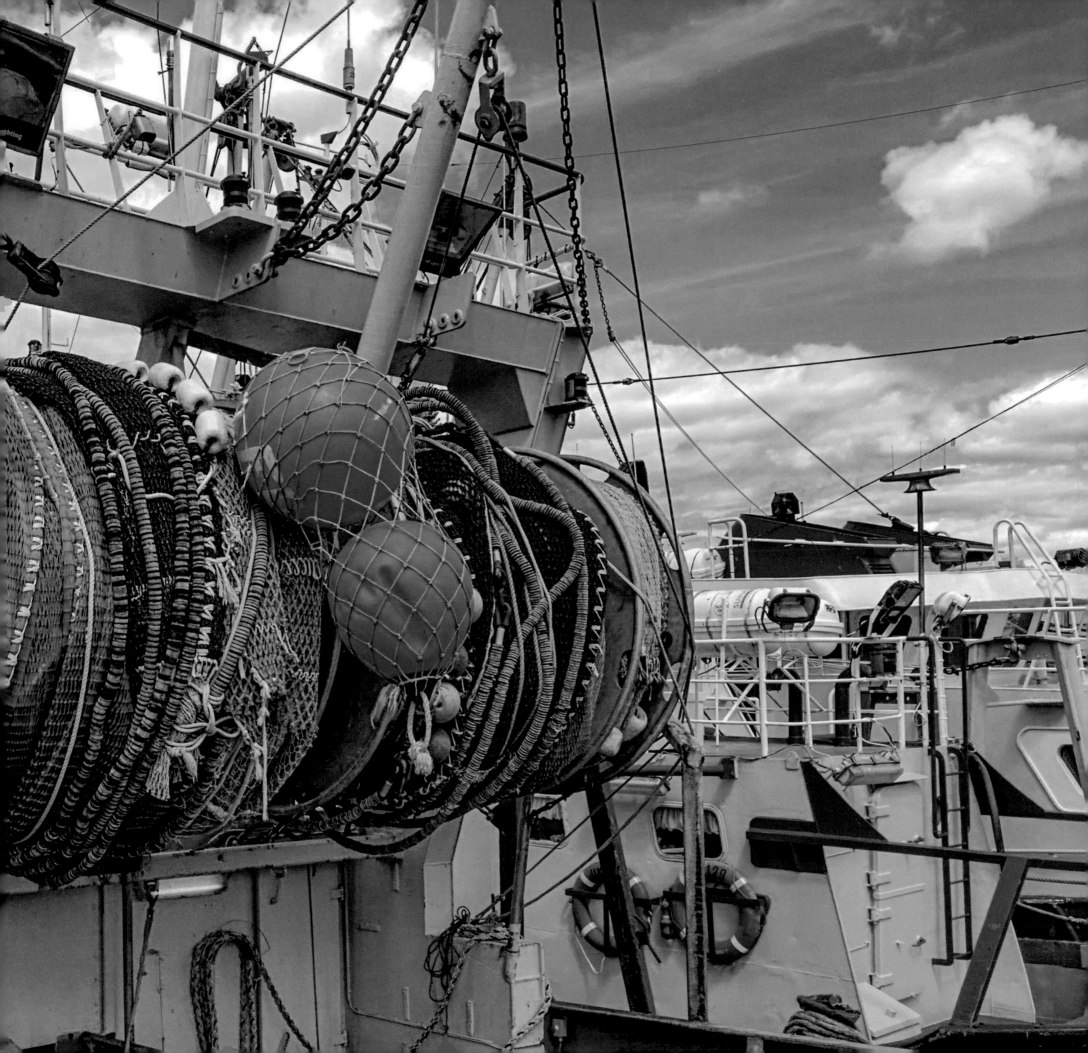

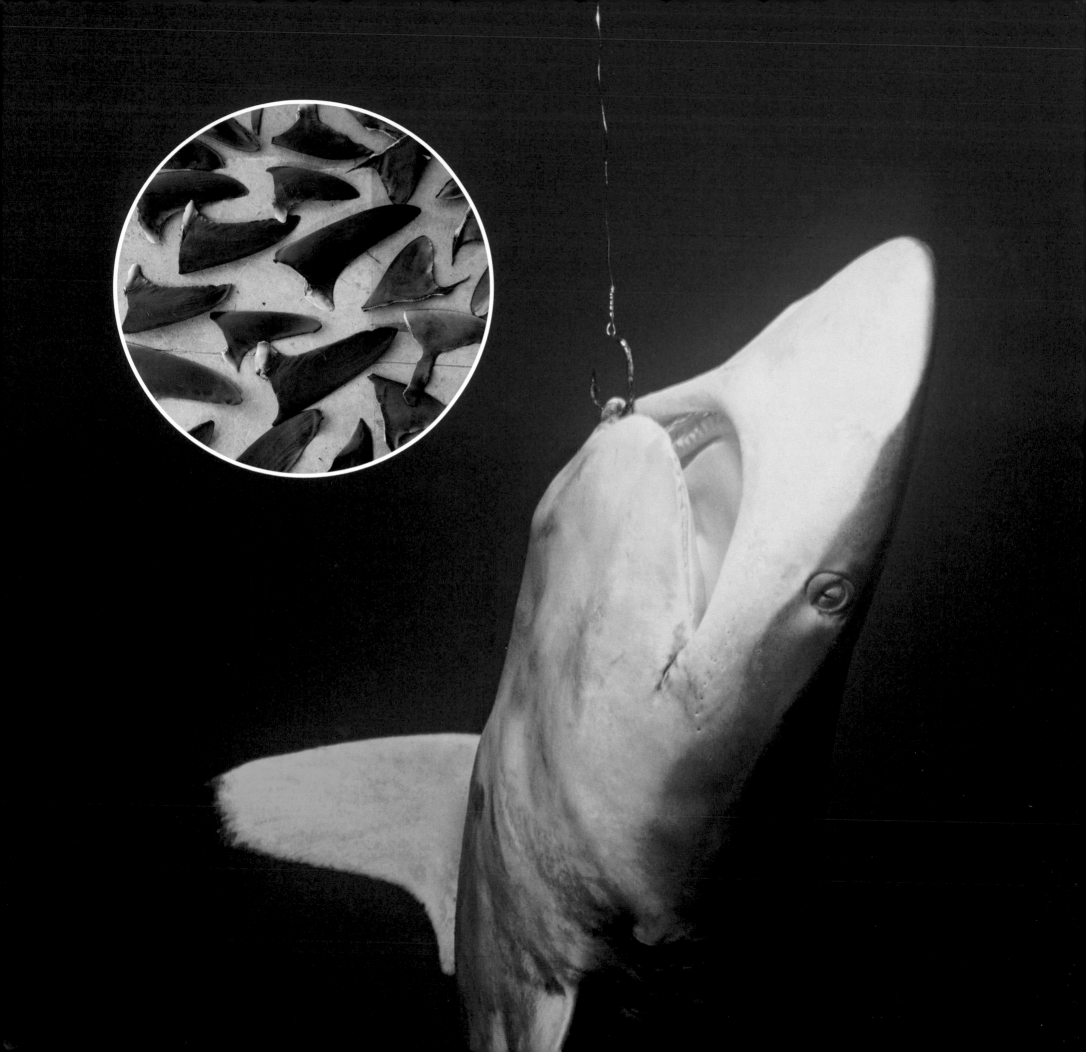

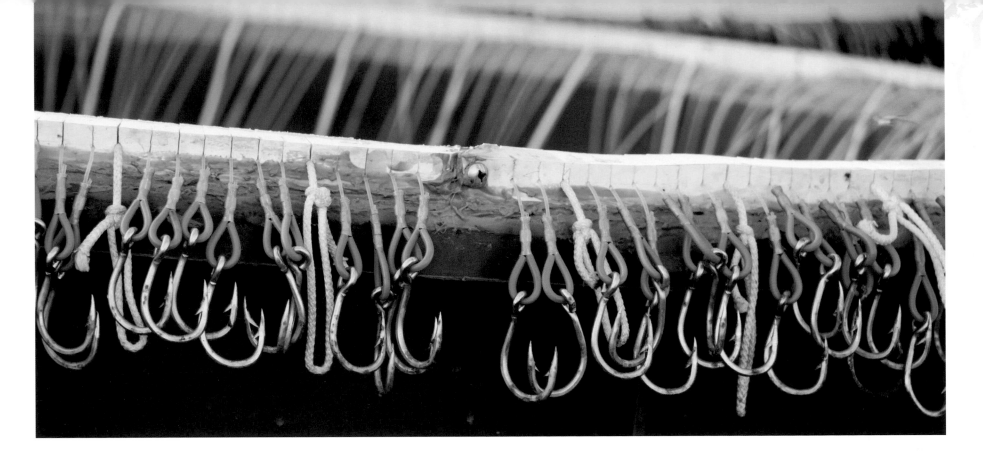

have insufficient enforcement to restrict all extractive activities. The extent of overfishing of international waters is astonishing. Almost 90 per cent of global marine fish stocks are fully exploited, overexploited or depleted. Even more sobering is the fact that government subsidies are largely to blame. Without such subsidies more than half of the current fishing grounds in the high seas would be unprofitable given present fishing rates.

The Deadliest Species

Shark attacks are always headline news. The widespread media attention and publicity they receive perpetuates negative perceptions of these big fish, sometimes even resulting in unfavourable consequences for shark populations. In reality only a handful of the 75 to 100 unprovoked attacks that occur annually worldwide are fatal. When the roles are reversed, however, the figures are quite different. Between 100 million and 240 million sharks are slaughtered each year just for their fins. The sharks are hauled to the surface and their fins savagely hacked off while the poor creature is still alive. The mutilated bodies are thrown back into the sea where the shark slowly bleeds to death or

suffocates. Shark fins are a key ingredient of shark fin soup, a jelly-like dish served at Asian banquets and weddings. Since the fins have almost no flavour, they are more of a symbol of wealth and status. It can be difficult to identify a species by just its dorsal fin, which makes enforcing the ban on the trade of certain species virtually impossible. Many of those traded are undoubtedly from endangered species, a fact that shop owners selling shark fins often do not know. In May 2020 officials seized 26 tons of shark fins in Hong Kong; they had been cut from the bodies of 38,500 endangered sharks from Ecuador.

Besides the finning industry, millions of sharks are caught as accidental bycatch on longlines set out for fish each year. The decimation of shark populations worldwide could lead to the collapse of marine ecosystems. Healthy oceans rely on these apex predators to control the abundance of species further down the food chain. By hunting old and sick individuals they strengthen the gene pool of the prey species, resulting in stronger and healthier fish stocks.

Opposite inset: A collection of shark fins from endangered species, commercially fished in Guatemala. This brutal practice serves a global finning industry.
Opposite and above: Sharks are often caught as accidental bycatch on the hooks of longlines.

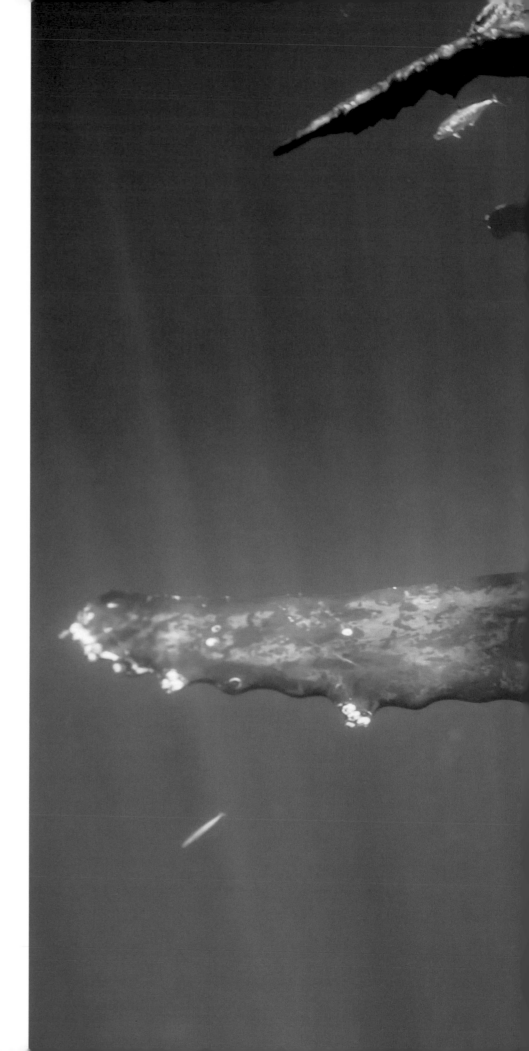

Taking the Plunge

The high seas require our protection if they are to remain rich and healthy. By reducing our dependence on single-use plastic and managing our addiction to consumption, we can help to keep these wild waters clean. But international cooperation and the support of our governments is vital if we are to prevent the high seas from being pillaged in the future.

Reduce, Reuse, Recycle

We have all heard this mantra at one point or another. Three simple words, but what do they actually entail? Most people do not appreciate the importance of the order of these three words, which reflects the effectiveness of each method. Reduction is the best solution. We are constantly bombarded with advertisements telling us that we need this product and that clothing item, but most of the time they are entirely superfluous. Before buying something, it is always worth thinking whether you really need it. This brings us to reuse; if you are unable to reduce, consider whether you can repair your existing item, purchase it second-hand or perhaps even make something out of items you already own. Recycling, last in the sequence, receives the most attention; yet, while it has its purposes, it is much less impactful than the previous two. This is because, sadly, only a very small fraction of what we put in the recycling bin is actually recycled, and most materials can only be recycled a certain number of times.

Right: *After decimation by whaling, humpback whale populations have rebounded, and yet like many marine creatures they are still threatened by pollution, entanglement in fishing gear, ship strikes and more.*

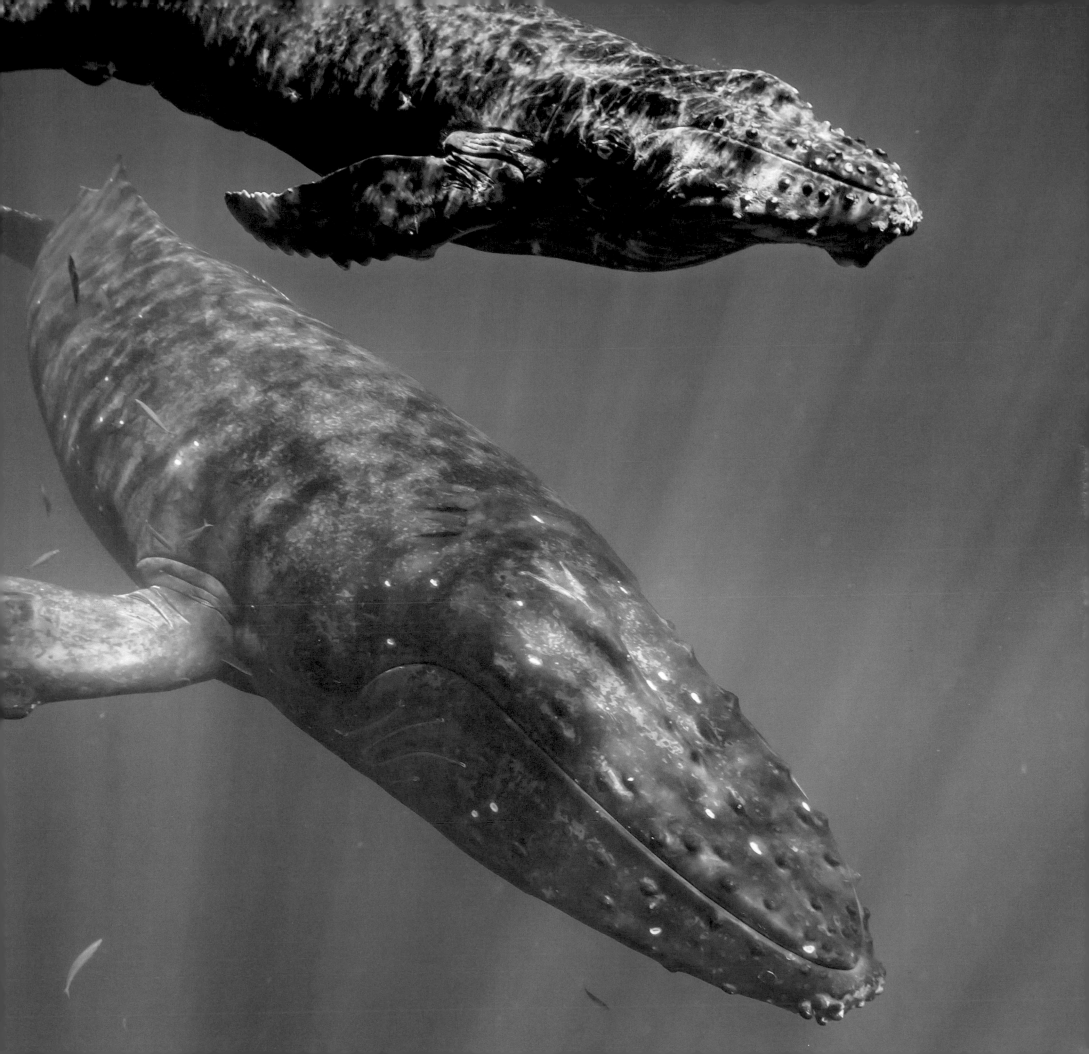

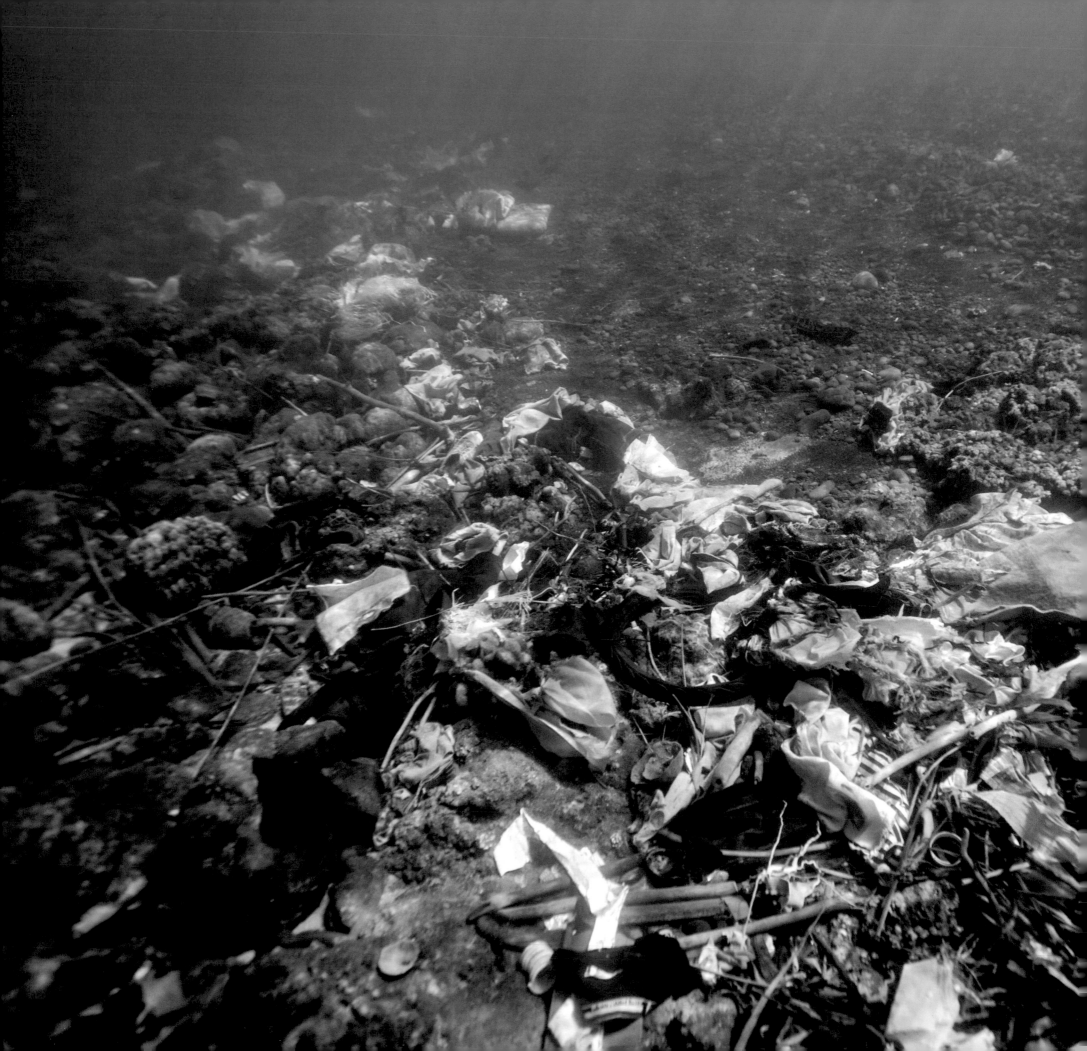

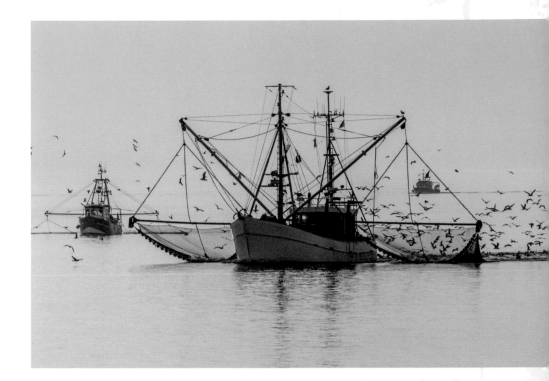

Coming to an Agreement

The United Nations Convention on the Law of the Sea (UNCLOS) 1982 is an international treaty intended to ensure better regulation of the use of the ocean and its resources. While the treaty has been relatively effective at mitigating conflict over resources, it has been less successful at reducing our impact on these predominantly lawless waters. Negotiations are underway in order to address this lack of legislation, with the aim of defining the conservation and sustainable use of marine biodiversity of areas beyond national jurisdiction (ABNJ). These negotiations have been disrupted by the COVID-19 pandemic, but are scheduled to recommence in 2021. Scientists have suggested that 30 per cent of the ocean should receive protective status by 2030 to ensure we do not lose any more biodiversity. The UK has taken this advice by launching the 30x30 campaign; several other countries, including Belgium, Costa Rica and Kenya, have declared the same intentions.

Above: *Overfishing remains a serious concern.*
Left: *We need to reduce the amount of plastics and disposables we use so less ends up in the ocean.*

Open Ocean

Deep Ocean

Into the Deep

The ocean is the largest single habitat on Earth, and the deep
ocean comprises 90 per cent of this vast volume of water. Depending
on the definition used, 'the deep' may begin at 200 m (600 feet) – the
depth at which sunlight is no longer measurable; others prefer 500 m
(1500 feet) – the depth at which surface variations in temperature and
salinity cease to have an influence. Semantics aside, the deep ocean
remains one of the most inhospitable and mysterious parts of our planet,
home to creatures beyond the imagination of even the most far-fetched
science fiction.

Under Pressure

We are used to believing that humans have conquered the underwater
realm – after all, we have submarines and scuba divers. The
truth is that, despite all our technological advances, we
struggle to go deeper than 300 m (900 feet). We are
only scratching the surface of the vast ocean depths.
While specialist submersibles and remotely operated
vehicles (ROVs) permit us briefly to visit the deep
ocean, it remains tantalizingly out of reach to most.

As well as the cold and dark, the main barrier to
overcome is the crushing pressure associated with the
ocean depths. Unless you are reading this on top of a
mountain or are in a submarine yourself, it is a safe bet
that you are under one atmosphere of pressure (15 psi).

Previous page: A DeepSee diving submersible exploring the seabed, Cocos Island, Costa Rica.
Inset: The spherical dome of this deep-sea submersible is able to withstand extremely high pressure,
protecting the operators inside from being crushed to death.
Right: A diver explores the bottom of the Red Sea.

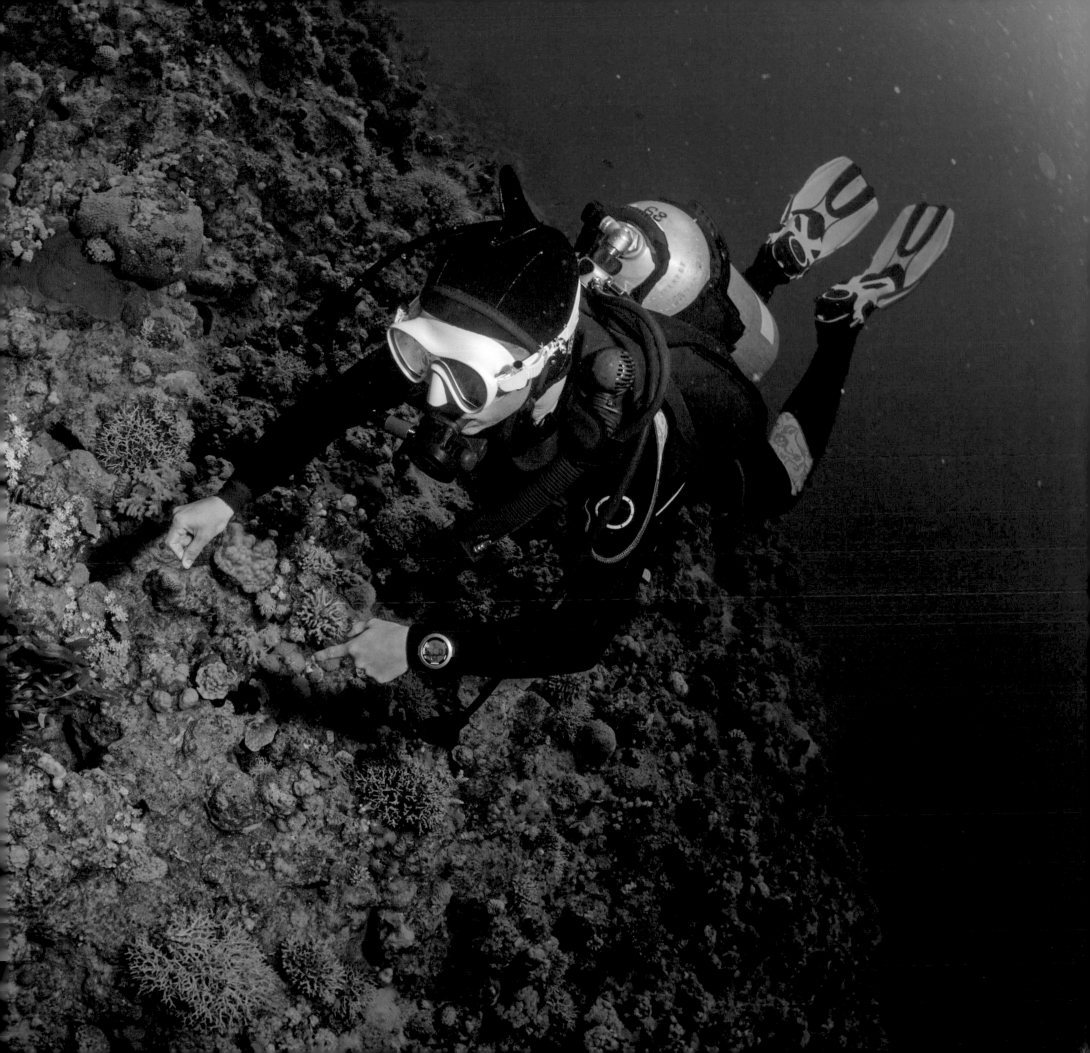

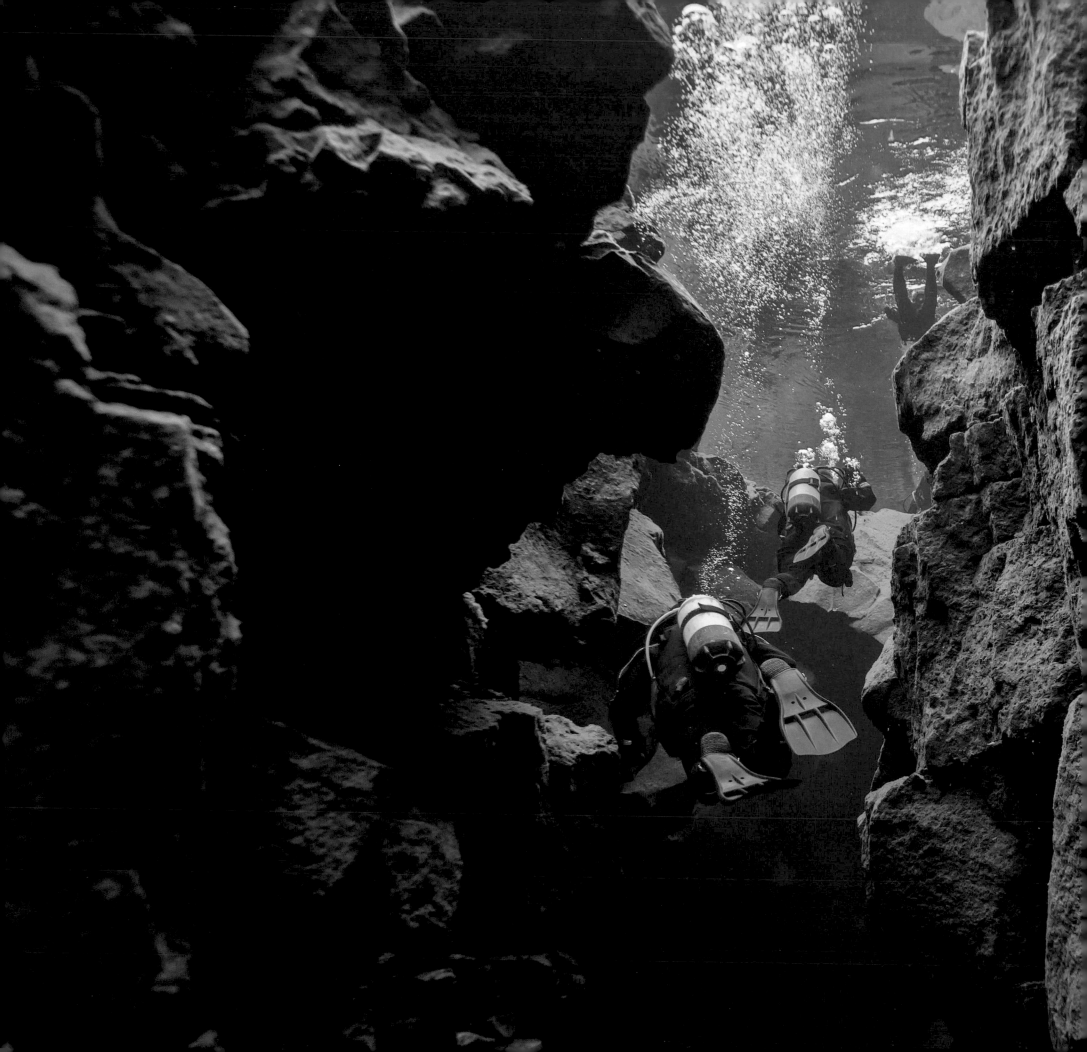

The Earth's atmosphere is approximately 100 km (62 miles) high, and the weight of air pushes down on the surface of every object. This air exerts a pressure equivalent to a 1 kg bag of sugar pressing down on every square centimetre of you (or 15 one-pound bags of sugar on every square inch). In normal conditions we don't notice this as any gases dissolved into our body tissues are also at atmospheric pressure. But as water is heavier than air, we do not have to descend far before pressure becomes an issue.

Underwater, the pressure increases by one atmosphere for every 10 m (30 feet) of depth. So, at 10 m depth, a diver would be subjected to a pressure of two atmospheres (29 psi). At 40 m (120 feet), the pressure has already crushed a diver's lungs to the size of their fist (don't worry – lungs expand back to their regular size upon resurfacing!). The current deepest scuba dive stands at 305 m (915 feet); continue going deeper and the depths quickly become unmanageable. At the average ocean depth of 3600 m, a submersible would have to contend with a pressure of 360 kg pressing down on every square centimetre (5290 psi). To put this into perspective, the International Space Station has to keep one atmosphere inside the craft against the vacuum of space: a pressure differential of one. A submersible has to keep 360 atmospheres out of the craft.

Exploring the Deep

Scientists originally postulated that the deep ocean was too harsh an environment to support complex life. In the nineteenth century the *Challenger* expedition

Inset: Charles Wyville Thomson (1830–82) was the chief scientist on the Challenger expedition of 1872–76.
Left: The first deep-sea maps revealed the Mid-Atlantic Ridge, an underwater mountain range where the North American and Eurasian tectonic plates meet. It extends above sea level as it runs through Iceland, and some of it is submerged in the crystal-clear glacial waters of Þingvallavatn lake, as shown here, where divers explore Silfra rift.

Deep Ocean

149

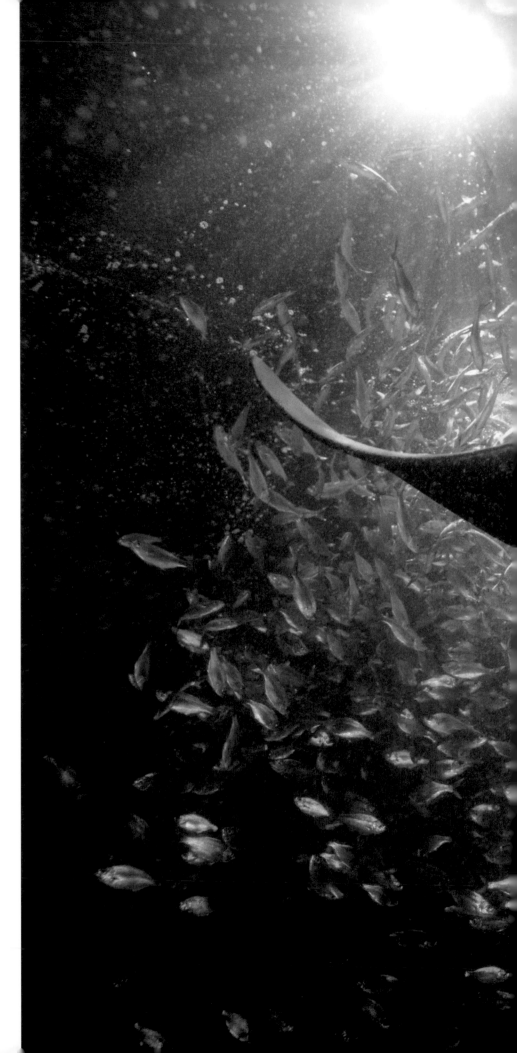

debunked this idea by trawling up creatures never seen before from all depths in all oceans. At the same time marine expeditions were crudely mapping the ocean depths using plumb lines – lumps of lead attached to winches that paid out rope of a known length.

The advent of sonar during the Second World War enabled vessels to easily map the ocean floor. This also brought with it a number of surprises, continuing to challenge the scientific consensus of the 1950s. As the first deep-sea maps were being produced, cartographer Marie Tharp revealed evidence of a colossal underwater mountain range, as high as the Alps and spanning the entire length of the Atlantic. Termed the Mid-Atlantic Ridge, Tharp's discovery provoked disbelief in the ocean science community who believed the ocean floor was a flat featureless plain. Even the famous ocean explorer Jacques Cousteau refused to believe the findings until he filmed the Ridge with his own underwater cameras.

As time went on, sonar operators began to report depths of 300 m to 500 m (900 feet to 1500 feet) in areas where charts gave depths of 2000, 3000 and 4000 m (6000, 9000 and 12,000 feet). Even more weird was the fact that this 'false bottom' appeared to be shallower at night and deeper in the day. Sampling of this layer revealed that the phenomenon was caused by microscopic zooplankton called copepods, a key component in the marine food web. It was discovered that copepods swim up to surface waters under cover of darkness to feed in the photic layer, thus avoiding detection from predators. Subsequently termed the 'deep-scattering layer', this migration is now recognized as the largest on Earth. The copepods, only 2 mm (0.08 in) long, swim almost 2000 m (6000 feet) in a 24-hour period – the human equivalent of a daily swim from London to Lisbon.

Right: Schooling Hawaiian flagtail fish and a reef manta ray feed on plankton that have risen to the surface waters at night, Kona, Hawaii.

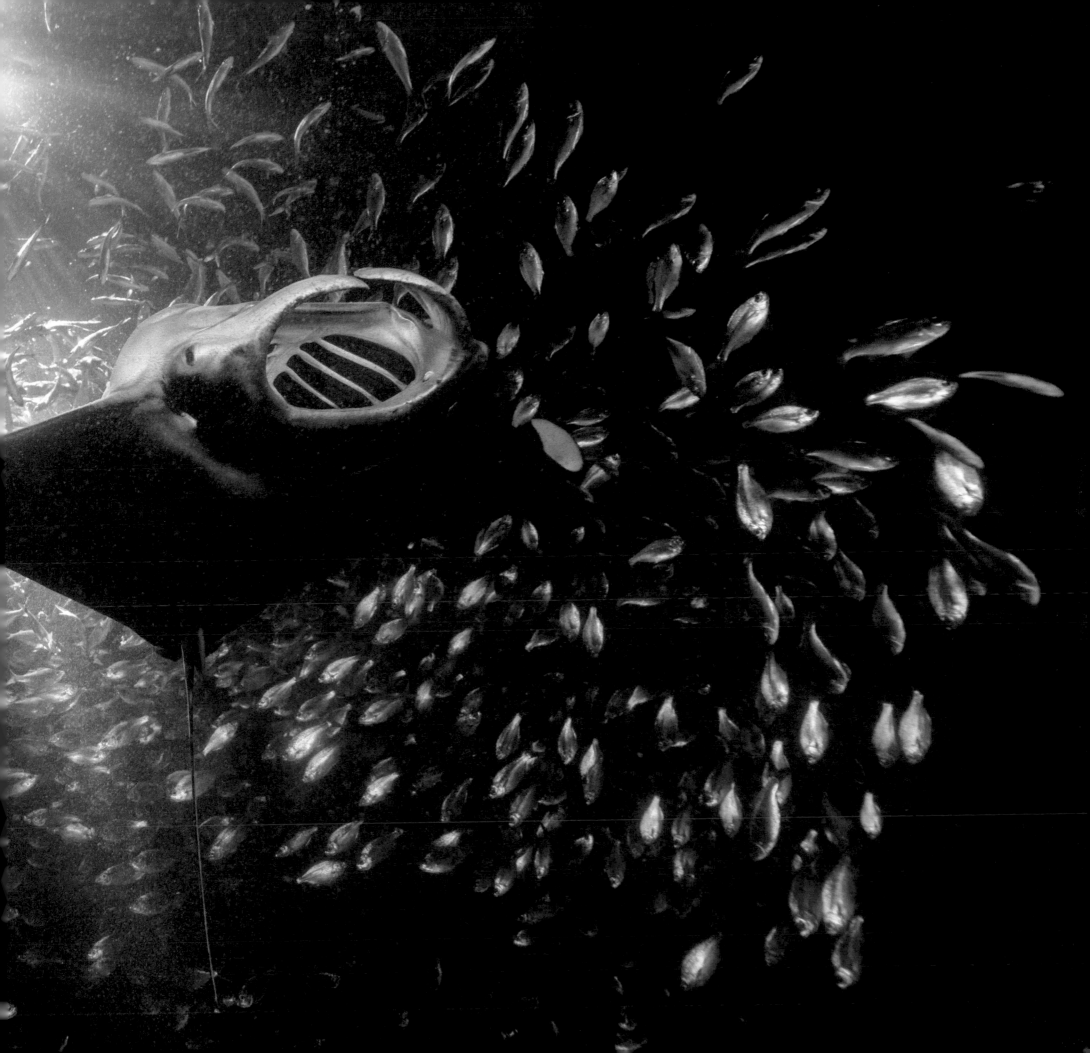

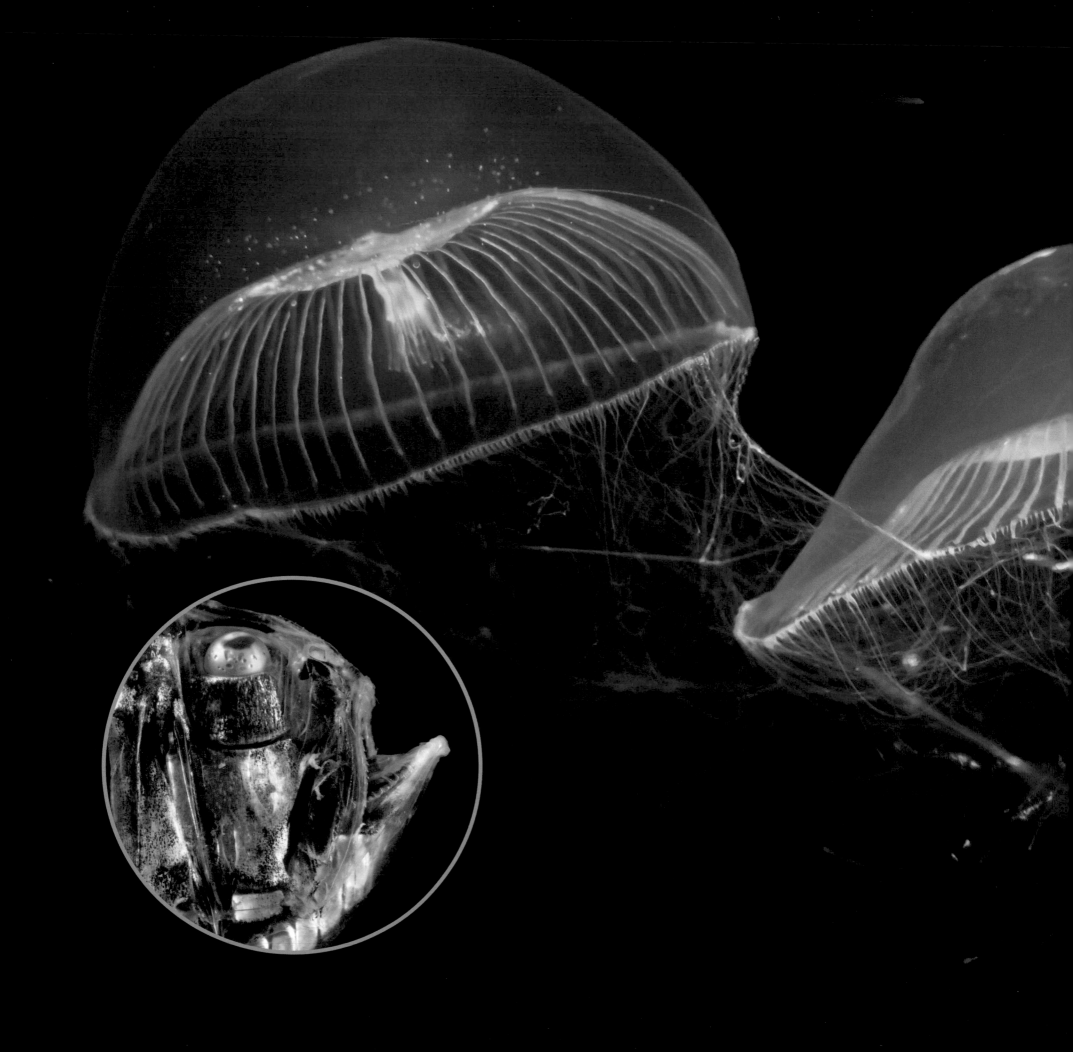

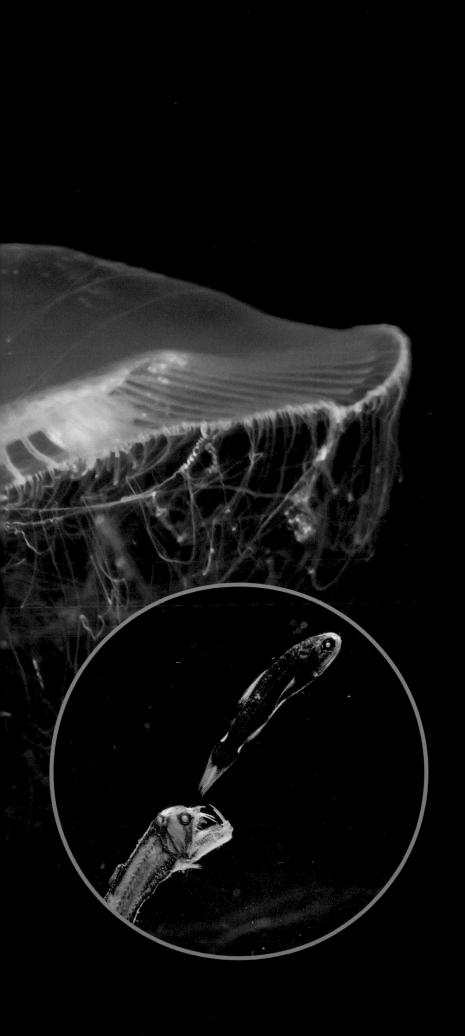

The Twilight Zone

A majority of ocean life is confined to the photic zone, the upper 200 m (600 feet) where photosynthesis is able to take place. Sinking deeper, we leave behind the influence of the Sun and enter an almost alien realm. The twilight zone, aka the mesopelagic or dysphotic zone, begins at 200 m (600 feet) and extends downwards to 1000 m (3000 feet). At this depth light is too weak for photosynthesis to occur. Despite its darkness and pressures, numerous surface creatures are known to visit this region to hunt for prey. Emperor penguins have been clocked at depths of 450 m (1350 feet), while various species of seals, turtles, dolphins and whales make frequent forays into this zone.

It is here that we begin to encounter bioluminescent animals. Despite the depth, there is still a faint glimmer of sunlight permeating through from above. Creatures at these depths have highly attuned vision and can discern the darker silhouettes of prey drifting overhead against the lighter upper ocean. In the photic zone animals deal with this using counter-shading, being lighter coloured underneath and darker coloured on top. But this adaptation would yield little benefit in a zone almost devoid of light; it is now that bioluminescence must be used. Hatchetfish, among other organisms in this zone, have rows of photophores (light-emitting organs) on their underside. They are able to alter the intensity of the light given off from these organs so it perfectly matches that coming from above. The hatchetfish thus merges into the background.

The peculiar barreleye fish also inhabits these depths. Originally trawled up in 1939, it was not until 70 years later that the true nature of this fish became apparent. Spotted hanging motionless in the water, an ROV

*Left: The crystal jelly (*Aequorea victoria*), a hydrozoan jellyfish, is found off the west coast of North America. It produces flashes of bioluminescence through the use of two proteins.*
Opposite inset: With its eyes pointed upwards, the hatchetfish surveys the waters above for the silhouettes of prey. Meanwhile, its illuminated underside will help hide it from predators below.
Left inset: A viperfish attacking a lanternfish in the twilight zone. The arrangement of a lanternfish's bioluminescent photophores varies for each species.

Deep Ocean

153

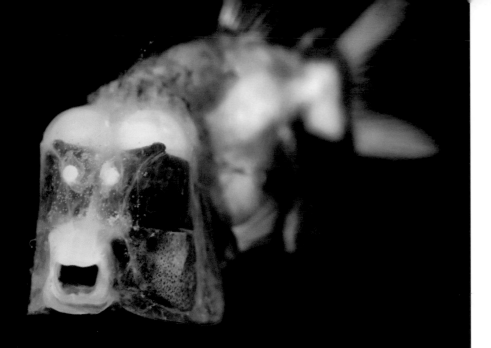

recorded a feature of the barreleye not seen before: a transparent, fluid-filled head. As the fish had originally been trawled up from depth, this delicate structure was obliterated and thus overlooked by its discoverers. The ROV allowed us to film the barreleye in action; with large tubular eyes situated inside the head cavity, the barreleye is able to switch the orientation of these eyes from forward to directly upward. This amazing adaptation allows the barreleye to locate silhouettes overhead and then zoom in for the kill.

The Midnight Zone

Beyond the twilight zone lies the midnight zone, also known as the bathypelagic zone. From 1000 m (3000 feet) down to 4000 m (12,000 feet), this is the deep ocean proper. Despite the distance, the zone is also frequented by surface dwellers; tagged elephant seals have been seen to dive to depths of 2300 m (6900 feet) in search of prey. The sperm whale makes hourly excursions to depths of 2500 m (7500 feet). We are accustomed to thinking of the sperm whale as a surface creature, but in reality they spend 50 minutes of every hour at depths in excess of 1000 m (3000 feet). Making

Above: *A transparent-headed barreleye.*
Right: *A group of sperm whales returns to the surface near the Ogasawara Islands, Japan. A piece of giant squid is clearly visible in the mouth of the large female.*

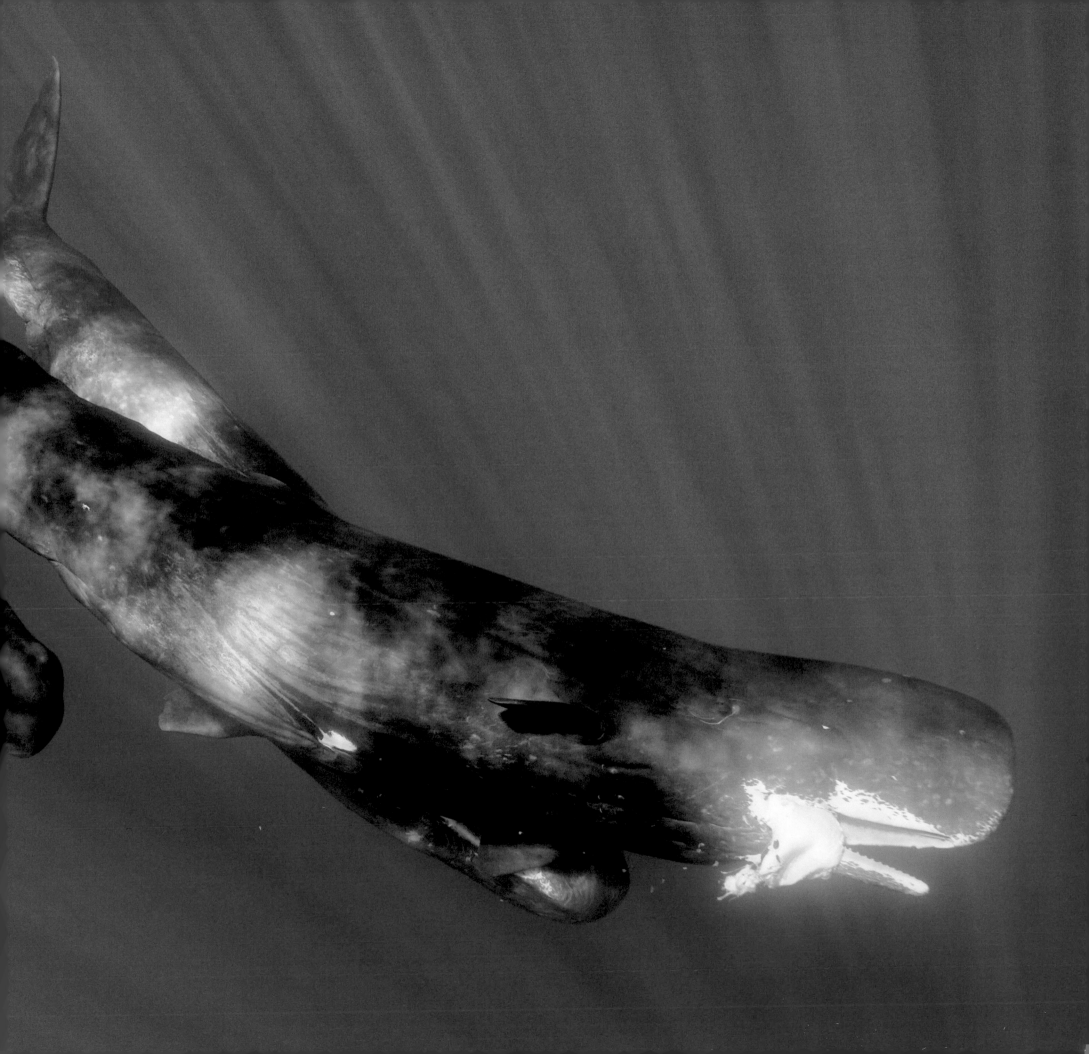

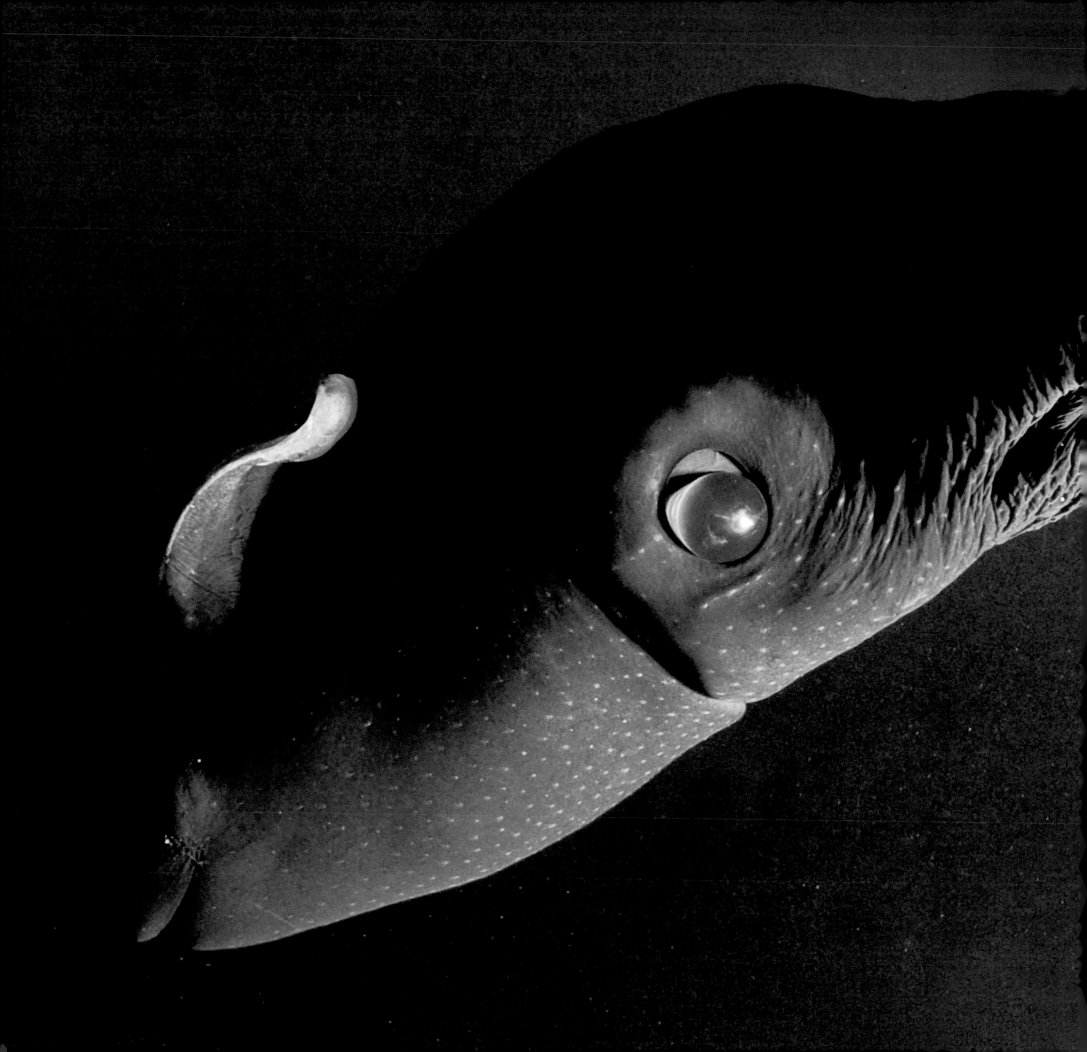

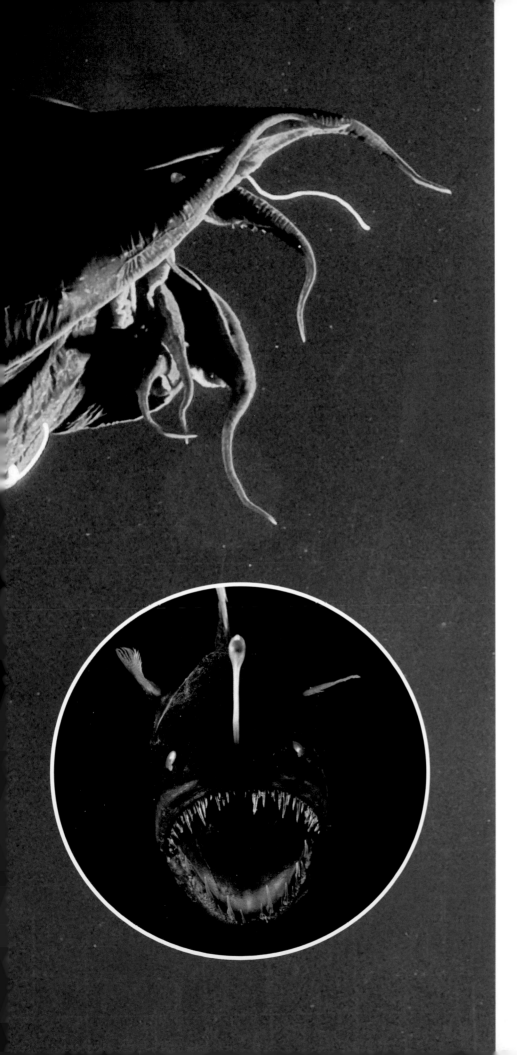

the most of every breath, the whales can extract up to 90 per cent of the oxygen from each lungful. They can also control their heartbeat, slowing them to just two beats per minute; for comparison, your heart is currently beating at around 70 beats per minute. Whales also limit the blood supply to organs they are not using, so just the brain, heart and muscles are supplied during a dive. Their muscles are also laced with myoglobin, a protein that allows the storage and subsequent release of oxygen. Once in the midnight zone, the sperm whale no longer uses its eyes. Instead it relies on precision echolocation techniques to map the underwater realm in exquisite detail.

The whale is searching for giant squid. A formidable predator, the giant squid is a classic example of gigantism in the deep sea, possessing a body as large as a human and tentacles in excess of 11 m (36 feet). Each arm is lined with rows of suckers, themselves lined with serrated rings able to cut disc-shaped segments of flesh out of attacking whales. The squid also possesses the largest eyes in the animal kingdom. Each eye is 27 cm (11 in) in diameter, larger than a basketball and capable of detecting the faintest of light.

This zone is also home to the charismatic blobfish, recently voted 'the ugliest animal on Earth'. Also known as fathead sculpins, blobfish at their natural depth are in fact a somewhat unremarkable, wide-mouthed fish covered in small spines. Their blob-like appearance is the result of extreme tissue damage brought about by rapid depressurization as they are hauled to the surface in trawls.

No journey to the deep ocean would be complete without the anglerfish. Best known for their elaborate bioluminescent lures that attract prey, the anglerfish earns its moniker by casting lures back and forth, much as

Inset: This anglerfish shows off her glowing lure in the deep Atlantic. The lure is powered by a mass of bioluminescent bacteria on top of a modified fin.
Left: Much smaller than the giant squid, Vampyroteuthis infernalis *or 'the vampire squid from hell' is a deep-sea species, bearing similarities to both squid and octopuses. Despite its name, this living fossil feeds on marine snow, fish and other detritus.*

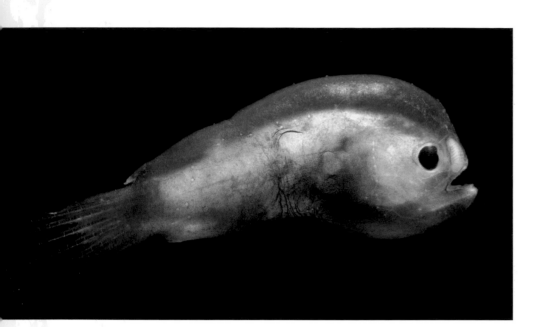

someone does in fly-fishing. With large, fang-toothed mouths and extendable stomachs, the anglerfish ensures it can engulf its prey no matter what size. Typically no bigger than a football, the anglerfish we often see are females. The male is diminutive by comparison; he lacks a full digestive tract and is dominated by a large olfactory organ to assist him with finding a mate in the deep ocean. Mating opportunities are few and far between, so once a female is located, the male bites on to her, never relinquishing his grip. Over time his body is subsumed into hers until only a pair of testes remain, providing her with a constant supply of semen. And you thought online dating was tough.

The Bottomless Abyss

Eventually we arrive at the ocean floor, dominated by the vast abyssal plains. This zone is known as abyssopelagic from the Greek 'abyss' meaning 'no bottom'. These plains are comprised of muds and siliceous oozes, accumulating from the constant rain of dead and decaying organisms from above. This debris, known as marine snow, is a vital food source for

Above: The anglerfish male is up to 10 times smaller than the female.
Right: The giant deep-sea isopod is a distant relative of the familiar woodlouse. It can reach lengths of up to 50 cm (20 in).

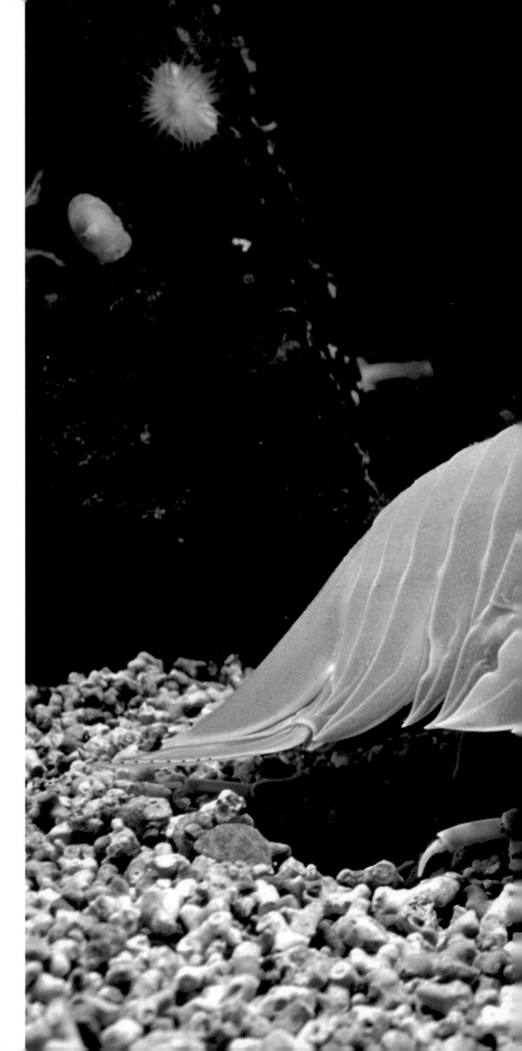

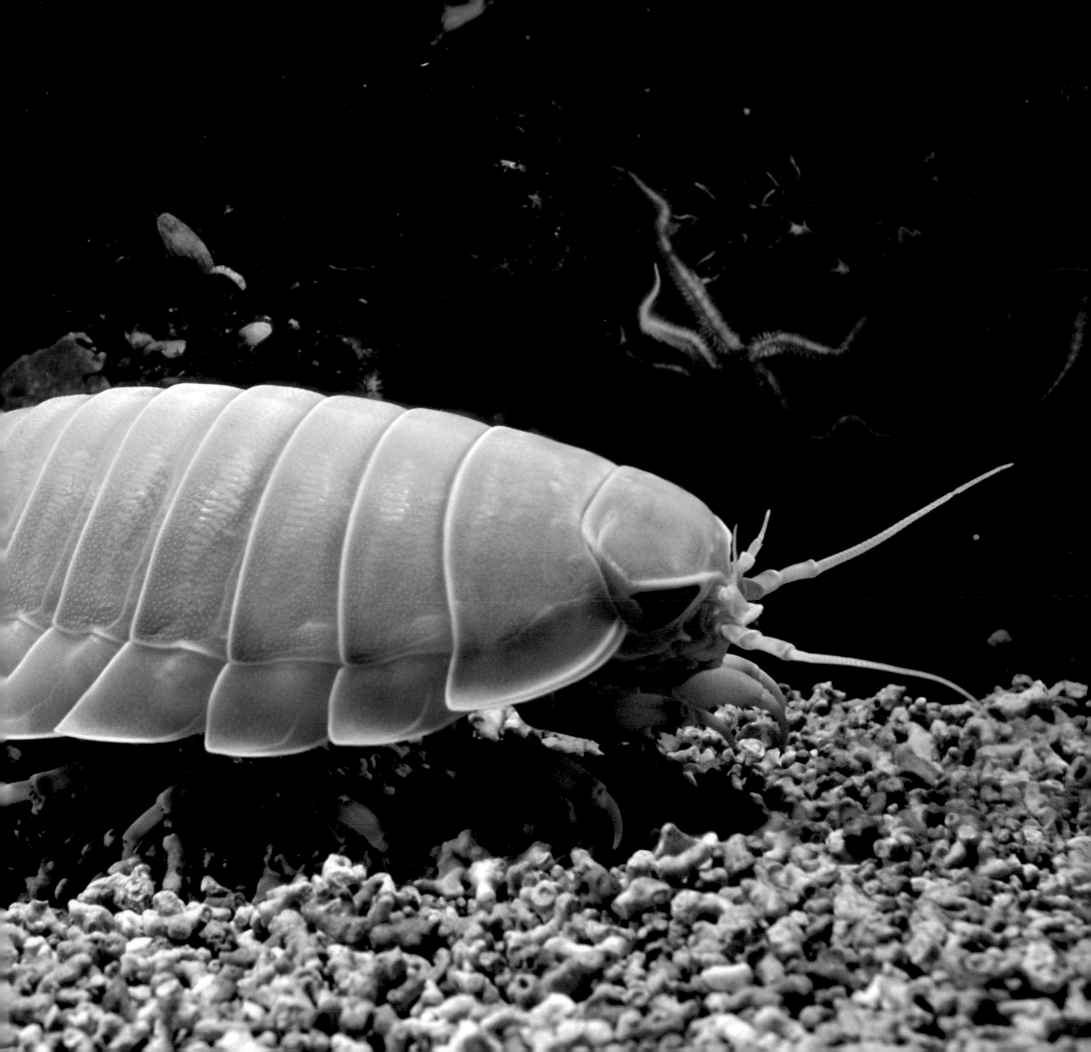

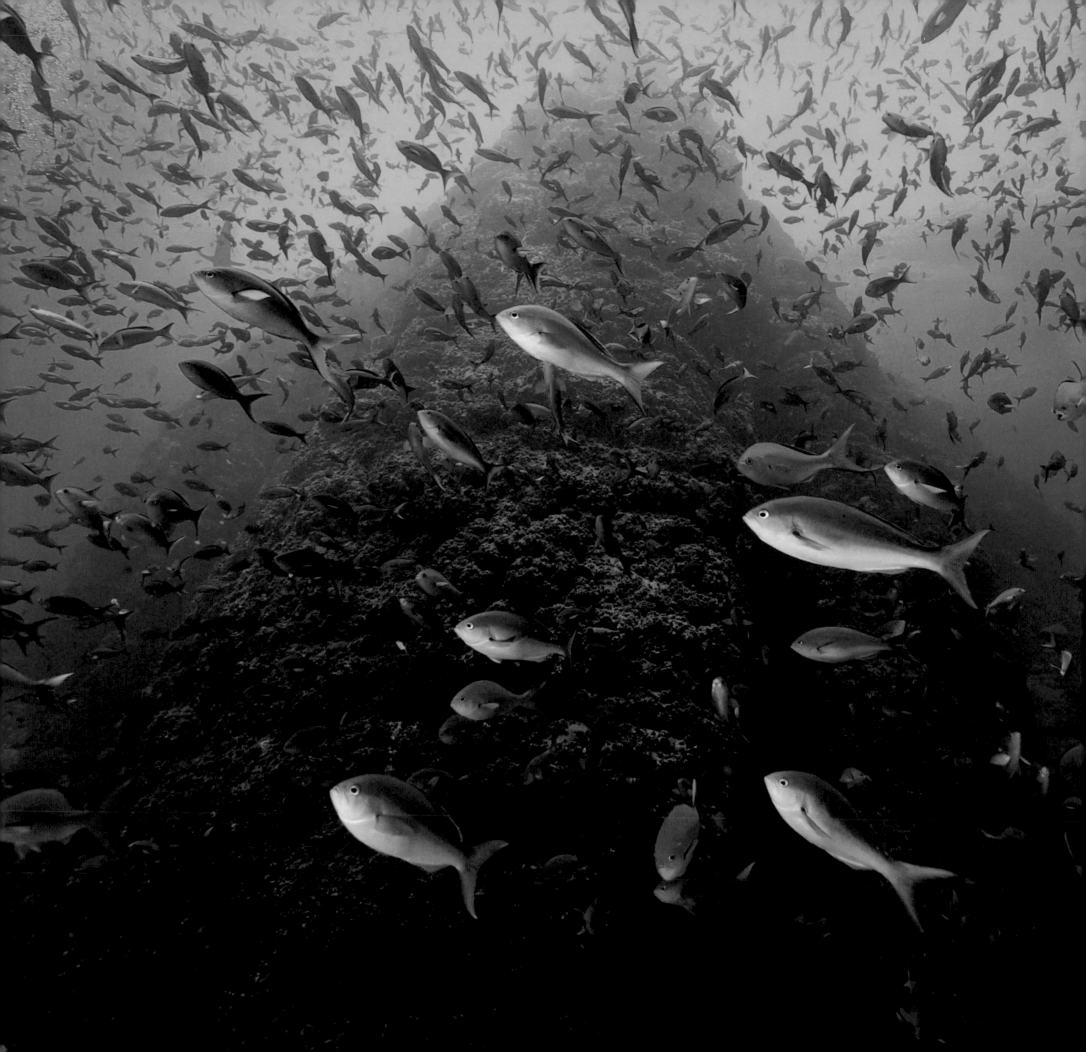

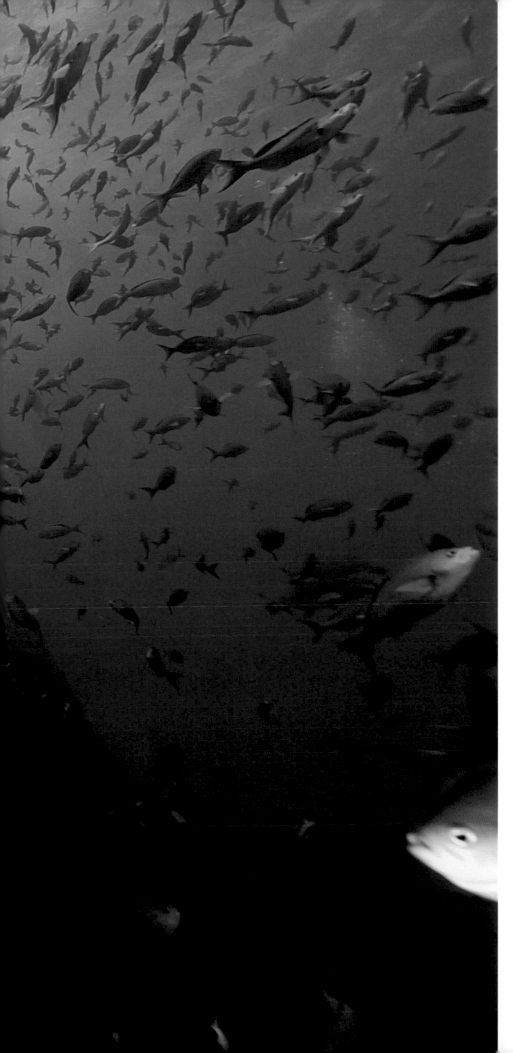

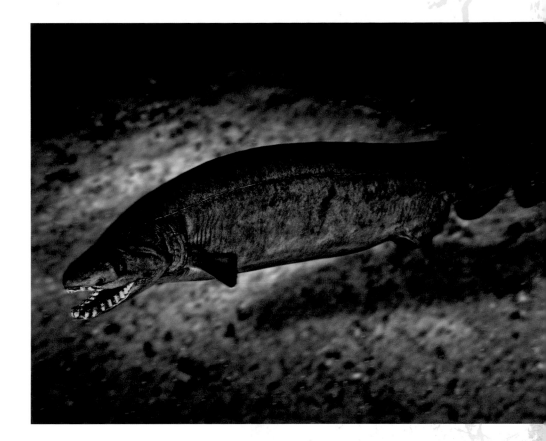

the deep-sea ecosystem. Among this detritus are sites known as whale falls, where dead whales have sunk to the seabed. Here their decaying carcasses are slowly broken down by serpentine hagfish, archaic six-gilled sharks (such as the frilled shark), giant deep-sea isopods, transparent sea cucumbers and numerous other scavengers. The dead whale is a veritable oasis of food; even its bare skeleton is consumed by small worms that excrete acids into the bones to extract the nutrients within.

Rocky seamounts break up the monotony of the abyssal plain, presenting a steep slope of rock that protrudes upwards from the depths. This exposed rock makes a suitable base for dense communities of cold-water corals, sponges and fans, analogous to their warm-water counterparts but

Above: The frilled shark is a true living fossil. It has hardly changed since arriving in our ocean around 150 million years ago.
Left: A dense shoal of Pacific creolefish gathers around a seamount off the coast of Mexico. Using close-range binocular vision, creolefish hone in on tiny zooplankton which they suck into their mouths.

Deep Ocean

lacking the ability to photosynthesize. These deep-sea reefs also support an expansive seamount ecosystem comprised of brittle stars, sea stars, sea cucumbers and barnacles, as well as diverse shoals of fish. Some seamounts have recorded over 800 species of fish alone.

In the late 1970s anomalous temperature readings indicated the presence of extremely hot waters emanating from the ocean depths. Upon investigation using the deep-sea submersible Alvin, scientists came across the first hydrothermal vent system. Also known as 'black smokers', these vents are formed when sea water is drawn down into the Earth's crust, dissolving minerals en route, until it is superheated to temperatures of up to 464°C (867°F). Eventually the superheated water erupts from a fissure. Over time the dissolved minerals precipitate out from the superheated water, forming chimneys that tower up to 60 m (180 feet) above the seabed. While most ecosystems are photosynthetic in origin, relying on energy from the Sun, the ecosystems around hydrothermal vents are chemosynthetic. Here, instead of plants, bacteria form the basis of the food web, as they are able to metabolize sulphurous compounds present in the warm water. Scientists believe that these bacteria could be some of the oldest forms of life on Earth. Through the study of hydrothermal vents, therefore, we may ultimately discover how life on Earth began.

Feeding upon these bacteria are clams, limpets, mussels, giant tube worms 3 m (9 feet) in height and teeming troupes of shrimp. The shrimps themselves are blind to light within the visible range. Instead they possess an organ that detects the infrared heat signature from the vent, preventing them from getting too close to the scalding water. Feeding off the shellfish are a myriad of fish, eels, crabs, barnacles and octopuses, all unique

Left: A hydrothermal vent or 'black smoker' erupts from the Mid-Atlantic Ridge. The force of the eruption projects mineral-laden, superheated water upwards into the ocean.
Right: Shrimps and crabs clamber over a rich mussel bed at the Eifuku Champagne hydrothermal vent, 1600 m (5400 feet) underwater off the Northern Mariana Islands.

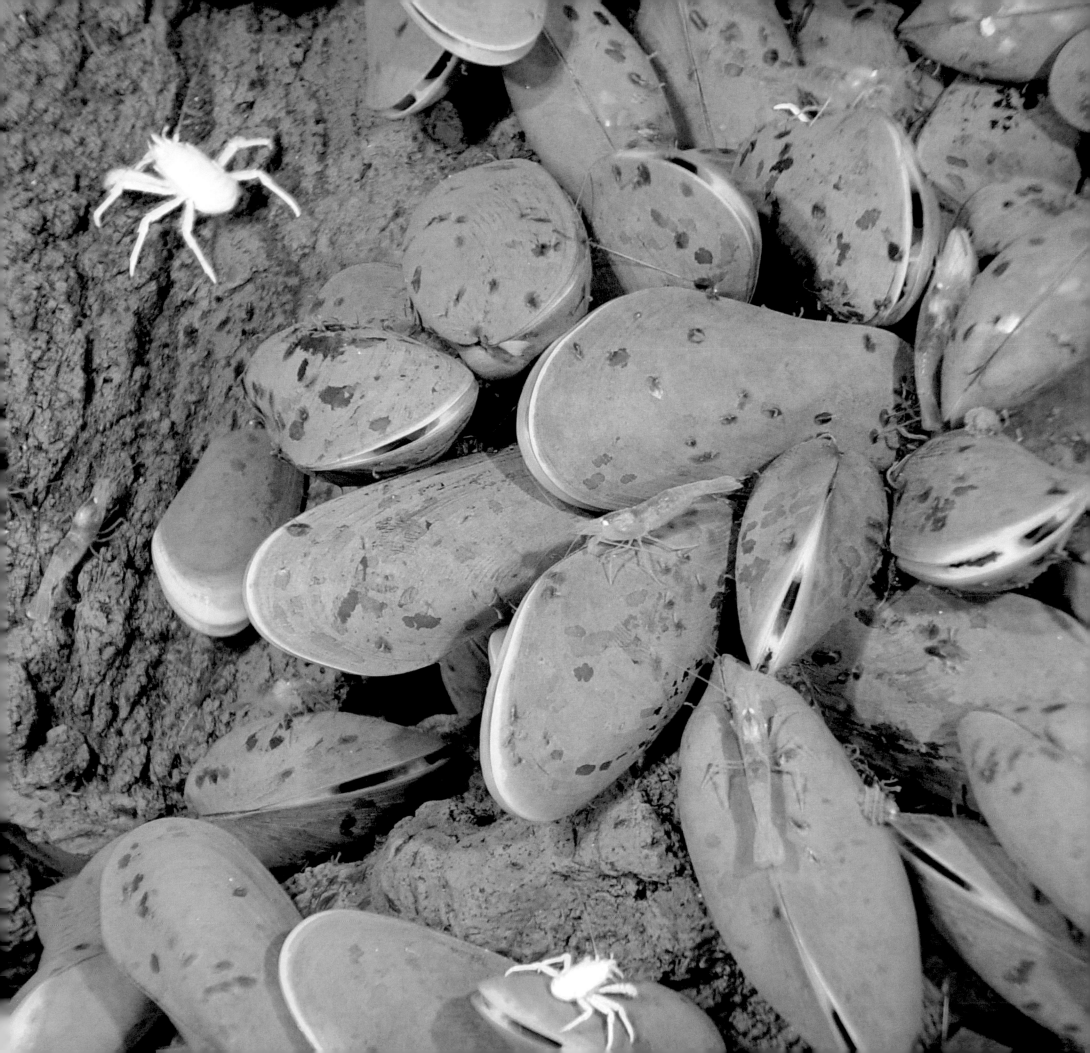

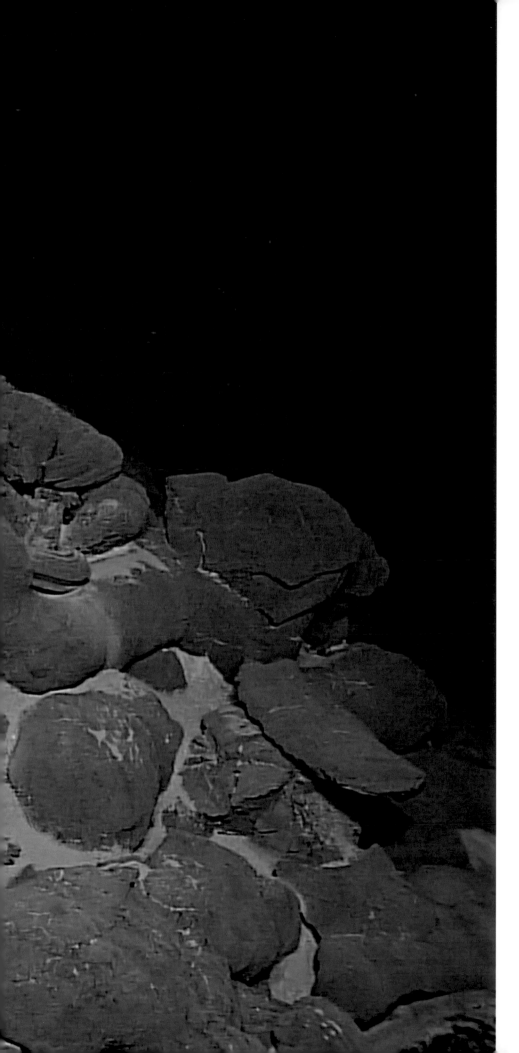

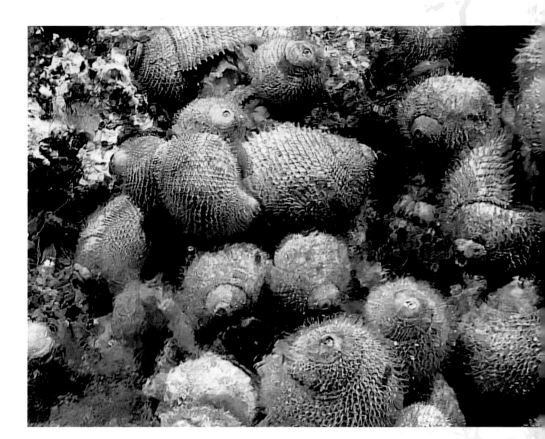

to hydrothermal vent ecosystems. To date we have identified over 300 hydrothermal species, adding weight to the hypothesis that equivalent ecosystems could exist elsewhere in our solar system.

The Underworld

Where an oceanic tectonic plate meets a continental plate, a subduction zone is formed; the oceanic plate is forced underneath forming a precipitous trench. These cavernous trenches make up the hadal zone, aka the hadopelagic, named after the realm of Hades, Greek god of the underworld. This zone extends from 6000 m (18,000 feet) down to the deepest point on our planet, the Challenger Deep in the Mariana Trench, at a colossal depth of 10,929 m (35,856 feet) beneath the waves.

Above: These snails were seen on a dive at the South Chamorro Seamount, 85 km (53 mi) off the Mariana Trench – the mineral-rich hot water released by the vents has blurred the image.
Left: A mound of pillow lava discovered during a 2016 dive off the southern Marianas, at around 4000 m (13,000 ft). The cold water chills the basaltic eruption creating theses pillowy tubes.

At this depth the pressure equates to over a ton pressing down on each square centimetre (16,000 psi). It is this crushing pressure that makes that Challenger Deep one of the least hospitable places on Earth. Should a submersible spring a leak, the water would stream in with enough force to cut through human flesh; should the submersible fail altogether, its operators would be crushed into human smoothies in less than a second.

Above: A Pacific grenadier fish. Grenadiers have been recorded up to depths of 7000 m (22,970 ft).
Opposite (montage, clockwise from top left): A dumbo octopus uses his ear-like fins to swim away in a previously unobserved coiled posture, in an exploration of the Gulf of Mexico, 2014 – dumbo octopuses have since been spotted 7000 m (23,000 ft) down in the Java Trench; a small white drifting fish (potentially Malacosarcus*) recorded during a 2016 ROV dive to the 'Hadal Wall' of the Mariana Trench – a surprise to the scientists, as these types of fish are usually found at shallower depths; a cusk eel in the family* Ophidiidae, *possibly* Eretmichthys pinnatus *– some cusk eels are known to inhabit the upper hadal zone; a possible new species of slit shell snail, discovered during a dive off Pagan in the Marianas – snails are one of the few types of creature discovered to be able to survive in the deepest depths of the hadal zone; a deep-sea cucumber from the genus* Peniagone, *observed at the Mid-Atlantic Ridge, depth c. 2600 m (8500 ft) – other genii of sea cucumber, such as* Myriotrochus, *have been observed much further down, in the hadal zone.*

To date, 12 'aquanauts' have visited this foreboding place, 10 of whom have been in the last decade. The number 12 is significant in that at last, the same number of people have now visited our ocean floor as have the surface of the Moon.

Despite the crushing depths, life still finds a way to exist. Some fish, including grenadiers, eels and the recently discovered Mariana snailfish, are able to inhabit the upper levels. Below 8500 m (25,500 feet), the extreme pressure makes bone formation biochemically impossible; only invertebrates can survive there. Species of worms, sea cucumbers and snails have all been recorded in the Challenger Deep. However, recent dives into the Mariana Trench have yielded perhaps some of the most terrifying finds: plastic bags and food containers. Such discoveries highlight how humans are impacting even the most remote places on our planet.

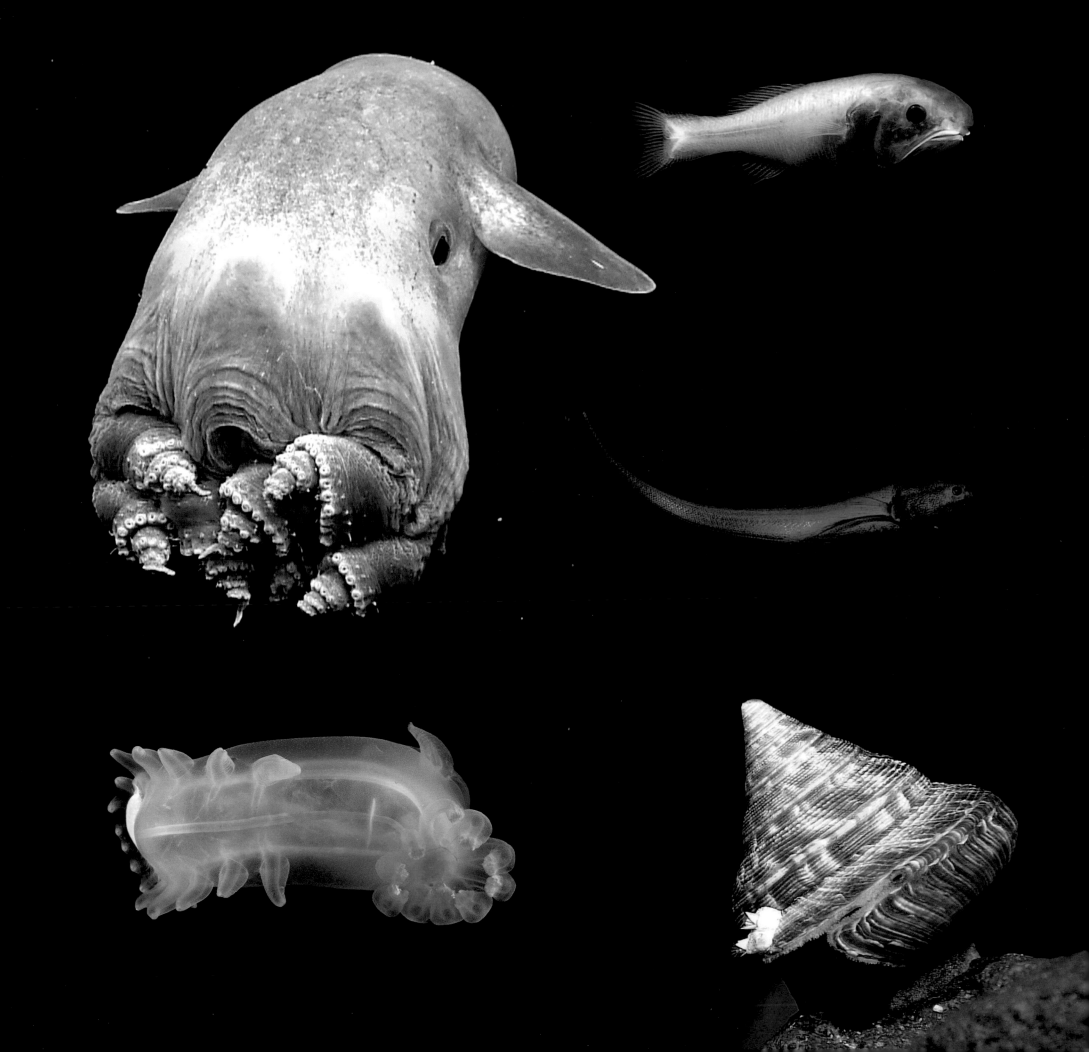

Under Pressure

It is easy to think that the deep-sea ecosystem is detached from the goings-on at the surface, yet this could not be further from the truth. We have already established that the ocean acts as a colossal carbon sink and temperature regulator, yet there have been few studies into the effects of climate change on the deep-sea ecosystem. It is difficult to know how these often slow-growing organisms, most of which are new to science, will be impacted by the warmer temperatures and increased acidity associated with global warming.

Trawling the Depths

As fish stocks in the surface ocean continue to be exploited at an alarming rate, we have now set our sights on the potential bounty of deepwater fish. Technological advances are permitting vessels to access progressively deeper waters; since the 1950s the average fishing depth has increased by over 100 m (300 feet). More and more deep-sea species are popping up in fish markets around the world. In recent years giant deep-sea isopods have been appearing on novelty menus across Southeast Asia. While it may seem prudent to supplement fishing quotas with deep-sea species, it is simply not sustainable. Many species do not reach sexual maturity for decades, making them extremely vulnerable to overfishing.

Left: A trawler net heads down to the bottom of the sea.
Inset: The Viarsa 1 and its catch of illegally caught 85 tonnes of Patagonian toothfish arriving in Fremantle after a 21 day chase, South Pacific Ocean, Australia, 2003. These deepwater fish, also known as Chilean seabass, only reach sexual maturity at about 10 years old, so it takes populations a long time to recover from overfishing.

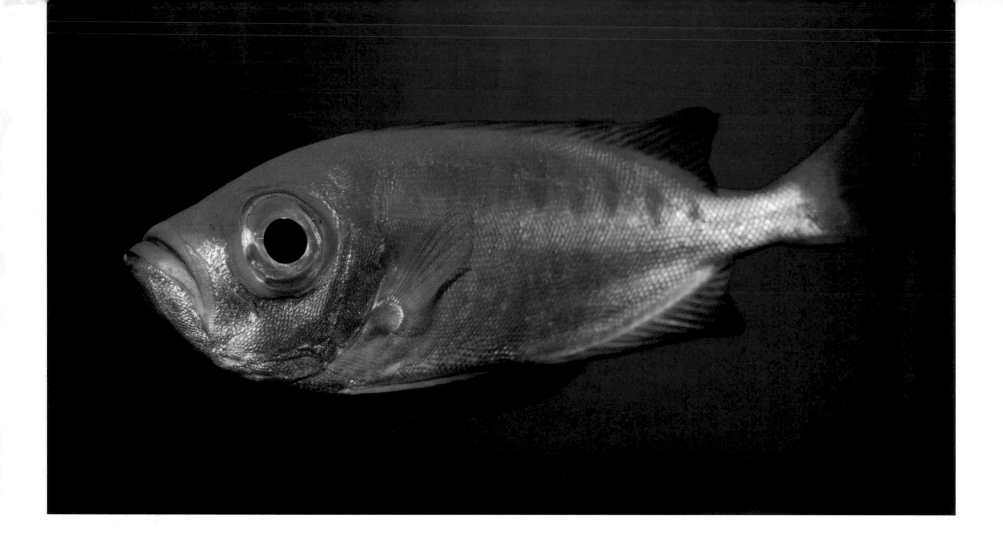

Advances in sonar have allowed fishing vessels to locate seamounts relatively easily, targeting the diverse fish communities found there. As seamounts are often located in the open ocean, beyond the jurisdiction of a country's territorial waters, they are vulnerable to exploitation. Trawlers drag weighted nets along the seamount, snapping the fragile corals, most of which are thousands of years old. Coral bycatch is commonplace, with tons of corals being inadvertently hauled to the surface; in some fisheries the coral bycatch comprises one-third of the total catch.

Mine, Mine, Mine

Nor are fish the only resources in the deep sea. Polymetallic nodules cover vast swathes of the ocean floor, slowly accreting over millions of years via various geochemical processes. As well as iron and aluminium, these egg-sized nodules harbour rich concentrations of rare-earth metals including manganese, nickel, copper and cobalt. With an estimated 500 billion tons of these nodules distributed throughout the abyssal plains, we now have the demand and the technology to begin harvesting them. Nodule harvesters with large tank-tracks are lowered into the deep ocean. Here they trundle along, sucking the precious nodules from the seabed up to a surface vessel.

As well as decimating the benthic organisms that inhabit the sea floor, such harvesters create vast sediment plumes in their wake that smother filter-feeders. The surface vessel also emits a sediment plume in the upper ocean, blocking out sunlight and disrupting the surface ecosystem. With so little known about the deep ocean, we risk wiping species out before we have even encountered

*Above: Because of their slow growth rates and late maturation, the splendid alfonsino (*Beryx decadactylus*) is another deepwater fish that is vulnerable to overfishing.*
Right: Deep-sea corals, as fragile as they are beautiful, grow slowly over thousands of years and are vulnerable to becoming bycatch in trawlers' nets.

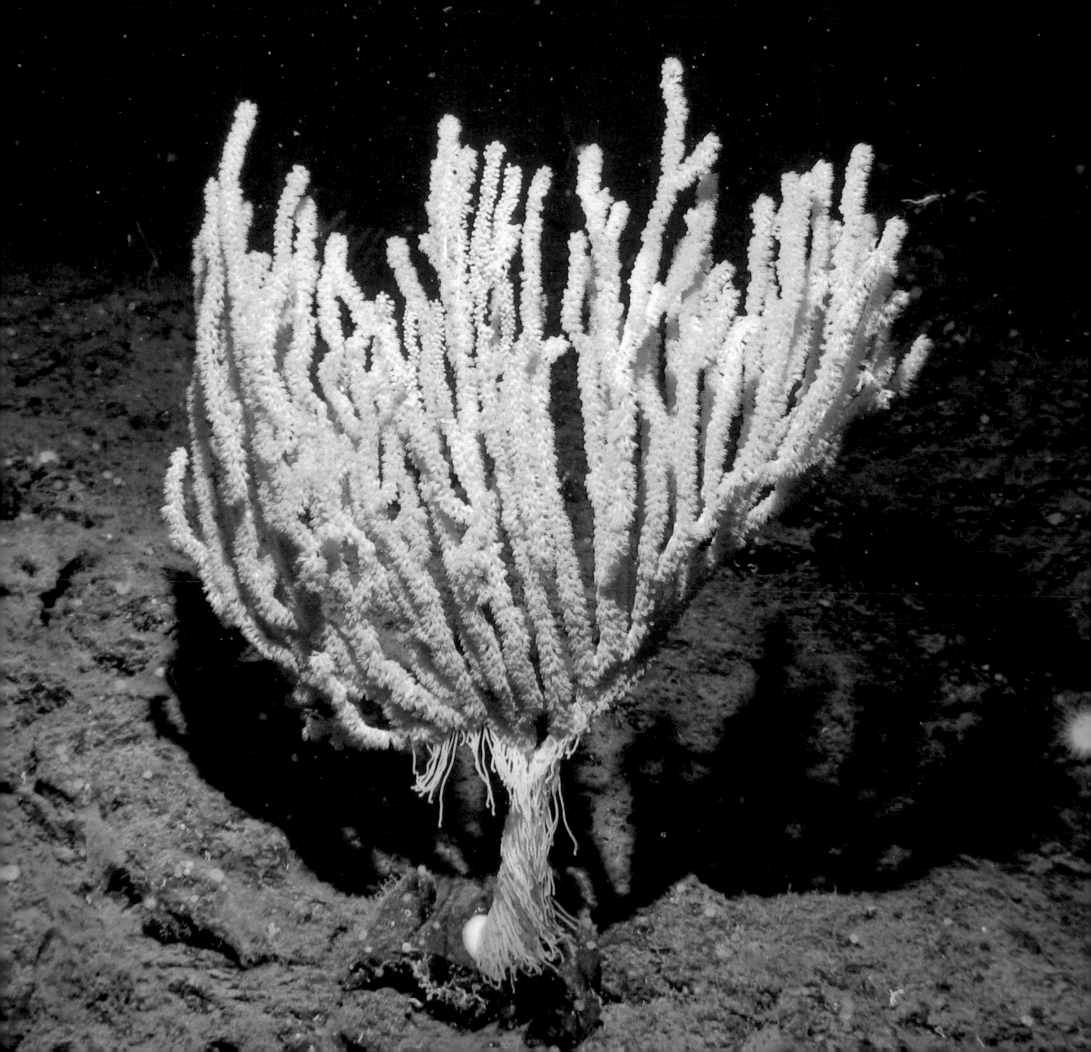

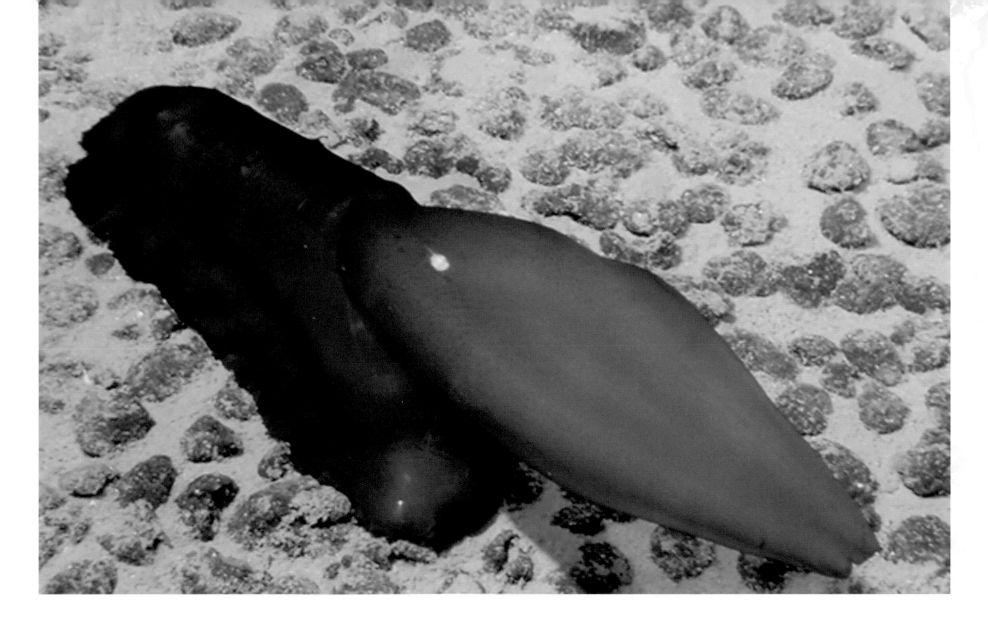

them. The rare scaly-foot snail, or sea pangolin, has the dubious honour of being the first species to become threatened due to deep-sea mining.

It is not just the abyssal plains that are at risk. The deposits that form hydrothermal vent chimneys have been found to be over 1000 times richer in metal ores than terrestrial ores. Plans are already afoot to use ROVs to break the chimneys up into manageable chunks, then to ferry them to surface vessels for processing. While hydrothermal vents are ephemeral features, typically lasting only around 20 years before collapsing, these fragile ecosystems are currently unprotected by any form of legislation. The rare-earth metals contained in the nodules are used in everyday electronics, from mobile phones through to computers and increasingly, our vehicles. In the frenzy to offset our carbon emissions, the switch from petrol and diesel engines to electric power is happening at an accelerating rate. The problem is that the electric vehicles require larger amounts of rare-earth metals than their fossil-fuel counterparts do. For example, an electric vehicle requires four times more copper than a standard car. It is not just electric vehicles that are increasing our demand for rare-earth metals, however; they are also essential constituents in solar cells and wind turbines. It is vital that our 'green revolution' does not simply shift the environmental damage from our atmosphere to our deep ocean.

Above: A sea cucumber (Psychropotes semperiana) *above manganese nodules on the Kaplan abyssal plain in the Pacific Ocean.*
Opposite: *An artist's impression of an ROV mining a hydrothermal vent chimney.*

Out of the Deep

As we slowly discover more and more about the deep ocean, it is imperative that legislation is put in place to protect these fragile, slow-to-recover ecosystems. As with the high seas, as soon as the sea floor reaches beyond a country's Exclusive Economic Zone, it is currently fair game for unimpeded exploitation. Until this is restrained, we can all play a part to ensure the continued prosperity of the deep.

Choose Wisely

As consumers, we all have the power to vote with our wallet. Quite simply, if you see a deep-sea species in a fishmonger or on a restaurant menu, it is best to avoid it. This is often easier said than done, especially when fish are

Above: Discovered as an alternative to overfished cod and haddock in the 1970s and rebranded from 'slimehead' to 'orange roughy', this deepwater fish was intensively harvested down to worrying levels within a few decades. Its chance of recovery lies in permanent reduction of fishing intensity.
Right: Black scabbardfish at Funchal fish market, Madeira. This deepwater fish has commercial value in France, Spain and Madeira. While not considered endangered, its deepwater nature makes it potentially vulnerable to overfishing

often mislabelled or not labelled at all. The best advice is to stick to surface species from well-maintained stocks that have been caught using sustainable methods such as line-and-pole; if you do, you can't go far wrong.

Exploration

Working in the deep ocean is orders of magnitude more difficult than working in space. While astronauts contend with the effects of micro-gravity and high radiation levels, astronauts typically stay in space for a minimum of six months; the longest continual stay is currently 14 months. By contrast, the longest underwater stint currently stands at a mere 73 days and that was at just 7.3 m (22 feet). As well as the crushing pressures, breathing compressed air in a humid environment takes its toll on the body of any aquanaut living underwater for any amount of time. As well as having to operate while being 'narced' (suffering from nitrogen narcosis, an intoxicating condition resulting from the breathing of compressed air), aquanauts are at the mercy of decompression sickness ('the bends'), fatigue, nappy rash, insomnia, trembling, ear infections, loss of taste and osteonecrosis.

Further advances in sonar technology are allowing us to survey the ocean floor in increasingly higher resolution. To date we have mapped around 15 per cent of the ocean floor to a resolution of 100 m (300 feet). In comparison, we have mapped the entire surface of the Moon to a resolution of 7 m (21 feet). Clearly we still have much to discover about our own planet. With the annual global space exploration budget being around 200 times greater than that of ocean exploration, it is little wonder that we know more about planets millions of miles away than we do our own ocean. At present we discover a new deep-sea species every two weeks; who knows what wonders are yet to be uncovered? Instead of looking upwards to the stars, we should focus on our own planet first and foremost. Or, as submariner Graham Hawkes has succinctly put it, 'your rockets are pointed in the wrong goddamn direction!'

Left: Almost every time we visit the deep ocean, we discover a species that has never been seen before.

Deep Ocean

177

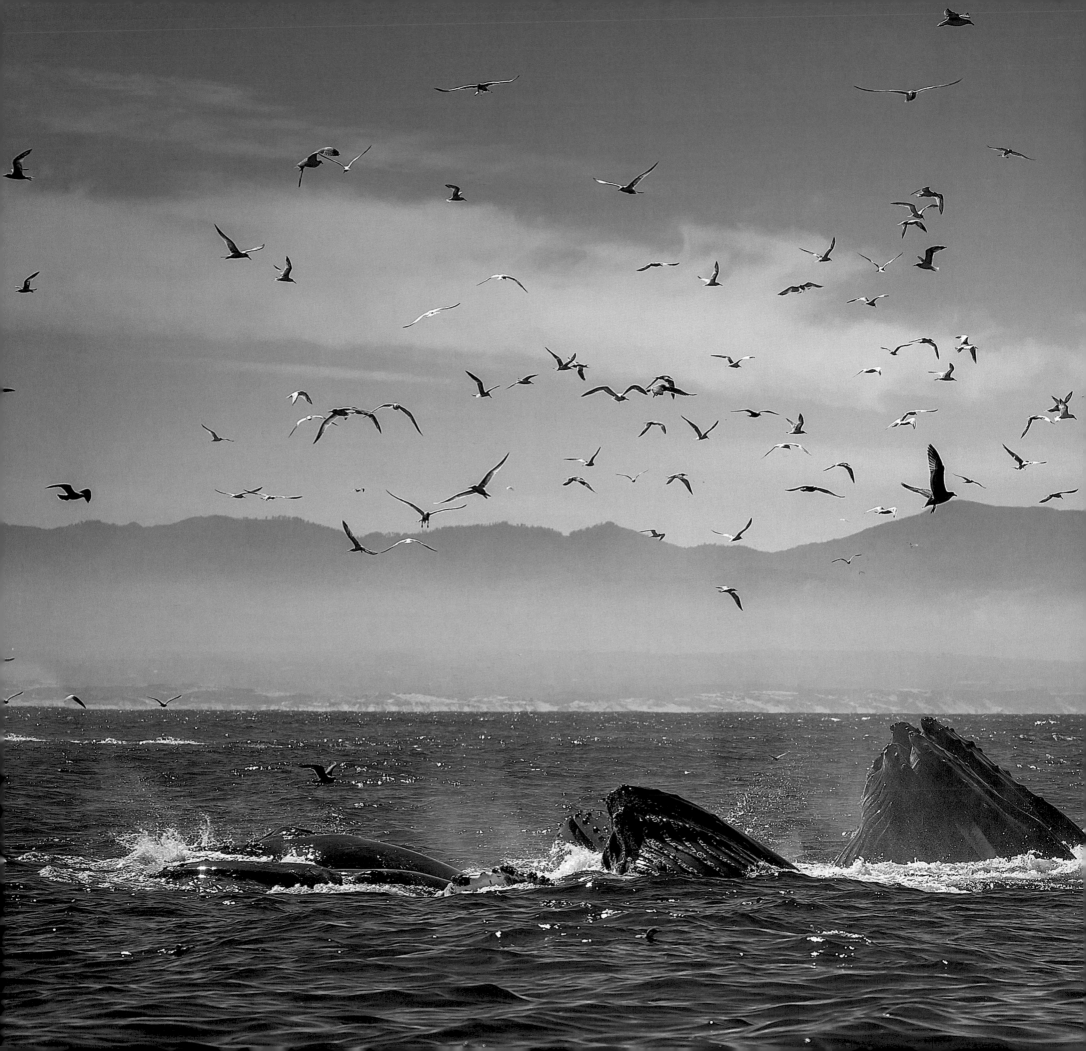

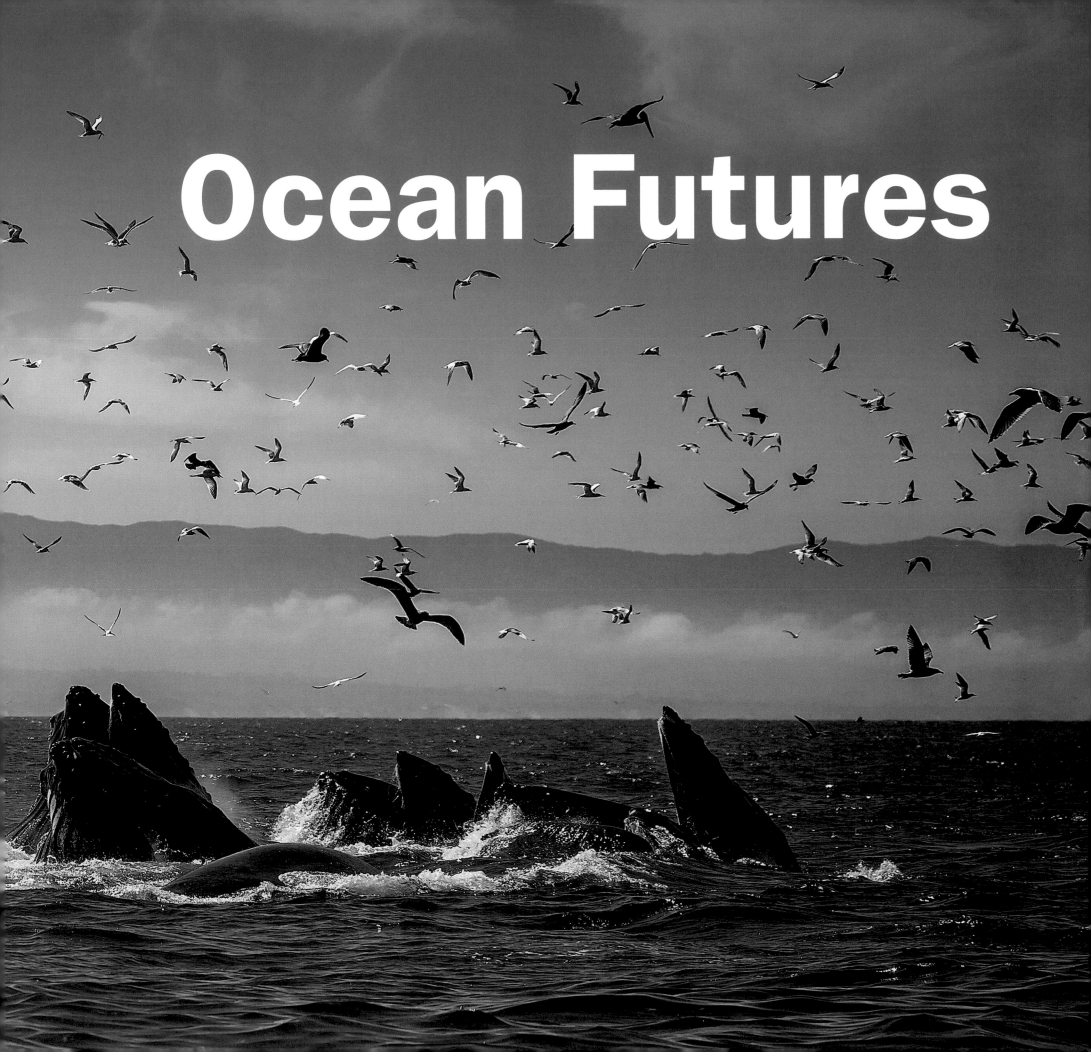

Ocean Futures

Celebrating Our Ocean

*'With knowing comes caring
and with caring comes hope.'*

Sylvia Earle, ocean explorer

Throughout this book, we have celebrated the wonders of our ocean in all its forms. We have also seen the multitude of threats the marine environment faces at all levels. While this new awareness can be overwhelming, it is important to realize that we currently hold the solution to many of these problems. As we increase our knowledge of the marine environment and understand the impact our activities have on it, we also understand better how to mitigate against these.

A Sea Change

When it comes to protecting the marine environment, education is the key. The term 'ocean literacy' has been coined to describe a fundamental understanding of the ways in which our ocean affects us and we affect the ocean. Ensuring society at all levels is engaged in our ocean is a challenge; one of the greatest barriers is the fact that the ocean is all but absent in most countries' national curricula. Unless we weave aspects of ocean literacy throughout the curriculum, we risk raising generation upon generation of people who do not appreciate the importance of our ocean. Thankfully

Previous page: *A pod of humpback whales lunge feed in Monterey Bay, California.*
Right: *Ocean education can take many forms, but at any age there is no substitute for a visit to the coast.*

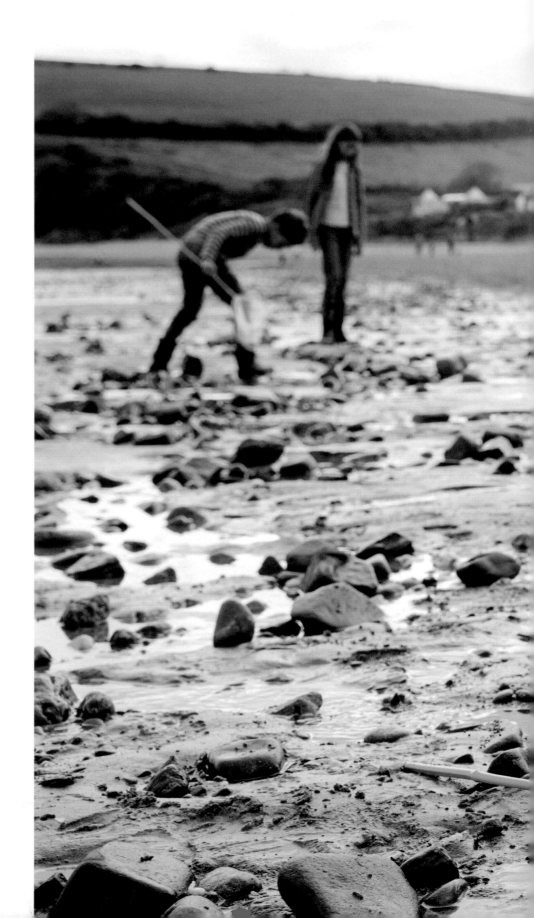

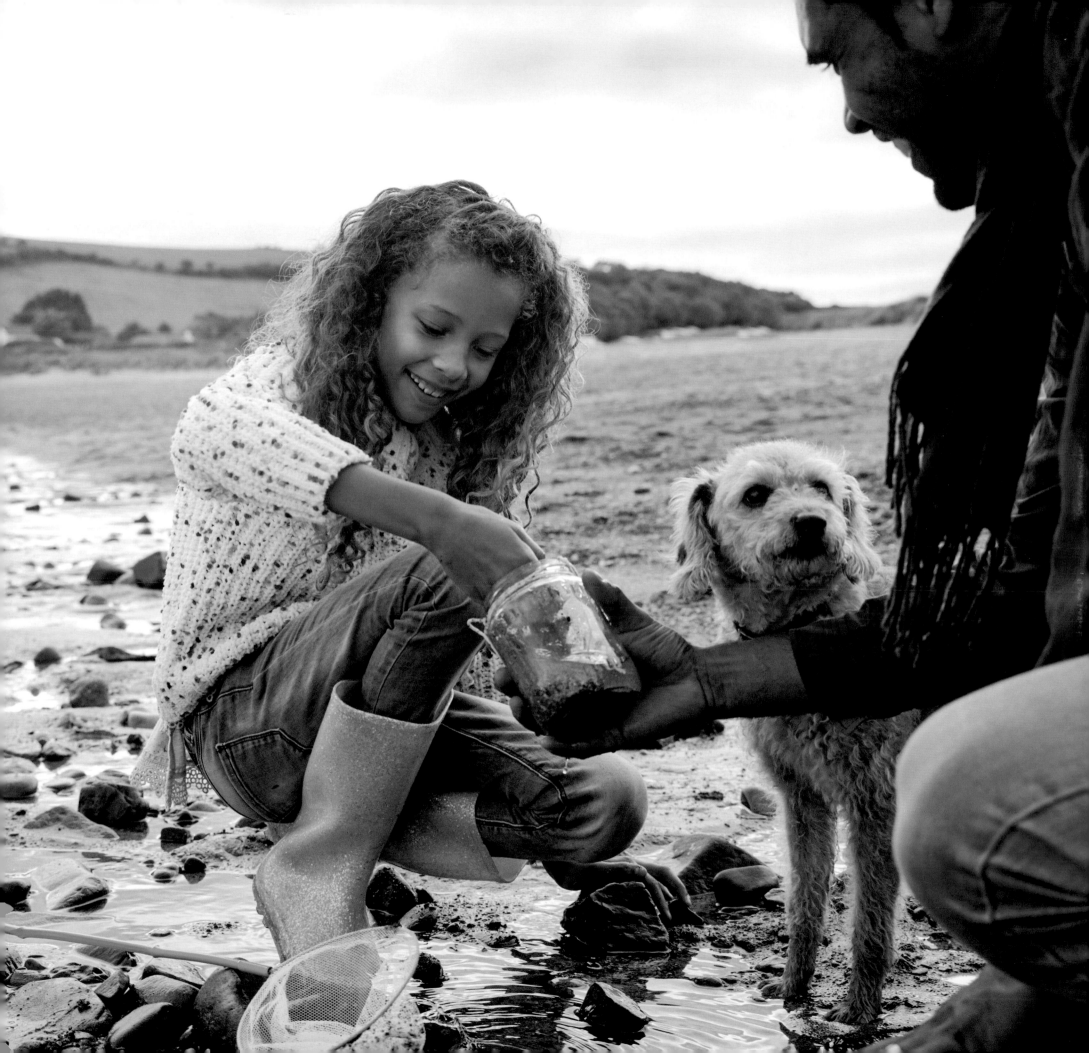

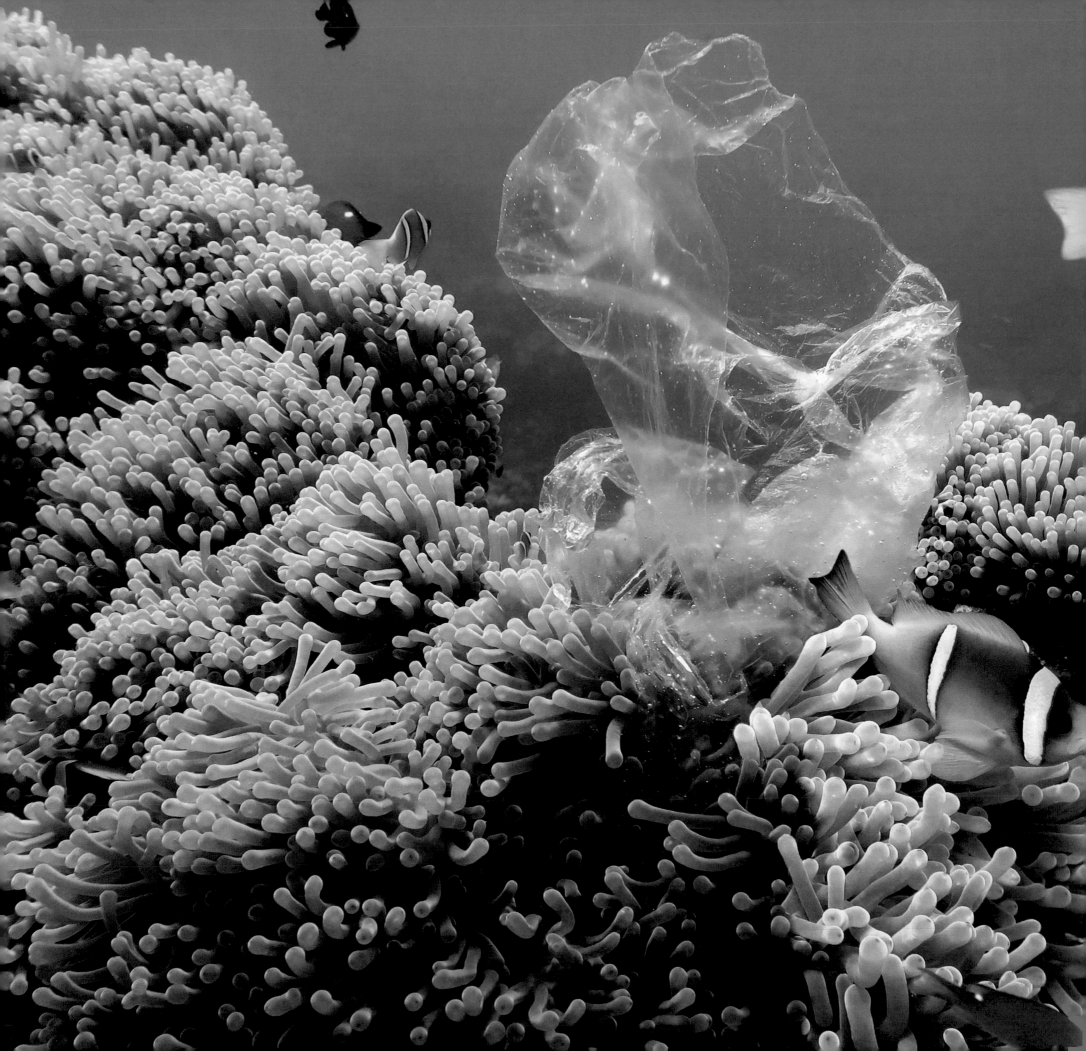

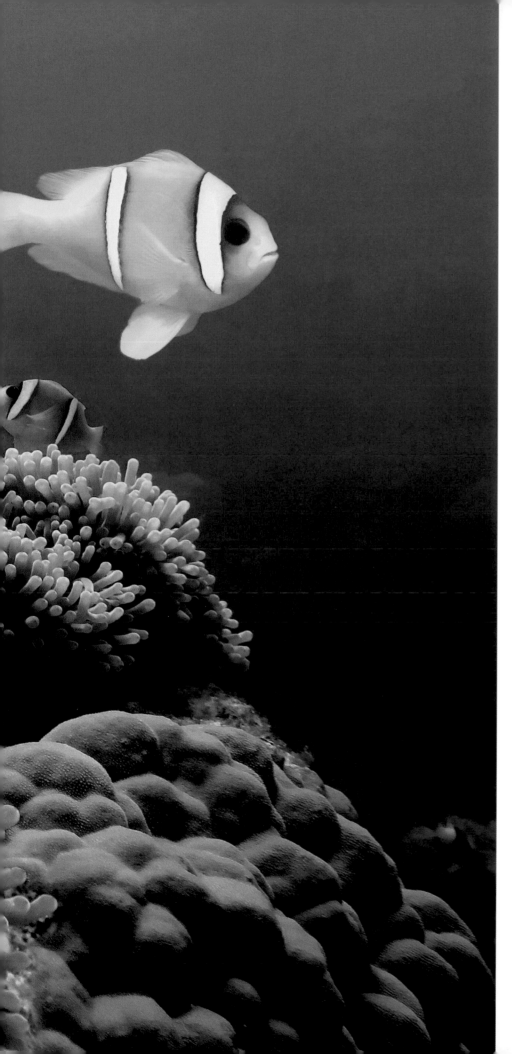

initiatives such as the Blue Schools programme in Portugal show how, with collaboration and proper funding, ocean education can be integrated successfully into schools across an entire country.

Cleaning up our Act

Slowly we are waking up to the environmental consequences of plastic waste. Social media and David Attenborough's television series *Blue Planet II* have mobilized people around the world to stand up against the disposable lifestyles thrust at us. With bans (to varying degrees) on microbeads, plastic straws and carrier bags achieved, we are making progress. Alas, most of the onus is still placed upon the consumer to make ethical decisions, which takes education, effort and (often) money. In order to be truly effective, we need government intervention to make manufacturers responsible for their products through their entire lifecycle.

Left and above: We should reuse or avoid disposable plastics so that they never even get to the beach or ocean to be cleaned up.

Bioplastics are an excellent alternative. Around the world scientists are developing new polymers using chitin from shellfish shells, seaweeds and corn starch which biodegrade quickly, dissolve or are even edible. However, this does not give us carte blanche to persist with our disposable lifestyles. Any items we make still require energy and use valuable resources, so we should be mindful not simply to replace one damaging practice with another. The true solution is reusing, not recycling.

A Shared Resource

Marine protected areas (MPAs) are a simple way to ensure the long-term health of our ocean. By restricting commercial activities and introducing effective legislation, an area is given space and time to recover. If properly implemented and policed, MPAs are highly effective. In 2012 the region around the island of South Georgia in the South Atlantic was designated an MPA. Covering over one million square kilometres, it is the fifth largest MPA on Earth. Despite having been the epicentre of modern whaling in the 1950s, South Georgia has seen a 70 per cent recovery of southern hemisphere humpback whale populations – proof that sustained conservation efforts supported by science are having an effect. At present, less than 3 per cent of our ocean is 'highly protected'. With industrial fishing present in 432 of the 727 European MPAs, much work is still to be done if we are to meet the goal of protecting 30 per cent of our ocean by 2030.

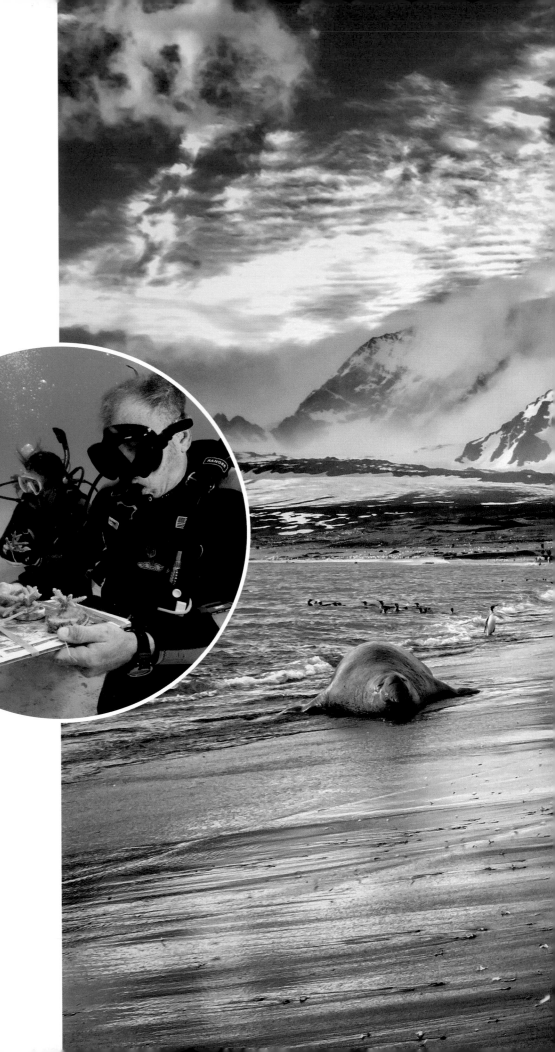

Inset: Marine biologists cultivate stag-horn coral in an underwater nursery off the coast of Florida. Once the coral is established, the colony will be relocated to a damaged reef site off Key Largo in the Florida Keys, one of 16 marine protected areas in the US.
Right: King penguins and a southern elephant seal at St Andrews Bay, South Georgia, home to the fifth largest marine protected area on Earth.

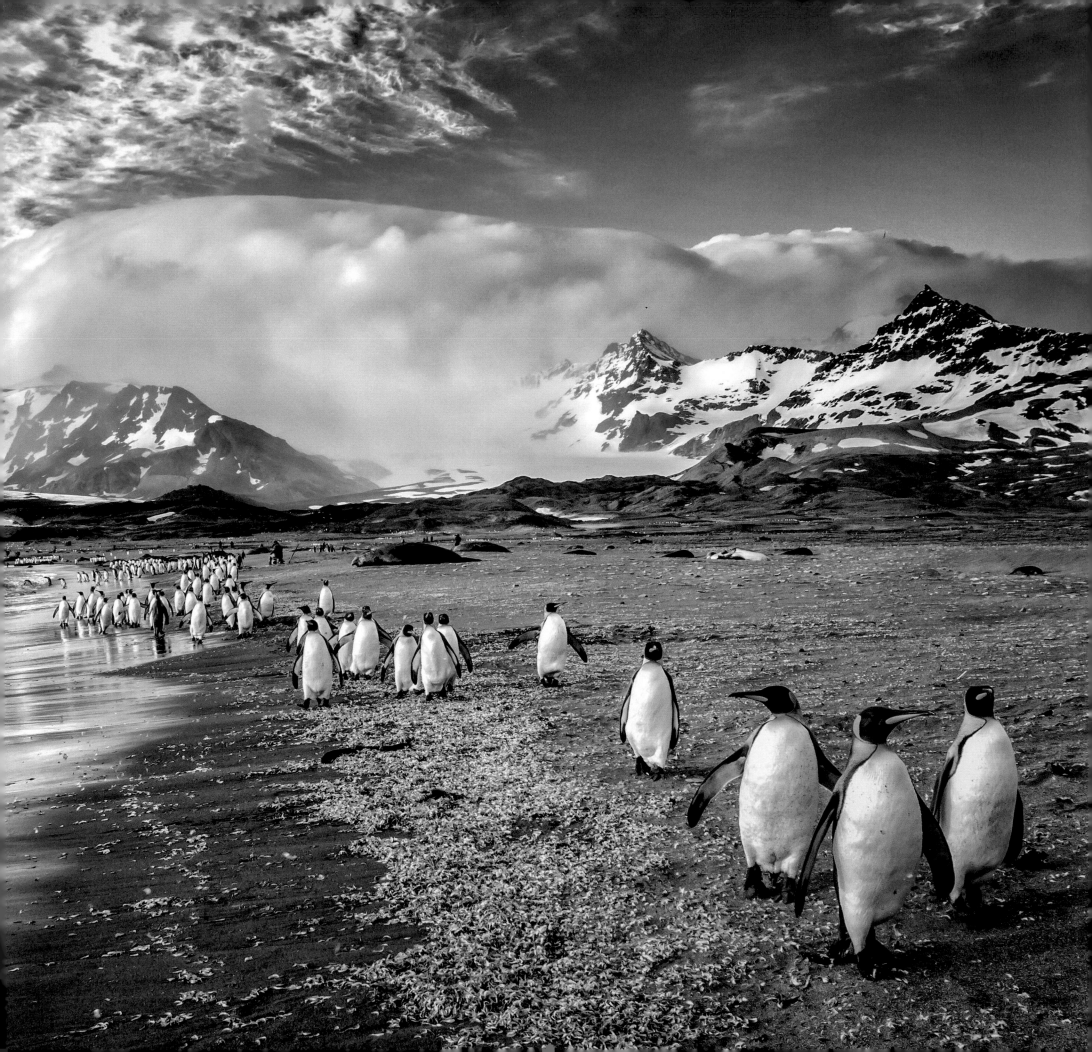

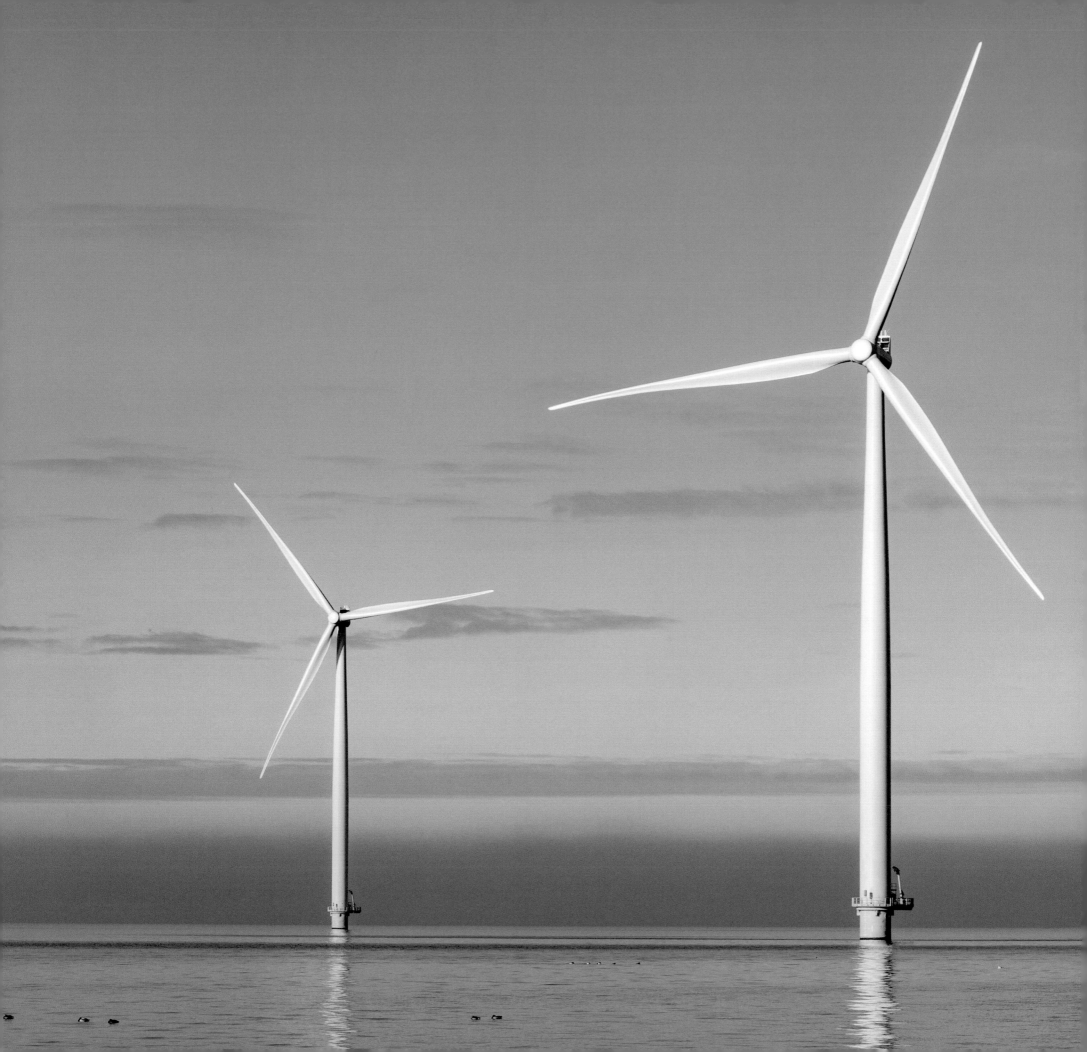

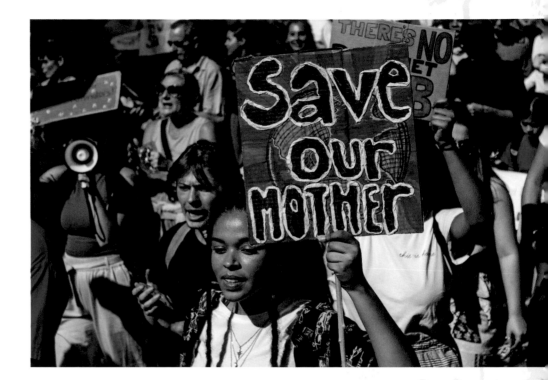

Turning the Tide

The issue of climate change has never featured so highly in people's minds. From the School Climate Strikes started by Greta Thunberg through to the global Extinction Rebellion movement and even the British Royal Family, people of all ages and backgrounds are rising up to lobby governments and companies to act.

One of the most frustrating aspects of climate change is climate justice, or rather injustice. The affluent lifestyles of the richest 1 per cent of people produce double the amount of greenhouse gas emissions than the poorest 3 billion people combined. Yet the poor communities are least able to protect themselves from the rising sea levels and extreme weather events that are the consequence of climate change. Just as we have been viewing our ocean

Above: "What do we want? Climate action! When do we want it? Now!" The climate protests and school strikes of recent years, such as here in New York in 2019, have seen people of all ages and backgrounds come together for the good of the planet.

Left: Westermeerwind Wind Farm, the largest near-shore wind farm in the Netherlands. As well as providing clean electricity, offshore wind farms also provide a safe haven from shipping and fishing for many marine species.

Ocean Futures

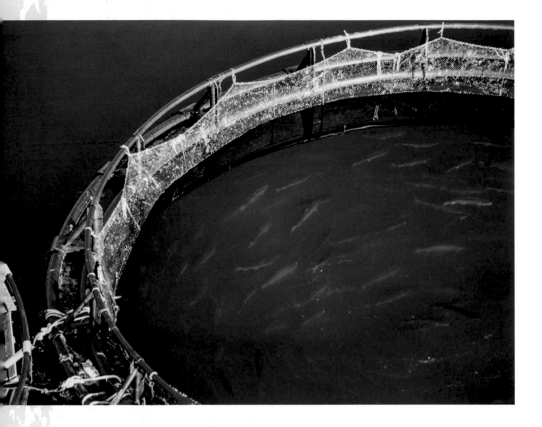

Ripples of Change

Since 1990 there has been a 500 per cent increase in aquaculture and a 120 per cent increase in fishing; fish now accounts for 17 per cent of all the animal protein consumed globally. This growth in demand puts increasing pressure on our marine resources. The good news is that proper management of fisheries does yield results; an increasing amount of our fish is now being caught from biologically sustainable stocks. As more emphasis is placed on aquaculture to subsidize the wild-caught fish, it is imperative that this sector also adopts more sustainable practices. Innovations such as floating mariculture spheres allow entire shoals of fish to be encased in deeper waters. This both provides more humane conditions for the fish and circumvents much of the environmental impact.

Then, of course, there is the burgeoning industry of seaweed farming. As well as providing a fast-growing, sustainable source of healthy food, seaweeds can be used in cosmetics and fertilizers. With a focus on providing a sustainable alternative to our fossil fuels, seaweed biofuels now have the endorsement of the aviation industry. While the majority of seaweed is grown and consumed in Asia, new farms are now starting up across the world.

as a single entity throughout this book, we also need to view our planet as a single interconnected system. Recognizing that we all share the Earth and that all of our individual actions, intentional or otherwise, have repercussions is crucial in addressing climate injustice.

Using our remaining fossil fuel reserves to implement a green future is not only the ethical thing to do, but also makes economic sense. With 30 per cent of our global energy needs now being met by renewables, the world is on track for a greener future. As technology advances, we are improving the efficiency, robustness and price of existing technologies, helping them to be implemented around the world. As more people invest in renewables, greater focus is being placed on our ocean as a means by which to generate electricity; as well as offshore wind farms, we now have wave power, tidal power and geothermal energy to add to our arsenal.

Rising to the Challenge

Most promising is a 2020 study, 'Rebuilding marine life', that was published in the scientific journal *Nature*. Bringing together marine scientists from across four continents, the study details a road map to recovery for our ocean; it emphasizes that we possess the technology and expertise to repair the damage by 2050, within a single human generation. As lead scientist Dr Carlos Duarte put it: 'We have a narrow window of opportunity to deliver a healthy ocean to our grandchildren's generation, and we have the knowledge and tools to do so. Failing to embrace this challenge – and in so doing condemning our grandchildren to a broken ocean unable to support high-quality livelihoods – is not an option.'

Above: Salmon fish farm, Grand Manan Island, New Brunswick, Canada. Aquaculture can be a force for good, but the industry needs to adopt more sustainable practices.
Opposite: Seaweed plantation, Zanzibar, Tanzania.

Index

Page numbers in *italics* indicate illustration captions

For further illustrated books on a wide range of subjects,

in various formats, please look at our website:

flametreepublishing.com